Art in Europe 1700-1830

Oxford History of Art

Oxford History of Art

Art in Europe 1700-1830

A History of the Visual Arts in an Era of
Unprecedented Urban Economic Growth

Matthew Craske

Oxford New York

OXFORD UNIVERSITY PRESS

1997

Oxford University Press, Great Clarendon Street, Oxford OX2 6DP
Oxford New York
Athens Auckland Bangkok Bogota Bombay
Buenos Aires Calcutta Cape Town Dar es Salaam
Delhi Florence Hong Kong Istanbul Karachi
Kuala Lumpur Madras Madrid Melbourne
Mexico City Nairobi Paris Singapore
Taipei Tokyo Toronto
and associated companies in Berlin Ibadan

Oxford is a trade mark of Oxford University Press

British Library Cataloguing in Publication Data
Data available

Library of Congress Cataloging in Publication Data
Data available

0–19–284206–4 Pbk
0–19–284246–3 Hb

10 9 8 7 6 5 4 3 2 1

Picture Research by Elisabeth Agate
Designed by Esterson Lackersteen
Printed in Hong Kong
on acid-free paper by
C&C Offset Printing Co., Ltd

Contents

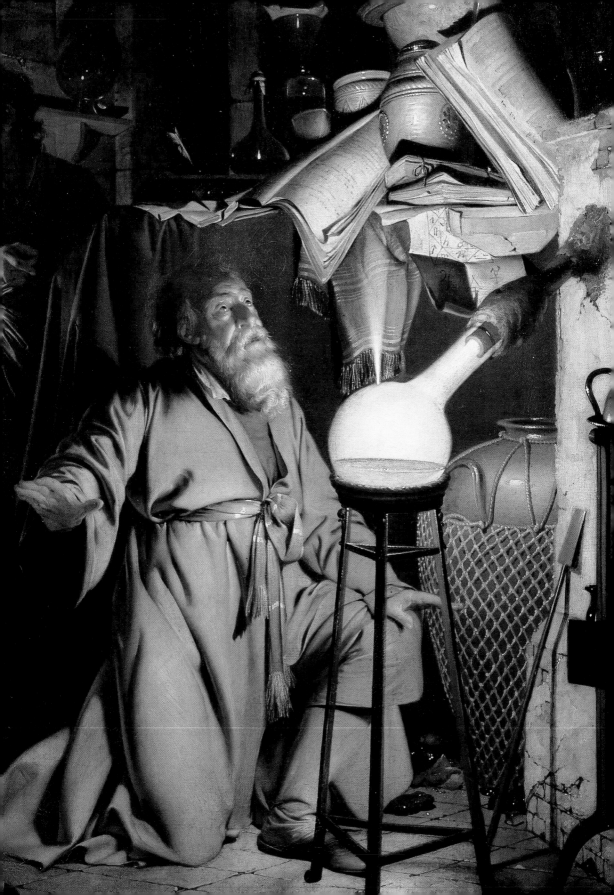

Introduction

Rococo to romanticism: a problem of definition or a question of belief?

The late twentieth century is an age of academic specialization. Modern scholars need encouragement from publishers to write ambitious historical surveys. I have not been an exception. This book was written in response to a request to compile a thematic account of the visual arts of eighteenth- and early nineteenth-century Europe. My brief was interpreted as an opportunity to identify and analyse the essential and characteristic artistic preoccupations of the times and to posit some historical explanations for the emergence of these preoccupations.

The reader might find my concern to arrive at historical explanations of change to be rather commonplace. I argue, on the contrary, that a considerable amount of energy has been devoted to producing accounts of eighteenth- and early nineteenth-century art which display little interest in analysing the fundamental historical causes of change. Broad surveys of the development of the visual arts in the Europe of this period are largely concerned with the process of classification rather than analysis. European art was variously categorized as 'rococo', 'neo-classical', and 'romantic'. All three terms are, even by the admission of those who have promoted their use, either completely anachronistic or powerfully associated with a mass of 'modern' inflections of meaning which render them difficult to define and meaningfully to employ.

Those who have expended much thought on trying to define these European art 'styles' or 'movements' or to explain the transformation from one to the other have generally resigned all responsibility for explaining what brought about their supposed existence. Fiske Kimball in the introduction to his *The Creation of the Rococo* (1943, reprinted 1964 and 1980), declared openly that he considered it wise not even to ask why the rococo came into existence or to question what it connotes.

As in any broad study of artistic creation and evolution, the questions to be answered are: what? how? when? where? and who? As to why; we follow

Detail of 100

Goethe's sage advice, and do not ask. It is possible to point to certain relationships with political, social and economic movements, certain analogies with trends in criticism and other arts, certain influences and derivations but not causalities. Essentially, we shall find, the development is immanent, the miracle of creation is wrapped in the mystery of personal artistic individuality.

Kimball argued that the term 'rococo' derives from the word *rocaille* or 'rock work', a word which was in use during the so-called era of the rococo. He could not, however, claim that the term *rocaille* was employed to describe a cogent style and settled for the assertion that the concept of the 'rococo style' came into existence at some time in the nineteenth century. This left him with the task of defining the style in accordance with unhistorical and largely personal criteria. Kimball's title, *The Creation of the Rococo* is ironically apposite for it was he that was creating the rococo.

As a consequence of having no contemporary currency the term 'rococo' has come to be used indiscriminately. The style has been seen in a bewildering variety of art works with little tangible connection. Anthony Blunt, sensing that the word was being applied so broadly as to lose all meaning, wrote what he hoped would be a definitive pamphlet entitled *Some Uses and Misuses of the Terms Baroque and Rococo as Applied to Architecture* (British Academy, 1972). Blunt also could not determine what the rococo was in concrete historical terms and chose instead to assert what he, as an authority on art, believed it to be. A 'misuse' of the term 'rococo' became, in essence, no more or no less than a usage which did not please the author. To use the term rococo and to pontificate on the origins and meaning of the supposed style remains, inevitably, a matter of arbitrary connoisseurial judgement rather than historical reasoning.

To describe an art work as rococo is, as a consequence of these academic problems, to say very little that one explicitly means and very much that one does not. To say what one does not explicitly mean when using this term can easily run contrary to one's responsibility to act as impartial historical commentator. It is easy not only to abuse the term but also to turn it into abuse. As a word which began life in the late 1790s as an insulting onomatopoeic term for the art of an *ancien régime* court then considered decadent, frivolous, and vapid, 'rococo' is, perhaps, inseparable from a set of derogatory connotations. Michael Levey in his *Rococo to Revolution* (1966) provides a textbook example of how unguarded use of a style term can reduce historical writing to a set of cavalier value judgements. The rococo is first invested with a biographical identity, with phrases like 'the rococo was not yet exhausted', and then subjected to a character assassination with phrases such as 'the truths so lacking in rococo art'.

Amongst the reviews of the supposed phases of European art in this period Kimball and Levey's approach stands out as conspicuously ahistorical. Robert Rosenblum's rightfully admired *Transformations in Late Eighteenth Century Art* (1967), perhaps the most authoritative study of the transition from 'rococo' to 'neo-classicism' to 'romanticism', is clearly a considerably more sophisticated work. However, it is not, by its author's own admission, an analysis of the fundamental historical causes of these supposed transitions.[1] Rosenblum worked within a scholastic milieu in which such European artistic movements were habitually construed as largely autonomous cultural phenomena rising and declining in accordance with grand shifts in the direction of civilization. The rise of 'neo-classicism' was routinely associated with that of a supposed 'age of reason'. In turn, the decline of the 'movement' has been associated with the dawning of a supposed 'age of passion' which found its expression in the art of 'romanticism'. Rosenblum, a subtle scholar, attempts to liberate his account from such clichés by, for instance, acknowledging the high emotionalism of art that might otherwise be defined as 'neo-classical'. His whole account of the period, however, is fundamentally concerned with keeping the old, period clichés alive by acknowledging their limitations and subtly departing from them.

In the introduction of his *Transformations* in which he deals with 'some problems of definition' Rosenblum is careful to assume a sophisticated sceptical stance. He admits that when confronting the phenomenon of 'neo-classicism' that 'must at times comprise forms and emotions as unlike as those found in Fuseli and David, Carstens and Girodet, Sergel and Greenough, Schinkel and Nash' he finds himself wondering whether, 'neoclassicism may properly be termed as a style at all, or whether, it should not be properly termed, to use Giedion's phrase, a "coloration" '.

The concept of a cultural 'coloration' is highly problematic if not impenetrable. It would appear to describe a tendency which, like a colour, we appreciate as distinct with our senses or intuition but would be incapable of intellectually defining. Rosenblum, probably unconsciously, suggests that this manifestation 'must' be deemed to exist whatever the problems of defining it. Appropriately for the study of a period in which 'great art' began to assume the aura of a religion, the existence of such movements as 'neo-classicism' and 'romanticism' has become a matter for belief. Like gods in an era of agnosticism, belief in them is upheld even when it is acknowledged that there is little concrete evidence of their existence and that they are beyond definition or clear comprehension. The demand of writers of textbooks that their readers should believe first and ask questions later is made clear with varying degrees of subtlety. In the first sentence of his *Romantic Art* of 1978 William Vaughan declares that: 'Whatever else is said about the

Romantic movement, no one can deny that it really did happen.' This rather doctrinaire claim can be taken as a very considerable spur to independent thinkers to assume the role of 'no one'. Having assumed this role one could point out that the 'romantic movement' as both a specific linguistic construct and broad concept did not exist in the period 1790–1830.

Scepticism within the context of *a priori* belief can be reduced to a rhetorical exercise. It has, accordingly, become a veritable generic characteristic of books on 'the romantic movement' or 'neo-classicism' that they should begin with a few pages of rigorous sceptical examination of terms so that the same terms can be used with impunity thereafter. Authors introducing general texts on 'romanticism' often begin with liberal reference to the works of sceptical scholars from the field of the history of ideas who are quoted but not taken seriously. The views of A. O. Lovejoy, in particular, are more often cited than taken into academic consideration.[2] His oft-cited advice that we should talk of a number of 'romanticisms' rather than 'romanticism' must, surely, caution against the glib use of the phrase 'romantic movement'. It is, on the contrary, quoted as a prelude to so doing. Similarly the reader's attention is regularly drawn to the sceptics' assertion that even the most famous 'romantics' denied that they were romantics on the understanding that the term was an insult. The caution having been registered, the same figures continue to be regarded as exemplary 'romantics'. It is as if it is too difficult to contemplate the period or the personalities without the term.

All of the phases imposed upon the period by art historians are assumed to be pan-European phenomena. This applies even when scholars acknowledge the essential differences between, for example, British and German manifestations of 'romanticism'. The mere habit of using a common vocabulary to describe disparate phenomena can cause considerable problems. A shared linguistic description gives the impression, even when it is not intended, that artists or art works share values and reinforces the myth of international art 'movements'.

To some degree the use of these period terms has reflected and sustained a monolithic vision of European art and civilization. When considering art-historical problems of international scope the majority of art historians have to adopt a cosmopolitan vision of Europe. Europe is assumed to be a distinct civilization which developed in cogent phases. This tendency reflects a tradition of cosmopolitan thought which, as we shall see in Chapter 2, stretches back into the eighteenth century; a tradition of associating cultivation of mind, both in scholastic and connoisseurial fields, with the assumption of a cosmopolitan vision of European culture. It is still deemed civilized to believe in European civilization. Works such as Levey's *Rococo to*

Revolution and Rosenblum's *Transformations* are the unacknowledged heirs of this intellectual tradition; covert arguments in favour of the concept of a monolithic European civilization.

In this book I have set out to avoid being civilized in this sense; to avoid working from the *a priori* supposition that we can talk in terms of the development of 'European art'. I have set out to explore the problem of whether Europe had a meaningful cultural identity rather than to proceed from the belief that it did. Readers will soon gather that I arrived at a certain ambivalence. I have been knowingly inconsistent in my attitude to the concepts of 'Europe' and 'European art'; willing at times to utilize concepts such as 'European thought' or 'the enlightenment vision' but on other occasions ready to insist that there can be no generalization in the discussion of the culture of one part of the Continent that can be transferred to another.

In defence of my ambivalence and inconsistency I maintain that the analysis of the art of a period which has variously been linked with the apotheosis of the ideology of cosmopolitanism and rise of 'modern' doctrines of nationalism demands such scholastic treatment. There are, at once, the strongest reasons for thinking in terms of 'art in Europe' as allied to a series of self-consciously different regional or national cultures and the strongest reasons for thinking in terms of a 'European art' tradition which was a facet of a broader entity described as 'European culture'. In respect to the complexities of these problems I have devoted a quarter of this book to the exploration of the impact of newly arising concepts of national and supra-national identity upon the visual arts. I have chosen to do this in the awareness that I write at a time when the issue of whether there is, or historically has been, such a thing as a cogent and meaningful European culture is haunting political debate and threatening the survival of political administrations. I am suspicious of attempts to make history relevant but argue in my defence that these matters are relevant to the late twentieth-century reader for good historical reasons. This period saw the birth of 'modern' debates on European cultural identity and we live out their ramifications today.

If to ascribe to and perpetuate the model of 'European art' developing through grand and cogent phases can be held to be a matter of belief, this book is declaredly the work of an infidel. It is, however, written in a spirit of respect for the faithful; intended to be read alongside the laudable surveys of Vaughan and Rosenblum rather than to be an alternative to them. Far from wishing to overturn their vision of the period I am deeply indebted to it, in particular that set down by Rosenblum in his *Transformations*. Much as sceptical acceptance of broad period terms was an academic stance dictated to Rosenblum by his scholarly ambit, to experiment with where history might take us if we should remove all sense of grand structure is part of my scholarly

world, a world which has had to absorb the consequences of decon-
structivist theory.

The impact of urbanization: new art publics, new types of art, new types of artist and new theoretical discourses

In accordance with fashion this book boasts a rather grand subtitle: 'A History of the Visual Arts in an Era of Unprecedented Urban Economic Growth'. True to the promise of my subtitle, my text gives priority to the discussion of the social and economic causes of art-historical change. Unlike the 'neo-classical' or 'romantic' movements urban economic growth is a demonstrable fact of history. When basing my analysis on a set of concrete historical occurrences I was not, how-ever, attempting to establish myself on an unproblematic scholastic territory. Although the growth of certain European cities and towns is measurable and well documented, historical debate on the causes, manifestations, and social consequences of European urbanization bristles with thorny problems. Similarly, discussion of the effects of urbanization on the various European art worlds is far from being an uncontentious area. It is, in fact, the *locus classicus* of modern Anglo-American debate upon the art history of this period.

European urbanization was a complex phenomenon both in geo-graphical and conceptual terms. Rapid urbanization was not a central part of the human experience of all Europeans at this time. Indeed, many European cities declined in population and economic productiv-ity. Urbanization occurred for a variety of reasons and was highly diverse in its social and political effects. St Petersburg, a city founded on a barren wilderness by Peter the Great, grew up around the hub of the court and was designed to affirm daily the authority of that court over trade and culture. London, by contrast, grew into a great trading capital at the direct expense of the power and significance of a court, the authority of which was limited by parliament and the decisions of which had little direct part to play in the city's economic prosperity.

The range of urbanization's social consequences was reflected in the extraordinary variety and complexity of cultural attitudes to the notion of the city and the country which appeared in the art of the period. We will see images which reflect the extreme progressivism of patron and artist alike; images which still powerfully communicate the artist's confidence in the benefits of urban 'improvement'. We will also encounter dismay at the ugly incursion of the city and city values upon the rural landscape, disgust at the regimentation of the environment, and artists' fear of losing their individuality and cultural identity in the social morass. A perplexing cocktail of positive and negative attitudes to urban growth arose concurrently not only in society at large but also in the minds of individuals.

I have attempted not to mask or ignore the complexity of these

problems; to think in terms of the diversity of urbanism's manifestations and to explore the cultural consequences of sharp variations in the economic performance of various regions of Europe. The final section of this book is exclusively devoted to the discussion of the effects of the emergence of major disparities in the economic performance of the major cities of northern Europe and the cities of the Italian peninsula. Similarly, much attention is paid to the strong disparity between the character of the art worlds which developed in eastern Europe and Scandinavia and those which developed in the great imperial trading capitals of France and Britain.

Discussion of the effects of urban growth on the visual arts in this period is bound to focus on the impact of the broadening social access to wealth and power, a process which took place in much of Europe but was most strongly evident in France and Britain and late eighteenth-century Germany. Recent scholars of French, British, and German art have given much attention to the emergence of new art 'publics' who are associated with the birth of a 'consumer culture' in which art works began to assume the status of products. In these countries a massive expansion in the market for prints and illustrated books allowed households of even modest income to own sophisticated artistic images. With the advent of the public exhibition and newspaper criticism portions of society formerly unfamiliar with the visual arts could boast discernment or 'taste'.

An aspiration towards 'taste' helped to define the eighteenth-century citizen as part of the 'polite' public. In turn, the development of the concept of 'the public' as an entity distinct from the uncultivated 'crowd' or threatening 'mob' was, in part at least, born of the broadening accessibility of the arts. In his influential *Réflexions critiques* of 1719 the Abbé Dubos defined the public thus:

I do not include the low people among the public who are capable of pronouncing on paintings and poems, or to decide what degree of excellence they possess. The word 'public' includes here only those who have acquired a certain illumination, either by reading or commerce with the world.[3]

The public, Dubos went on to suggest, helped to create the artwork. He argued that before being judged by the public, works 'remain, so to speak, on the desk' or are not fully accepted as 'art'. Here we see the evolution of an extremely important new concept. The ancestor of the modern notion that when one puts a picture in a public museum we define it as a work of art. The origins of this idea are explored in Chapter 3, in which I examine the relationship of 'art' to sensationalist street illusions, waxworks, light-shows, *commedia dell'arte* spectacles, or burlesque theatrical performances. Particular attention is given to the tendency to exclude or include these illusions from categorization as 'works of art' (or works suitable to influence a work of art) on the

basis of whether or not a substantial proportion of the polite urban public found them to be sophisticated enough to be considered tasteful.

Although, in the mind of Dubos, the public could be defined from the uncultivated masses by 'a certain illumination' gleaned from 'reading or commerce with the world', a strong tendency arose in mid-eighteenth-century France and England to define the public in different terms; as that part of the population with a capacity for 'feeling', 'sympathy', or 'sensibility'. New publics for the visual arts and literature were created through the invention of types of art which appealed strongly to 'the passions' thus cutting out the requirement for élite learning which had acted as a barrier to the appreciation of the arts.

The name of William Hogarth (1697–1762) comes most readily to mind in the discussion of this phenomenon. His graphic works regularly exhibit his tendency to promote the notion of the 'polite public' as something essentially defined from 'the mob' by its humanity and the refinement of its passions. He was probably the most conspicuous inventor of new types of art designed to fulfil the proclivities of this type of polite public and morally sustain its existence. In his autobiographical memoir he explains his decision to renounce his ambitions of being a history painter in favour of the production of topical prints in the following terms:

But as religion, the great promoter of this style [i.e. History Painting] in other countries, rejected it in England, I was unwilling to sink into a portrait manufacturer; and, still ambitious of being singular, dropped all expectations of advantage from that source, and returned to the pursuit of my former dealings with the public at large. This I found was most likely to answer my purpose, provided I could strike the passions, and by small sums from many, by the sale of prints, which I could engrave from my own pictures, thus secure my property to myself.

Hogarth's candid admission that he set out to trade on his ability to 'strike the passions' of the public reveals his exceptional business acumen. He saw the financial opportunities thrown up by the advent of a new public consisting largely of citizens with a greater claim to the possession of refined feelings allied to good sense and perceptiveness than a store of dusty bookish learning. Accordingly, his graphic art assumed the sort of knowledge of the world that a man could glean by reading newspapers and 'coffee-house' essays or the sense of drama and narrative he might absorb from reading novels or visiting the theatre. Some decades later Jean-Baptiste Greuze (1725–1825), borrowing some of Hogarth's narrative inventions, was capable of exploiting the same tendency in the Parisian public. As one salon viewer of his *Girl Weeping over a Dead Bird* of 1765 commented: 'Connoisseurs, women, dandies,

pedants, intellectuals, ignoramuses and fools, all the viewers are in agreement over this picture.' J.-B.-P. Le Brun, when reflecting upon Greuze's financial and critical success, remarked that the painter had conjured up a pathos which had 'astonished connoisseurs and brought forth tears from souls indifferent up until that day of the magic force of painting'.[4]

As the eighteenth century progressed it became increasingly apparent that the visual arts could become a disturbingly egalitarian medium of communication. If taste was deemed to be largely a matter of 'good sense' mixed with a little education, any polite citizen with a modicum of public credibility could claim to have it and to act as an arbiter of it. The taste of an ordinary private person, a hack journalist, or low-born essayist, was, theoretically at least, as valid as that of a peer of the realm or well-tutored gentleman connoisseur. There were, indeed, those who argued that an ordinary 'man of sense' whose mind was not full of connoisseur's preconceptions, whose tongue was free of the critic's jargon, whose spirit was not corrupted by aristocratic luxuries might be best qualified of any in society to pass judgement on art.

Such egalitarian views were generally promoted with the direct intent of subverting the authority which gentlemen amateurs and connoisseurs exercised over the European art market. Those who promoted these views were often setting out to assist certain factions within the art profession in their attempts to mould their market to their own image; to give encouragement to the cultural aspirations of those sectors of the public who seemed to be most in tune with the social prerogatives of an ambitious artist of the 'middling sort'. Occasionally these objectives were pursued through public campaigns orchestrated by the artists themselves in league with sympathetic publishers and journalists. The attempts of Hogarth and several members of the St Martin's Lane group to discredit the notion of the English cosmopolitan connoisseur in favour of that of the Protestant 'plain sense' Englishman during the 1730s and 1740s was, perhaps, the earliest example of this type of campaign. Jean-Étienne Liotard's (1702–89) *Traité des principes et des règles de la peinture* (1781), in which he argues that the judgement of technically 'ignorant' men of 'innate taste' to be superior to that of academicians, amateur critics, and connoisseurs is, perhaps, the most witty.

It was no accident that the cultural preoccupation with taste emerged in tandem with that for clothing and manners. As we shall see in Chapter 3, the various urban societies of eighteenth-century Europe developed a cultural fascination with sartorial display and the moral connotations of clothing which grew as fashionable garments became available to a broader spectrum of society and ceased to be reliable signs of social distinction. Polite manners, an accomplishment fundamentally related to 'taste', similarly became a matter of fascination

when they were made accessible to anybody who could afford the price of a conduct manual and the leisure to cultivate its precepts. The intensity of the debate on taste grew in rough proportion to the diminishment of the likelihood that the boast to 'taste' would set a man apart from his contemporaries. In order to reinforce the cachet of a visual art education the literary discussion on the criteria of artistic quality became progressively more sophisticated, esoteric, and theoretical. By the mid-eighteenth century a new scholarly discourse known as 'aesthetics' had come into being.[5]

The idea that quality in the visual arts might be neither more nor less than what pleased the public at exhibitions or sold in great quantities in the form of printed reproductions hung like a spectre over the art world of every country or region of Europe which developed a strong consumer economy. From the late seventeenth century onward it was clear that there were strong conflicts of interest between those who claimed a specialist knowledge of the visual arts and 'the public'. Many influential art commentators of the late eighteenth and early nineteenth century—the list includes Goethe, Fuseli, Lefébure, Reynolds, and Hazlitt—were positively hostile towards the idea that the 'public' should dictate the standards of taste.

Such critics of the public taste attempted to make a clear distinction between public opinion and public spirit or interest. On the one hand it was deemed lamentable that art should become a matter for the public consumption and that the tenor of the visual arts should be dictated by public opinion. On the other hand it was deemed desirable that art should aspire to be a grand expression of public spirit and national interest. The most extreme manifestation of this position emerged from the literary works of Henry Fuseli (1745–1825).

He combined a firm distaste for any suggestion that the wider public should be included in, or seek to be improved by, the world of art with the belief that modern art had entered into irreversible decline brought about by failures in the public spirit of the various nations of Europe.[6] These failures were themselves considered to have been brought about by the rise of a set of 'private' values associated with the rise of commerce which were considered a modern phenomenon and which distinguished his own society from that of Periclean Athens or Renaissance Italy.

The establishment of the ideal of art as an expression of 'public' values had, as Fuseli's Academy lectures suggest, much to do with the formation of the notion of 'private' interest and the truly private man. The 'bourgeois' urban consumer of the eighteenth century was in a new sense of the word 'private', in as far as he or she could be considered motivated by a narrow, and some considered banal, concern with the accumulation of property, wealth and a comfortable if not luxurious lifestyle. In order to make art 'public' by ideal—i.e. a matter of

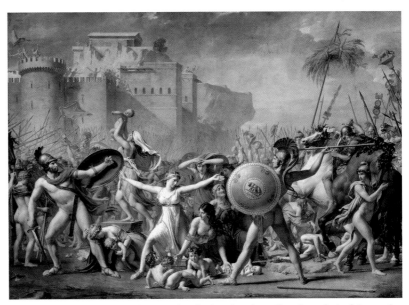

1 Jacques-Louis David

The Intervention of the Sabine Women, oil on canvas, 1799

public spirit—art was increasingly institutionalized and tied into the role of the moral indoctrination of the citizen. Thus this period witnessed not only the rise of the public art museum and the concept of public funding for the arts but also the apogee of what is now referred to as 'civic humanist ideology', the strong conviction that artists should set out to enhance the moral condition of public life.

Consumer power was undoubtedly a reality of many eighteenth- and early nineteenth-century European art worlds but scarcely an ideal. In the later six decades of this period it became a veritable convention in European art commentaries to argue that the public interest of the visual arts was better served by the public-spirited private citizen than the patronage of the public at large. Even in Revolutionary France the idea that the judgement of the 'public' should be the arbiter of the quality of art was not accepted without reservation. When David decided to exhibit his *Intervention of the Sabine Women* (1799) [1] in a marquee charging the public for entrance, he was obliged to publish a self-defence in which he argued that there was no wrong in an artist putting his faith in the veracity of mass opinion.

Similarly, British art theorists with radical leanings—men such as James Barry (1741–1806), William Hazlitt (1778–1830), and Benjamin Haydon (1786–1846)—proved positively hostile to the idea that art should be judged by the *vox populi*, or made a matter of consumer demand. Democracy was an idea which should be applied to political life but not the exalted realms of art. Hazlitt went as far as to argue that painting was 'lowered by every infusion it receives from common opinion'.[7] This view of art—that it is not in the public interest that art should be in the control of, or tainted by association with, the public—may be described as modern if only in the sense that it will probably be

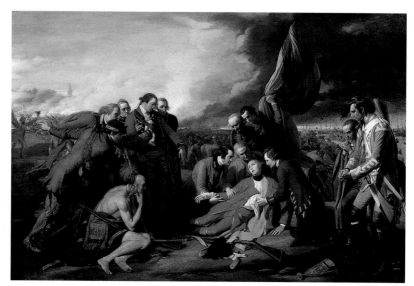

immediately recognizable to regular readers of modern art criticism and visitors to galleries.

From the time of Hogarth[8] onward, the great majority of English artists and art commentators campaigning to establish a school of British history painting that would raise the tenor of public life looked to great private benefactors, court, or public institutions as the ideal source of funding. That insufficient private individuals of public spirit were found to be forthcoming was held to be a reflection of the tone of national life. In the opinion of many the fault derived from a certain pettiness of mind deriving from this 'commercial people's' excessive concern with the narrow comforts and prosperity of the private citizen.

Britain was held to be, lamentably, the sort of nation where the art market would revolve around small commissions on domestically appealing subjects and money-making 'schemes' [2]. That it had been the English who invented the practice of setting up special exhibitions of history paintings to which the public were charged a shilling entrance fee was regarded by the engraver Valentine Green as a national disgrace. Green expressed his disappointment that artists had come to receive their own 'efficient protection from the public' and had 'been forced to the expedient of challenging attention, by offering (their) works to public view, and setting the price of a shilling in the humiliating practice'.[9]

The widespread hostility to the incursions of 'the public' into the exalted field of art is itself evidence for those who argue that art was broadly transformed into a part of the consumer economy in this period. Equally, the very fact that the dream and ideal of the great art patron was still so current in the early nineteenth century indicates that the basic idea that 'great art' was essentially something produced in accordance to the explicit demands of a protector was far from outdated.

Which form of artistic production one sees as typical of the era has been largely a matter of one's political convictions. The current art historical debate is broadly polarized between those scholars whose vision is of a European art world dominated by commissions and patrons, and those scholars who consider it to be dominated by consumers and artists who merchandized art products within a recognizably 'modern' form of consumer economy. Marxist and Marxian historians have, since the days of Hauser and Antal, generally sought to depict this as the period in which the tastes and economic power of the 'bourgeoisie' came to the fore in the European art market. Whereas, consciously or unconsciously, those to the right, and/or firmly attached to the property and art market, have clung to the notion that the eighteenth-century art world was the province of connoisseurs, courtiers, and country gentlemen who presided over a broadly traditional patronage system.

My own position—the position argued in this book—is that both conceptions of the European art world have merit. Cities which developed considerable consumer economies such as mid-eighteenth-century Paris, London, or late eighteenth-century Dresden gave rise to a great variety of markets for art. The characteristic of these consumer markets which defined them most clearly from those of the past (and the majority of eastern, southern European, and Scandinavian art markets of their own day) was their pluralism. In my own field of specialist interest, English sculpture, one can point to a major expansion in the width and variety of the market during the eighteenth century. In 1680 the commissioning of metropolitan sculpture was, by and large, limited to the aristocracy, the better-appointed gentry, and the richest of city entrepreneurs. By 1780 the market and range of 'products' available was much broader. A substantial bourgeois market for monuments and patriotic busts had developed. Although the market for sculpture made 'on spec' had mushroomed it had not dimmed the significance of august aristocratic protectors who generally commissioned rather than bought sculpture. With the rise of the Grand Tour such men were, if anything, more in evidence. A large, and for the most part new, market had begun to emerge for life-size classical figures to be placed in specially designed sculpture galleries which were largely the preserve of super-rich one-time Grand Tourists. With the rise of the empire public institutions and provincial city corporations were beginning to play a major role in the market. Enough sculpture was being commissioned from the colonies to encourage a few young hopefuls to emigrate. Sculptors had begun to specialize to corner sectors of the market. Joseph Nollekens (1737–1823), for instance, was specializing in the production of busts and Thomas Carter the younger (d. 1795) in the production of chimneypieces.

This particular industry is, I suggest, a microcosm of the whole. In

the major urban consumer economies of Europe a vast array of new ways to advertise, market, and merchandise art were introduced. The growth in the base of wealth created a host of opportunities for those, such as Hogarth with his invention of the narrative print series, who were capable of envisaging fresh approaches to visual communication. This became an era of specialist producers, such as the painter of sporting art or the printmaker devoted entirely to the commercial production of political and social satire. It witnessed the invention of a host of new techniques and types of art some of which, such as the manufacture of silhouettes, we might now class as art gimmicks.

The advent of new consumer art markets seems to have involved a great deal more women in the art market. As the number of women who appear in period images of art exhibitions indicates, their involvement was more notable in consumption than at the production end of the process. Some new genres or techniques did, however, become associated both with female tastes and female artists. The brothers De Goncourt described the pastel portraiture, a novel genre introduced by the Venetian woman artist Rosalba Carriera (1675–1757) to the Parisian public in the first half of the eighteenth century, as an 'art exercised by women and appealing to women'.[10]

Other new art forms became associated with the tastes of particular classes. As the size and social diversity of the public became increasingly apparent exhibition organizers began to pitch more at one sector of the public than another. The rise of the English technique or genre of watercolour painting was, to some degree, associated with gratification of the tastes of the bourgeois public and the talents of those at the patently commercial end of the art market. This was made most obvious in the choice of the Society of Painters in Water-Colour (founded 1804) to include the prices of works in their catalogues.

The notion of *the* art public began to evaporate. In Paris this process began in earnest in the mid-eighteenth century. It occurred somewhat later in most other European cities. The era of the comfortably distinct cultural élite for whom the Abbé Dubos had written his *Réflexions Critiques* (1719) soon passed; an era when a learned man had been able to regard the task of defining 'the public' from the ignorant and powerless 'others' as a fairly straightforward matter. It became widely recognized that art had begun to attract many publics. The opinions and values of these publics were frequently seen to be in direct conflict. One set of public interests were held to be more representative of 'the public interest' than another. With the rise of democratic political movements in the later part of this period even the assumption that the richest and most powerful public were the most legitimate representatives of the public interest or the public taste began to be seriously challenged.

In those countries which developed strong industrial and manufac-

turing economies in the later decades of the eighteenth century there was a growth of provincial towns and cities which led, by the late eighteenth century, to a substantial decentralization of the art market. This not only opened new markets for metropolitan artists—Greuze, for instance, sold the majority of prints of his work in France's provincial towns and cities—but also created new opportunities for artists willing to be mobile. Artists of quality who either chose not to compete in the metropolis or were temporarily out of favour were able to make successful careers in provincial cities and to produce art there which was provincial neither in quality nor conception. Joseph Wright of Derby (1734–97) became the most conspicuous example of this new type of artist. Similarly, improvements in transport infrastructure and trade systems allowed artists and art entrepreneurs in those countries with substantial imperial possessions to exploit global markets as never before. In the early nineteenth century, for instance, the English painter John Martin (1789–1854) was, according to his own testimony, able to earn the greatest part of his income from the sale of his prints in Japan, China, and America. By the late eighteenth century artists out of favour in Europe could, as did Johann Zoffany (1733–1810) and William Hodges (1744–97), go to India for a few years to recuperate their fortunes.

These opportunities were, it should be stressed, far more available to the citizens and domiciles of countries with major global market economies and substantial world-wide imperial possessions. The type of art economy experienced by an indigenous artist working in St Petersburg, Warsaw, or Copenhagen was entirely different. As we shall see, the eastern European and Scandinavian art markets were far less various and more centred upon court and aristocracy; the consumer economy there was far less advanced, and, as a consequence, the social power and creative liberty of the artist far more limited. Appropriately for an era when the social and economic performance of a state and that of its arts were habitually associated, strong correlations arose between the economic performance of the various European nation states and cities and their artistic significance. The diminishing importance of 'Italian' art in Europe and the world at large was, I shall argue, a consequence of the relative inability of Italian cities to offer the sort of vigorous variety of economic opportunity available in the great northern European cities. Conversely, it is clear that, during the last six decades of this period, artists from areas with vigorous pluralistic market economies began to set the agenda for the European art world. It was from the cities or citizens of England, France, and Germany that new ideas of European consequence tended to arise: new ways of selling art, new ways of talking about art, and, as the first chapter reveals, new ways of thinking about the role of the artist in society.

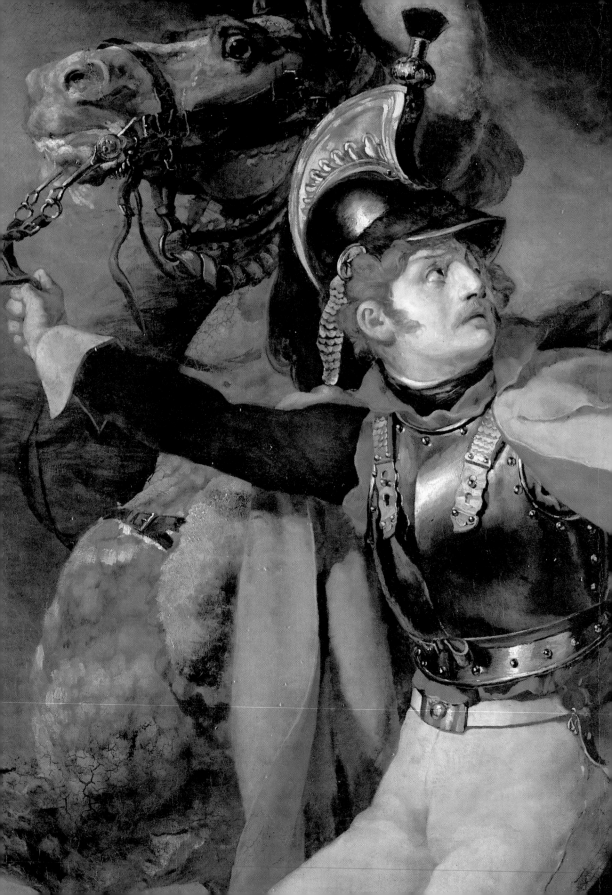

Beyond the Useful and Agreeable Man

<div style="font-size:3em; float:left;">1</div>

Art becomes a great concern for the polite public and a great deal more than a polite public concern

Those late eighteenth- and early nineteenth-century art commentators who penned their earnest complaints concerning the debasement of art at the hands of 'the public' assumed that the issues they addressed were of great public concern. To get seriously embroiled in heated public debate on the theory of artistic genius or the nature of the inventive process was not, as it might have been in their grandfathers' generation, regarded as unusual or downright ridiculous. With good reason these commentators expected their views on art to be of interest to more than a tiny group of élite readers. As they had perhaps forgotten, art was only regarded as of great concern because of its initial exposure to the public whose views on art they despised.

In the mid-eighteenth century the benefits accruing from the exposure of the visual arts to a broader public had been clear to many members of the art professions. The Parisian painter and art commentator Charles-Nicolas Cochin (1715–90), for instance, looked back on the revival of the Paris Salon in 1737 as a blessed intervention which rescued the arts from obscurity brought about by a serious failure in the private patronage system. By stimulating the interest of a wider public, this 'fortunate establishment' was deemed to have transformed the careers of the mass of artists who until that time had lived 'in a state of mediocrity verging on poverty' and 'saved painting, by a prompt showing of the most worthy talents and by inspiring with a love of the arts a number of people who, without the exhibition, would have never given them a thought'.[1]

It was very soon recognized elsewhere in Europe that the new Salon exhibitions would give France a genuine economic and cultural advantage over its competitors. On 25 August 1737 the *Daily Post*, a prominent London newspaper, published a report from a foreign correspondent who had recently been to see the first exhibition of the revived Parisian Salon at the Louvre. With a tone of genuine excitement, the correspondent records the sight of a huge crowd competing 'with great earnestness' to see the pictures. He lamented that, although

there might be similar enthusiasm for painting in Britain, there were no publicly organized ways of channelling it.

What a discouragement it is to the ingenious men of Great Britain that we have no yearly prizes to reward their pains and application for the service of mankind; or publick honour to bestow on their services as in France! They might well complain that we don't imitate the French in their best qualities, but take particular care to outdo them in their worst. Good painters, Engravers, and Statuaries are very useful men; they add to the capital stock as well as to the honour of the Country, besides the noble and instructing amusement which they afford.

The newspaper readers for whom this piece was intended were obviously in need of a little persuasion that the visual arts were worth approaching with the 'great earnestness' of their neighbours across the channel. The correspondent was forced to appeal to his readers on the most practical level by reminding them that artists were 'very useful men' who could add 'to the capital stock' and help to improve the moral tone of public life. It was a line of argument probably calculated to appeal to the paper's more practically minded City readers who might not have been persuaded by a less down-to-earth defence of the liberal arts.

The intellectual precept of this piece—a precept which seems not to have been absorbed by all this paper's readers—was that the visual arts deserved encouragement because they were good for society. The social efficacy of the arts could be appreciated in simple economic terms. It could also be argued that, if artists kept themselves to 'noble and instructing' subjects, art could become a useful tool for civic instruction. On a third level the visual arts were deemed good for society because they were a wholesome 'amusement'; because they inspired pleasing emotions which kept society agreeable and harmonious. Exposure to the arts could also be considered as indicative of the general tone of civic life in the state and function as an important guide to the level of civilization encountered therein. The display of the visual arts in the public forum could act as a useful means of measuring the quality of civic life in one European nation against another.

As the *Daily Post*'s correspondent was fully aware, Britain measured up to its Continental neighbour and traditional foe rather poorly when judged by such criteria. Some three years later in his *Treatise on Ancient Painting* of 1740 George Turnbull covertly reminded his readers of the same point:

the general and national Character of a People may be conjectured from the State of the Arts amongst them: and reciprocally, the State of the Arts amongst any people may pretty certainly be divined from the general, prevalent Temper and Humour of that People as it discovers itself by other symptoms of Government, Laws, Languages, Manners, etc.

At this time Britain still had no public system for the promotion of the arts. However, by the mid-1750s, with the foundation in London of that most 'useful' of institutions, The Society for the Encouragement of Arts, Manufacture and Commerce, with its scheme of prizes and public exhibitions, the situation was much improved. The effect of institutional encouragement of the arts on the moral tone of the nation was difficult to gauge accurately and highly disputable. The effect on the 'capital stock', however, was easier to determine. In the forty years following the foundation of the Society artists were indeed to prove 'very useful men' to Great Britain. Prints, for instance, were to become not just *an* important British export product but one of *the* most successful export products of the early Industrial Revolution. If an early nineteenth-century report in the *Morning Post* is to be believed, Francesco Bartolozzi (1727–1815) alone 'added to our revenue at least a million sterling'.[2]

Such examples could not be ignored. Across Europe the idea that the visual arts deserved the attention of the responsible patriotic citizen gradually became a commonplace. In the central decades of the eighteenth century there was a major upsurge of interest in the foundation of public institutions for the encouragement of the arts. By the 1780s virtually every major metropolis in Europe had a public scheme or series of schemes under full sway. A European state simply could not be considered fully civilized or economically competitive without one.

The consensus of public opinion in most European countries that had thriving art publics gradually shifted towards the idea that the visual arts constituted an important and profound form of social communication. As a truly élite field of interest in the early eighteenth century painting and sculpture struggled for a place of honour within the canon of liberal arts. In his *The Theory of Painting* of 1715, for instance, Jonathan Richardson (1665–1745) was obliged to resort to vehement argument in an attempt to persuade his contemporaries that painting could be studied theoretically and was widely mocked for so doing. By the late eighteenth century it was rare to encounter a man of intellectual substance who argued, as did Louis-Sebastien Mercier (1740–1814), that the visual arts were not a matter for serious consideration. Mercier was assuming the role of a maverick flying in the face of public opinion.

By the mid-eighteenth century serious enquiries into matters art historical and theoretical were becoming major successes for the publishing industry. Winckelmann's *History of Ancient Art* (1764) became art history's first international 'best seller'. Across Europe the demand for serious enquiries into matters artistic by those who did not aspire to a multilingual education was serviced by a steadily growing industry in translations. Translated excerpts of Winckelmann's works, for instance, appeared in English magazines within months of their initial publication.

The mass of theoretical works which entered the polite literary arena in this period bombarded Europe's art publics with a perplexing variety of intellectual stances. Much as a multiplicity of art publics arose in the second half of the eighteenth century, a multiplicity of points of debate arose to polarize and differentiate these publics. By no means all prominent texts promoted the notion that the visual arts, and artists themselves, should find a purpose in society through their moral usefulness. Indeed, many of the most influential works emerging from early and mid-eighteenth-century Paris—works most frequently quoted and bastardized in popular literary forms—ran explicitly counter to 'civic humanist' and utilitarian dictums. The works of Charles Coypel and the Abbé Dubos, in particular, placed more stress on the artist's task of gratifying the sensual appetites of the connoisseur than his duty morally to elevate the citizen.

Despite the pluralism of views on the question of moral utility most strands of opinion within the mid-eighteenth century discourse accorded with the belief that the visual arts should be some sort of 'amusement'; that they should incite agreeable sensations and rationally controllable emotions. Art, the basic argument ran, could only be deemed 'good' and useful to the formation of civilized society if it inspired sensations which ultimately pleased and civilized the spirit. However, with the publication of Edmund Burke's *Philosophical Enquiry into the Origin of our Ideas of the Sublime and the Beautiful* (1757) the British art world, and to a lesser extent that of the rest of Europe, gained access to a serious and accomplished argument which began to liberate the visual arts from their long subjection to polite ideals of emotional decorum.

Burke promoted a notion of art which stressed the expression of strong, ungovernable 'sublime' emotions. History paintings displaying such passions could be disturbing to behold. This undermined a strong early eighteenth-century tradition—a tradition derived from the theoretical works of De Piles and Du Fresnoy—which insisted that the characters depicted in history painting should behave towards each other with *bon sens* and *bienséances* (terms which rather inadequately translate as 'good sense' and 'good manners').[3] Much of the major work of James Barry, a long-time friend of Burke, was designed to run against these sort of decorous, polite conventions. He complained bitterly about the tendency of the English public to affect 'such nice feelings and so much sensibility, as not to be able to bear the sight of pictures where the action turns upon the circumstance of distress'. Barry's *King Lear and Cordelia* (etching, 1776) exhibited a wildness totally contrary to the spirit of *bon sens* and *bienséance*. To live and work to perpetuate such tame values as *bon sens* and *bienséance* was deemed by Barry and many of his contemporaries as positive insult to a man with a claim to grand and unrestrainable genius.

By the 1770s the idea that, in order to be accepted as a worthy field of interest, the visual arts needed to be fundamentally agreeable was losing its consensus in many European art worlds. However, the idea that art should be useful both in economic and social terms was less uniform in its decay. In some quarters of European society it was soon to reach an unparalleled importance, particularly in the school of David and in Revolutionary France where the visual arts were emphatically tied to the wheel of the propaganda machine. As we shall see, French artists' rebellion against the authority of civic humanist ideals was dramatically expressed soon after the end of the terrors. In other parts of Europe where art was not so heavily associated with programmes of political reform the process of disintegration began earlier and took a more gradual course.

To argue, as did the contributor to the *Daily Post* that art justified its importance to society by becoming a 'noble and instructing amusement' and an economic boon to the state, was to adopt a rather primary position. It was, as we have seen, the sort of argument which persuaded those with little prior interest in the visual arts that they were worth supporting on crude social and political grounds. Utilitarian ideology proved irksome to some within the generations of artists who followed the founders of useful societies and worthy academies. Equally the doctrine began to fail to appeal to sectors of the art buying public who disliked the notion that they were considered fodder for social indoctrination and were bored by their exposure to sonorous, worthy works. By the late eighteenth century there were a number of artists—most notably, as we shall see in Chapter 3, the patently amoral satiric moralist Thomas Rowlandson (1756–1827)— who made their entire careers by exploiting sectors of the art market bored by instructive art works.

For many of Rowlandson's contemporaries, including the prominent officers of art academies, the very idea of the usefulness of art and the artist seemed degrading. It turned the unique vocation into one profession amongst many and seemed to assemble the nation's artists into a sort of creative civil service. For Henry Fuseli the very notion that the arts were capable of improving the public was a trivialization. Like James Barry, he argued that great art was a medium for the exploration of lofty and unrestrained emotions.[4] He went further than Barry in the argument that such emotions ought to be pursued whether the sight of images depicting them was good for the public or not. Whilst he retained the notion that the level of public life could be measured by the state of the arts, Fuseli argued that the arts did not need to be, in any obvious sense, good for the citizen to achieve this end. Indeed, on occasion he argued that, when reduced to the banal role of public instruction, the arts gave a poor showing of the level of public life. A genuinely healthy state did not *need* art for its economic and social

welfare, it *produced* great art. Great art and great artists were by definition men unconcerned with the necessary, the useful, and the superficially agreeable.[5]

Fuseli represented an extreme, intentionally élitist, and possibly marginal, position. His very vehemence was, however, much in tune with his times. In the period of Fuseli's prominence in the art world (*c.*1770–1810) public debate on the arts began to excite strong emotions; the rhetorical tone of European discourse on the visual arts became more typically forthright, vehement, and heated than august and polite. As the assumption that art should incite polite and obviously pleasing emotions decayed, so also did any vestiges of politeness evaporate from debate between various factions of the art world. Art ceased merely to be taken seriously in the public sphere, it became the object of violent disagreement. As we shall see below, a number of self-portraits of artists of the late eighteenth and early nineteenth century include references to bitter conflict and scenes of tribal war.

Artists all over Europe began to embrace extreme positions. Earnest commitment to one's cause to the point of suicide or financial ruin, taking dramatic risks, dicing with the political or professional authorities on points of principle, began to signal the true artist. For many, art was becoming more than a matter of public concern, more than something pleasing or cultivating, it was becoming a matter for quasi-religious zeal. It was the era when Europeans began to regard art works (in particular antiquities) with a reverence formerly reserved for saintly relics, to whisper before 'great art' in public galleries, and consistently to employ religious metaphor in their discussion of art.

Artistic celebrity, artistic failure, and artistic self-expression: the problem of excessive numbers of artists

Like the literature of art theory and history, the genre of the art memoir or biography grew dramatically in the late eighteenth and early nineteenth centuries. To a greater extent than other literary forms associated with the visual arts it became an acknowledged field for public entertainment. Biographies certainly could take the form of worthy moral tales pointing out the wages of folly, such as the competing monographs published on the life of the disreputable George Morland (1763–1804) shortly after his death. More often, however, they were amusingly anecdotal in tone. The art memoirs compiled by J. T. Smith and Étienne Delécluze are, indeed, comic masterpieces. No matter how trivial or quizzical the productions of this anecdote industry might appear, they registered a serious new development in the history of the social role of the artist in Europe. The lives of famous artists were becoming public property; they were becoming 'celebrities' in something like the modern understanding of the concept.

The peddling of gratuitous, entertaining, or spurious biographical

anecdotes was not in itself a new development in the art world. Vasari was, by most modern estimates, a master of the genre. The popularity of his *Vite* in the late eighteenth century did much to stimulate the thirst for contemporary art anecdotes. It was the sheer immediacy of its anecdotal trivia which set the late eighteenth and early nineteenth century apart. The 'celebrity' artist could find himself consumed by a voracious and prurient anecdote and gossip industry. He or she, for female artists such as Angelica Kauffmann (1740–1807) were of particular interest to the gossip industry, might find even the most casually dropped comments dissected in the public arena or their romantic liaisons the topic of public speculation. Gossip could dictate careers. Rumours concerning a supposed romantic connection between the English society portraitist, Thomas Lawrence (1769–1830) and an impressionable princess for a time threatened his career, as female sitters refused to be left in his company. As the memoirs of celebrities such as James Northcote (1746–1831) and Antonio Canova (1757–1822) record, learning to handle the press, to deal with the ephemeral whirl of public criticism, was considered an essential part of the job of a modern artist.[6] Finding himself yet again the object of speculation in the popular press, Northcote stoically remarked:

A man in a conspicuous position must stand strict examination; every fault of his own, or even his family, will be raked up, and, if possible, brought against him; the world will not let him enjoy his distinction for nothing, for it is looked upon by them as an infringement upon their common rights.[7]

It was not without reason that Vasari's *Vite* and art-historical anecdotes pertaining to the relationship of great artists to great patriotic figures began to assume a new importance in the later decades of our period. Perhaps the central cause of this phenomenon was a strong cultural identification with epic phases of history. The growing conviction of many who lived through this period of European history was that they were also witnessing great times; times which in future would be compared to the Renaissance, the nascent Roman Republic, or Periclean Athens. The powerful sense of the consequence of the times emerged from the mid-eighteenth century onward. Horace Walpole described his writing of *Anecdotes of Painting in England* (1760–71) as his 'Vasarihood' and, though he described the genesis of a national tradition which was a limited success, considered himself to be charting the beginnings of something which might become great. Later, with the burgeoning of the empire and national confidence, it became more common to believe that the biography of a modern English artist might have some importance to posterity equivalent to their Vasarian prototypes. John Flaxman's (1755–1826) posthumous eulogy of the sculptor Thomas Banks (1735–1805) made this point clear.[8] Here Flaxman compared Banks to Nicola (1258–78) and Giovanni

(1265–1314) Pisano, artists whom Vasari had depicted as the fathers of Italian Renaissance sculpture.

The confidence which Flaxman showed in the capacity of his own times to rival the Renaissance or Antiquity, was as we shall see in Chapter 4, profoundly related to his belief that the Britain he inhabited was the Rome of its day. Dramatic economic growth manifested in massive new urban building projects gave substance to the fantasy within various northern European societies that they were reliving and exceeding the achievements of the epic lives of 'the Ancients'. In the nineteenth century the sense of epic struggle attending the Revolutionary and Napoleonic conflicts heightened this cultural tendency. By the early decades of the nineteenth century some European artists were living as if aware of a responsibility to make their own achievements as epic and universally impressive as the times in which they lived. The architect and painter Carl Friedrich Schinkel (1781–1841)—a man who, as Peter Betthausen points out, was 'convinced he lived through an age of profound and necessary revolutions'—seems to have worked himself to death in the resolve to compete with his age. His death was, as one friend recalled, brought about by 'the cruel dominion of mind over body'.[9]

The triviality of early nineteenth-century art memoirs also reflects, but in rather an ironic manner, this sense of the auspiciousness of the times, or history in the making. Many memoirs of this era reflect the tendency to collect artistic souvenirs. Trivial letters were often considered of equal value to serious manifestos of belief: they kept some spark of the private personality of a great man. After the death of the sculptor Francis Chantrey (1781–1841), for instance, collections of even his most frivolous correspondence, including his hearty thanks to a friend for an excellent meal, were considered worth publishing.[10] That such letters were considered worth keeping is, in itself, clear evidence of the extraordinary rise in the social status of the artist during this period. The letters of Chantrey's predecessors who dominated the early and mid-eighteenth-century British sculpture trade were, for the most part, not considered worth preserving. Thus we know next to nothing of their private lives or intimate personalities.

Despite finding the incursions of the prurient press irksome, few artists of this period became public celebrities without their own active connivance. The potential of every new public forum was soon realized by artists in search of public recognition. This became the first true age of the art publicity stunt. It was soon recognized that exhibition venues were not just places to exhibit but to make spectacular public statements which could make a commercial career. The De Goncourt brothers in their famous *L'Art au dixhuitième siècle* record the attempts of the Parisian pastelist Maurice Quentin de la Tour (1704–88) to exploit the French Salon in exactly this way.[11] He is reported to have

invited his rival Jean-Baptiste Perronneau to make a portrait of him whilst secretly working on a self-portrait. Through the offices of his friend Jean-Siméon Chardin (1699–1779), he arranged for this self-portrait to be hung in the Salon next to that made by Perronneau. Thus, the public were allowed to witness de la Tour's superiority by way of a clear comparison. Through such manœuvres de la Tour was able to drive up his prices to levels which would have been difficult to contemplate in the seventeenth century.

The potential of that particularly eighteenth-century form of communication, the newspaper, for the promotion of the artist was very soon realized. This was the first era in which artists started regularly to advertise themselves and their works and to use the services of friendly journalists to compile 'puffs' (an eighteenth-century term for a favourable piece of publicity in which the person or group of persons publicized had an unacknowledged hand). The very concept of news began to be exploited by resourceful artists who needed to establish their reputation. Moving to Dublin under strained financial circumstances Francis Wheatley (1747–1821) launched himself on that city's public by immediately setting out to sketch the most newsworthy event of the times, a meeting of Volunteers on College Green which took place on 4 November 1779. To exploit the patriotic mood of the moment he had his painting of the event shown at the Society of Arts in William Street and engraved forthwith. It was as close as the technology of the day could take him to reportage. The publicity stunt appears to have worked. Wheatley's reputation grew by association with a good patriotic story.

Fame grasped through such transient media was itself transient. It was a sign of the times when the English newspaper *The World* of 29 April 1790 greeted the young Julius Caesar Ibbetson (1759–1817)—an artist who had made his public reputation with a canvas recording George Biggin's first ascent in Lunardi's balloon—as 'the most conspicuous genius of the year'. Ibbetson's choice of an image of a manned balloon ascent to make his reputation was very appropriate. Balloon ascents, and the gawking crowds which gathered around them, became powerful metaphors for the transience of urban life and public reputation. A brilliant comic French print of the 1780s (Anon., *The Devotees of Physic*, 1783) makes this point clear; a man drifts across the sky on a huge breath of hot air and life in the city beneath turns to chaos as all fall over themselves to keep his image in view.[12]

Long before the invention of the hot-air balloon, images of transient hot air, in particular of children inflating bladders, had been used as *vanitas* symbols. The invention of the balloon, a large and highly public bladder, simply gave artists an ideal opportunity to turn this tradition to the depiction of the transience of fame in that bubble that was the public sphere. Before the invention of the balloon the image of the

inflated bladder was also adapted to these purposes and was used to symbolize the transience of the artistic fame of those who were perceived to put too much faith in that mass of hot air which was the *vox populi*. A print relating to Greuze, including the device of the air bladder, was published for the delectation of his rivals and detractors. It showed a monument to the artist collapsing and falling on his engraver M. Lavasseur who had shared in his fortunes. An inscription explained that the image showed:

M. Lavasseur crushed by the fall of an obelisk erected in honour of the defunct celebrity of Greuze—an accident caused by a pin-prick in one of the bladders as a foundation to the monument on which may be seen the portrait of Greuze crowned by thistles and peacock feathers . . . the whole completed by a cat-call.[13]

It is an indication of the enmity inspired by Greuze's success that the first edition of this print sold out in three days. Celebrity artists were by this stage capable of inciting public hatreds and jealousies akin to those inspired by politicians. The imagery of this print may, indeed, have been borrowed from the iconography of political satire. In Britain, Pitt the Elder, a politician who pioneered the strategy of appealing to raw public opinion, had been shown floating in the air on a bladder of hot air (Anon., *Sic Transit Gloria Mundi*, early 1760s), his magnificent cushion of public acclaim ready to burst at any time. The career of the celebrity artist and that of the politician striving to stay in office in an increasingly democratic urban world were not altogether dissimilar.

The image of the artist building himself up on bubbles of hot air was particularly appropriate, to this the first era when the furnaces of the various European art worlds began to be stoked by critics. Greuze's rise and fall had itself been associated with the whim of critical reviewers. His career, more or less, pivoted around the poor critical reception of his first major attempt in the genre of history painting, the *Septime Sévère* of 1769. It is an indication of how seriously he took poor critical reviews that he himself penned a long and spirited counterblast to his detractors in *L'Avant-Coureur*.[14]

The rise of the critic contributed significantly to the ephemeral nature of artistic celebrity in this period. The art profession was quick to realize that it was in the professional or social interest of the ambitious critic to be destructive and ruin reputations. As Joseph Farington (1747–1821) grumpily observed in 1797, the critic was 'likely to take the safe side of remarks, knowing that to object signifies a superior taste,—while to approve may be to hazard something'.[15]

No artistic 'celebrity' of the age was able to build a reputation solid enough to ignore a sustained period of critical abuse. Even a powerful artist such as J. M. W. Turner (1775–1851) felt obliged at the height of his career to write cringing verses to a prominent newspaper critic who

praised his work.[16] The power of the press in Britain meant that here, more than anywhere else in Europe, artists were forced to 'dirty tricks' to promote themselves publicly. Fuseli was just one of those artists who wrote favourable reviews of his own work under newspaper pseudonyms. As art critic for the *Morning Post* John Hoppner (1758–1810) not only praised himself but also savaged rivals.

By the late eighteenth and early nineteenth century any serious attempt to introduce something new or redefine the role of the artist required the pen of an individual capable of explaining the theoretical basis of the novelty to the public at large. German artists living in the Rome of this period were particularly reliant upon such support. The career of the Danish artist Asmus Jacob Carstens (1754–98) in Rome was much dependent upon the support of his friend Karl Fernow, who bombarded the public both at home in German-speaking Europe and in Rome with favourable reviews of his work. Carstens was sold to the highly select readership of Fernow's articles as 'the creator of a new art ideal'. His somewhat radical and forbidding works—he declined to use colour or perspectival devices—enjoyed a measure of success which it is difficult to imagine them attaining without having the support of an accomplished and eloquent theorist.

Rome, the city in which Carstens sought to establish himself as an international celebrity, was simply overflowing with artists from all over Europe. The extraordinary lengths to which he went to promote and differentiate himself is a clear indication of the competitive atmosphere in the city. In late eighteenth-century Rome, as in contemporary Paris and London, artists and art commentators regularly complained about the surfeit of artists. As Carstens was probably aware, the great majority of artists who came to Rome experienced financial hardship. No matter how many wealthy connoisseurs came to Rome, the City remained, as far as the majority of artists were concerned, a buyers' market. It was, as we shall see below, a world in which a figure such as the Earl of Bristol could force even a highly respected artist such as John Flaxman to work at an unprofitable rate.

By the late eighteenth century the majority of urban art worlds in Europe were experiencing a glut of artists. Despite the consequent difficulty of surviving in the competitive market, the art professions maintained a glamorous image which attracted young men like moths to a candle. In his opening Academy lecture of 1807 John Opie (1761–1807) made special point of attacking the idea that entering the Academy was a place for young men who wanted 'easy and amusing . . . profitable profession'. Art, he insisted, was not an easier way of turning a penny than an ordinary job. He challenged anyone to leave who hoped to 'get rid of what he thinks a more vulgar or disagreeable situation; to escape confinement at a counter or desk'. As Opie's colleague James Northcote observed, the memoirs of famous artists filled the

public imagination with images of a glamorous life-style which was, in practice, the privilege of a tiny minority. The majority of young hopefuls drawn into the profession by the prospect of riches and celebrity found themselves in penury. Northcote humorously observed that it would be in the public interest for someone to publish biographies of a few of the most tragic failures.[17]

Whilst Northcote blamed the writers of art memoirs for the problem, it seems more likely that it was caused by the fundamental disparities between the formulation of the public ideal and the realities of life in the public sphere (a problem which I introduced at the beginning of this book). The extraordinary increase in the number of European art academies, institutions for the improvement of arts and manufactures, and drawing schools inevitably produced thousands of young men whose expectations were bound to be shattered. As one notable nineteenth-century critic of the eighteenth-century European academic movement sardonically observed: 'The great effect of the academies has been to elevate the standard of mediocrity, and greatly to multiply the number of artists.'[18]

No matter how large or how pluralistic the art markets of cities such as Paris, London, and Rome might be, they were not as big as those who officially represented the operations of the public spirit assumed them to be. Much as the later part of this period was plagued by grandiose projects for public monuments which failed because they never could be practically or economically supported, the will of national institutions to produce artists exceeded the public's capacity to support them. This was a serious problem. One early nineteenth-century critic of British schemes for the improvement of the arts writing in the *Gentleman's Magazine* even considered proposing that such public projects should be abandoned as they merely helped to litter the streets with destitute artists. One need only look at the lists of artists being turned out of the British Royal Academy schools, the great majority of whom do not now merit a footnote in the pages of art history, to see that the worries of this critic were genuine.

The sheer number of artists in the art market was, on occasion, taken to induce creative sterility. Chardin, for instance, complained in 1765 of the 'two thousand wretches (who) break their brushes in the futile attempt to imitate the worst paintings in the Salon'.[19] On most occasions, however, the phenomenon was powerfully associated with the production of an unhealthy number of novelties. Though it is difficult for our twentieth-century minds to grasp it, novelty was generally presented as a thoroughly negative concept in eighteenth-century art commentaries. It carried inflections somewhat similar to the modern concepts of 'gimmickry' or 'trickery'. In its most pejorative senses 'novelty' was associated with the fickle appetites of the public and the effects of petty consumer demand on the visual arts. Hogarth

and some of his colleagues in the St Martin's Lane coterie were running against the general tide of European thought when they publicly stated their belief that the vigour of the market and the boredom of consumers should throw up a variety of interesting new products and artistic ideas.[20]

From the 1760s onward the concept of novelty started to exist in uncomfortable relationship to that of artistic 'originality', a phenomenon which was considered in an altogether more positive light. Originality in most of its eighteenth-century usages was a form of novelty which arose from imitation; to be original, or 'an original genius', was to show exceptional skill in the 'inventive' combination or reinterpretation of hallowed precepts and traditional elements. In a sense the concept of artistic originality—a concept which is one of the defining preoccupations of the later eighteenth-century European art world— was promoted as a means of making 'novelty' socially and academically respectable. To draw distinctions between a mind concerned with cheap novelties and an original thinker was to exercise one's social prejudice. One man's original genius was another man's perpetrator of cheap artistic gimmicks.

It can be no coincidence that texts concerning original genius— works such as Edward Young's *Conjectures upon Original Composition* (1759) and Alexander Gerard's *An Essay on Genius* (1774)—appeared in those decades when the problem of excessive numbers of artists really began to have an impact on the art world. To appropriate the reputation of an original genius—a capacity which most theoreticians asserted was innate and could not be acquired—was an excellent way of an artist differentiating himself from his many ambitious peers. It was, similarly, a forceful means of justifying his spectacular novelties as something worthy of critical respect. Art historians have given little thought to the problem of why the concept of original genius rose to prominence in this period. It is presumed to have occurred for no better reason than the immanence of 'the romantic movement'. I suggest that the concept was socially generated by the appearance of conditions of excessive economic competition within the new public art markets of northern Europe and Rome.

The connection between fear of competition and doctrines of original genius is most clearly ascertained from Henry Fuseli's literary works. Fuseli was clearly much concerned by the growing competition between artists and regarded the consequences as a rising tide of mediocrity and spurious novelty. Airing, as he was prone to do, his disgust at his own times he implored his contemporaries to: 'Expect no art in those [times] that multiply their artists beyond their labourers.' His feelings on the matter were so strong he was even drawn to imply in his second Academy lecture that modern academies and public art institutions had achieved little but to encourage a 'mass of self-taught and

tutored powers' to 'burst upon the general eye'. Novelty was, for Fuseli, a decadent phenomenon which emerged when art ceased to be grand and exclusive and artists resorted to 'popular amalgama' intended to 'please the vulgar'.[21] Real elevated geniuses—in which class of men he, by implication, placed himself—were born with a gift for genuine original invention. His anxiety to cast himself and those he admired in a totally different class of humanity from the competitive throng of ordinary talents and perpetrators of cheap novelties was, we can posit, directly related to his fears that he might in truth be one of them.

Inevitably the immense competition for social recognition within the European art world warmed the debate on how the status of the artist was to be defined. The original genius was just one new 'product' of the extreme commercial pressures of the late eighteenth century. Much as these pressures threw up a whole new variety of art products, genres, and specialist producers, they encouraged artists and art commentators to invent myriad new ways of defining the role of the artist. The role of the artist was ultimately redefined in the social interests of those who lived out the new role. Failure in accordance with the ideas of one's competitors on what constituted success could be translated into success within a set of new criteria defined by oneself and one's allies.

Every competing faction and successive generation fought to redefine success in accordance with their own interests. Prominent academicians naturally sought to define their success, at least partially, in terms of their titles of office, regalia, and bureaucratic responsibilities. This in turn drove those who were marginalized from the centre of institutional power to seek the endorsement of wider public acclaim or to retreat entirely from public life with the consolation that they would satisfy the demands of posterity. Similarly the fact that a proportion of the art profession sought to improve its material condition through its labours, and patently aspired to a life of public respectability and domestic comfort, drove others to untidy garrets in search of higher ideals.

Of all the new ways of considering the function of the artist that arose in this period the most important, at least as posterity has considered it, was the notion that the essential concern of the artist should be to express himself or to give physical substance to his 'imagination' or personal vision. The ideology of self-expression is held to be *the* defining ideology or aesthetic of the 'romantic movement', *the* primary new way of thinking about the role of the artist to emerge in the early nineteenth century. Abrams, whose *The Mirror and the Lamp* (first published 1953) exercised enormous authority over late twentieth-century conceptions of this period, considered that the world of literature was completely transformed by the arrival of this new aesthetic. He argued that: 'The year 1800 is a good number and Wordsworth's

Preface a convenient document, by which to signalise the displacement of the mimetic and pragmatic by the expressive view of art in English criticism.' Like most scholars of his generation Abrams was more concerned with tracing the origins of the development of 'the expressive view' than with suggesting historical causes for its appearance. It is thought to have come into vogue for no better reason, one presumes, than that it was part of the inevitable 'romantic movement'.

In his *Art and Illusion* (first published 1960) E. H. Gombrich, also a believer in the transforming powers of the 'romantic movement', applied the Abrams stance to the analysis of the visual arts. In the final section of the book entitled 'From Representation to Expression' he points to the art of John Constable (1736–1837) as a defining example of this transition. He isolates, somewhat inevitably, a passage in Constable's published correspondence when he refers to his motivations for becoming a painter:

The sound of water escaping from mill-dams, etc, willows, old rotten planks, slimy posts, and brick work, I love such things . . . I shall never cease to paint such places . . . painting is with me but another word for feeling, and I associate 'my careless boyhood' with all that lies on the banks of the Stour; those scenes made me a painter.[22]

Had Gombrich looked for a German parallel to this phenomenon he could well have pointed to the landscapes *œuvre* of Caspar David Friedrich (1774–1840) in which landscape is similarly turned into a medium of physiological or spiritual biography. Friedrich was, perhaps, even more emphatically committed to his task than Constable. His device of including his own portrait within his landscapes as a lay figure seen from behind—a device intended to invite the viewer to look at the world through the medium of the artist's personal perception—constituted a remarkably inventive adaptation of the generic conventions of landscape painting to the demands of creative self-expression.

The historic significance of artists who showed an overt interest in self-expression has, perhaps, been exaggerated. This aspect of their works seems important and representative in hindsight largely because it happens to represent the beginnings of an aesthetic ideal that went on to become predominant in the twentieth century. It seems reasonable to question whether those painters interested in self-expression can be held as typical figures of their times. I argue on the contrary, that, they were rather untypical and that self-expression was consciously a statement of a minority, if not isolated, position. In the field of the visual arts as distinct from poetics, 'the expressive view of art' developed as one of many new ways of thinking about the role of the artist and one which, at least initially, was more associated with the margins of the European art professions than their centres.

The 'expressive view of art' was born, at least in part, of a dissatisfaction with the competitive atmosphere of the early nineteenth-century urban art markets and with the hustle and bustle of cities themselves. Both Constable and Friedrich were interested in the notion of the private and personal encounter with nature. Friedrich indeed, was, captivated by the notion of encountering nature in solitude on the pinnacles of mountains, which was about as far from urban civilization as European man could get. The very conception of 'self-expression' was, in its earliest manifestations, powerfully associated with that of physical and spiritual isolation. Accordingly, the artist who looked to explore his own emotions stood outside the throng competing for a slice of consumer markets or resorting to gimmickry in order to assert and maintain their positions.

To a greater or lesser extent those who pioneered this view of art did so in the expectation that the majority of potential patrons would not understand their point. It was a common characteristic of those artists that they were at one time or another profoundly misunderstood and that they continued, despite this, to pursue their personal vision. Indeed the very fact that those who pioneered 'the expressive view of art' were so frequently misunderstood is in itself a powerful indication of the degree to which this view of art was outside the mainstream and beyond common comprehension. They cannot be held representative of *the* aesthetic movement of their times.

The 'expressive view of art' was not necessarily the ideal of radicals nor did it constitute a 'revolution' in the European art world. It was not, as Gombrich postulates with reference to Constable, a radical 'anti-establishment' doctrine necessarily related to a revolutionary turn of mind; a counterblast to 'timidity' and 'conservatism' in 'the higher ranks of art and society'. Contrary to Gombrich's insinuation, Constable was no romantic revolutionary. Indeed, he described his own work as the expression of permanence, continuity, and sobriety; an attempt to give 'one brief moment caught from fleeting time a lasting and sober existence'. Those who became concerned with self-expression were not consciously constructing a 'romantic revolution', as Gombrich describes it, in order to accompany the earlier revolution in the political sphere. Both Constable and Friedrich were, in some respects, conformists who at one time or another sought a place within the art 'establishment'. They were frequently torn between a role as social 'insider' and 'outsider'. Friedrich on one occasion sought isolation, on another stipended academy positions. Far from being a radical, Friedrich appears to have been of highly conservative political bent. Constable similarly appears from his published correspondence to be at one time a fairly canny careerist and art politician while, at another, a declared 'outsider' resolving not to become the sort of artist that was blithely accepted by the public.

It is significant that neither Constable nor Friedrich were *dramatis personae* or eccentric individuals. The ideology of self-expression, the exploration of one's individual vision, was something quite distinct from playing the public role of being an extraordinary individual. In certain respects, indeed, to be interested in self-expression was to take up a stance against artistic eccentricity; to opt for a life of serious, private creative enquiry as opposed to a life revolving around the public display of superficial difference.

Firebrand eccentric artists were, ironically, quite the norm in the art world which Constable and Friedrich inhabited. Much as the competition between artists produced a variety of novel art products and gimmicks it forced artists into turning their whole public persona into a gimmick. The late eighteenth and early nineteenth century was an era in which to be 'normal' as an artist was to be different. A shrewd and somewhat sardonic wit, the sculptor Francis Chantrey quickly identified the majority of artistic eccentrics of his day to be little more than careerist in a sophisticated guise. One of his biographers recalls that: 'He had but little feeling for the eccentricities of genius; he thought it but an excuse of the ambitious to usurp the place of real and developed talent, and an appeal to the public by presuming individuals of slender abilities.'[23]

In this climate truly serious artists who did wish to follow Chantrey's example and become stage conformists were naturally attracted towards more profound notions of personal identity and idiosyncrasy. William Blake (1757–1827), for instance, set out to be something far more than an eccentric. He became a type of artist who was challenging to the whole notion of token weirdness; at times he seems to have conducted his life as a self-conscious parody of the eccentric artist.[24] Of the handful of patrons who did employ him most seem initially to have been quite ready to give work to an eccentric genius but found, to their chagrin, that he was interested in expressing a personal cosmology and had radically individualistic ideas about artistic form. Dr Thornton, who employed him to illustrate his *Virgil* of 1820, was so shocked by the results he needed persuasion to publish them and only did so along with the disclaimer that: 'they display less art than genius, and are much admired by some eminent painters.'

Blake's career demonstrates a willingness to pursue a personal vision to the point of social marginalization and financial ruin which we shall explore in detail in the next section of this chapter. It was an effective strategy for emotional survival in a competitive art world where failure was the inevitable fate of the majority. To fail because one embraced failure was at least to be in control of failure. It was a means of preserving one's dignity in commercial conditions which seemed to require an artist to exhibit extraordinary political intelligence or commercial acumen to survive.

Genial geniuses and ungovernable genies

The European Enlightenment is frequently associated with optimistic philosophic doctrines which expressed man's natural gravitation towards 'sociability'. To be civilized was, in the view of David Hume (*A Treatise on Human Nature*, 1739–40 and *Of the Standard of True Taste*, 1757)[25] and others, to be bonded by natural sympathy to one's fellow man, to be part of a moral community. Wherever a strong urban public developed in the eighteenth century individuals gravitated towards clubs. Such organizations were the forum where private individuals became public citizens. Man, especially creative man, was construed as a facet of a broader social organ, the public urban community. Mid-eighteenth-century artists (particularly Parisians and Londoners) proved, for the most part, a highly 'clubbable' community. Academies and artistic societies can, indeed, be regarded as expressions of a broader tendency towards artistic sociability in the mid century. Freemasonry, in particular, attracted artists all over Europe. Hogarth was an archetypal example of a social and community man: a freemason, a stalwart member of numerous worthy charities, a less stalwart member of a number of less than worthy but highly amusing clubs, a wit, a boon to his friends but a terror to his enemies, a lover of his country, friend of his city, and a hater of foreigners. His art was, accordingly, highly concerned with cultivating the social bonds of the polite community and the moral improvement of the citizen.

In clubs and societies eighteenth-century artists mixed not only with the blood gentry but also a host of other professionals. Through his clubbable persona the artist expressed the notion that he was part of a respectable profession analogous to other professions. The club or society became a venue where the artist could feel part of a stolid professional élite, part of a profession whose public profile was rising simultaneously with his non-artist friends. These friends were, to an increasing extent, also his patrons. By the mid-eighteenth century writers, doctors, actors, theatrical impresarios, etc. were reflecting their new-found wealth and status in becoming major sponsors of the visual arts. In England, for instance, David Garrick, the actor and theatre manager, became one of the single most important art patrons of his time.

The fact that artists frequently came to work for their peers is, perhaps, one of those essential factors which distinguish the eighteenth-century European art world from its predecessors. Portraiture, in particular, was transformed by the closure of the gap of deference between sitter and artist. Jean Baptiste Pigalle's (1714–85) extraordinary bronze bust of Denis Diderot, affectionately inscribed on the reverse 'En 1777, Diderot par Pigalle, son compère, tous deux âgés, de 63 ans', is, perhaps, the quintessential image of enlightenment socia-

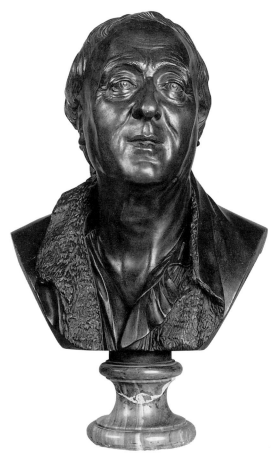

bility [**3**]. Diderot's extraordinary frank and characterful expression communicates a sense of 'sympathy' which is unique to its times.

Enlightenment conceptions of artistic 'genius' were, to a large degree, adapted to the culture of sociability. A high value was set on the concept of *ingenium*, which was translated into English as the concept of 'wit' and into French as the concept of 'esprit'. On the whole, mid-eighteenth-century thinkers perceived the genius, or more often the person with genius, as an essential part of the moral community. As Kinteret Jaffe has pointed out, the mid-eighteenth century typically stressed the common ground between the man in possession of genius and his fellows:

Most of the *philosophes* believed that the laws of nature could be understood by a method of reasoning that is shared by all men; every human mind is capable of perceiving the world through the senses and organising these senses in a logical manner.

The capacity for genius did not, Jaffe points out, make a man intrinsically different from all other men, 'it only made him a better perceiver and imitator of nature'.[26]

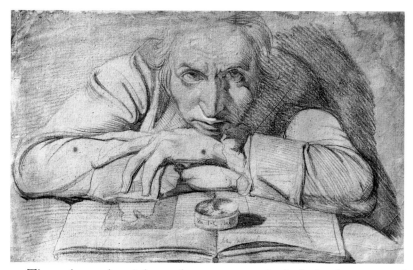

4 Henry Fuseli
Self-Portrait, black chalk, c.1779

Throughout the eighteenth century, particularly in the tracts of William Duff and Alexander Gerard, genius was strongly associated with powers of combination and 'invention' which gave rise to 'agreeable' productions. The genius, these theorists held, was defined by an extraordinary capacity for invoking pleasing harmonious sensations which were, in general terms, useful to society and consistent with the maintenance of decorum and public order. Wildness and uncontrollable flights of the 'imagination' were largely frowned upon as displeasing to the world at large. To say an art work was 'inoffensive' or 'pleasing' was a veritable compliment in many mid-eighteenth-century circles.

Probably because these doctrines were so heavily ingrained into European literary culture the backlash against them was remarkably powerful. Late eighteenth- and early nineteenth-century European art worlds began to become populated with a myriad of extreme social outsiders; artists who wished to stand beyond economies, beyond petty codes of public decency, beyond professional associations and societies, and beyond public service. By the early nineteenth century the notion that artistic genius might be by definition a state of madness—a state of mind which placed a man outside the moral community and was feared more emphatically than death in the enlightenment psyche—was becoming commonly acceptable. The idea had, indeed, become so fashionable in early nineteenth-century England that Charles Lamb felt obliged to publish an essay on *The Sanity of True Genius* (1826). As George Becker explains in his exploration of *The Mad Genius Controversy*, in the early nineteenth century European thought swung towards a notion of genius 'as a defining mark of an extraordinary individual'. 'The aura of mania', he adds, 'endowed the genius with a mystical and inexplicable quality that served to differentiate him from the typical man, the bourgeois, the philistine, and quite importantly the

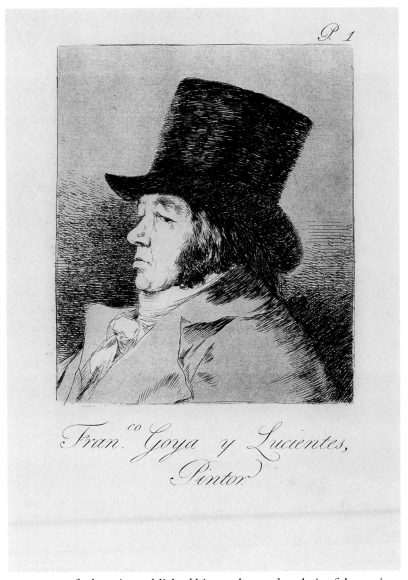

Fran.^{co} Goya y Lucientes, Pintor

mere man of talent; it established him as the modern heir of the ancient Greek poet and seer and like his classical counterpart, enabled him to claim some of the powers and privileges of the divinely possessed and inspired.'

The revival of classical notions of the genius as a demonic presence, or ungovernable 'genie' to be let out of its bottle with caution, is, perhaps, best encapsulated in Henry Fuseli's drawn self-portrait of *c*.1779 [**4**]. Here we capture the artist brooding over a sketch book. His intense gaze and furrowed brow are probably intended to be intimidating to the 'ordinary' viewer. He is a living representative of *terribilità*, that magnificent turn of mind often associated at the time with the genius of Michelangelo. This was a man born to be different.

An instructive comparison can be made between this drawn self-portrait and the Madrid artist Francisco Goya's (1746–1828) etched self-portrait for a frontispiece for his *Los Caprichos* series of etchings (first published 1799) [**5**]. Goya's self-portrait is, in many respects, an expression of the classic Enlightenment conception of genius as defined by the majority of the *philosophes*. The comparison clearly illustrates the degree to which Fuseli had moved away from this conception.

The self-portraits share something important; a rather unpleasant expression intended to disturb the viewer. Goya's scowl is intended to prepare the person looking at his series of prints for a discomforting view of the world. It was described by his contemporaries as a 'malign' and 'satiric' expression and has since been recognized as an adaptation of Charles Le Brun's expression for 'contempt'.[27] Unlike Fuseli, Goya profoundly believed in the capacity of art, in particular these prints, to improve the moral condition of society. His scowl prepares the viewer for the idea that the prints contain some uncomfortable lessons. Goya's truths were painful, he did not expect to be liked for airing them. Goya, like Fuseli, seems to have regarded himself as an uncomfortable 'outsider'. He too had moved away from the mid-eighteenth-century polite Parisian notion that art should be pleasing. Goya, however, only stands outside society in as far as society at large had become a place in which polite sociability and reasoned debates were held in contempt. The *Los Caprichos* etchings themselves depict the world at large as a place of madness and display the typical enlightenment horror at the sight of insane frenzy. Goya differentiated himself from his society by his extreme sanity. This self-portrait is a reaction against, rather than endorsement of, the association of genius with madness, frenzy, and what Alexander Gerard described as 'irregular' fantasy. It would, in fact, have made an equally good frontispiece for Charles Lamb's *The Sanity of True Genius*.

Neither Goya or Fuseli could be regarded as outright outsiders to the art worlds of their day. Both men sought and obtained official academic posts. Their slight embarrassment at becoming part of the establishment was similarly reflected in their speeches as Academy officers in which they purposefully subverted the fundamental doctrines which the academies had been founded to promulgate. The very acceptance of such forceful and irreverent characters as prominent academic officers does, indeed, pose the question of whether the academies in which they served can be held as representative of the art 'establishment' at all. As, in the final six decades of our period, anti-academic opinions became entirely conventional it became inevitable that it would be difficult to find artists of credibility who were not anti-academic or in some way anti-establishment. Thus the institutions associated with the art establishment became the haunts of the anti-

establishment. Many of Europe's royal and princely foundations became meeting places for radicals and democrats. In England King George III was so convinced that his Royal Academy had become a hotbed of radicalism he refused royal visits.

This situation, of course, drove those artists who wished to be considered seriously 'anti-establishment' figures to adopt ever more extreme stances. Similarly, it led to sectors of the public becoming rather cynical about artists' postures of unconformity. E. J. Pigal in his comic lithograph of a supercilious *Academician* (published 1833) set out to expose the hypocrisy of the anti-establishment, establishment man [**6**]. The academician, his fine waistcoat bulging out before him, is depicted as an archetypal prosperous professional. His ear-ring remains an incongruous formal concession to the unconventionality and the anti-establishment air expected of the 'real' artist of the day.

Pigal's second line of attack was directed at the pompous professional aspirations of the *Academician*. His print was, indeed, part of a

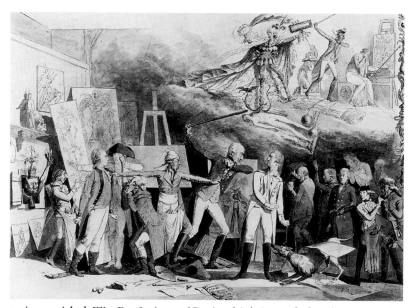

series entitled *The Professions of Paris* which intended to lampoon the prominent physical types recognizable within that city's respectable professional élite. European anti-academic rhetoric often proceeded from the assumption that art was a vocation and fulminated against the idea that the art institutions sought to reduce art to a profession. It was a charge difficult for the institutions' apologists to counter. Most European academies had been founded on the idea that they would turn practitioners of the arts into respected gentlemen-professionals. Their pension schemes and bureaucratic organization gave academicians a genteel professional air. Some European cities, most often those under the governance of rather conservative political regimes such as Stuttgart and St Petersburg, actually required art students to wear civil service uniforms.

The sense of righteous indignation with which a heroic modern artist of anti-academic bent was supposed to greet the attempts of academic officers to reduce his vocation to a utilitarian profession was dramatically captured in a comic drawing by the Swiss artist, Joseph Anton Koch (1768–1834) [**7**]. The drawing refers to an incident in the studios of the Stuttgart Academy, in which the artist was involved in a dispute between some of the more liberal students and the director of the Academy. Although this drawing is usually supposed to date from the early 1790s, the composition appears to have close echoes of David's most famous image of heroic conflict, *The Intervention of the Sabine Women* of 1799. If this is so—and it is likely because Koch was a student in David's atelier—Koch's drawing can be seen as a mock-heroic statement. The protesting students appear in the role of the valiant masculine Roman and Sabine warriors upon whose struggles the fate of civilizations depend.

The Stuttgart Academy was a notoriously restrictive institution which modelled itself on a military academy. The institution's pedantic insistence upon mechanical techniques, its desire to instil skills of value within useful crafts such as that of the cabinet-maker and technical draughtsman, is parodied throughout the drawing. It is particularly evident in the curiously phallic pyramidal measuring devices which emerge from aprons of the conformist tutors and students. In his memoirs Koch described leaving the Academy and making his way toward the egalitarian environment of Revolutionary France in the vivid terms of a heroic escape from prison.

Some years after Koch produced this drawing a comic lithograph appeared on the Parisian market of very similar composition [8]. It also depicted a studio revolt and was based on David's *The Intervention of the Sabine Women* [1]. The revolt concerned occurred in the studio of David himself when a group of students more radically committed to reform than their master rebelled against his tuition. David, the arch-reformer and one-time leader of rebellious factions, is shown as a fop and his students as brave antique heroes taking up arms about his unmanly mannerisms. The print satirized the attempts of early nineteenth-century artists to outdo each other in the search for radical 'anti-establishment' postures.

After leaving David's atelier the group were posed with a problem of how to organize themselves without becoming anything like an organization. Organizations smacked of the establishment and the establishment of corruption. To this end, the group chose instead to form a pseudo-ascetic sect and took up residence within a ruined and abandoned shell formerly inhabited by a religious community. It was not the only group of artists to adopt such a stance. At about the same

8 Anonymous

Riot in David's Studio, lithograph

time another quasi-monastic association was established around a core of artists who seceded from the Vienna Academy and moved to Rome. Both groups were soon gifted with nicknames; the Parisians became known as 'the Barbus' and the Germans as 'the Nazarenes'. The German-speaking group, who actually styled themselves the 'Brotherhood of St Luke', came to inhabit the ruined monastery of San Isidoro. Here they chose to live in a close fraternity under a form of rule. This was presumably considered to be a desirable alternative to the impersonal hierarchical rule which they had encountered in the Viennese Academy.

Both groups saw art as something entirely removed from the values of a profession or business. They did not labour to acquire the accolades enjoyed by the 'celebrity artist' or to earn the privilege of enjoying gentlemanly recreations in their spare time. Indeed, spare time was an anathema to these artists. Art was about total commitment; a commitment required of an all-consuming quasi-religious vocation. The largely Catholic 'Brotherhood of St Luke' embraced a version of medieval Christian asceticism which, although controversial, was acceptable, even endorsed, in certain official circles. The Parisian group were, by comparison, wholehearted nonconformists. They embraced just about every form of mystic piety available at the time, an exotic cocktail of Mohamedanism, Buddhism, Christianity, speculative Free Masonic ritual, free-love, and American Indian philosophy. Their general ethos is best understood in the broader context of the profound reaction against the attempts of Revolutionary ideologues completely to dedicate the visual arts to the utilitarian cause of mass public indoctrination. Shunning the hackneyed role of disseminator of 'official' culture, the Parisians turned themselves into a radically useless association. They set out to produce little or nothing that could be understood or enjoyed by the public.

Unlike the 'Brotherhood of St Luke' which was enthusiastic to exhibit its works and foster critical appreciation, the Barbus made few realistic efforts to promote a wider understanding of their aesthetic objectives. That their work was appealing to neither private collectors nor public institutions is indicated by the scarcity of surviving examples. Those paintings which do survive, such as Paul Duqueylar's *Ossian Chanting his Poems* (1800), give the strong impression that their work was not intended to be saleable in mainstream markets. Interpreting absurdly lofty subjects on huge canvasses and rejecting any superficially appealing use of colour or brushwork they did not set out to win applause in comfortable Parisian drawing rooms. Indeed, their work was the contrived opposite of all that smacked of petty bourgeois domesticity; a complete antidote to the modestly sized prints of domestic scenes based on the works of Morland or Stodhart which sold by the thousand across Europe in the 1780s and 1790s.

Although more worldly in some respects, many of the artists within the 'Brotherhood of St Luke' also seem to have courted failure by giving little practical consideration to economic reality. The engravers of the group, for instance, were not inclined to exploit the potentially lucrative consumer marketplace; seeking morally satisfying alternatives to consumerism they became excessively reliant on the support of a handful of sympathetic admirers who were drawn into idealistic schemes that were doomed to break down in disappointment and mutual acrimony.

There can be little doubt that for some of the members of these communities the heroic failure to live in accordance with an ideal was better than the success recognized by the materialistic criteria of 'ordinary' society. The role of social pariah was welcomed by the Barbus. Some members of the group opted to wear clothing so distinct from 'normal' fashions that they reportedly became accustomed to being pelted with rotten fruit in the streets. Their need to be regarded as martyrs to the elevated cause of art caused one of their apologists to claim, without foundation, that a high proportion of the group had committed suicide. The group's leader Maurice Quay, whose death was appropriately tragic and premature, was ennobled by comparison with the misunderstood figure of Christ as man of sorrows.

The Barbus' self-destructive tendencies were far from unusual. Across Europe spectacular lack of commercial acumen became positively *de rigueur*. In Britain, where society artists were making unprecedented fortunes, artists were particularly prone to embarking upon huge *tours de force* based on dauntingly serious themes which brought about their financial ruin. The English artist James Ward (1769–1859), for instance, twice risked ruin by painting vast canvasses which cost more to produce than he received for them. Ward's massive *Gordale Scar* (completed 1812), which took four years to produce and was eventually sold for only £300, less than the price Thomas Lawrence was obtaining for a few weeks' work on a portrait. *Gordale Scar* was made to appear a sensible creative indulgence by comparison with his *The Triumph of the Duke of Wellington* of 1816–21. The expenses of producing this huge canvas (21 × 35 ft.; 6.4 × 10.7 m.) well exceeded the £1,000 prize money the British Institution had awarded him for the commission. The canvas was so enormous that not even the Institution could find a room large enough for its exhibition.

Heroic creative struggle

Although many of those artists who committed financial suicide in this period were proclaimed social 'outsiders', their actions were not of marginal significance. Their broad conception of the production of art as a process of heroic struggle—an ideal which had developed in conformity to the militaristic values of the Revolutionary and Napoleonic

period—was held in wide regard. The artist's search for fame can be broadly equated with that of the aspiring warrior; the greater the odds against his success, and the greater the privations and personal losses incurred, the more likely his deeds were to be hallowed by posterity. It was, therefore, no coincidence that James Ward ruined himself attempting to capture in paint the triumph of a great military figure.

An illustration of this shift toward the heroic can be drawn from the comparison of the first President of the British Royal Academy, Sir Joshua Reynolds's (1723–92) *Self-Portrait in Oxford Academic Gowns* (painted for the Royal Academy in 1773) [**9**] and Christoffer Wilhelm Eckersberg's (1783–1853) portrait of Bertel Thorvaldsen (1768–1884) painted for the Royal Academy of Fine Arts in Copenhagen (1814) [**10**]. Both portraits show the artists dressed in academic gowns, vestments which gave overt expression to their intellectual or 'academic' aspirations. In his self-portrait Reynolds depicts himself in the robes worn when recently accepting an honorary Doctorate in Civil Law

9 Joshua Reynolds
Self-Portrait in Oxford Academic Gowns, oil on panel, 1773

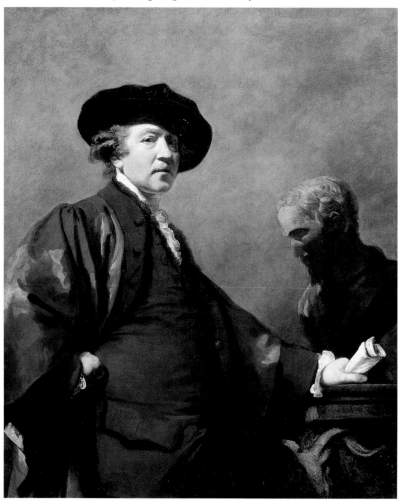

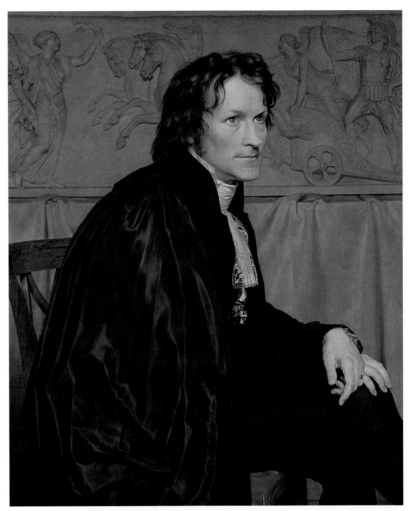

from Oxford University standing beside a bust of Michelangelo. He presents himself as a man whose claims to intellectual distinction have not overwhelmed his modest belief in the human scale of his achievement. One is reminded of the final passage in the fifteenth and final *Discourse* where Reynolds described his feeling of humility when faced with the titanic achievements of the 'truly divine' Michelangelo. His patent reliance upon the inspiration of Rembrandt's self-portraits sets the tone of an image which is quietly reflective rather than self-aggrandizing.

Reynolds's self-portrait closely reflects his stance in the academic debate between the 'ancients' and the 'moderns', by then a traditional debate, which had begun in the French Academy in the late seventeenth century. Throughout the *Discourses* and in his con-tributions to *The Idler* Reynolds was consistently mocking of those 'modern' painters who claimed to rival the achievements of the Renaissance or Antiquity. Indeed, he regarded such claims as positive vulgarity. The

11 Christoffer Wilhelm
Eckersberg

*Thorvaldsen's Boat Arriving in
Copenhagen*, oil on canvas,
1838

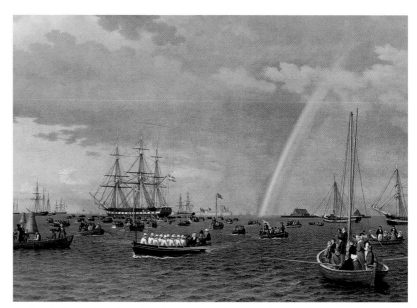

truly philosophical artist, he assumed, would regard his prospects of rivalling the achievements of Antiquity with pessimism. Modest achievements could be made if art was laboriously studied with humility and reverence to past achievement. Such achievements were, however, more likely to be engaging than awesome.

By contrast Eckersberg and Thorvaldsen appear to have taken a more optimistic view of the capabilities of 'the moderns'. Thorvaldsen is in fact shown as a modern of truly ancient stature, a figure of mythic potency. The sculptor is seen sitting beneath his studio model for the famous *Triumph of Alexander* frieze in the Palazzo del Quirinale at Rome, a work commissioned by Napoleon which thrust the sculptor toward European celebrity. As Eckersberg himself testified, his intent was to draw connections between artistic and military triumph. He compared the sculptor's achievement to that of Alexander at the moment of his heroic entry into Babylon standing on a splendid chariot crowned by fame. The parallels between military and artistic triumph did not stop here. Bonaparte intended that the image of this triumphal entry into the corrupt city of Babylon should be seen as a prefigurement of his own heroic entry into Rome. The comparison of Thorvaldsen with Alexander also implied a comparison between the artist and Napoleon.

Thorvaldsen, like Napoleon, was seen to carry the genius of the age within him. Far from being an 'outsider' Thorvaldsen was taken to represent everything magnificent in public life. Whilst Reynolds depicted himself as a man limited by his age, Thorvaldsen is depicted as a man ennobled by his age. Reynolds's portrait appears to be that of a man who considered that the plaudits of academic institutions did him an honour beyond his meagre claims to genius. Thorvaldsen's portrait, by

contrast, seems more like that of a man of genius bestowing honour and credibility upon an institution with which he had once been connected. Although willing to sit for the portrait, Thorvaldsen was, at this time, actively resisting all attempts to get him to return to Copenhagen and serve the Academy which had initially sponsored his education. Eckersberg's portrait might, indeed, be compared to a modern school portrait of a celebrated former pupil which is commissioned to enhance the reputation of the establishment.

Thorvaldsen, like his rival Canova, had not joined in the chorus of early nineteenth-century public criticism of the academies. It is, however, significant that both sculptors chose to operate large private studios and to avoid protracted service within academic establishments. Both men accepted the plaudits and honorary memberships heaped upon them by academies throughout Europe and, in doing so, built themselves into international celebrities who were more potent than the academic institutions which competed to give them tribute. The whole practice of inviting internationally famous artists to become honorary academicians which took off in the early nineteenth century was a sign of shift away from the authority of the public body toward the cult of the individual genius. Europe's academic establishments began to need artistic celebrities more than artists needed academic endorsement in order to be recognized as men of substance.

The extent to which Thorvaldsen's public lionized him was most clearly demonstrated by the scenes which greeted him on his return to Copenhagen in September 1838. The official welcoming of the artist and his public presentation was the sort of flag-waving national event usually reserved for the arrival at home ports of victorious martial heroes or triumphant statesmen. Eckersberg recorded the scene of the sculptor being rowed to shore as an almost supernaturally portentous moment; as on the actual day, a huge rainbow appears in the sky and the ocean is illuminated by an appropriately uncommon ethereal light [**11**]. Thorvaldsen was no unwilling hero of the people. Although he publicly feigned embarrassment at the extent of his welcome, joking that the Pope would not have been more ecstatically received, he proceeded to order a copy of Eckersberg's painting for himself.

The valorization of the artist was a truly European phenomenon. In his diaries of the Napoleonic period Benjamin Haydon reveals that he was consumed by fantasies of entering military or naval service. On one occasion he and David Wilkie embarked upon a short voyage on a Man of War in hope of witnessing some of the gory conflict at first hand. For a while Haydon's favourite anecdotes were borrowed from mighty cavalry officers who he invited into his studio as models. One favourite model excited the artist tremendously with his tale of splitting a man in two with a single blow of the sword.

Across the Channel Théodore Géricault (1791–1824), a dashing

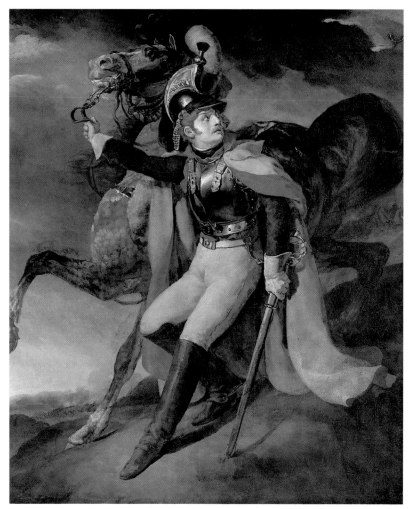

horseman capable of more than the mere fantasy of being a military
hero, actually entered a cavalry regiment. He painted a tremendous
series of images of cavalry officers some of which, especially that bril-
liant image of heroic defeat *The Wounded Cuirassier* of 1814 [**12**], per-
fectly accord with Haydon's military fantasies and anecdotes as jotted
down in his diaries. The painting perfectly captures the contemporary
fascination with heroic responses to adversity, failure, and defeat. A
work of impressive proportions, allegedly painted in three days, it was
created in a manner no less heroic than its subject-matter. Greeted
with universal critical disgust, it was also a heroic failure.

Heroic failure was a subject which Géricault had much opportunity
to contemplate. After the fall of Napoleon he became part of the social
circle of the prodigiously talented painter Horace Vernet (1789–1863),
the son of his teacher Carle Vernet (1758–1835). Both Horace and his
father supported Napoleon to the bitter end and were present at his last
stand at Clichy. After his fall Horace clung to the Napoleonic vision of

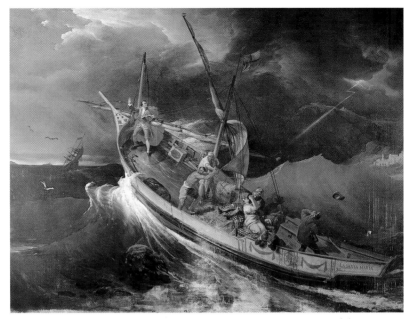

heroic conquest and opposed the Restoration government. To this end he set up his studio in a suburb of northern Paris which had become the ghetto of loyal Napoleonic officers on half pay. One commentator described him in the following terms:

His stature is neither tall nor short, he has the musculature of an antique gladiator. An ardent hunter, indefatigable horseman, instinctive musician, a soldier by inclination, a painter by passion, we see him handling his palette and his gun in turn, smoking like a Spaniard, singing like an Italian, fencing with his foils, blowing his hunting horn, telling a story of sentiment and melancholy, cracking a joke, shooting his pistol, and starting a boxing bout.[28]

In cutting such a dash Horace Vernet was aware that he was living up to a dynastic tradition of heroic independence and resolution in the face of danger and adversity. In order to celebrate and embellish this tradition he painted in 1822 a magnificent canvas in which he related a heroic legend drawn from the life of his grandfather, Claude-Joseph Vernet (1714–89) [**13**]. In his youthful desire to experience the forces of nature at their rawest, Vernet is reported to have requested to be strapped to the mast of a ship which was riding into the eye of a terrible storm off the coast of Italy. Significantly, as Levitine noticed, this episode in Joseph Vernet's life had appealed little to eighteenth-century commentators but began to feature prominently in French artistic folklore during the first decade of the nineteenth century when the search was on for tales of artistic heroism.[29]

Horace Vernet's sense of heroic valour caused him to make public his opposition to the loss of the Napoleonic vision of French military

prowess. He made frequent public register of his discontents through his works. Typical of these is an engaging painting, now in the Wallace Collection, of a muscular cavalry officer dreaming of past glories in a break from ploughing, lamenting the dishonour of beating swords into ploughshares [**14**]. Two years after the completion of this painting Vernet organized an exhibition in his own studio of *The Defence of the Barrier of Clichy* and *The Battle of Jemmapes* (1822) as a protest against the rejection of these works by the Restoration Salon committee. The very presentation of the paintings, which glorified passages of Revolutionary and Napoleonic military history which the new ministry would have preferred to have been forgotten, could be considered an act of brave defiance.

Living in the ambit of the Vernets probably inspired Géricault to take on the Administration in his vast history painting of *The Raft of the Medusa* (1818–19). The painting dwelt on a tragic shipwreck which was caused by the incompetence and thoroughly unheroic behaviour of the captain, an incompetent aristocratic officer who on return from Napoleonic exile had been granted a command by the new ministry. Initially at least, the painting was conceived as a political protest against the unheroic tenor of the new age.

A significant difference between Géricault and Vernet, however, was the former's impulsion to retreat from society. The affable Vernet did not allow his independent spirit to damage his material prosperity; proceeding to become one of the wealthiest and most popular painters of the post-Napoleonic period.[30] By contrast Géricault, a man of darker temperament and more complex vision, struggled and suffered for his talent. He shunned the lifestyle of the slick artistic professional capable of devoting himself to his work during the day and finding pleasant diversions in his leisure hours. Whilst painting *The Raft of the Medusa* he entered a period of protracted social isolation, emerging from his studio only for such mortifying activities as studying the expression of dying men in Parisian hospitals. Like the modern method actor, Géricault insisted on total emotional absorption in the terrifying drama he was depicting. In order to mortify his mind with visions of an episode of human depravity which had brought men to cannibalism he obtained parts of the corpses of executed men to study in the seclusion of his studio.

In some respects *The Raft of the Medusa* was just another example of the vast, financially suicidal endeavours which characterized the Parisian art world in his day. Géricault, who took many years to finish the painting, considered it purely as a creative trial of strength and gave no real consideration to the matter of how his labours might be rec-ompensed. Eventually he was obliged to recoup some of his expenses by resorting to the most blatantly commercial means. Two months were spent promoting the work during its display in London

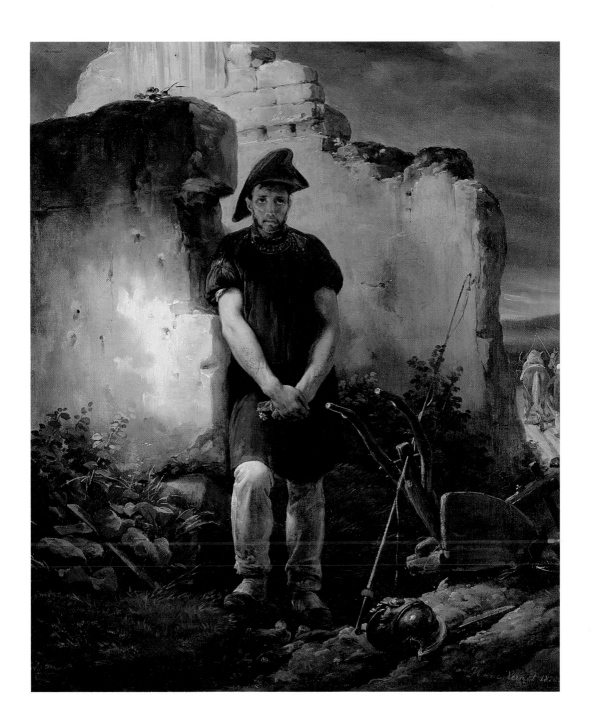

where it could be seen upon the payment of an entrance fee within William Bullock's somewhat downmarket Egyptian Gallery in Piccadilly.

Géricault had many things in common with the Barbus; he was similarly uninterested in commercial success, passionately individualistic, anti-academic, and attracted by asceticism. His personal journals contain self-imposed vows of abstinence not unlike those of a monk. Indeed, he is known to have shaved his hair in order not to be distracted by the attention of ladies attracted by his good looks. Benjamin Haydon, who shared Géricault's military fascinations, also shared his monastic bent. His early diaries proliferate with vows of chastity and forbearance uncannily similar to those of Géricault. On one occasion he compares his own frustrated pacing around his studio to those of 'a lion burning for coition'. Haydon was, to a greater extent than Géricault, driven by a self-destructive urge. He appears to have taken pleasure in putting his thirst for grand achievement above his immediate concerns for financial security. His eventual suicide was the inevitable consequence of a life devoted to glorious martyrdom. Indeed, as a young man he was prone to making melodramatic predictions of his own premature death.

Like the majority of British artists interested in generating a school of history painting, Haydon was convinced that the future of British art was dependent upon the arrival of a generation of great benevolent patrons. Invitations for his exhibition of *Christ's Triumphant Entrance into Jerusalem* at the Egyptian Hall in 1820 were addressed: 'To all ministers and their ladies, all foreign ambassadors, all bishops, all beauties in high life and all the geniuses of the Town.' Whilst Haydon was aware that he needed to court high society to make a living out of history painting he was, on account of his perverse nature and democratic political principles, unable to work under any remotely subservient patronage relationship. He was, indeed, so convinced of the grandeur of his mission and superiority of his genius that he was regularly patronizing in his attitudes to his patrons. Lady Beaumont, who reasonably objected that a painting her husband had commissioned was too big to be hung in the house, was referred to in Haydon's diaries as 'impudent'.

Haydon reserved the greatest possible derision for artists who, in his opinion, had prostituted themselves to the taste of the day. Particular disgust was reserved for Sir Thomas Lawrence, whom he considered to have pandered to the vanities of the rich and powerful, and also for Benjamin West (called by Haydon, a 'venereal pungency'). Like his friend William Hazlitt and others of his immediate circle, Haydon combined democratic views in politics with a staunch opposition to the incursion of 'the public' into the art market. His liberal democratic convictions did not extend to a desire to bring the elevated

art of painting to broader consumer markets. Caught between egalitarianism, which turned him against his patrons, and élitism, which turned him against 'the public' as art consumers, Haydon burnt all bridges to financial survival and glorious failure became entirely inevitable.

This self-destructive formula of lofty élitism and politically driven resistance to the élite establishment was pioneered in Britain by James Barry, the only artist in British history to succeed in being formally dismissed from his positions at the Royal Academy. Barry became the champion not only of Haydon but also of a generation of British artists who chose to struggle against a perceived art establishment. It was entirely appropriate that this trend in British art should have been pioneered by a man who undoubtedly suffered from a form of acute paranoia, which would now be described as a 'persecution complex'. This mental condition is clearly expressed in his powerful self-portrait of *c.*1780 in which he shows himself sketching beneath a massive statue representing Hercules crushing a symbol of Envy [15]. The painting belonged to the same broad tradition of militaristic or combative imagery as Koch's portrait of his rebellion at the Stuttgart Academy or the anonymous lithograph of the rebellion in David's studio. Barry also turns the studio into a field of combat. The sculptural imagery of the crushing of envy beneath the feet was, indeed, strongly identified with military triumph. Barry might well have seen the same imagery on Michael Rysbrack's (1694–1770) monument to the Duke of Marlborough (Blenheim Palace, 1732–6), the one-time military saviour of the nation who found himself vilified and dismissed from his offices for the convenience of a faction.

Barry's famous decision to devote seven years of his life to painting for no charge the cycle of canvases depicting *The Progress of Human Culture* and other subjects for the Great Room of the Society of Arts (1777–83) was, perhaps, the definitive act of artistic martyrdom. In William Blake's opinion this act cast Barry as the heroic antitype of the affable society portrait painters who traditionally dominated the English art scene; men such as Joshua Reynolds who had become wealthy by gratifying the vanities of the social establishment. In his famous marginal commentaries to Reynolds's *Discourses* Blake applauded Barry as a martyr to his art:

Who will dare say that polite art is Encouraged or either wished or tolerated in a nation where the society for the encouragement of Art suffer'd Barry to give them his labour for nothing, a society composed of the flower of English nobility and gentry?—suffering an artist to starve while he supported what they, under the pretence of encouraging, were endeavouring to depress.—Barry told me that while he did that work he lived on bread & apples.

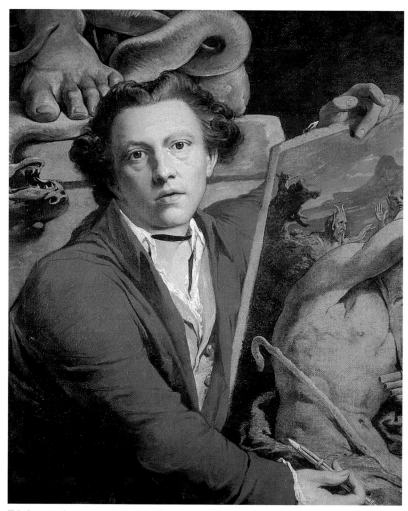

Blake neglects to mention that it was Barry who stipulated the terms of his employment and proved so arrogant in his dealings with patrons that he was unable to sell many copies of the engravings after the paintings which were intended to rescue his losses. Barry predictably ended his days in embittered seclusion within his semi-derelict London house, the draught from his broken windows symbolically excluded by unsold copies of his own engravings.

From the domestic dream to the domestic nightmare

Perhaps fortunately, Barry did not marry. He lived and died in a condition which might be described as the contrived opposite to a state of comfortable domestic felicity. By the time of his death the idea that the true artist could be found living or working in such chaotic conditions had become conventional from Milan to Copenhagen. Observing the genre of portraits of early nineteenth-century Danish artists in their disordered garret studios, Henrick Bramsen has suggested that con-

scious attempts were made to distance the image of the artist from that of the comfortable bourgeois professional. In his comic image of *The Chamber of Genius* (engraved 1812) Thomas Rowlandson cleverly lampooned this social cliché [**16**]. An artist is seen in his garret painting an horrific gorgon's head with the instruments of alchemy lying around. Absorbed in his grandiose reflections, the great man has become immune to the sufferings of his wife who stares at him wretchedly from a bed in the corner of the room.

Rowlandson's down-to-earth attitude to the profession is refreshing in an era when the search for elevated genius was generally taken rather seriously. J. T. Smith's famous memoir of *Nollekens and his Times* (first published 1828) also provides amusing testimony of this gradual turn of the British art world against the artist with aspirations towards social respectability. The book, which was published in 1828, but centres upon candid details of the workings of the London art world in the last three decades of the eighteenth century, is a unique record of changing values. Joseph Nollekens (1737–1823), a leading London sculptor, is presented to early nineteenth-century readers as a mean-spirited, trivial, money-obsessed aberration from a past era.

Smith was devoted to reinforcing the notion that British art was progressing away from the bourgeois values of Nollekens's generation. Throughout there is a clear sense that Nollekens's younger or intellectually superior competitors had rescued the world of sculpture from tawdriness. Smith makes much of a comparison between Nollekens, who distinguished himself in the domestic field of portrait sculpture, and the younger John Flaxman (1755–1826), the most elevated protagonist of the new milieu of purist classical statuary:

16 Thomas Rowlandson

The Chamber of Genius, coloured engraving, 1812

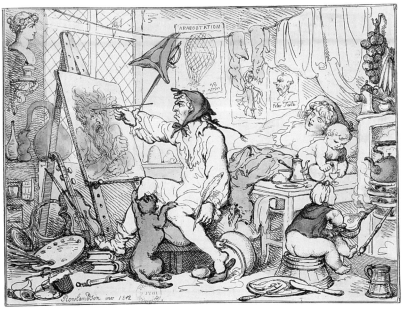

It was highly amusing to notice the glaring contrast between the two sculptors, Nollekens and Flaxman, whenever they came into contact in a fashionable party, which I own was rarely the case. The former, upon these occasions was never known to expatiate upon art, generally took out his pocket book and, in order to make himself agreeable, presented his recipes, perhaps for an inveterate sore throat or virulent scorbutic humour to some elegant woman with as much alacrity as Dr Bossy, of Covent Garden fame, formerly did to the wife of a Fulham or Mortlake market gardener. The latter, however, like a true descendant of Phidias, was most modestly discoursing in a select circle upon the exquisite productions of Greece.

Smith devotes a few pages to describing Nollekens's marriage to the daughter of the prominent London Justice of the Peace, Saunders Welch. The entire passage is intended to lampoon an *arriviste* preoccupation with gaudy social display. Much attention is given to the description of the rather over-expensive wedding dress which the bride herself haughtily declared was intended to make her appear above 'the fleeting whimsies of depraved elegance'.

Although directed at an individual, Smith's lampoon might as easily apply to the whole tendency of socially ambitious eighteenth-century artists to take immense pride in having offered sufficient financial prospects to attract a beautiful and well-heeled wife. His criticisms could have applied to any one of the vast corpus of eighteenth-century portraits in which a successful artist dwells upon the delights of a well-appointed family. Giuseppe Baldrighi of Parma's superb self-portrait (*c.*1760) is a definitive example of the genre. The artist depicts himself standing proudly in expensive silk attire beside his beautiful and extravagantly appointed spouse [**17**].

Nollekens's and Baldrighi's criteria of success were unashamedly material. Their governing aspiration was to improve themselves in the manner of other respected professionals and command, either for themselves or their children, the social respect due to an independent gentleman. These values did not, contrary to Smith's suggestion, die with the older generation in the last few decades of our period. Goya, for instance, measured his early success in terms of his ability to afford one of the finest carriages in the neighbourhood. He followed the familiar pattern of early eighteenth-century artists of devoting much of his energies to setting up his eldest son as a gentleman of leisure.[31]

Like Goya, Francis Chantrey (whom Nollekens recommended as his young successor) advanced himself in society by redeploying his artistic eye in the landed gentleman's skill of shooting game. His brilliant carving of a pair of woodcock killed by a single shot from his own gun whilst hunting as a member of an aristocratic party at Holkham in Norfolk remains one of the whole period's most powerful visual testimonies of an artist's social and material ambitions. Presented in 1834 as a gesture of friendship from the sculptor to Thomas Coke, the future

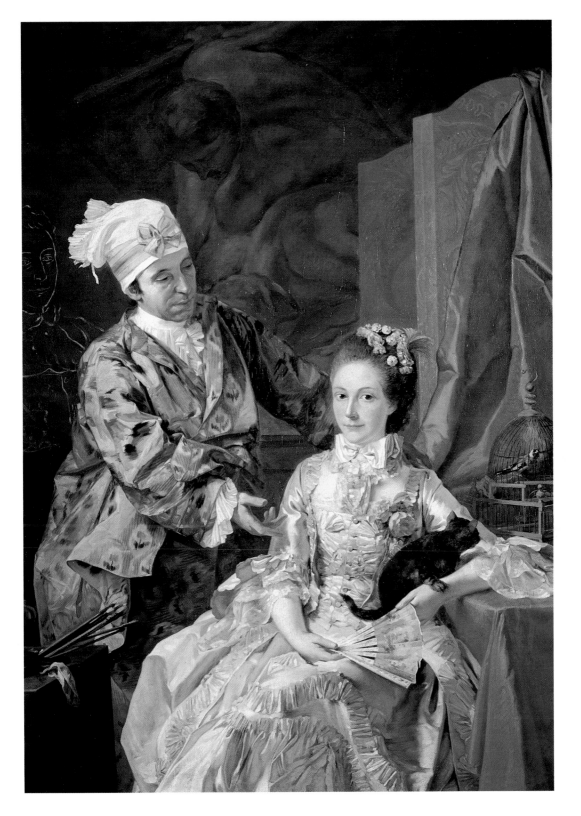

18 Francis Chantrey

Two Woodcocks Killed at Holkham, inscribed 1830, presented to Thomas Coke in 1834, marble relief on a grave *stele*

Earl of Leicester, the monument has the air of a joke between friends and, to some extent, equals. Even the form of the monument, that of a severe antique grave *stele* turned to more light-hearted use, suggests Chantrey's aspirations to parade his familiarity with the nobility [**18**]. Chantrey earned more (dying in possession of £150,000) than any other artist of his day. His career demonstrated the way in which an early nineteenth-century artist could aspire not only to associate with the senior political establishment but also to become one of them. Chantrey became an 'insider' in elite society whilst Nollekens, with his petty bourgeois gaucheries, was doomed to remain an 'outsider' despite his wealth and ambition.

Chantrey's marble woodcocks can be seen as a humorously defiant celebration of values and behaviour that would have disgusted some of his more high-minded contemporaries. His frankly expressed material ambitions were held by many of his critics to be largely incompatible with any claim to be a great creative figure. As Chantrey was probably aware, his frank materialism was more a traditional than a fashionable stance. He appears to have seen himself as working somewhat in the tradition of bluff 'no-nonsense' materialism begun by Hogarth. Emulating Hogarth he adopted his scruffy little British dog, Pepper son of Mustard, as his mascot. He had the dog painted sitting in his studio amongst the tools of his trade by his friend Edwin Landseer (1802–73).[32] Its pose is much the same as a terracotta portrait of Hogarth's 'Trump' produced in the 1740s by Louis François Roubiliac (1702–62), a sculptor whom Chantrey much admired. The dog is seen protecting the Holkham woodcocks—a prey which bears witness to his master's social aspirations—from the ravages of a hungry cat who struggles from beneath the table to get his paws on them. The picture was an obvious homage to Hogarth's famous self-portrait with his pug, Trump [**40**]. It has also some broad similarities with Barry's *Self-portrait with Hercules and Envy*. However, in this case the envy, symbolized by the destructive cat approaching from a subversive angle, is the envy of 'outsiders' for the artist's place in the establishment.

Chantrey was probably aware that in the age of Hogarth (*c.*1720–70) there would have been far fewer ideological opponents of his frank ambition and materialistic values. In mid-eighteenth-century London where Nollekens have his training there were quarters in which it was entirely expected that an artist should have overt social and material ambitions. There arose a generation of artist businessmen, men such as the sculptors Sir Henry Cheere (1703–81), Sir Robert Taylor (1714–88), and the builder/architect Andrews Jelfe (d. 1759), whose real goals were to enter city politics and set up their children in more genteel livelihoods. Hogarth, the most famous product of this cultural environment, was the most muscular champion of such values. His print cycle *The Industrious and Idle Apprentice* (pub. 1747) both encapsulated and promoted the ideals of material self-improvement.

Hogarth refused to rely on the cold comfort of posthumous acclaim. There had to be some concrete material foundations upon which success could be measured. In his anecdotal memoirs, he asked why an artist should consider a long and arduous training when 'a porter-brewer, or a haberdasher of small wares, can without any genius accumulate a small fortune in a few years, become a Lord Mayor, or a member of Parliament and purchase a title for his heir'.[33] Hogarth's attractive group portrait of his servants communicates subtly that genteel sense of well-being and domestic intimacy to which he aspired as a member of a professional élite [**19**]. The fact that Hogarth had such a household gave a strong indication of his hard-earned prosperity. Paternal authority over his household is, however, lightly expressed. By giving careful consideration to his servants' particular characters he exhibited his humanity as an employer. Hogarth was careful to avoid associating himself with those brash *nouveaux riches* who sought to distance themselves as quickly as possible from their origins by pretending they were of a different stuff from their servants. He aspired to a type of polite virtue recommended in many conduct manuals of the day; to be genteel, virtuous, and worthy of status rather than haughty and keen to impose a status which had no moral legitimacy.

Such domestic aspirations were not unusual. His competitor Joseph Highmore (1692–1780), a mid-eighteenth-century English painter of modest genre scenes and portraits, produced a fascinating little group portrait in which an artist, probably himself, is seen arriving home from his business [**20**]. As he opens the door he finds to his satisfaction that his wife and family are happily employed in the worthy and 'improving' occupations of reading, sewing, and drawing. Like other professionals, this artist's day ends at a certain hour, at which time he returns to the family for which he has worked to provide. Here are enshrined the very professional values which the likes of Géricault, Barry, Quay, and Haydon were trying to escape.

Daniel Chodowiecki (1726–1801) produced a similar image of comfortable domesticity in 1771 as a gift for his mother whom he had not seen since leaving his home city of Danzig in search of his fortune some thirty years before [**21**]. The gift was obviously intended to reassure his mother that he had attained a respectable domestic household which she, a shopkeeper's wife, could recognize as a clear symbol of success. Like Hogarth's portrait of his servants, this is intended as a gesture of modest self-congratulation rather than as a gaudy *arriviste* display of new-found status. The furnishings and paintings which surround the family are obviously of high quality but modest in scale and unpretentious. The children, like their father and mother, are quiet and industrious and respond to each other in a relaxed and affectionate manner.

Chodowiecki lived to witness the decline of this domestic ideal.

Heads of Hogarth's Six Servants, oil on canvas, c.1750–5

Conversation Piece, Probably of the Artist's family, oil on canvas, c.1732–5

Goethe, who at the time of this print's production was establishing himself as one of the most potent literary voices in the German art world, deplored the cosy domestic aspirations of some late eighteenth-century German artists. Ever the opponent of bourgeois popularism in the arts, it was not surprising that Goethe, who admired Chodowiecki's work as an oil painter, deplored the fact that he sought to better himself through his engravings. In Book II of his *Propylean* (published 1799) Goethe employs the clever literary device of high-

lighting tensions between familiar types of artists by taking on the voice of a high-minded admirer of Henry Fuseli who dutifully, but reluctantly, visits a relation who had become a portrait painter with unashamedly bourgeois aspirations. It is to be assumed that Goethe himself is critical of both extremes. However, he appears most contemptuous of the portrait painter whose work evoked the era, now happily past, when it was thought necessary that 'every well-off man of sensibility should have portraits of himself and his family at various stages of life'. Goethe's personal disgust with the portrait painter leaps from the page as he treats the reader to a catalogue of his small-minded domestic obsessions; his vacuous admiration of pretty domestic English prints, fascination with household furnishings, and habit of painting his adored family at least once a year.

During the Napoleonic period this latent disgust at artists' petty concerns for domestic comfort and self-advancement became far more widespread within German artistic circles. A comparison of the family portraits of Caspar David Friedrich, Karl Friedrich Schinkel, and Philip Otto Runge (1777–1810) with that of Chodowiecki gives a clear indication of the changing tenor of the times. The portraits give further evidence that the intensity of Napoleonic conflict—all the canvases were painted against the background of the Napoleonic invasions of German soil and the threat to the fatherland—caused a profound shift of attitudes toward the social role of the artist. Dark, heroic dynastic fantasies displace the quest for a mundane and comfortable private existence.

Runge, Schinkel, and Friedrich explored their family life in a broadly similar manner: intense, if not mystic, family unions are

21 Daniel Chodowiecki
The Study of a Painter,
etching, 1771

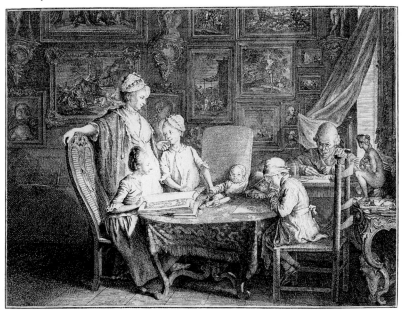

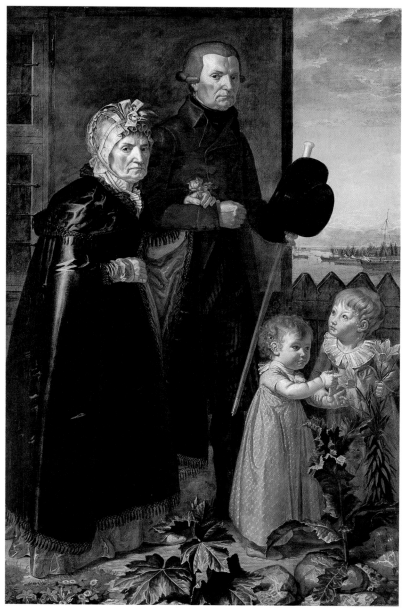

pictorially expressed in terms of profound allegory and symbol; and the
private institution of the family is elevated to public importance by
being depicted as a microcosm of the nation at large. Runge's *We Three*
(1805), a portrait of the artist, his wife, and his brother Daniel was
intended as a gift for his parents. It powerfully communicates that
quest for intense personal relationships which scholars have tradition-
ally considered a definitive part of 'romantic' sensibility. The union of
'the three' is symbolically communicated by the framing shelter of an
ancient oak tree, frequently used as a symbol of the permanence and
strength of the German fatherland in times of threat. The family is

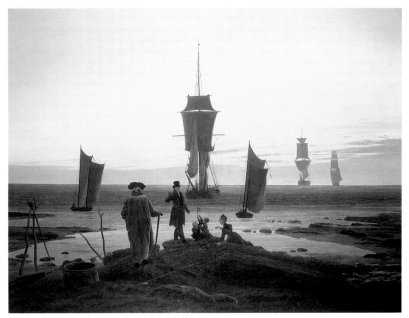

depicted as a symbol of heroic landed permanence in an age which saw the very existence of 'the fatherland' threatened.

A year later Runge was to complete a memorable portrait of his parents, the prosperous owners of a Hamburg shipping company, at the moment when they were forced to leave their home by occupying French forces [**22**]. Runge's communication of the defiant dignity of an old and defenceless couple forced to surrender against their will, remains an astounding achievement. In the distance a ship flies the Swedish flag, indicative of the hope given to the German-speaking peoples by the continued resistance of Gustav IV of Sweden. The couple's grandchildren, who stand directly beneath the Swedish flag (one fingering the generative symbol of a lily), were undoubtedly intended to represent the idea that the hopes of the nation for rebirth were closely linked with the production of a new generation.

A similar sentiment is expressed in Caspar David Friedrich's extraordinary landscape, *The Stages of Life* which was painted for Friedrich's brother a full twenty years after the defeat of Napoleon [**23**].[34] Friedrich here drew conventional parallels between the cycle of the generations in family life and the broader cycle of national civilization which, as we shall see in the final chapter, was considered also to pass from youth to maturity and decay. Three generations of Friedrich's family stare out at the half-lit landscape, the painter in 'old German' costume with his back toward the viewer looks towards his wife and children who are accompanied by an unidentified youthful member of the family. That all the boats are returning to shore suggests the end of an era and the pessimism of old age or maturity, the stage of life which the painter himself was experiencing. In his old age Friedrich, who had

seen the promise of national rebirth end in disappointment, had witnessed enough to darken his vision of human hope. Optimism is, however, preserved in the naïvety of children; the minute figures of the painter's daughter and son (whom he named Gustav after the heroic Swedish monarch), hold up a Swedish flag against the dying light as a symbol of the youthful hope for national regeneration.

Schinkel's beautiful drawing of his pregnant wife, Susanne, which was drawn at some time in the three years following their marriage in August 1809 is a similar blend of pessimism and optimism. His bride is presented as a symbol of generative femininity posed in the gothic porch before the cloister of some great Cathedral [24]. The portrait was probably made in 1813, the year of the liberation from Napoleon, the birth of their third son, and the death of Susanne's father. A gloomy black shadow, probably signifying her family loss, passes across the cloister. Thoughts of personal loss bring melancholy, clouding her enjoyment of a victorious juncture of national history which promises a bright new gothic future for her unborn son.

This was not an age when an artist with claims to greatness could be seen to have selfish domestic aspirations. Schinkel, like Friedrich and Runge, ennobled his pursuit of private happiness by suggesting that his desire to cherish and support his family was his patriarchal contribution to the grand process of national renewal. Fatherhood and Fatherland became synonymous concepts: the private search of the artist for domestic harmony was intimately linked with his public role as defender of the national identity.

The decline of dependence and deference

The passionate personal loyalty which many nationalistic German artists of the Napoleonic and immediate post-Napoleonic era felt toward the traditional hereditary monarchy and aristocracy was a sign of a broader conservative reaction to the threat of destabilizing anti-authoritarian movements. By naming his son Gustav, Caspar David Friedrich was, consciously or unconsciously, returning to the practice of eighteenth-century court artists of loyally naming their children after prominent members of the court. There was even a precedent for the use of this particular name. Some decades before the Swedish sculptor Johann Tobias Sergel (1740–1814) had named his first son Gustav as a gesture of his profound admiration of Gustav III, the monarch he had served adoringly as court sculptor and court tour guide to the archaeological sites of Rome.

It is significant, however, that neither Friedrich nor any of the prominent artists of his day could be described as court artists in the sense that Sergel had understood the role. Although official court appointments continued to be sought after throughout Europe during the early decades of the nineteenth century, artists no longer aspired to

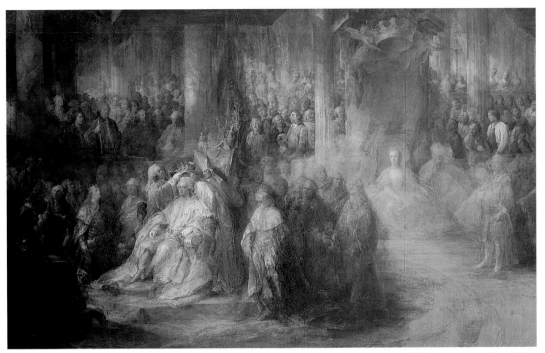

25 Carl Gustav Pilo

The Coronation of Gustav III,
oil on canvas, 1782–93

live entirely under the umbrella of court society. The speed with which a nation or region outgrew the concept of the dependent court artist was largely dictated by the strength of the 'public' or 'consumer' market for art. In a country such as Britain, where an artist of repute had a host of economic alternatives to court service, a court appointment came to mean little more than a professional endorsement and the right to a number of exceptionally lucrative Royal commissions. In Russia and eastern Europe, where bourgeois and gentry markets for art developed most gradually, artists' aspirations for independence from court or noble faction were slow to manifest themselves.

The art market in late eighteenth-century Sweden was closer to the Russian than the British model. Gustav III's artistic policy reflected his absolutist philosophy of rule. He commissioned theatrical festivities which employed the entire skilled and labouring work-force of Stockholm and brought the entire city to a standstill for weeks at a time. The Gustavian court was one of the last in Europe to support a retinue of artists whose sole function was to find grandiose means of reinforcing and celebrating the authority of a presiding dynasty. Carle Gustav Pilo (1711–93), for instance, was employed from 1782 until his death solely to produce a massive painting of *The Coronation of Gustav III,* a propagandist work of stunning grandeur which invests the monarchy with a near mystical authority [**25**].

Like the contemporary Bourbon court—an institution which used lavish ceremonial to invest itself with an air of grandeur which might otherwise have evaporated in the light of public criticism—the Gust-

avian court made extensive use of artistically designed ceremo-nial. Sergel and his friend Louis-Jean Desprez (d. 1804), who designed and organized most of these court ceremonials, harnessed their talents entirely to court service and lived in fear of losing their place at court. Both men found it difficult to work after the assassination of Gustav III in 1792. Desprez, accustomed to working out his ideas on a grand scale and commanding legions of employees without cost constraints, was unable to adjust his talents to serving the needs of Gustav IV, who established a cost-conscious and intimate court in line with post-revolutionary European fashion. His contract was not renewed in 1798 and he lived out much of the rest of his life in frustrated obscurity.

Sergel was so personally affected by the murder of Gustav that he seldom sculpted afterward. One of those statues he did make was a posthumous monument to Gustav for the Sheppsbron in Stockholm. At the dinner in celebration of the unveiling of the statue on 24 January 1808 he is reported to have stood up and drunkenly to have exclaimed:

Gentlemen, our sun was drowned in blood, but he has risen again in order to spread his light over another world: for, the devil may take me, if Gustav III was not a ray of eternal light . . . The effigy I have made is rubbish, but we can carry his image in our heart, and there he will live as long as we have a drop of blood in our veins. I give you the toast of Gustavus III, our father and our benefactor.

In this sector of the European art world, at least, the dream of utter dependence on a benevolent regal protector had not disappeared. Sergel's hyperbole was generated by nostalgia; the Gustavian Court world was by 1808 a distant memory, a dream of absolute protectorship absolutely defiled.

Although there are some grounds for arguing that this period wit-nessed the successful struggle of the European artist for social and cre-ative independence, it should be pointed out that there were many who saw the advantage of living under the protectorship of a court or aristo-cratic patron. Making one's money in the capitalistic market place offered constraints as well as liberties. The patronage of 'great men' could promise an alternative to expending one's energies in-venting entrepreneurial 'schemes' or promoting one's critical reputation with the public. It could also offer ambitious artists the chance of working on large creative projects over long periods of time. It was primarily for this reason that British painters who hoped to promote the production of great works of history painting continued to place their faith in the rise of liberal aristocratic patrons rather than consumer markets.

One of the main reasons why Rome thrived as a European centre of the visual arts in this period was that it provided artists from countries where the great 'public' art markets had developed with a refuge from the more prosaic demands of consumerism. British sculptors who went

to work in Rome in the late eighteenth century, for instance, frequently had the objective of escaping the often anonymous drudgery of producing chimneypieces, small-scale funerary monuments, and portrait busts. Connoisseurs who came to Rome generally wished to purchase sculptors' more ambitious *chefs-d'œuvre*, statues and reliefs on antique themes. Such works, although often less profitable to produce than more practical pieces, had the advantage of allowing a sculptor to express his genius.

The Venetian townscape painter Bernardo Bellotto (1720–80) is an example of an artist who explicitly sought out court protectorships as a refuge against burgeoning consumer markets. He was actively attracted by the sort of starched court positions which survived in Russia and other eastern European capitals long after social and commercial pressures had made them unfashionable and unavailable elsewhere. Successively employed as a court artist in Dresden, Vienna, and Warsaw, he sought to remain a court dependant throughout his career. Although Bellotto had considerable financial rewards from his various court positions—sufficient, as his 1765 self-portrait [26] demonstrates, to posture as a Venetian nobleman—he does not seem to have been able or willing to survive long without some form of protector.

Having been appointed in the position of official court view painter at Dresden, a thoroughly traditional position which had been made since the mid-seventeenth century, he worked almost exclusively under the patronage of Augustus III and his prime minister, Heinriche Bruhl. Bellotto's complete dependence upon this narrow protectorship is indicated by the fact that it became necessary for him to leave Dresden after his primary sponsors had died. His social impotence when detached from his noble protectors was clear to see after the loss of a legal claim against the heirs of Count Bruhl who had failed to respond to his highly reasonable request to be paid the 4,200 thalers owed to him for twenty-one views of Dresden and Pirna.

Despite the loss of this legal case, Bellotto appears not to have looked for the greater social independence that a move to Paris or London might have brought. On the contrary, he decided to move to Russia, a move which was only prevented by the receipt of an invitation to Warsaw and the court of King Stanislaus Augustus Poniatowski. In Poland his role was even more that of court officer. Along with Bacciarelli and Pillement he was lodged in studios within the Royal Castle and spent much of his time working on great propagandist images which justified Poniatowski's controversial election to the throne of Poland.

Bellotto's tendency to move eastward indicates that, like many Venetian artists of his generation, he was at his most comfortable within court culture. The fact that he named his children after prominent

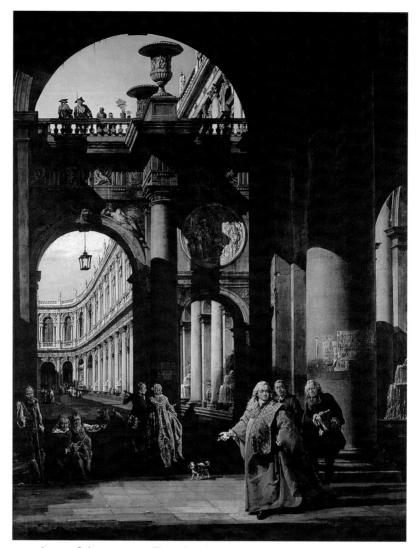

members of the court at Dresden bears witness to this. Indeed, as his most recent biographer Stephen Kozakiewicz has suggested, one of the factors persuading him to move eastward from Dresden may well have been the growth of the bourgeois art market.[35] These commercial conditions were obliging him to turn from a world of grand commissions to a world of speculation in which he produced paintings and prints to appeal to the wider market. A move to Warsaw was a move away from grubbing a living through speculation. Warsaw did have an art market beyond the court as is indicated by one of Bellotto's own townscapes, a beautiful painting of Miodowa Street in the mid-1770s, which shows a rather shabby printseller vending his wares. There was, however, no major bourgeois Polish art market of the type that was emerging in mid-eighteenth-century Germany until well into the nineteenth century.

Late eighteenth-century artists of republican inclination did not, of course, regret the passing of the day when artists could obtain security of employment by attaching themselves to the service and interests of a court. Koch, whose dramatic escape from the tyranny of the aristocratic Academy at Stuttgart was reviewed above, regarded the demise of the starched court artist as a definite sign of progress. In his opinion the European art world thankfully had moved on from an era in which the primary role of the artist was to conjure up the sort of flattering conceits which sustained aristocratic potentates' vain and fallacious notions of their continuing significance. In his memoirs he bitterly attacked those grand scenes of apotheosis which sprung up in 'aristocratic palaces' of the mid-eighteenth century. He laughed heartily at the memory of times when 'artists with titles such as *peintre du cabinet, de la cour* and so forth' lived to reinforce the preposterous claims to authority of 'tiny, effeminate despot(s)'.

Koch may well have had in mind the experience of staring up at any one of the vast princely apotheoses created by Venetian muralists for minor German potentates of the mid-eighteenth century. To some degree he was justified in mocking the pretensions of such works. The typical provincial German prince of this era was, as Habermas has suggested, in 'authority as much as he made it present'.[36] Tiepolo's great fresco cycle of *The Four Continents* at the Treppenhaus in Wurzburg (1750-3) seems to be a ringing endorsement of Habermas's observation. Paintings which at first appear to be a tribute to an emperor with claims to world dominion were created for a prince bishop whose claims to power and fame were at best provincial. In his native northern Italy Tiepolo had, like many of his contemporaries, been used to producing such grandiose apotheoses and imperial cycles for the country villas of an aristocracy who were anything but potent within the forum of international affairs.

The empty, though artistically stunning, grandeur of so much mid-eighteenth-century court art could well be used to substantiate the arguments of leftist scholars such as Habermas and Hauser who argue that this starchy deferential world was an anachronism in its own time. We should, however, be cautious in assuming that splendid court or aristocratic imagery in this period necessarily represents the empty pretensions of a class under threat.

A veritable *locus classicus* within this art historical debate has emerged around the interpretation of Goya's *Family of Carlos IV* (1800) [27]. Taking the evidence of the image itself (which is a dangerous art-historical methodology) many twentieth-century observers have had the impression that Goya intended to present the royal family as a disturbingly mortal clan many of whom resemble mannequins in finery. Janis Tomlinson's recent revisionist account of the artist (*Goya in the Twilight of Enlightenment*), however, has challenged the conventional

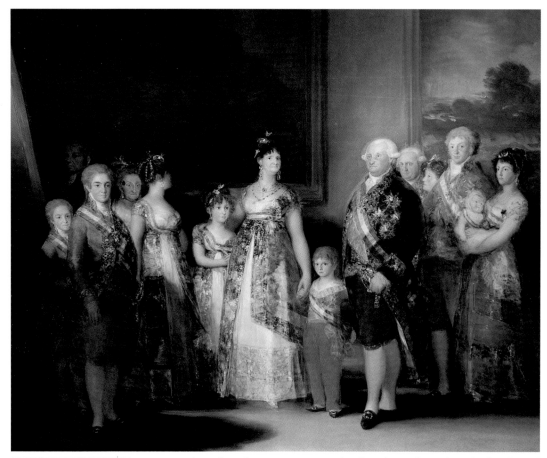

27 Francisco Goya
Family of Carlos IV,
oil on canvas, 1800

assumption that, by representing the family in disturbingly frank and unflattering terms, Goya was setting out to expose the empty pretensions of a Bourbon dynasty toppling on the edge of collapse. She points out that there is no documentary evidence to support the argument put forward by Marxist art historians, that this frank depiction of the royal household reflects a 'bourgeois' artist's 'insurgent' rebellion against a formal role as a deferential servant of monarchical order. She argues that quite the opposite is true; that references to Velazquez's court portraiture within the painting seem to assert Goya's respect for the grand continuity of court tradition. The painting is taken to represent a defiant assertion of the maintenance of monarchical authority:

the family represents itself in the latest fashion, with the orders and insignia that proclaim its dynastic heritage. In short, Goya's patrons determine their representation as the modern Bourbon monarchy that has withstood the revolution to present itself in all its contemporary glory.

The problem of interpreting this painting condenses the greater problem of interpreting the evidence of Goya's personality. Do we see Goya as an ambitious court artist and huntsman with aspirations to landed

gentility or a radical with revolutionary sympathies [**28**]? The biographical evidence is itself so mixed that it provides little firm ground upon which to interpret this most arresting image.

It is not an accident that Goya's political sympathies are difficult to determine from his major public works. Living in a highly unstable political environment in which national government frequently alternated between phases of 'enlightened' democratic reform and conservative backlash, Goya understandably remained somewhat of a political enigma. In more uniformly restrictive societies even modest criticism of the political order would have been both dangerous and pointless. St Petersburg, for instance, was obviously not a city in which foreign artists from more liberal political worlds thought it prudent or profitable to oppose systems of patronage.

European artists who went to work for the Russian court were generally not expected to be treated with the respect that accompanied their celebrity at home. Diderot predicted that the notorious antics of Greuze and his wife would not be tolerated by Catherine who, he joked, would soon find a place for Madame Greuze in Siberia. Thomas Lawrence, who was engaged to paint a portrait of Tsar Alexander as part of his series of portraits to mark the Peace of Aix la Chapelle (1818), was surprised and honoured when his sitter condescended to handle a peg which had fallen from the artist's easel.

For indigenous Russian artists the struggle for professional independence continued on a more primitive level than anywhere else in Europe. Even after the establishment of the St Petersburg Academy a high proportion of Russia's most accomplished painters either lived and died as serfs or were forced to buy their way out of serfdom. It is a sign of Russian artists' low expectancy of attaining social independence that, although there were those who in the 1830s railed against the authority of the highly restrictive reformed Academy, no organized anti-academic movement emerged until the mid-nineteenth century.

In Revolutionary France, by contrast, many artists prudently adopted a mantle of radicalism. Even these artists found the economic systems upon which they relied to be seriously disrupted. Despite becoming an overnight revolutionary, Fragonard was forced to retire to the country. The Revolution was more tolerant of artists who did not simply wish to become propagandists than some have supposed. Nevertheless it had the effect of polarizing the art world between those who became part of the radical establishment and those who found it difficult to find a role and market in the new society. A few, such as Hubert Robert (1733–1808) whose services as Keeper of Louis XVI's pictures led to a period in prison, really suffered from their clear associations with the *ancien régime*. Most simply failed to thrive and were forced into retirement or exile, precipitating the greatest shift of

28 Francisco Goya

You who Cannot Do it (from *Los Caprichos*, 1799, no. 42), etching and burnished aquatint

This etching is one of two in the *Los Caprichos* series in which peasants are depicted bearing beasts on their shoulders. As in no. 63 the riding beasts may well be symbolic of Church and State. Asses in other prints in the series represent the ignorant professions and 'pure-bred' aristocracy. Similar imagery was employed by French Revolutionary print-makers and may well have inspired this print.

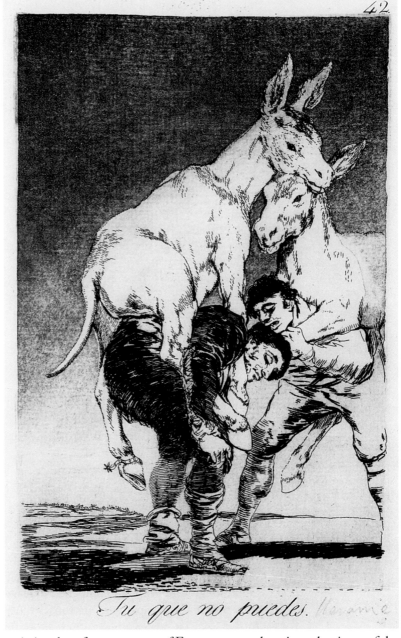

Tu que no puedes.

artistic talent from one part of Europe to another since the times of the great Huguenot emigrations.

There was ample scope for those *émigrés* who had been comfortable with the aristocratic social rounds of *ancien régime* Paris to find employment of a congenial type. The suave canvases of prominent artistic *émigrés* such as François-Xavier Fabre (1766–1837) and Elizabeth Vigée Le Brun (1755–1842) are often overlooked as documents of their time. The latter's glittering portraits of noble socialites

coupled with her ultra-conservative diary commentaries tell a tale of an aristocratic world which, if it was unnerved by events in Paris, was trying very hard to carry on extravagantly despite them. Having painted the most celebrated portrait of Marie Antoinette with her children and associated herself strongly with the values of the *ancien régime*, Le Brun observed the rise of republican politics in disbelief and was genuinely horrified by the regicide. Motivated by a profound nostalgia for the glitter and romance of court life she set out to find first in Rome and then in central and eastern Europe the kind of court society which she had known in her youth. She was not disappointed. The sight of Prince Esterházy riding through the streets of Vienna with his saddle studded with diamonds was a reassuring delight. Russian high society pleased her most of all; she commented approvingly on the system of serfdom and the affecting sight of noble ladies knitting socks for needy peasants in their opera boxes. She was in her element at a formal reception organized in her honour at the St Petersburg Academy. Here she discovered a world in which a noted artist's only real exhibition 'public' was the noble circle attracted to court.

In Britain, where citizens had unparalleled freedom of political expression, the rise of political radical movements had polarized attitudes towards patronage in a more gradual though no less fundamental manner than that in France. From the era of the American Revolution onward, democratic political ideology began to play a role in creating a sense of enmity between artists who felt themselves to be at odds with some form of 'establishment' and those who were considered to have pandered to the needs of high society in the quest for riches or the superficial baubles of status.

A high proportion of artists committed to the cause of regenerating history painting and accustomed to lamenting the contemporary state of the arts—men such as Barry, Haydon, Romney, Northcote, Mortimer, and Blake—had radical political sympathies. Whether professional discontents warmed them to such political causes or their politics motivated their discontents is a moot point. Radical political sympathies affected artists' careers to varying degrees. A few, such as Robert Edge Pine who felt compelled to leave England in 1784 to seek more politically sympathetic patrons in America, found that their political convictions completely prevented them from conforming to established patronage conditions.

The majority of artists, however, were more subtly affected. The sculptor Thomas Banks (1735–1805), who was arrested on account of his friendship with Tooke but acquitted of links with treasonable activities, sustained a curious balance between the roles of pillar of the art 'establishment' and rebel. Despite living on amicable terms with such conformist figures as Reynolds and West and serving an important role at the Royal Academy (which drew a substantial part of its funding from

with radicalism to improve their social credibility amongst their peers. It gave them a social profile of daring nonconformity and distanced them from all suggestion they had improved themselves by grovelling. Appearing publicly to remain in touch with the interests of the common people from whom they originated was an important means of an artist suggesting that he had risen by virtue of his genius alone.

Naturally enough, artists who eschewed radical political ideology bore the whole business of hunting for preferment with better humour than their radical peers. David Wilkie (1785–1841), who Haydon affectionately mocked as a 'cautious Tory' with 'an inclination for bowing', composed the most light-hearted but poignant testimony to the practice of making one's way in society. His brilliant *Letter of Introduction* records an excruciatingly embarrassing episode from his youth [**29**]. Having ventured south from Edinburgh in May 1805 Wilkie, then a particularly gauche provincial, was obliged to make his entry into London society by approaching the old urbane connoisseur Caleb Whiteford armed only with a letter of introduction. This was, however, a light-hearted commentary on the social system rather than

a bitter memory. It was painted, possibly as a form of memorial, in 1813, a year after the death of Whiteford who had become a firm friend. Having in this year begun to establish himself as one of London's most famous and prosperous artists, Wilkie was celebrating the kind of social indignities which those who aspired to greatness had to endure with good humour.

Throughout the eighteenth century Britain sustained a Europe-wide reputation as a liberal creative environment where it was possible for a man of talent to make his way without losing his creative liberty in the service of some grandee. The composer Joseph Haydn, for instance, found his visit to England an opportunity to experience a liberty unknown to the German artist who relied on court appointments. As a consequence, a proportion of British artists found the starched sense of social hierarchy upon which certain Continental artists thrived little short of ridiculous. The pomposity with which John Raphael Mengs (1728–79) conducted himself in Rome was the subject of particular derision. The gentleman painter, Thomas Jones (1742–1803) records going to the exhibition of Mengs's *Perseus and Andromeda* in his studio at the Palazzo Barberini in 1778. Here, he reports with some astonishment, the visitor was processed through a building populated by pupils who behaved with all the cringing propriety of courtiers. On witnessing a similar scene, the English painter James Ward is reported to have turned to James Northcote and exclaimed with relief 'such a thing as that could not occur in our country'.[41]

The Grand Tour art market, the ultimate territory of the connoisseur art buyer, was inherently geared to producing such artistic grandees. As Hogarth observed with reference to the London art market, when powerful connoisseurs gained control of fashionable taste it was to the benefit of a few 'monopolizers' who succeeded to the detriment of the profession as a whole. The law of the free market competition generally assured that, for a period at least, these 'monopolizers' could command whatever prices they wished. In 1758 the English Grand Tourist, George Lucy wrote from Rome: 'These painters are great men, and must be flattered; for 'tis the custom here, not to think themselves obliged to you for employing them, but they oblige you by being employed.'[42]

Pompeo Batoni, who monopolized the Roman portrait market, was obviously in this position. As Northcote recalled in his Roman anecdotes, Batoni was able to be as rude as he liked to his sitters. Offered a diamond-studded cross by a cardinal he is reported to have refused the gift informing the cleric that 'he had a drawer full at home'.[43] Rudeness of this sort should not be confused with subversion. Had he expressed his impudence in political terms it is unlikely that it would have been tolerated. Criticism from below was very little tolerated in most eight-

eenth-century 'Italian' cities where libels and unauthorized lampoons were considered capital offences.

Superficially it would seem ironic that the art of caricaturing notable personages first became fashionable in this deferential and politically restricted world. P. L. Ghezzi's (1674–1755) works are considered to have started the European fashion for caricature which had its most complete expression as a truly subversive art form in the liberal political climate of late eighteenth- and early nineteenth-century Britain. Luigi Landi, author of a notable *History of Painting in Italy* (first published 1796), suggests that Italian lampoons of persons of quality were 'a particularly gratifying' form of release in 'a country where the freedom of the pencil was thought a desirable addition to the license of the tongue'.[44] Whilst these early caricatures were a form of social release they were not in any sense subversive of the public reputation of the person depicted. They were, as Landi reminds us, generally to be observed in the seclusion of 'cabinets'. Even the British artist Thomas Patch (1725–82), who made a name for himself with caricatures of prominent members of Grand Tour society, took the precaution of requesting the permission of the individual lampooned before any circulation of the image.[45] The art of caricature in Grand Tour Italy was not, as it became in Britain, an invitation to one class to laugh at the foibles of another.

The satirical canvases of Pietro Longhi (1702–85) also operated on the level of an 'in joke' between gentlemen. As Alessandro Longhi later wrote in a biographical sketch of his father's life, Pietro's elegant critiques of genteel manners principally appealed to the Venetian nobility. This was, of course, the very class of person whose vanities and foibles he most frequently satirized.[46] Whilst Longhi's art was not subversive it was clearly not toothless. His satires could be cutting and explore the boundaries of the deferential relationship of artist and patron. A painting known as *Milordi's Salad*, for instance, is a rather acute joke at the expense of the Venetian aristocracy's ludicrous attempts to imitate the behaviour of simple rustics when staying at their comfortable rural retreats. Longhi's particular talent was to get close enough to uncomfortable social issues to amuse but not to dismay; to ask penetrating questions about the relationships between the various orders of society without challenging the system itself.

Longhi's painting, which most contemporaries saw as a wholly original departure in Venetian art history, was in many ways the opposite of the type of art for which the Venice of his day was internationally renowned. The most highly paid and sought after Venetian painters were muralists, men such as G. B. Tiepolo (1696–1770), J. Amiconi (1682–1752), and G. Pelligrini (1675–1741) whose unrivalled technical accomplishment allowed them to cover vast spaces with improbable power narratives in whose iconography they were neither

Punchinello as a Portrait-Painter, pen and brown ink, brown wash over black chalk, 1790s

asked to take nor took any particular interest. Longhi was, by contrast, very modestly endowed with technical skills (particularly in the field of perspective in which the Venetian muralists of his day specialized) and was largely valued for his wit. His career is an excellent example of how competition in the eighteenth-century art market could encourage the redefinition of the role of the artist.

Giambattista Tiepolo, the most successful exponent of the courtly apotheosis, was certainly not responsible for the complex iconographic programmes used in his great frescoes at Würzburg and Madrid. Moreover, as a recent biographical study by Alpers and Baxandall suggests, there are numerous indications in his murals of *The Four Continents* at the Treppenhaus in Würzburg (commissioned 1750) that Tiepolo played ambivalently with the power iconography.[47] It seems significant that the *Capricci* and *Scherzi* etchings, which most scholars consider to be a reflection of Giambattista's more intimate thoughts, reveal an artist much preoccupied with the vanity of man's aspirations to power and fame. Punchinello, the *commedia dell'arte* figure with whom Giambattista and his son Domenico (1727–1804) appear to have had a personal fascination, makes sporadic appearances in the etchings. Here, as in Domenico Tiepolo's later drawings relating scenes from the life of Punchinello, this tragi-comic, enigmatic, and pathetic figure seems to be a focus for the painter's private reflections of human vanity.

The Tiepolos clearly felt a powerful personal identification with Punchinello. Domenico produced two drawings in which Punchinello is shown painting. In one of these Punchinello is shown painting a Tiepolo. The other is an obvious parody of his father's painting of *Alexander and Campese in the Studio of Apelles* (*c*.1720–30), a subject

31 Giambattista Tiepolo

Self-portrait with his Son Domenico (from the fresco *Continent of Europe*) on the ceiling of the staircase hall of the Residenz, Würzburg, 1750–3

which, as it recalled Alexander's willingness to offer his own mistress to a painter, was often used to argue an artist's claims to parity of status with great men of worldly affairs [**30**]. The exact meaning of Domenico's private joke is unclear. It is, however, certain that he was pointing in some way to the absurdity of his own claims to social significance and public role as the flatterer of human vanities.

One is reminded of J. T. Smith's anecdote upon the behaviour of Domenico Tiepolo's contemporary, the Roman mural painter Biagio Rebecca (1735–1808), a skilled manufacturer of grandiose allegories for the houses of the English nobility. Whilst painting at Windsor he relieved the tedious deferential atmosphere of George III's court by sticking a paper star to his breast and setting out to deceive the short-sighted king that he was 'a man of distinction'. Such an apparently trivial joke gives an insight into the type of quietly subversive frame of mind with which these itinerant Italian manufacturers of vapid power fantasies maintained their own private dignity. Their quizzical distrust of the world of appearances which they were employed to perpetuate can be interpreted as a private relief from the pomposity of their public role.

The portraits of Giambattista and Domenico Tiepolo in the corner of the fresco symbolizing the *Continent of Europe* on the ceiling of the staircase hall of the Residenz at Würzburg invokes a similar sense of an artist's suspicion of grandeur [**31**]. Giambattista Tiepolo, whose por-

trait appears in the foreground, appears somewhat out of place in the grandiose world he has manufactured for the glorification of his employer. He is shown in the loose cap and gown, clothing which in the eighteenth century was usually adopted in portraits of scholars and men with claims to profound 'penetrative' insight. The group of informally attired artists makes a vivid contrast with the image of their employer, the Prince Bishop von Greiffenlau whose periwigged bust portrait in golden frame is carried by winged Fame across the European sky. Directly below, the portrait of Balthasar Neumann (1687–1753), the architect of the Treppenhaus, appears similarly out of place in his grandiose surroundings. Posturing humorously in a snappy pseudo-military suit and seated upon a canon, a reference to his boast that his vault was strong enough to sustain a canon being fired beneath it, he is sniffed by a passing dog which he affects not to notice. Surely this dog smells the ordinary human flesh beneath the courtly swagger?

By this stage in his life Giambattista Tiepolo had made enough money to count himself a fine Venetian gentleman. His payments for the Würzburg cycle alone exceeded what many reasonably successful German muralists would earn in a lifetime. However, it was reported that, rather than act out the role of court painter, Giambattista Tiepolo gradually removed himself from official duties at Würzburg. At first he chose to eat with the servants but later withdrew completely to his own quarters. He seems, from the evidence of his son's fresco portrait, to be a man who has moved beyond defining himself through the trappings of material wealth and beyond taking pride in his ability to move in the finest circles. Although gratifying his employer's outrageous vanity he is above entering into the spirit of rhetorical bombast which perpetuated that vanity. As an artisan genius—a man of wonderful manual dexterity who kept his thoughts to himself—Giambattista Tiepolo could keep aloof from the absurdities of his formal role as courtier.

PAINTED BY T. COLE
FOR I. TOWN ARCH.
1840.

'Commerce and politics connect all parts of the world'

Improvements in international communications in the eighteenth century gave rise to art worlds that were in an unprecedented sense 'European'. Printed word and printed image not only began to move around the Continent with unprecedented speed but also to penetrate far deeper into the strata of society. Europe witnessed the formation of an international 'public sphere' of consumers; new art markets which gave even those of moderate income the opportunity to buy 'foreign' art works in the form of printed reproductions. The same publics could also keep in touch with ideas on the visual arts formulated abroad through translations of books of art history and theory which became available in large numbers at reasonable cost and were, on occasion, serialized in popular magazines. By the second half of the eighteenth century it was possible for anyone who could afford the price of a journal or a newspaper to keep their finger on the pulse of Europe-wide artistic developments.[1] To service the demands of such readers specialist publications dealing specifically in international artistic and cultural news were put on the market. One of the most successful of these was Pierre Rousseau's *Journal Encyclopédique* (1756–93), which promised its readers to provide 'every fortnight news about what is happening throughout Europe in the arts and Sciences'.

Those who subscribed to cosmopolitan ideals naturally came to believe that improvements in communication between nations would pave the way to the eventual realization of the dream of a single European art world. However, those who did not subscribe to such ideals, or were in practice incapable of transcending a chauvinist predisposition, employed the new opportunities for foreign travel and access to information about other European cultures to reinforce their prejudices. To observe that eighteenth-century French connoisseurs sought to find out more about the artistic traditions of other European countries only to confirm their own convictions concerning the superiority of the French arts would be a humorous exaggeration, but one not altogether removed from the truth. Similarly mid-eighteenth-century Englishmen of robust Whig politics appear to have travelled to the Continent in search of proof of the inferiority of the culture of their European neighbours, in particular their Catholic neighbours.

Hogarth, perhaps the definitive example of the Whig abroad, seems to have regarded travel as little more than an opportunity to rationalize his contempt for Continental culture. This attitude was best summarized in his painting of *The Gates of Calais* (published as an engraving in 1749), which was executed shortly after a visit to the Continent. The painting was, according to the artist's own testimony, an attempt to express the 'Roast Beef' Englishman's sense of the unpalatable foreignness of England's neighbours across the Channel:

The first time an Englishman goes from Dover to Calais, he must be struck with the different face of things at so little a distance, a farcical pomp of war, pompous parade of religion, and much bustle with little business. To sum up all, poverty, slavery, and innate insolence, covered with the affection of politeness, give you here a true picture of the manners of the whole nation.[2]

With the rise of nationalist movements in Europe, particularly the Europe of the post-Napoleonic period, international art reports became an important medium for reflections upon the sources of division in the European art world. Up-to-date comparative accounts of the European arts, a type of publication best exemplified by Stendhal's *Survey of the State of Sculpture in Europe* (1824) began to feature large in the literature of the visual arts. Accordingly it became a relatively ordinary accomplishment to have developed an acute awareness of the distinguishing characteristics of the various national 'schools of art' operative in Europe.

Nationalistic movements were themselves fostered by improvements in communication systems. Inevitably the infiltration of 'foreign' ideas, manners, and consumer goods into many of Europe's urban communities became so profound as to shake fundamentally many of these communities' sense of their own cultural identity. For the first time in European history artists began to respond in an organized and self-conscious manner to the charge of actively manufacturing local or national identity or preserving some visual record of fast-disappearing indigenous customs. European artists became concerned as never before with issues of cultural identity; artistic production increasingly reflected the tensions between the sometimes conflicting ideologies of cosmopolitanism, universalism, and nationalism. It is in the late eighteenth and early nineteenth-century when these ideologies began to clash in spectacular fashion that this chapter begins.

The promise and threat of an 'enlightened' universal culture

Claude-Joseph Vernet's (1714–89) *Constructing a Road* of 1774, survives today as an important monument to the progressive ideals of what is now known as 'the age of travel' [**32**]. Commissioned by Joseph-Marie Terray, who as *Contrôleur Général des Finances* had ultimate responsibility for the administration's road-building programme, it was

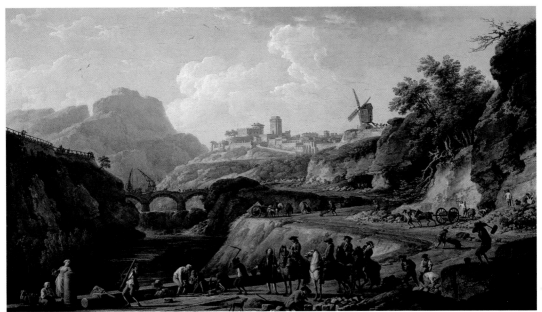

32 Claude-Joseph Vernet

Constructing a Road, oil on canvas, 1774

intended to commemorate the triumphs of modern French transport technology. The principal figure directing work from horseback in the foreground is thought to be a portrait of one of eighteenth-century France's most well-known engineers, Jean-Rodolphe Perronet (1708–94). A number of Perronet's technological inventions are recorded in detail. Most notable of these are the cranes used for the construction of the bridge in the distance and the distinctively shaped wheelbarrow, known as the *camion prysmatique*, which is used by a workman in the foreground.[3] These technological innovations have allowed the construction of the road to proceed through a craggy mountainous landscape, reminding the viewer of man's ability to conquer even the toughest of nature's barriers.

Vernet's painting encapsulates one of the definitive articles of faith of Enlightenment ideology: the belief that obvious 'improvements' in the public weal would only occur when those guided by clear rational principles were entrusted with public office. Perronet's personal commitment to such values is indicated by the fact that he wrote many of the major articles on engineering for *L'Encyclopédie*. Indeed, Vernet's method of presenting technological improvements may well have been influenced by the engraved illustrations of engineering technology within that definitive Enlightenment text.

Terray served in a ministry led by the economist turned statesman, A.-R.-J. Turgot, who was appointed Finance Minister in the year the painting was completed. This ministry was concerned with the application of physiocratic principles to government; these were, broadly speaking, the belief in an authoritarian though 'enlightened' or 'rational' administration which operated to secure free trade and set up a

firm economic base of efficient rural production. Turgot's commitment to the ideal of forming utopian *urbes in rure* communities in such mountainous regions was signalled by his personal involvement in Ledoux's famous project for establishing an ideal city at Chaux. It is possible that Vernet's painting shows the mountainous area of Jura in which this city was to be constructed.[4] The establishment of high quality transport links ensured the economic viability of such rural communities by allowing them to benefit from national and international markets.

Twenty-four years before he came to power Turgot published a series of philosophical *Observations* in which he stressed the centrality of improvements in communication systems to his progressive physiocratic vision of society. The forces of history were, in Turgot's opinion, leading inexorably towards a society in which:

the human mind becomes more enlightened, isolated nations draw nearer to each other, commerce and politics connect all parts of the world, and the whole mass of the human race, alternating between calm and agitation, good and bad conditions, marches always, though slowly, toward perfection.[5]

Such universalist ideals are often encountered in the writings of those at the most progressive fringes of French Enlightenment. The tendency to associate man's desire to create repressive territorial and intellectual barriers with his least advanced impulses was not only a central but also a defining theme of Enlightenment discourse. In his famous account of *L'An 2440*, for instance, Louis-Sebastien Mercier looked forward to the day some five hundred years hence when advanced transport systems would have created a universal society in which state borders would have ceased to have any significance. He indulged his readers with the fanciful prediction that manned balloon technology, recently pioneered by Montgolfier, would eventually allow Chinese mandarins to take routine flights to Europe to discuss matters of philosophy.

As Hazard and Gay have convincingly argued, a new concept of Europe emerged within Enlightenment thought.[6] Europe was conceived by many prominent Enlightenment *philosophes* as a 'Republic of letters', a community of enlightened minds whose reflections were deemed to have a universal validity and utility. This concept of shared belief quickly formed a powerful secular alternative to the ideal super-state of Christendom familiar from medieval sources. Inevitably such ideas filtered beyond the world of letters into the world of images. In 1786, for instance, the Parisian printmaker and dealer F.-C. Joullain produced the following eulogy for his own profession:

Those who protect the arts and those who practise the arts, no matter what distance, opinions and customs separate them, are united by indissoluble ties.

Therefore, there are no foreigners! This truth is corroborated by the perfect agreement which exists between French, English, Italian etc. art lovers and the artists and in the large trade in prints which England sells to France at very dear prices and from which it gets considerable sums, in fact, larger sums than it gets from the trade in goods.[7]

Joullain's idealistic euphoria needs to be set into context. Like many of the leading figures of international publishing it was in Joullain's commercial interests to promote the notion of Europe as an intellectual republic. His words are probably more a reflection of how he wanted his trade to be perceived than evidence of how it actually operated. To depict the ultimate end of his business as the furtherance of cosmopolitan values was to bestow upon himself a gloss of noble disinterest.

Joullain's words were not prophetic. Although such cosmopolitan ideals would not become entirely outmoded, his particular belief that the art trade could transcend national enmities would soon prove to have been unfounded. In the following two decades the international art trade, most conspicuously that between France and Britain, was seriously disrupted, and even on occasion brought to a standstill, by military conflict.

As Joullain may well have been aware, though not prepared to admit, print buyers all over Europe were influenced by less than generous nationalist preconceptions. German print buyers of his generation, for instance, were not above the exercise of such prejudice. A widespread reaction against 'French affected' manners and luxury goods—imports which were increasingly considered to threaten the stolid, industrious Germanic values—severely affected the fortunes of those exporting French prints into Germany during the 1770s and 1780s. This gave an advantage to the English print dealers who, as we shall see in the final chapter of this book, had been conducting what at times appeared to be a trade war with France. Within a decade or so the balance of this trade war was severely disturbed by the imposition of a blockade on British exported goods by Napoleonic forces. Their international business already severely affected by the Revolutionary conflicts, a number of England's most powerful print producers and exporters, most notably John Boydell (1719–1804) and Valentine Green (1739–1813), were plunged into severe financial difficulties. Green, in particular, would have needed little reminder that the international art trade could not totally transcend the realities of international conflict.[8] He lost his fortune as a direct consequence of French bombardment of Dusseldorf in 1798 during which the art museum was badly damaged. This destroyed a collection of paintings of which his firm had been engaged to make a series of reproductions. Ominously the contract for this cosmopolitan scheme had been

33 Claude Michel, known as Clodion

Model for a proposed Monument to commemorate the Invention of the Balloon in France in 1783, terracotta

signed in 1789, the year of the political Revolution which precipitated the conflict between France and its European neighbours.[9]

The rise of the ideal of international fraternity certainly encouraged that free trade of goods which Joullain celebrated as its ultimate manifestation. Ironically it also played a fundamental role in the conflicts which caused major disruptions in international trade some years later. As Stuart Woolf has argued in his penetrating analysis of the causes and consequences of the Napoleonic wars, the aggressive French imperialist agenda grew directly out of this cosmopolitan dream of the Enlightenment *philosophes*.[10] The Revolutionary and Napoleonic conflicts themselves can be interpreted as the dramatic consequences of attempted realization and inevitable breakdown of the Enlightenment dream of human fraternity.

Although many French universalist thinkers were committed to the idea of making international conflict a thing of the past, the broader phenomenon of French universalism was inherently a threat to the national sovereignty and cultural traditions of its European neighbours. As Europe's most culturally and militarily influential society, the French could reasonably expect that their own 'enlightened' civilization would provide the core of the ideas that would become universal. It was even likely that French technological inventions, such as Perronet's bridges or Montgolfier's balloons, would lead the way in making this universal society possible. In the eyes of many of the French Republic's foes during the Revolutionary wars, the notion of the fraternity of enlightened minds would seem just another manifestation of French cultural imperialism. A country which had for much of the eighteenth century been Europe's dominant commercial and military power, and the main exporter in the fields of fashion, art, and manners, now threatened to let loose an export which posed an even more direct threat on Europe's traditional national institutions: secular egalitarian politics.

J. P. L. L. Houel's (1735–1813) engraving of a project for a public monument to be erected in year VIII of the Revolution bears stark witness to the threatening tone of Revolutionary universalism.[11] Intended to celebrate the ideals of universal fraternity, the monument was also to be the most bombastic symbol of expansionist military aggression conceivable. Like many of the grandest allegorical artistic schemes of the Revolutionary years the monument was never completed. It would have taken at least a decade to produce by which time the events celebrated were no longer politically relevant. Houel envisaged a huge globe resting on a mass of clouds populated by flying allegorical figures. The globe itself, which was described as 'the most perfect emblem of égalité' was meant to function as symbol of the universal validity of the ideology of French conquest. A horseman symbolizing French victory rode imperiously over the globe's summit. Metal stars

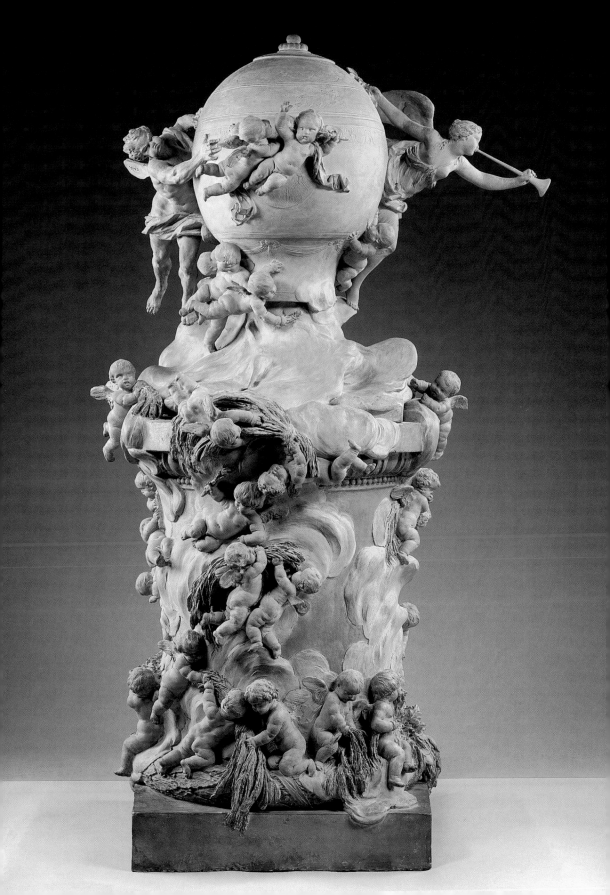

were to be inserted in those points on the globe where Revolutionary
generals achieved victories in the international theatre of war.

Although the basic form of the monument, a huge sphere mounted
on populated clouds, was highly unusual it was not totally unpre-
cedented. Before the Revolution another aborted scheme for a public
monument, a large commemorative sculpture to mark Montgolfier's
first manned ascent from the Tuilleries Gardens in 1783, had included
designs of essentially the same type. The main difference was, as a
beautiful competition model by Clodion (1738–1814) shows, that the
huge orb mounted upon populated clouds was to be a balloon [**33**].
Houel may well have seen some of the many models for the
monument which were available for viewing at the Academy in 1784.
For many the 'globe' of the balloon had also been regarded as a portent-
ous symbol of the promise of future international fraternity. On wit-
nessing the first manned flight of the Montgolfier brothers' 'globe of 26
feet in diameter' Benjamin Franklin wrote to his friend Dr Ingenhauss
in Vienna:

It appears as you observe, to be a discovery of great importance and what may
possibly give a new turn to human affairs. Convincing sovereigns of the folly
of war, may perhaps be the effect of it: since it will be impracticable for the
most potent of them to guard his dominions.[12]

It is an intriguing possibility that a design centring on Montgolfier's
balloon, a piece of modern transport technology which encouraged
dreams of the end of human conflict, had some influence over the
design of this most threatening symbol of territorial expansionism.

The menace of such aggressive universalism was felt particularly strongly in those areas of German-speaking Europe which were invaded by French forces. In the nationalist euphoria which inevitably gripped post-Napoleonic German cities, many sectors of the artistic community became committed to the production of images which would facilitate the reconstruction of a threatened German identity. It was reported that in Rome German artists who had entered military service proudly identified themselves by continuing to wear their old military coats. The practice of wearing service coats was established by Carl Philipp Fohr (1795–1818) who, like other artists in the German colony at Rome, appropriated hairstyles and manners of dress seen in 'old German' paintings. Samuel Amsler's (1791–1841) brilliant engraved portrait of Fohr of 1818, which was made as a memorial of the painter after he had drowned in the Tiber, bears witness to the ideals of this movement [**34**]. It shows a young man who had earnestly modelled his whole image, in particular his angular intensity of facial expression, on Albrecht Dürer's most penetrating self-portraits.

The awakening of a sense of German artistic identity was not solely a result of the threat of military conquest. For three decades before the Revolutionary wars there had been a vigorous interest in promoting the traditions of German art culture. This was largely associated with the desire to reject what was perceived to be the corrupting influence of foreign imports which appealed strongly to expanding bourgeois populations of the late eighteenth-century German cities. A return to the linear seriousness of an 'old German' or Düreresque print tradition was partially stimulated by the swamping of urban markets by sentimental British mezzotints. Leading German engravers of the post-war era such as Carl Russ (1779–1843), and Johann Friedrich Weber (1793–1819) brought this process further by applying this 'old German' style to works of more overtly militaristic subject-matter.

The rejection of French secular universalist culture brought about a strong revival in religious art. Friedrich Von Schlegel set out to defend the sense of religious mysticism which pervaded the German art on exhibition in Rome in 1819 by suggesting that it was a reaction against the secular culture of the French aggressors; a rejection of the art of David and his supporters which was felt to have borne the encoded demand 'that all Europe should . . . become heathen'.[13] This nationalistic impulse toward the revival of traditional forms of religious art originated over twenty years earlier in German conservative reactions to the Revolution. It continued throughout the Napoleonic invasions receiving its finest expression in Caspar David Friedrich's at once startlingly novel and purposefully archaized *The Cross upon the Mountain* or *Tetschen Altarpiece* of 1808. This painting, which is commonly considered the seminal and definitive image of German mysticism, was at first intended as a gift for Gustavus Adolphus of Sweden, a gesture of

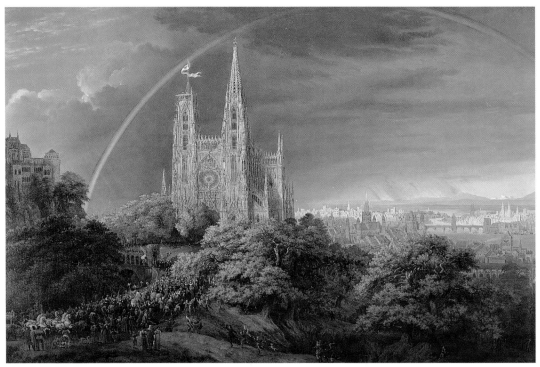

35 Karl Friedrich Schinkel

Medieval City on a River,
oil on canvas, 1815

gratitude for a King who had resolutely maintained the opposition to Napoleon in times when the cause of the traditional Germanic states looked lost. As Friedrich's champion Basilius Von Ramdour explained, the painting was intended to be a statement of eternal hope in the face of temporary adversity. Friedrich's crucified Christ stares out at adversity, symbolized by the setting of the sun. His cross stands defiantly against the dying light, 'unshakeably firm like our faith in Jesus Christ'.[14]

German Gothic cathedral architecture, an appreciation of which had been promoted by Goethe long before the Revolution, became a veritable symbol of nationalistic resistance in the immediate post-Napoleonic era. Karl Friedrich Schinkel's imaginative landscape vision of a great German cathedral and city being approached by the victorious forces of a medieval German Prince gave expression to this spirit of resistance [**35**]. It was painted in 1815 to commemorate the new national beginning which was expected to follow in the wake of the victories of Friedrich Wilhelm III. The cathedral towers over the landscape as a symbol of religious revival. Its form is broadly reminiscent of an unexecuted design for a cathedral which Schinkel intended to act as a memorial to the wars of liberation. In the heavens above the cathedral a rainbow appears, a symbol of the creator's blessing of the victory. Brought into existence by a beam of light shining through the clouds of a clearing black sky, this rainbow presages a period of peace after a storm.

Schinkel's painting was one of a pair. A second historical landscape, which is now lost, depicted a new dawn of Grecian architecture. This pairing of images was probably intended to indicate that the artist did not see the German Gothic revival as a denial of the European antique legacy. Unlike the imagery of Roman republicanism which had been totally contaminated by association with the French aggressor, the artistic forms of ancient Greece could, in many artistic circles, still be considered appropriate for use in the art of German national revival. However, many of Schinkel's more radical German contemporaries were more inclined to reject the entire pre-Christian classical inheritance. As Schlegel explained in his review of the 1819 exhibition of German painting in Rome, the majority of young German artists in Rome dismissed 'the tragic heroes' of both 'Greece and Rome' and looked to 'our modern Christian era' for inspiration. The classical inheritance which C. A. Dufresnoy (1611–68) had described as the 'one clear, unchanging, universal light' of European civilization was confidently disregarded.

To enter Roman Grand Tour society without sharing its primary concern in exploring the classical legacy was a profoundly challenging gesture. The international community of connoisseurs were profoundly shocked by the refusal of exhibitors at the great 1819 exhibition of German art in Rome to make conventional homage to the classical inheritance. Even Goethe, who had encouraged German artists to follow the example of 'manly Dürer', considered this a step too far. Most exhibitors looked exclusively to a Christian art tradition enshrined in the major works of Raphael and his immediate precursors. Franz Pforr, a prominent member of the Brotherhood of St Luke, produced a notable drawing of *Raphael and Dürer Kneeling before the Throne of Art* that is symbolic of this perceived union between the two Christian Renaissance schools.

Leading members of the Brotherhood of St Luke seem to have identified closely with the notion of Christendom, the main pre-Enlightenment concept of shared European culture. Their Utopian dream of Christendom was inspired by the works of Novalis (1772–1801) in particular his poem *Christianity or Europe* of 1799 which conjured up those 'beautiful and glittering times when Europe was a Christian country'.[15] Although the Brotherhood were happy to glorify a past when men of different parts of Europe were united by a common religion, they were not, in general, committed to recapturing this spirit. In common with many in the German-speaking art world of post-Napoleonic Rome, they were overtly xenophobic. After the Napoleonic wars the myth of the inherent racial superiority of German artists—a myth which, as we shall see, had grown up in the 1790s—gained further currency amongst the German-speaking community in Rome. Schlegel was not untypical when he predicted that the 'modern'

renaissance, a new Rome to spring up in the ruins of the 'capital of the old world', was destined to be led by his own northern compatriots. These emotions ran high when in 1818 Prince Ludwig of Bavaria toured Rome and visited the German artists' colony wearing his old German service coat. Having witnessed the event, Julius Schnorr Von Carolsfeld (1795–1872) declared enthusiastically: 'The real time belongs to us. Had it depended on us we would have crowned the Prince King of Rome and chased the Italians out of the Temple.'

The tendency to reject the universal authority of the antique had its intellectual origins before the Napoleonic invasions. To a degree it arose as a gesture of rebellion when the universal standards of classicism were at their most culturally suffocating. The earliest phase of attack focused on Winckelmann's *History of the Art of Antiquity*, which more than any other single work of art history had reinforced and disseminated the notion that Europe had only one valid common artistic tradition. Herder's *Yet another Philosophy of History* of 1774 mounted a brilliant onslaught on Winckelmann's tendency to evaluate all ancient civilizations by standards of classical Greek culture.[16] He made an extraordinarily powerful case for culturally autonomous criteria of artistic value; arguing that historical cultures which naturally expressed themselves in a variety of modes could not be condemned for their failure to conform to a fictitious universal norm.

The powerful logic of this argument provided the essential intellectual basis for subsequent breaks with the universal classical tradition. It was the foundation for the stylistic pluralism of early nineteenth-century European art and paved the way for the concerted exploration of a 'gothic' legacy which the orthodox Vasarian tradition had dismissed as mere signs of cultural degeneration from the pure classical path. Herder's ideas were adapted by Wilhelm Wackenroder in his *Outpourings from the Heart of an Art-Loving Monk* (1797), a book written as an intellectual response to the culture of aggressive republican secularism being promoted in Revolutionary France. Wackenroder, whose literary works inspired many members of the Brotherhood of St Luke, looked forward to the birth of a tolerant religious society; a society which would not judge the world from what we would now call a 'Eurocentric' position and would delight in the variety of world culture.

Despite his accent on the diversity of world culture Wackenroder aimed to invent a universal doctrine; a passive Christian alternative to the aggressive universalist agenda of secular egalitarianism and global imperialism which had been promoted by the military opponents of the German states. Wackenroder's aesthetic was founded on the fundamental theological observation that, although God is one, he had chosen to express his creation in a constant variety of forms. It followed that a truly religious individual—the person who had cultivated some

36 Thomas Cole

The Architect's Dream,
oil on canvas, 1840

insight into the mind of the creator—would naturally develop a mystic appreciation of the unity within the diversity of God's creation. This would enable men to recognize intuitively certain common sensations of beauty which were fundamental to all world cultures. Part of the advantage of creating a mystic doctrine was that Wackenroder could excuse himself from the problematic business of defining this universal element of beauty.

Although preaching an entirely different philosophy of universalism Wackenroder shared some broad convictions with Turgot. He also believed that late eighteenth-century man had reached some sort of new plateau of history at a time when a universal society was becoming technologically feasible. Modern man, with the aid of his sophisticated communication systems, was able to take a broad look at world culture and reach new heights of achievement:

To us, the children of this century, has fallen the privilege of finding ourselves at the summit of a high mountain from which we may see many lands and many ages spread at our feet. Let us then profit from this good fortune and look about with a calm clear eye at all epochs and all peoples and endeavour to discover the constant human element in all their feelings and works.[17]

This general conception of modern man's place in history was most notably captured some forty years later by the great American landscape painter, Thomas Cole (1801–48). In his *The Architect's Dream* of 1840 [**36**] Cole shows the visionary modern artist looking down from

just such a fictive vantage point upon buildings representative of the great architectural traditions of the past. As one contemporary commentator explained, Cole intended to conjure up 'an assemblage of structures, Egyptian, Grecian, Gothic, Moorish [*sic*], such as might present itself to the imagination of one who has fallen asleep after reading a work on the different styles of architecture'.[18] Cole, himself widely travelled and well informed in matters art historical, may well have been indirectly celebrating his own position in the history of art. His brilliant conception provides perhaps the clearest visual representation of a conception of modernity particular to the early nineteenth century. Modernity is presented as a watershed of history, a new beginning spouting from the point where all the waters of cultural tradition begin to meet. Accordingly the modern artist is presented as a master of inspired eclecticism who extracts from all great past civilizations the kernel of their greatness.

In the thirty years after Wackenroder's death the European art world as a whole was much preoccupied by the tensions which formed between this modern spirit of eclecticism and trends towards a newly articulated sense of national identity. The essential Herderesque principle that human culture like nature was essentially driven by a tendency towards a diversity of form could be used to support the position of the aggressive nationalist as well as the cultural eclectic. Artists throughout Europe in the early nineteenth century were influenced by new pseudo-scientific doctrines of nationalism which drew on the evidence of newly emerging sciences such as phrenology, geognosy (or historical geology), or ethnography. The evidence of such sciences was exploited by those who wished to establish that variations in national styles and artistic preoccupation were environmentally determined and conformed to natural laws of diversity. The particular impact of such ideas amongst German-speaking artists has been recently pointed out by T. F. Mitchell in his stimulating analysis of the connection between 'natio' and 'nature' in early nineteenth-century German landscape art. Mitchell has convincingly shown that the late eighteenth- and early nineteenth-century Germanic fascination with landscape was driven by a wider concern with the origins of cultural identity. The emphasis which artists such as Friedrich, Reinhart, and Koch placed on the study of mountains and geological formations in particular was inspired by a desire to explore the essential natural bedrock from which regional character sprang.

Such pseudo-scientific doctrines also had an impact in Britain. Perceived differences in national artistic styles were in some quarters considered as naturally determined. They were cited as evidence by those who believed that the age-old antipathy between France and Britain was based on the two nations being essentially destined not to mix. This argument tended to promote the idea that the Frenchman

was inherently a complete foreigner; not of the same strand of humanity as his English and German rivals. Benjamin Haydon, who had spent the previous evening in the company of the famous German phrenologist Johann Gaspar Spurzheim, made the following entry in his diary: 'Spurzheim commented last night French skulls were all remarkable for the organ of individuality [i.e. details] or facts. The language shewed it and God knows the art does. It is only a compilation of facts or details.'[19]

Also present at Haydon's meeting with Spurzheim was William Hazlitt, who had for some years been perpetuating the view that recent British and French schools of art had developed upon antithetical lines. Hazlitt had developed his theories in a series of essays on the character of modern French and English national schools which were published in 1814, the year of Napoleon's final defeat.[20] In essence he argued that, whilst the English artists had a tendency to resort to vigorous and occasionally glib generalities, their French contemporaries tended to concentrate on the particular and factual at the expense of the whole. French paintings were described in overtly threatening terms as an assemblage of facts reminiscent of the most frighteningly modern system of communication, 'telegraphic machinery'. This analogy probably grew out of the French tendency to refer to history paintings as 'grandes machines'. Hazlitt may also have had in mind that it was the French, most notably de la Mettrie in *L'Homme machine*, who had first put forward the notion that man was no more than an elaborate mechanism. This view of French imperialist culture curiously anticipates the Western cold war generation's tendency to characterize the Russian people as faceless cogs in a social machine.

This sense of having been threatened by a mechanistic force naturally gave impetus to the post-war movement to turn the new evolving British school of art into a patently Christian phenomenon. Benjamin Haydon, who was much involved in this movement, indicates in his post-war diaries that he regarded the spread of Voltarian anti-clericalism as a profound threat to his sense of Christian cultural identity. As in Germany, the Revolutionary and Napoleonic threat reawakened the utopian vision of 'Christendom'. Blake, writing in the preface to Book three of *Jerusalem* (published 1818), was one of the earliest Britons to laud the ideal of Christendom, claiming that it was a vision of Europe destroyed by the *philosophes* who had failed to realize that 'it is the classics & not Goths or Monks, that desolate Europe with wars'. However, the idea of reviving Christendom only began to receive full expression in the 1830s. In his *Contrasts* (first published 1836) A. W. Pugin (1812–52), the son of a French *émigré* who deplored the Revolution as the ultimate manifestation of 'modern paganism', passionately advocated a return to art forms which had, in his rather

rose-tinted view, symbolized the fundamental unity of Christendom. He declared that:

> While Catholic faith and feelings were unimpaired, its results were precisely the same in different countries. There was scarcely any perceptible difference between the sepulchral monuments of the old English Ecclesiastics and those of the ancient Roman churchmen.[21]

The optimistic mood of nationalist euphoria which naturally arose in the victorious countries immediately after the fall of Napoleon in-evitably left its trail of disappointment. When the dreams of national rebirth began to seem as hollow as dreams of universal empire some sectors of the European art world began to move against all forms of public political bombast. Many major European artists, reacting against the heavy propagandistic uses of art in the war years, decided to dissociate themselves from political ideology of all descriptions; the pomp of nationalism was held to be as empty as Napoleon's vain dreams of universal empire. This process contributed to the develop-ment of what is now considered the 'romantic' tendency of artists to focus their creative efforts on the expression of their own 'private' sensation or intimate communication with the a-political forces of nature.

Art works which exhibited a powerful sense of disgust with all machinations of power, and the cant of political ideology of every hue, became popular across Europe. A pan-European enthusiasm for epic scenes of apocalyptic destruction gave rise to such magnificent works as John Martin's *Deluge* cycle, Caspar David Friedrich's *Arctic Shipwreck* (1820–1), or the brilliant Russian painter K. Briullov's (1799–1852) *The Last Day of Pompeii* (1830–3) [**37**]. The last of these paintings, the first Russian art work to create a major international

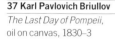

37 Karl Pavlovich Briullov
The Last Day of Pompeii,
oil on canvas, 1830–3

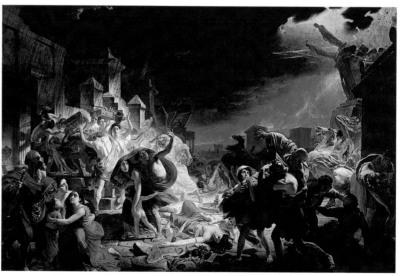

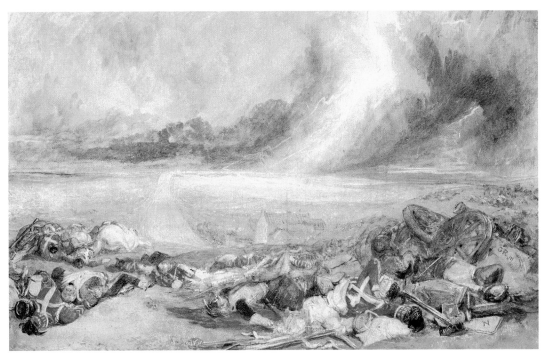

38 J. M. W. Turner

The Field of Waterloo,
watercolour, *c.*1817

sensation, stood as a focus for virtually every doom-laden prophecy current in post-Napoleonic Russia: the imminent destruction of St Petersburg as retribution for it having become a modern Babylon; the future decline of the West and coming pre-eminence of Russia; the fall of Russia's degenerate landowning classes; and the termination of the autocratic rule of Nicolas I.[22]

To some degree an enduring cultural preoccupation with the notion of universal destruction came to supplant the Enlightenment faith in universal progress. J. M. W. Turner became particularly associated with this supra-political fatalistic stance. Many of the major canvases he produced in the period between 1816 and 1825 were suffused with a mood of profound pessimism. Criticism of the vanity of Napoleon's imperial machinations accompanied equally stern castigation of the nationalist enthusiasms of his fellow countrymen. In 1817, for instance, he painted *The Decline of Carthage* with the express intention of warning the recently victorious English public that pride and wealth had brought about the fall of great civilizations in the past. In the same spirit he produced an extraordinarily pessimistic watercolour depicting the aftermath of the Battle of Waterloo in which the bodies and refuse of victor and vanquished alike mingle in a scene of uniform carnage [**38**].

It is in the art of Francisco Goya, however, that the sense of the failure of all ideology was communicated most powerfully. Although he at no time functioned as the organ of orthodox nationalist propaganda, Goya maintained a strong interest in the traditional regional customs

5 *Si son de otro linage.*

39 Francisco Goya

As if They are Another Breed (from *Disasters of War*, c. 1810, no. 61)

of his homeland. These interests are evident throughout his *œuvre* but particularly in the various series of tapestry cartoons which he executed before the Revolution. Despite this he developed into a forthright critic of those conservative elements within the church and aristocracy who purposefully perpetuated traditions of ignorance and prejudice. Album C of his drawings includes a number of particularly strong indictments of this order. Below scenes of humiliation and torture we find the harrowingly simple inscriptions, *For having been born elsewhere*, *For being a Jew*, *For being a liberal*.

War with France, initially stimulated by that nation's attempt to realize egalitarian ideals for which Goya had some measure of support, helped to dim the last embers of Enlightenment optimism within him. Enforced by the brutal power of arms French ideals of universal enlightenment appeared to transform into realities of universal barbarism. Moreover, nationalist resistance appeared to stoop to the level of the barbaric aggressors. Goya studiously avoided turning scenes of Spanish victory into empty displays of nationalist bombast. His painting of the successful guerrilla attack on French cavalry on 8 May 1808, an episode which other painters presented in triumphalist terms, was shocking rather than stirring. The knife-wielding guerrillas are presented as brutal assassins rather than virile patriotic heroes. Similarly

his *Disasters of War* series of etchings charts the descent of a nation into universal barbarity. It contains one particularly poignant image which seems to summarize the failure of all ideals. Entitled *As if they are another breed*, it shows a Napoleonic officer engrossed in cheerful debate with some of his well-dressed compatriots whilst a ragged group of Spaniards starve to death before their eyes [39].

The valorization of the champions of cultural idiosyncrasy: folk heroes, the 'victims of history', and defiantly nationalistic artists

Like many in Madrid's fashionable society at the time Goya was intrigued by the culture and sartorial *panache* of the Mayas, a lawless, blade-happy, street culture. Throughout Europe in the late eighteenth and early nineteenth century the characteristic styles of clothing worn by common people proved attractive in fashionable society. It was, to some degree, an era of proletarian *chic*. A probable cause of this tendency was the growth of the international fashion trade and the increasing availability of high fashion garments amongst the urban middle classes. Naturally the cachet of cosmopolitan style decreased in these circumstances. Those in search of clothing styles with which to identify themselves as distinct from the lower bourgeoisie looked for inspiration to the fashions of the underclasses who, as a consequence of being excluded from fashionable consumer markets, preserved an appealing sense of regional identity.

At the beginning of the eighteenth century the concept of 'politeness' was most associated with the assimilation of cosmopolitan values, most notably the sort of manners, clothing, and accomplishments which would allow one to converse agreeably in French court circles. As this form of accomplishment became more common, it inevitably became possible, even desirable, to define politeness in other terms. In some quarters politeness was redefined as behaviour which accorded to the values of the supposed national temperament. A bigoted hatred of the foreign, an ability to turn one's wit to the mocking of the cosmopolitan aspirations of one's compatriots, could be considered a veritable civilized accomplishment.

In England during the third and fourth decade of the eighteenth century a strong, largely bourgeois, anti-cosmopolitan movement sprang up which had vital consequences for the history of art. Large sectors of the newspaper-reading public seem to have responded to the airing of strong xenophobic sentiments; politeness was reinvented in terms of the exercise of plain Protestant graces. Bluff 'no nonsense' opinions were adopted along with a set of manners which contrasted markedly to the contorted etiquette demanded at Continental Catholic courts. By the mid-1730s the 'Coffee House' readers of English newspapers and magazines—publics which previously had little familiarity with the world of art—could protest a cosmopolitan

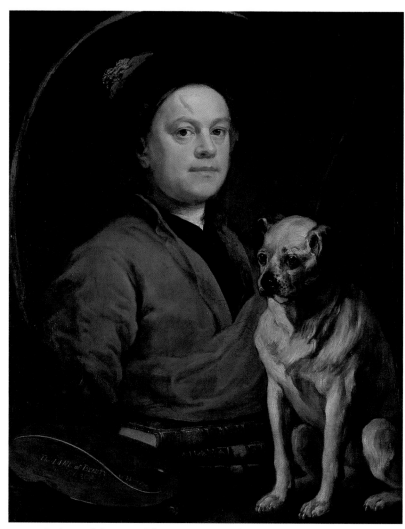

appreciation of the arts. Newspaper articles appeared on subjects such as the merits of recent exhibitions at the French Salon, proposals for the establishment of a British academy in Rome, and theories current in recent French art criticism.

A substantial proportion of this public, however, were by no means predisposed to acquiring the effusive critical 'jargon' (ironically a French word imported in the vocabulary at the time) of the cosmopolitan gentleman connoisseur. A press campaign orchestrated by journalists linked to Hogarth's St Martin's Lane circle in the mid-1730s exploited the fact that many English periodical readers had a 'plain speaking' distrust of the genteel exclamations of cosmopolitan connoisseurs.[23] A series of articles launched a concerted attack on the reputations of Italian artists employed in London, in particular Pietro Amiconi. Also targeted, although only by inference, were the values of the nobility who chose to employ them.

In 1737 Hogarth, under the pseudonym 'Britophil', became the first British painter to use the medium of the open letter to the press to influence the behaviour of the art market.[24] He warned the art-buying public against emulating the tastes of pretentious cosmopolitan connoisseurs who admired the overblown visual rhetoric of Continental Catholic painters. Europe's first organized public campaign to counteract the cosmopolitan culture of the art market had begun. It was still in progress in the late 1750s when Hogarth went as far as to suggest that he had been motivated to publish the *Analysis of Beauty* to demonstrate that one did not have to be 'a deeply read and travelled man' to have a profound grasp of the principles of art. 'Let it be observed', he wrote in his own defence 'that a few things well seen, and thoroughly understood, are more likely to furnish proper materials for this purpose, than the cursory view of all that can be met with in a hasty journey through Europe.'[25]

As Gerald Newman has suggested, this xenophobic campaign can only be understood in the broader historical context of the growth of bourgeois nationalist movements.[26] At the inception of the campaign large sectors of the London public had already been persuaded of the pernicious effects of a panoply of supposedly morally corrosive foreign elements. Italian strolling players, Geneva wine, French dancing masters, and Italian *castrati* had all been held up as the scapegoats for national *malaise*. Hogarth was certainly aware that the fermentation of this broader trend of xenophobia could serve his own particular professional interests. He engaged in an explicit attack on such foreign imports in his cycles of moral engravings. In the second plate of the *Rake's Progress* of 1735, for instance, Rakewell is shown to be lured into further moral danger by keeping the company of Italian musicians and a French fencing master. Ten years later in the *Marriage à la mode* (1745) series a fashionable marriage is seen to dissolve amid a sea of luxurious imported or foreign-style products. The French-style furniture and clothing of the couple's fashionable home become the stage-props around which their relationship declines. A plethora of imported paintings, one of which is so indecent it must be hidden behind a curtain, compound their loss of moral direction.

Hogarth was, as he certainly intended to be, a novel type of artist. He was the first European artist to set out to define, in an organized manner, his public artistic persona in terms of his national identity. The sense that this identity was threatened and that he was its embattled guardian was expressed in his most famous engraved image of himself based on the 1745 self-portrait with his pug dog 'Trump' [**40**]. By choosing this aggressive little English dog as his personal emblem Hogarth created his own image as an iconic symbol of a certain thoroughly British quality of pugnacious independence of mind. His very physical presence could be considered that of the sturdy 'Britophil'.

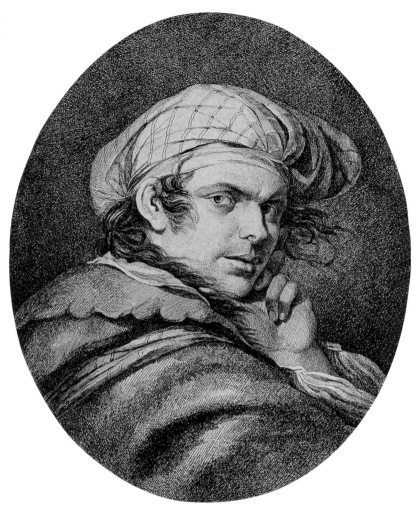

41 John Hamilton Mortimer
Self-Portrait in the Guise of a Bandit, pen and ink, *c.*1775

This painting is indicative of a highly significant change in artistic attitudes to national and regional identity. The growing numbers of accessible international art collections and the availability of prints from all over Europe allowed eighteenth-century artists of even the most mediocre fortunes to build up a cosmopolitan visual imagination. This, combined with the decline of the tradition of regional workshop training, established a social environment which, in general terms, did not favour the natural production of idiosyncratic regional styles of production. Increasingly, therefore, national and regional artistic character had actively to be invented or re-established in the wake of vigorous political campaigns to assert national identity. Being the artist of a certain locality or nation increasingly became a matter of choice rather than accident of birth. Those who took this path often did so in a spirit of aggressive determination; took upon themselves the role of warriors in a losing battle against the socially enervating effects of international consumerism and the corrupting influence of the cosmopolitan art market.

To some degree Hogarth's stance in *The Painter and his Pug* was prophetic of movements which transformed art history later in our period. It anticipates the angry glare of Carl Fohr with the proud inscription 'Pictor Heidelberg' in Amsler's memorial engraving [34]. Amsler's portrait, which was produced in 1818, belongs to an era when European art culture in general was far more geared to the notion of the artist as an angry, independent-spirited, defender of marginalized causes. Those sectors of the art profession which attempted actively to distance themselves from the organized art establishment and the values of bourgeois consumerism were generally predisposed to the valiant defence of threatened cultures. The artist as social outsider could immediately identify himself with the causes of cultures which had been threatened or marginalized by the heavy hand of official government policy or the onward march of modern consumerism.[27]

It was no accident that the British artist John Hamilton Mortimer (1740–79), who was an ardent democrat and resolute member of the rebellious Incorporated Society of Artists, came to identify his whole artistic personality with the bizarre and lawless Italian banditti, the social group which made part of its living from robbing travellers in pursuit of the cosmopolitan experiences of the Grand Tour. In one of his finest self-portraits Mortimer presented himself in the guise of a turbaned bandit [41]. Referring to this portrait one early nineteenth-century commentator recalled that: 'It was his chief pleasure in this fine painting before us to imagine himself a chief of the Banditti—a Rob Roy of the Mountains—and stamp a sort of poetic grandeur on his looks.'

In the first decades of the nineteenth century artistic interest in Brigand culture became even more clearly an expression of the sense of social and political isolation of artists living in and travelling to Italy. In 1819 the Roman authorities launched a firm, if not draconian, campaign to eradicate this constant threat to road travel. All captured brigands were taken to Rome, most of the men being imprisoned and their families compounded in the Thermes of Diocletian. It was in this picturesque environment that artists came to draw them and observe their extraordinary costume.

The artists who made conspicuous use of this experience were the Roman engraver Bartolomeo Pinelli and his acquaintance from the French academy in Rome, Leopold Robert. Robert went as far as to rent a room for three months in the locality that he might virtually live amongst the banditti.[28] His vision of Brigand culture was most sentimental and consequently had the greatest appeal amongst the international community visiting Rome in whose interests Brigand culture had initially been suppressed. His *Family of Brigands Dressing up in Objects Stolen from Travellers* of 1825, in which the awkward question of what happened to the victims of such crime is most deftly

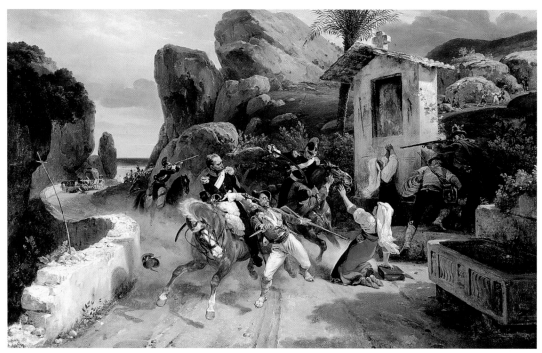

42 Horace Vernet

Italian Brigands Surprised by Papal Troops, oil on canvas, 1831

circumvented, was sold immediately to the Countess Nesselrode. Robert's friend Horace Vernet, the director of the French Academy in Rome, also completed a few major paintings on the plight of the brigand. His extraordinary *Italian Brigands Surprised by Papal Troops* of 1831 captures the sense of outrage provoked by this threatened culture's systematic persecution more fully than any other contemporary work [**42**]. Papal troops are presented as the ruthless and brutal hand of officialdom overwhelming a brave but powerless mountain people.

Bartolomeo Pinelli also catered to the desire of tourists to indulge their sentimental compassion for Brigand culture. He was, however, more inclined to take a realistic view of the barbarity of those who made their living by the perpetration of often horrific highway crimes. One of his best print series, the *Storia del brigante decapitito* of 1823 explores a supposedly true tale of domestic violence in which a Brigand wife beheads her sleeping husband in revenge for his beating her baby to death. Like Mortimer, Pinelli's interest in marginalized peoples had political dimensions. Pinelli's republican sympathies led him to believe that the common people of Rome had naturally preserved the primitive sense of independence and liberty found in the earliest phases of Roman history. A beautiful graphic portrait of a noble Roman peasant of 1820 inscribed 'A true descendant of the Romans' seems to summarize this political stance [**43**].

Pinelli's sympathy with the common man was not just an academic conceit. He lived as he preached, continuing to reside, despite his con-

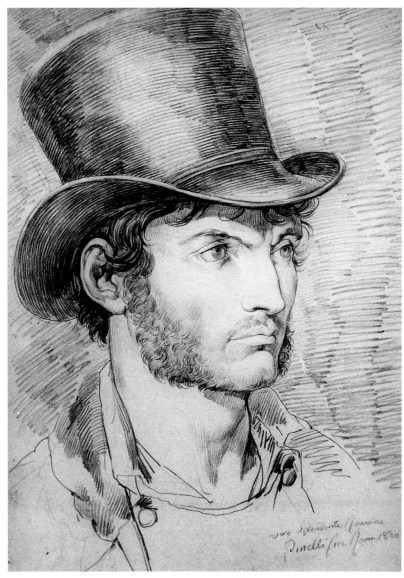

siderable earnings, in a poor quarter of Rome. A great host to the working men of the district, he died prematurely of liver failure with the consolation that he had become a veritable hero of his locality. Even his attitude to Antiquity was influenced by his alcoholism. He cultivated the idea that modern Roman man drew his capacity to enjoy himself from his links with the earthy primitive cults of Antiquity. An engraving of the Roman carnival in the Piazza Collona (1822) displays his belief that the carnival itself was a relic of Italian primitive rituals. The postures of the central group of revellers clearly echo the inter-twined relief groups seen on Roman bacchanal sarcophagi.

Pinelli's art records the strong populist trends in early Italian nationalism. According to his biographer Oreste Raggi, Pinelli was

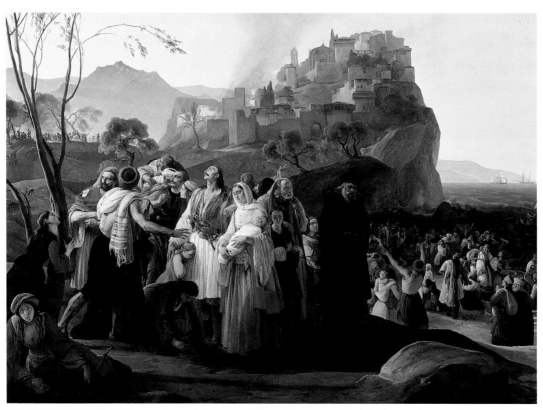

44 Francesco Hayez

The Inhabitants of Parga Leaving their Homeland, oil on canvas, 1826–31

motivated by a profound sense of pride in nation and locality. He insisted, for instance, that he felt no temptation to travel to other parts of Europe and that he became unwell if he had to cross the Tiber. A similar identification of national identity with 'the people' can be found in a number of the most important propagandist images of early Italian nationalism. Francesco Hayez's *The Inhabitants of Parga Leaving their Homeland* of 1826–31, for instance, was designed as a monument to Italian nationalist sympathies for the 'romantic' cause of Greek independence [44]. It shows the eviction of traditional peoples from their homeland. These noble people had been betrayed by the British in 1818 when the city of Parga was ceded to the Alì Pacha of Ioannina in direct violation of the rights of citizens to self-determination.[29] Hayez's careful observation of the traditional costumes of these noble but humble citizens serves to make clear the atrocity of alienating a traditional culture from its homeland. The painting was exhibited at the Brera in 1831 immediately after the suppression of Italian patriotic uprisings. Its relevance to the cause of establishing Italian national identity was reinforced by the public praise of Guiseppe Mazzini himself.

In the two decades after the fall of Napoleon, Italian scholars and artists developed a profound interest in the idea that the vestiges of fundamental, ancient 'Italian' identity had survived in those sectors of

local culture least touched by the incursions of modern urban society. In Naples, for example, Andrea de Torio published a book entitled *Mimica* (1832) in which he argued that the gestures and facial expressions of common Neapolitans reflected the lost culture of Antiquity. This kind of nostalgic sentiment had an immediate appeal to French painters such as Robert and Vernet. Increasingly French academicians came to Italy in order to pursue a sort of alternative Grand Tour in which the primitive virtues of Antiquity were sought in the living people rather than the ancient monuments of Italy. The cosmopolitan ideals of an earlier Grand Tour ethos were replaced by a fascination with the variety of rural culture and exploration of local identity. Leopold Robert was highly successful in converting his quasi-anthropological fascination with the local custom of rural Italy into canvases which enthralled Parisian society. Both Robert and better informed sectors of his public were aware that these were records of a rural world which was fast disappearing. In November 1827 Baron Gerard (1770–1837) wrote to the artist from Paris giving his thanks for allowing him to 'see again with pleasure those customs that happily have not changed'.[30]

Robert brought a kind of scientific rigour to his cultural investigations; methods which remind one of the pseudo-scientific enquiries into human typology pioneered by men such as Spurzheim. He took painstaking notes of the particular customs of certain regions and made scholarly comparisons between the customs and artefacts of various regions. Much in the manner of the ethnological explorer, Robert formed collections of folk objects, in particular of musical instruments. From 1819 onwards these objects festooned his studio walls. He experimented with means of introducing his comparative observations to the cultivated Parisian public. In 1830, after painting a tribute to the reapers of Pontine marshes intended for permanent exhibition at the Luxembourg, Robert announced his intention of supplying another comparative painting. This was to contrast the rural customs of the Naples area with those of the Papal States.

Robert was not the only artist to use such 'anthropological' methods. His friend Achille-Etna Michallon (1796–1822) set about producing detailed visual records of the various customs and hairstyles of rural Italy. Both men were probably influenced by the work of their distinguished compatriot, the landscape painter Pierre-Henri De Valenciennes (1750–1819), an established member of the French colony in Rome who had actively promoted the exploration of locality. In his *Advice to a Student on Painting, particularly on Landscape* (1800) De Valenciennes developed the concept of the 'landscape portrait'. He encouraged the artist to look in detail at the various styles of building, costumes, local materials, and agricultural practices to give his painting a sense of a particular place. He comments:

If the landscapes vary so much one district from another what would happen if one compared the differences of governments and climates from every part of the world! Were one to add the diversity of costumes and the variety of fashions in certain countries, one would understand how susceptible the genre of the landscape portrait is to embellishments and variety. It is even interesting solely because of the locality, which gives a hundred times more pleasure to amateurs than views of countries so well known that one is bored of seeing them so often.[31]

De Valenciennes makes the very interesting suggestion that, in order to attract the patronage of 'amateurs', an artist should seek to depict ever more idiosyncratic cultures. The commercial opportunity he noticed was a real one. Within a few years the English painter Samuel Prout (1783–1852), for instance, was to base his whole career on his ability to capture the idiosyncratic crumbling architectural remains and regional customs of Europe. Engravings after his drawings which seem to have struck a particular chord with the British public were produced in a particular linear style which emphasized the processes of decay, lending the prospects of Europe's regional towns the uniform air of an antique bazaar.

The enthusiasm of 'amateurs' for studying unusual views and intriguing customs did not, of course, only encourage an interest in images of the less familiar areas of Europe. It contributed to the increasing commercial appeal of landscapes depicting the architecture and customs of the most intriguingly foreign corners of the world. To some degree, indeed, the 'anthropological' attitudes which many late eighteenth- and early nineteenth-century travellers/painters brought to their study of the 'primitive' European peoples grew out of the tradition of scientific observation and ethnological collection established by artists employed in the documentation of voyages of world exploration. De Valenciennes's words are somewhat reminiscent of those of the intrepid British painter William Hodges (1744–97) when promoting the architecture and landscapes of India. In his *Travels in India* (1793) Hodges made an impassioned plea for 'cool judgement' and unclouded observation in landscape painting, attacking those painters who, in their flights of generalizing fancy, dismissed all that was characteristic of the national or the regional. Having made his reputation as principal artist aboard James Cook's *Endeavour* Hodges had become accustomed to producing paintings which could be evaluated both as works of art and as accurate scientific records. It was the latter aspect of his art which he emphasized in *Travels in India* in which he informs the reader that:

Pictures are collected from their value as specimens of human excellence and genius exercised in a fine art; and justly they are so: but I cannot help thinking they would rise still higher in estimation, were they connected with the history of various countries, and did faithfully represent the manners of mankind.[32]

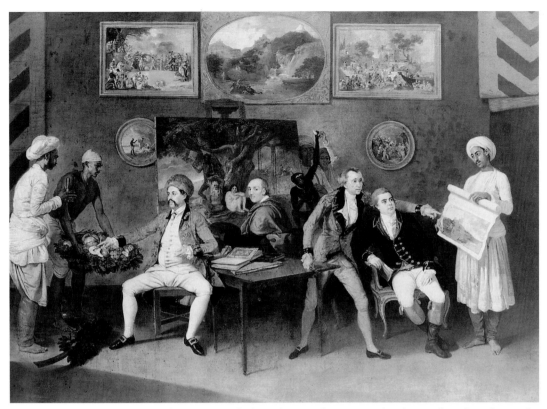

45 Johann Zoffany

Colonel Pollier and his Friends, oil on canvas, 1786

Hodges rejected the ethos and canonical values of mid-eighteenth-century Grand Tour cosmopolitanism and the values of connoisseurs who were only interested in art works as symbols of their own taste. He may well have assumed this stance when mixing in the circles of the gentlemen explorers on Cook's *Endeavour*, who were generally in search of experiences a little more challenging to their imaginations than a formulaic cultural tour around Italy. A principal member of the *Endeavour* expedition, the amateur scientist Joseph Banks is reported to have declared that he had chosen not to go on the Tour of Europe because 'every block head does that'.[33]

Hodges strongly believed in evaluating Indian culture on its own terms. His views, to some degree, resemble those of Wackenroder who in his contemporary *Outpourings from the Heart of an Art-Loving Monk* decried those people who would 'condemn the Indian because he would speak his language and not ours'. Though motivated by entirely different social circumstances both men sought to establish alternatives to dogmatic Eurocentric universalism. Hodges, however, was no mystic. He was not, as was Wackenroder, in search of an alternative spirituality. At the time of writing *Travels in India* he was mixing in the society of those at the helm of imperialist commercial ventures in India. The book itself was a major venture within his broader aim of making money out of Indian experiences.

46 Julius Caesar Ibbetson
Aberglaslyn: the Flash of Lightning, oil on canvas, 1798

Colonial administrators of Hodges's acquaintance such as Warren Hastings were fast realizing that in order to exploit more fully India's economic potential they would have to 'go native' to some degree. As Hodges had no doubt noted on his voyages in the South Seas, those Europeans who judged the whole world from their own cultural perspective were unable to work with native cultures or derive profitable conclusions from their observations of new phenomena. Late eighteenth-century European colonial exploitation of India, particularly that conducted under the authority of the East India Company, was generally performed under the governance of those who understood the advantages of working with, and taking a cultivated interest in, local laws, customs, and traditions.

This colonial spirit was brilliantly captured by Zoffany in his group portrait of Colonel Polier (an associate and patron of William Hodges) and his friends in Lucknow (completed 1786) [**45**]. The painting functioned as a celebration of a particular brand of mercantile cosmopolitanism. It depicts a convivial group of various European origins: the Swiss engineer Antony Polier, the French General Claud Martin, the British accountant John Wombwell, and, in the centre, the German/British Zoffany. All were in the service of the British East India Company and were in India to make their fortunes. Zoffany, indeed, had gone to India for the purpose of rescuing himself from

financial failure. For the purposes of this painting, however, the artist and his friends appear to have come to Lucknow to indulge their gentlemanly interests in Indian tradition and custom.

Zoffany is seen in the process of painting an image of Hindu devotees under a banyan tree. He has covered the walls with other studies of Indian customs. Seated beside him Polier pauses from his study of an illuminated oriental manuscript to order the day's provisions from his Indian servants. Although, as the submissive postures of various natives indicates, their respect was more directed at India's traditions than at the individual Indian, this was evidently a group who considered it civilized to delight in the diversity of world culture. Zoffany's attempts to come to an understanding of Indian customs was remarkable. He even produced a painting which extolled the nobility of suttee (widow-burning), a custom which caused uniform horror in most quarters of the 'enlightened' European community. His Indian paintings represent a colonial attitude which was soon to wane as, with the decline of the authority of the East India Company, British imperial policy became increasingly dominated by an evangelical agenda. Power gravitated to the hands of those who regarded cultural diversity as a sign of barbarity and the failure of church mission.

The tendency of artists to apply methods of observation learned in their experience of world exploration to their observations of European culture is evident in the career of Julius Caesar Ibbetson, a painter who built his artistic identity around making first-hand records of local customs observed on his intrepid adventures. From his youth Ibbetson seems to have been captivated by the adventure of travel. As

47 Julius Caesar Ibbetson

Blind Harper of Conway, or *Penillion Singing near Conway*, 1792

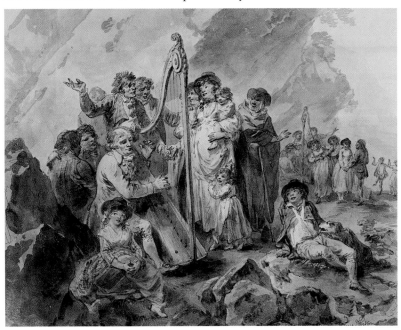

we noticed in Chapter 1, his earliest press notices were received for an evocative painting of George Biggin's ascent in Lunardi's balloon (29 June 1785). In 1787 Ibbetson was chosen as official artist accompanying the first British mission to the imperial court of Peking—an adventure on which he proved himself more robust and able than those who led the expedition. Much of the rest of his career was devoted to the production and sale of sketches made on his tours around Britain. A series of paintings executed on trips to Flamborough and other coastal towns on the customs and dress of English mariners (often valorized as the muscular foundation of British imperial power) constitute some of the most important examples of the burgeoning genre of British art directly connected with the practice of indigenous travel.

In the wild and obscure Welsh mountains Ibbetson was able to recreate some of the thrill of intrepid and dangerous travel he had experienced on his voyage to China. A superb painting known as *Aberglaslyn: The Flash of Lightning* (1798) [**46**] records a life-threatening incident aboard a coach journey crossing a craggy mountain pass. It was painted for his friend and patron Robert Greville who had also been aboard. A sense of mystery, akin to an explorer's emotions at the discovery of some lost ancient civilization, lies behind his painting of the *Blind Harper of Conway* (1792) [**47**]. This is in fact a study of a certain J. Smith who established himself as one of the most prominent tourist icons of the early Welsh heritage industry. Smith is shown playing before the slopes of Mount Snowdon in a rather contrived attempt to reproduce the wild bardic spontaneity of his ancestors. Ibbetson here gives visual expression to the widely held supposition that the more isolated of contemporary Welsh rustics were direct heirs to the bardic tradition of British druidic culture.

The growth in the popularity of images relating to the ancient British bardic tradition has recently been explored by Sam Smiles in a stimulating survey of *Ancient Britain and the Romantic Imagination*. Smiles points out the popularity of paintings relating to Edward I's suppression of the bards in which the viewer's sympathy is concentrated on an image of a hunted druid clutching his harp as the King's armies appear in the distance. John Martin's *The Bard* of 1817 is perhaps the most dramatic rendition of this familiar theme [**48**]. It would not be unreasonable to suggest that the popularity of images of this episode of history reflected a wider cultural sympathy with those on the threatened fringes of a regimented and bureaucratic modern urban society. A profitable comparison can be drawn between Martin's painting and Vernet's mountainous scene with papal troops attacking banditti. One is reminded that it was in the early nineteenth century, in particular in the works of the French historian J. N. A. Thierry, that the concept of there being whole cultures who could be considered 'the victims of history' was first developed.[34]

The belief that remote mountain communities threatened by modern urbanization and economic 'improvement' held some precious vestigial memories of a noble primitive past was propagated with even more enthusiasm by the intellectual champions of Scottish Highland culture. Indeed, the impulse to make visual record of declining customs, to preserve the physical and literary remains of a passing world, was stronger and more cogent in Scotland than anywhere else in Europe. Those who in the late eighteenth century posited or took seriously the theory that Highlanders were the surviving heirs of Roman occupying forces anticipated the early nineteenth-century valorization of Italian rustic peoples. Connections were inevitably drawn between the kilt and greaves (*ocreae*) of Roman battledress. Such observations encouraged William Gilpin (1724–1804), who toured the Highlands in 1776, to comment on the similarity of passing Highland horsemen and the famous equestrian statue of Marcus Aurelius.[35]

David Wilkie (1785–1841) began collecting rare Scottish folk objects for use in paintings recording threatened rural traditions at about the same time that Robert and Michallon arrived in Italy. Like his French contemporaries he regarded rural societies as fast disappearing storehouses of ancient tradition. After a trip around rural Scotland in 1817 he was moved to describe the country as 'a volume of history' and 'a land of tradition and poetry'.[36] Every area he thought 'has some scene in it of real or fictitious events, treasured with a sort of religious care in the mind of inhabitants'. A high proportion of the Scottish genre scenes with which he initially made his London reputation were undisguised essays in nostalgia. His portrait of *A Veteran Highlander*, a painting first exhibited in 1819, communicates a subtle sense of loss; behind the watery eyes of this venerable Scot the viewer can imagine a storehouse of faded memories [**49**]. According to early exhibition reviews, his particular character's claim to fame was that he had served in the Battle of Minden in 1759. This clearly identified the Scot with the cause of Hanover and the Union and the painting with a loyalist form of nationalism.

Wilkie's identification with the common man was generally in line with his own politically conservative outlook. Despite his conservatism there were occasions when his work was thought to suggest that the activities of landowners were contributing to the decline of unique local cultures. His *Distraining for Rent*, can, with some justification, be regarded as a proud nationalistic defence of the treatment of the tenant under traditional Scots law. It was interpreted as an attack upon the draconian practice of requisitioning a tenant's property to reclaim rents due to the landlord. This land law—a law which applied in England but not in Scotland—was perceived as a threat to the traditional order of the countryside, the old world of the Tory squire who extended a generous 'old English hospitality' to his social dependants. The

50 Edwin Landseer

The Highland Still,
oil on canvas, 1826–9

painting briefly endangered Wilkie's career. As Haydon recorded, 'the aristocracy considered it an attack on their rights'. Most scandalized was Sir John Beaumont who asked Wilkie to explain why he had not shown the reason for rent being distrained by the landlord.

Wilkie's attitude to the Scottish Highlands was not dissimilar from that of Edwin Landseer (1802–73) who in the late 1820s completed a number of paintings of the lawless fringes of Highland society. The most ambitious of these was *The Highland Still* (1826–9) which depicted an illicit whisky still [**50**]. In his loving attention to the details of the various traditional cooking implements and garments Landseer is also reminiscent of Robert. Indeed, the painting won critical approval for being 'nationally characteristic, well-coloured and as wild as the Highlands in which the scene takes place'.

The painting was commissioned by the leading light of the Tory establishment, the first Duke of Wellington, hardly an individual expected to be sympathetic to rural law-breakers. It was not, indeed, intended as an endorsement of law-breaking elements in Highland society. Landseer himself is recorded to have frowned upon the Highland people's resistance to 'improvement'; views reflected in the demeanour of his Highland distiller who is presented as a cruel and

ignorant rogue. The artist's own political attitudes were most fully communicated by a painting of the same period based on John Gay's lampoon of cosmopolitanism, entitled *The Monkey who has Seen the World* [51]. The painting is a reworking of a conservative nationalist engraving of 1793 which attacked Thomas Paine's *Rights of Man* as a form of dangerous radical cosmopolitan ideology. In this vision of culture, cosmopolitanism was regarded as akin to subversive radicalism.[37] Landseer's own concept of local identity appears to be akin to that of Walter Scott, a deeply conservative nostalgia reflecting an overall desire to protect the traditional rights of the landed interest.

A different political attitude to Scottish tradition can be seen in the landscape art of Alexander Nasmyth (1758–1850), whose irreverent political radicalism has already been discussed. Nasmyth combined apparently contradictory personal preoccupations: a strong 'Whiggish' interest in highly progressive engineering schemes for improvement of modern urban society did not prevent his landscape art from exhibiting a nostalgic regret for the disappearance of rural Arcadian and noble primitive cultures. This was not a uniquely Scottish turn of mind. Indeed, he resembled his English contemporary John Martin, a man of equally radical political opinions who on one hand specialised in the production of apocalyptic visions of ruined urban worlds and on the other created schemes for urban development. To mourn the loss of the past and welcome the prospect of a better future was, however, very much part of the Scottish condition. During Nasmyth's lifetime

51 Edwin Landseer

The Monkey Who has Seen the World, oil on panel, 1827

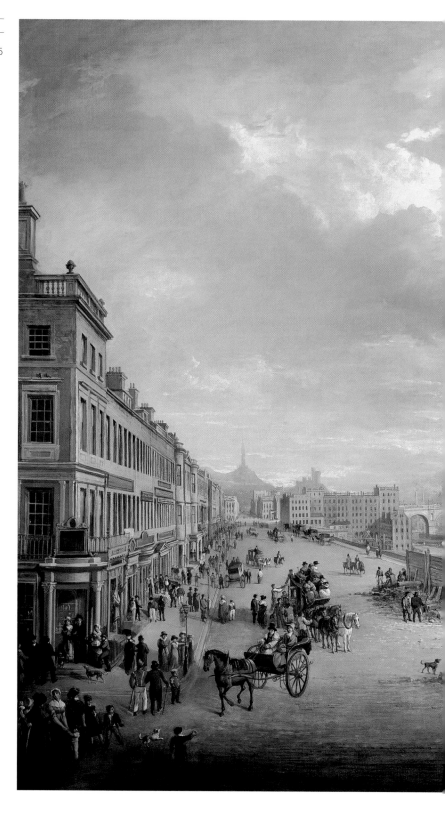

Le Berceau

53 Jean-Baptiste Le Prince
The Cradle, aquatint, 1769

Scotland's principal cities were thrust into the modern European world with unparalleled force. They were transformed from relative backwaters into dynamic centres of industry and the hubs of social and political ideas which had influence throughout the Continent of Europe.

Edinburgh intellectual society was particularly noted for its ambivalent attitudes to urbanism. The city itself developed an appearance which reflected the divergent cultural impulses of its most prominent citizens. It turned into a city of emphatic visual contrast; physically divided into a dirty though picturesque 'old town' and a hygienic, well-ordered 'new town'. To some extent the architecture of the 'new town' came to enshrine the progressive, entrepreneurial, and cosmopolitan vision that thrust late eighteenth- and early nineteenth-century Scotland into the forefront of European civilization. Those sections of the 'old town' which survived the clearances of 'improvers' equally came to stand as an emblem of nostalgia for an 'old' world of indigenous Scottish traditions.

The two aspects of the city as well as Nasmyth's twin interests in painting and engineering are captured in his extraordinary painting of *The Building of the Royal Institution* [**52**]. In this important painting

Nasmyth commemorated the erection of a structure that was to form the architectural centre of Edinburgh's great new classical cosmopolitan city, the new town. The principal figure of the painting is Nasmyth's friend, the architect William Playfair, who is shown conducting the works. Playfair postures before his great engineering achievement in a manner highly reminiscent of Vernet's image of Peronnet in *Constructing a Road*. In the background looms Edinburgh's old town whose ancient indigenous architecture was to some degree being sacrificed to 'progress'. It was an old world which Nasmyth believed should not become the victim of the new. He was, indeed, the artist most concerned with lamenting the demolition of the greatest works of traditional Scottish architecture in the old town. No less than nine major paintings recording the decay and destruction of the old town were produced by the painter. His impressive *Destruction of the Old Tollbooth* of 1817 can, perhaps, be seen as a counterpart to *The Building of the Royal Institution*: the latter vision of urban construction forms a satisfying balance with his earlier one of urban destruction.

Like many prominent Scottish artists of his day, Nasmyth was a member of various antiquarian societies which were dedicated to recording and preserving Scotland's cultural heritage. The most prominent of these was the Society of Antiquaries, an Edinburgh institution founded in 1780. Such societies had a major role in the invention, or crystallization, of the notion that Scotland was a unique cultural entity that grew out of an immediately distinctive landscape. Nasmyth and the landscapist Jacob More, who was also a member of several antiquarian societies, can be credited with 'discovering' the Scottish landscape. It was they who first isolated those unique qualities of light and geographical form that caused the untrammelled Scottish landscape to become so celebrated in the mid-nineteenth century.

The essential social conditions that encouraged the nostalgic 'invention' of national tradition in Scotland—new urban centres growing up like islands of modern cosmopolitanism within a bleak and primitive rural landscape—were in some superficial respects echoed in contemporary Russia. Late eighteenth-century Russian patrons of the arts, however, appear to have had little or no interest in nostalgic imagery of indigenous local culture. For the sophisticated urbanites of Catherine the Great's St Petersburg traditional Russian rural culture was a barbarity to be forgotten rather than a heritage to be defended and retained. Catherine, indeed, built her European reputation on her commitment to the task of dragging Russia out of a barbarous rustic dark age and towards a bright cosmopolitan future.

St Petersburg itself became an architectural emblem of Russian aspirations to be part of broader European culture; a city constructed upon a dank marsh as proof of the capacity of modern Russian civilization to rise out of nothing. The city's population became accustomed

to defining their own claims to be considered cultivated in terms of their ability to absorb the culture of other parts of Europe. This was most obviously reflected in the number of languages readily spoken and understood in the metropolis. One traveller to the City in 1765 noted that: 'Even the lowest servant speaks Russian, German and Finnish and amongst those people who have some education one often meets some who speak eight or nine languages'.[38]

It was foreign artists, most of them ironically attracted to Russia by the cosmopolitan court agenda of furnishing the capital to the finest standards of workmanship available in Europe, who seemed most interested in the characteristic customs and costumes of the Russian countryside. Jean-Baptiste Le Prince (1734–81), a talented artist who lived in St Petersburg from 1758 to 1763, gambled on the idea that Parisian society would be captivated by the peculiarities of dress and behaviour he witnessed on his rural tours. Between his return from Russia to Paris in 1763 to 1769 he founded his financial success on the production of a series of prints based on his sketches. The six-year print run suggests that the attraction of such scenes was considerable. At this stage of history, however, Parisian interests in Russian rural culture were essentially light-hearted. Like Chinoiserie wall hangings Le Prince's prints created a superficial sense of the exotic [53]. Diderot summed them up when on seeing yet another of Le Prince's Russian scenes he complained: 'If a Tartar, a Cossack, a Russian saw all of these, he would say to the artist: you have plundered all our wardrobes but you have not known a single one of our passions.'[39]

Russian art buyers' interest in their own traditional rural culture was only stimulated by the threat to national society by Napoleonic forces. As part of the drive to awaken a spirit of national consciousness in the visual arts the St Petersburg Academy established 'a class for domestic exercises' aimed at the promotion of genre painting. With official encouragement genre painting began to thrive, the academy produced amongst others the excellent Aleksei Venetsianov (1779–1847), a master of the pastoral genre scene who was reported to have felt happier living in rural retirement than amongst the cosmopolitan crowds of St Petersburg. Venetsianov's vision of the Russian rural scene, best exemplified in his *The Threshing Floor* of 1821, was lyrical and homely. Although he probably never met Leopold Robert or saw his paintings, Venetsianov's images of noble rustics living out a life of Arcadian dignity on their farms capture a similar mood to the pastoral works of his French contemporary.

Public art policy as the agent of cultural uniformity

In 1835 a committee was formed at the Houses of Parliament in London to debate the question of whether a national art academy was the best means of promoting the arts. Evidence was given by the Berlin

gallery director Dr Waagen, a friend of Schinkel and avid proponent of Herder's doctrines, who constructed a cogent and highly persuasive case against art academies. The central plank of his argument was that academies had effectively imposed a monotonous uniformity upon the European art world:

The natural result of the academic institutions consequently, was that on comparing a number of specimens of different schools, such as those of Paris, Petersburg, and other places all exhibited a striking similarity of manner, while in earlier times and in the earlier method of teaching, the character of the schools of different nations, and that of each individual artist, was entirely original and distinct. As, in Dutch gardens, the different kinds of trees were clipped to the same forms, so it was with the different talents of different pupils. Would not anyone feel a greater pleasure in the free growth of the trees in a forest, in preference to the monotonous uniformity of a Dutch garden?[40]

As Waagen's comments suggest, the 'romantic' enthusiasm for freedom of expression and diversity of style developed as a reaction to the claustrophobic dogmatism that accompanied the Europe-wide institutionalization of the visual arts during the second half of the eighteenth century. Thirteen years before the meeting of the Parliamentary committee John Constable had expressed similar sentiments. Taking the familiar early nineteenth-century stance on the diversity of nature, Constable concluded that direct observation of the world was bound to lead to the spontaneous generation of a stimulating diversity of artistic approaches. When hearing of proposals to establish a national gallery of art in London he confided in a friend that he could see no good coming from such an institution: 'Should there be a national gallery (which is talked of) there will be an end to the art of poor old England, and she will become in all that relates to painting, as much of a nonentity as every other country that has one.'[41]

This institutionally imposed standardization of European professional practice was an inevitable consequence of a still more fundamental phenomenon: the advent of serious international competition in the realm of public art policy. Although seldom, if ever, discussed in general historical reviews of the period, the particular Enlightenment understanding of the concept of competition between states had a profound impact on the development of the visual arts. As Edward Gibbon noted in chapter 38 of the *Decline and Fall*, modern European states were to an unprecedented extent motivated by the impulse for mutual emulation. In Gibbon's opinion modern Europe's hopes of realizing the Enlightenment goal of becoming a 'Republic of Letters' rested on the maintenance of this spirit.[42] To emulate was to ascribe to shared values. Competition between European nations fostered the development of common criteria of achievement and perpetuated the dream of a universal culture.

Accordingly those who in the mid-eighteenth century set out to improve their country or region's artistic performance were typically not concerned with encouraging indigenous traditions or the development of characteristic national schools. On the contrary most sought to bring production in line with a set of loosely defined international standards which as a whole could be seen to constitute a 'civilized' public realm. This loose sense of European standards operated most obviously in the establishment of codes of professional practice within art institutions. By the last three decades of the eighteenth century a broad consensus of international opinion had formed around a corpus of 'enlightened' institutional policies. National academies were generally required to have some sort of welfare scheme to protect academicians or their widows from utter penury. It was also generally recognized that prizes and scholarships should be awarded to young artists on the basis of their talent rather than advantages of birth or some other consideration.

If international consensus could be said to have been achieved on any single point it was that the practice of the visual artist should be recognized as a liberal profession rather than a mechanical occupation. This meant that those who wished to be at the centre of that civilization should not be seen to allow the art professions to remain subject to the authority of quasi-medieval guilds. It was in this spirit that the secretary of the Academy in Vienna wrote in 1773 to that institution's protector Count Kaunitz complaining that art guilds continued to have authority within the City: 'It must not only be deeply degrading in general but also detrimental to the impression which foreign visitors receive from our national mentality of state, if skill in art is restricted by the rules guilds'.[43] Significantly, both the secretary and the Count appear to have been less concerned for the welfare of artists than with creating a good impression to the world at large of the 'national mentality of state'. Such comments highlight the degree to which eighteenth-century public art policy was generated and steered by the imperative of creating a laudable impression in the international sphere.

Public institutions which set out to improve the manufacturing performance of their city or country could not afford to produce very locally idiosyncratic styles of workmanship. As the example of Josiah Wedgwood established, those attempting to sell luxury consumer goods in late eighteenth-century international markets needed to find some universally recognized medium of visual communication. For Wedgwood, of course, this was the language of refined classicism. Charged with refounding the Dresden Academy with a strong emphasis on improving manufactures Winckelmann's friend Christian Ludwig von Hagedorn (1712–80) was soon to overcome his patriotic obligations to local masters. He opted for the conventional policy of

filling most of the senior instructional positions with Italian masters and French academicians. His objective was ultimately to produce a generation of young German-speaking artists whose work could be measured for quality within the European mainstream and whose designs would be saleable on the international market.

It was through the establishment of public institutions that the ideal of a shared European culture was most completely realized. Indeed, it became necessary for any European city that wished to be considered part of European civilization to have some sort of public art policy. The desire of cities on the perceived fringes of Europe to assert that they belonged to this 'civilized' or 'enlightened' community testifies to this. The major cities of America and South America, for instance, were very keen to develop the conventional assortment of public art institutions. Mexico had an academy, the Real Academia de S. Carlos de Nueva Espana, by 1785 and Philadelphia an art school (established 1791) which was transformed into an official Academy of the Fine Arts by 1805. The American academy at New York (1816) seems to have gone to the greatest lengths to cultivate a cosmopolitan attitude, taking the fashion of inviting international celebrities of the art world to accept honorary academic membership to an extreme. By 1817 Napoleon Bonaparte, Vivant Denon, Benjamin West, Antonio Canova, and Sir David Wilkie, to name but a few, had agreed to become honorary associates. To some degree the academy was run to show that the fresh new world was inherently capable of producing a purer state of civilization than old-world Europe. One early nine-teenth-century commentator claimed that the American academies 'alone possess the enviable distinction of being free from gothic and feudal error, and abuses of barbarous ages, which have been perpetuated throughout Europe'.[44]

Certain state institutions were acknowledged throughout Europe to have been conspicuously successful and thus functioned as the standard prototypes for a continent. When it became internationally apparent that London had emerged as the most successful manufacturing and trading centre of Europe, that city's Society of Arts, Manufacture, and Commerce (established in 1754) naturally assumed the status of *the* preferred model for other institutions which were aimed at national economic regeneration. Similarly the rigidly stratified academic hierarchy evolved at the French Academy during the sixteenth century—a system that was considered to have propelled that nation into the undisputed position of Europe's most influential artistic power—became the most popular prototype for European foundations with more elevated artistic objectives. Even Britain, France's most consistent military opponent, opted to emulate the well-tried, rigorous hierarchical formula of the Parisian academy. Hogarth was a voice in the wilderness when he protested, on hearing of an

intention to copy the French model, that a British art institution should reflect a characteristic national inclination towards the exercise of individual liberties.

Although the curriculum of European academies generally reflected the particular social and economic needs of the state or nation of which they were representative, there was a broad uniformity in the basic doctrine propounded within them. Discourses and lectures delivered from London to Madrid, perpetuated broadly similar interpretations of central matters of doctrine: the superiority of morally elevating history painting within the hierarchy of genres: the desirability of pursuing a 'grand style'; or the precedence of design over luxuriant use of colour. Joshua Reynolds, whose *Discourses* in many respects promoted a set of attitudes that would render the British Academy part of an imagined international mainstream, famously recommended the pursuit of a 'grand style' as a kind of elevated international language of art. Taking as a point of departure the generous cosmopolitan assumption that intellectual refinement knew no territorial barriers, he argued that only such arts as were considered to communicate a readily discernible quality of 'intellectual dignity' would be guaranteed recognition all over Europe.

For Reynolds, art of the 'grand style' was naturally a cosmopolitan form of communication. Unlike the language of words that naturally evolved upon separate regional lines, great art transmitted a set of dignified universal human emotions recognizable to all those with the cultivation to discern them. The 'grand style' was conceived as a universal visual language; only the words used to attempt to define it varied: 'The *gusto Grande* of the Italian, the *Beau idéal* of the French and the great style, genius and taste among the English are but different appellations for the same thing.'[45] It followed that, in order that it should be universally appreciated and understood, art should be purged of all signs of local dialect. Everything within an image that indicated particularities of time and place was, in Reynolds's opinion, to be eradicated as a provincial vulgarism: 'the whole beauty and grandeur of art consists, in my opinion, in being able to get above singular forms, local customs, particularities and details of every kind.'[46]

Budding young history painters were advised that if they wished to be admired beyond the shores of their own country they should apply themselves to elevated classical subjects:

Strictly speaking, indeed, no subject can be of universal, hardly can it be of general concern; but there are events and characters so popularly known in those countries where our art is in request, that they may be considered sufficiently general for all our purposes. Such are the great events of Greek and Roman fable and history, which our early education, and the usual course of reading, have made familiar and interesting to all Europe, without being degraded by the vulgarism of ordinary life in any country.[47]

Hidden within this comment was a criticism of the everyday morality paintings of Hogarth, who was admonished at another point in the *Discourses* for producing topical satires; images of specific episodes in modern life that would lose relevance with time. Reynolds's attitude to the task of improving national performance in the visual arts was diametrically, and probably consciously, opposed to that of Hogarth and the St Martin's Lane group who had been the dominant intellectual force in the London of the previous generation. His dismissal of the achievement of his predecessors was forcefully communicated in a jocular claim in the first *Discourse* that Britain on the foundation of the Academy was a country with the singular advantage of having 'nothing to unlearn'.

Hogarth, who had billed himself in his 1737 'Britophil' letter as the 'finest painter in England, perhaps in the world, in his way', expected to be evaluated on his own terms and praised precisely because he used the visual language of a particular time and place. Through his consistent demure acknowledgement of the humble debt owed by modern British artists to the superior Continental artistic masters of the past, Reynolds contrived to distance himself from the brash nationalistic confidence of the most well-known painter of the previous generation. He used the *Discourses* to steer British art away from the realms of talented eccentricity, attempting to set a cosmopolitan course that guaranteed the sort of recognition on the European stage which British artists of the immediate past were considered to have failed to achieve. Fuseli, in the third of his Academy Lectures (1801), went further than Reynolds. He expressed relief that English painting had been diverted by Reynolds and other academicians from the 'contaminated descent' of Hogarth whose

representations of local manners and national modifications of society, whose characteristic discrimination and humorous exuberance . . . we admire . . . but which, like the fleeting passions of the day, everything contributes something to obliterate, which soon after becoming intelligible by time, or degenerate into caricature, the chronicle of scandal, the history book of the vulgar.[48]

Reynolds's ambition was not limited to the transformation of the culture of the British profession. It was equally essential that the art-buying public were receptive to his cosmopolitan agenda. His major academy pieces were designed to appeal to those sectors of the exhibition crowd who had become fully acquainted with the primary tenets of a cosmopolitan art education; a public who understood that European art had developed through certain historical phases and could be divided into the variety of discrete 'schools' or 'manners'. Soon after the establishment of the Academy, Reynolds began to exhibit works which the more educated of his viewers would have recognized as being in the 'manner' of a particular European master. Reynolds's

famous, or in some circles notorious, practice of 'imitation' centred upon the witty use of visual quotations drawn from the stock of European art-history's best-known compositions.

This novel form of contrived eclecticism was in some respects the natural outcome of the growth of the international trade in printed reproductions—most notably engravings of 'master works' in major European private collections. Like a great many wealthy artists of his day, and the majority of his most well-informed patrons, Reynolds amassed a very large collection of engravings from all over Europe. However, he exploited this knowledge to far greater effect than his professional contemporaries. Reynolds adapted the techniques of the cosmopolitan scholar who sets out to press his erudition upon the world, by quoting wittily from the canon of classical and European literature. Viewing art was conceived in a novel, and particularly eighteenth-century manner, in which the spectator was drawn into polite, cosmopolitan games of recognition.

The idea that the function of a national academy was to bring the fine arts of that country into line with received international standards was most forcefully stated by the Dresden painter, Anton Raphael Mengs. Never known for his modesty, Mengs informed the assembled academy at Madrid, of which he had been recently appointed director, that before his own era Spain had been a mere province of the fine arts. It was deemed to resemble 'a country of infirm people placing guards on their boundaries that no foreign physician might enter'.[49]

Mengs based the authority of his instruction on the assurance that he was capable of discerning certain universal rules of art. He considered himself a veritable Newton of the arts, capable of defining the fundamental laws which lay at the basis of his science. His monumental statue in the Pantheon at Rome, which he had a hand in designing, grandly described him in only two words: PICTORI. PHILOSOPHI. Like Reynolds and just about every major academic authority of his time, his real authority lay in the perception that he was capable of discerning the rules of art rather than his actual ability to set them down. In fact he wisely avoided serious attempts at definition. He began a particularly doctrinaire speech to the Academy in Madrid by asserting the superiority of the academies over traditional regional workshops that merely offered a training in things mechanical: 'By an academy is understood an assembly of men the most expert in science or in art, their object being to investigate the truth, and to find fixed rules, always conducing to the progress of perfection.'[50] This air of confidence and authority, however unjustified it appears in historical hindsight, lent him an unprecedented international authority. At the height of his powers Mengs was close to being a 'godfather' (though his methods were never overtly criminal) figure within the European art world. He had a role in establishing the regulations of the academies of

Madrid, Rome, Naples, and Genoa and had pupils who progressed to important teaching roles at Copenhagen, Vienna, Stuttgart, Turin, and Dresden.

The gradual demolition of the assumption that art was governed by rules which occurred in the last forty years of our period was, perhaps, the most significant factor in the decline of cosmopolitan academic values. In 1792 Goya signalled a new era when in his speech delivered to the Madrid Academy—the institution at which Mengs had most rigorously imposed his authority over the arts—he denounced the very idea that art had rules.[51] Goya's supposition that art could not be systematized and was a matter of the enigmatic communion of personal genius with nature was itself becoming an orthodox stance within European thought. The focus of artistic achievement was shifting from one extreme to another: the objective of conforming to universal values was in some quarters being replaced by the objective of exploring personal experiences. Ultimately, the notion that art should be a reflection of personal quest and unique vision played a more decisive role in the destruction of the ideal of a universal European art than the ideology of nationalism.

It would be an exaggeration to argue that European academies became the last bastions of beliefs in universals—the 'rules of art' and doctrines of absolute standards of beauty—in an early nineteenth-century world which was embracing the 'romantic' concepts of the wonderful diversity of nature, culture, and imaginative vision. Goya's speech at the Academy appears to have been received without a great deal of controversy, indicating that by this date Spanish academic doctrine was moving away from its rigid stance in the era of Mengs. It is significant that pupils of Mengs only aspired to sporadic terms of office at the Academy in the three decades after their master's death. In some quarters the arguments of aesthetic relativism actually led from within the walls of the academies. At the meeting of the four academies held on 24 April 1817 Girodet-Trisson, who like many major French academicians of his generation had become deeply interested in the culture of Africa and the Near East, publicly questioned the conventional academic doctrine of aesthetic absolutes:

How can the artist, driven as he is by curiosity into remote regions, and seeing as he does in each of the peoples of the world the different and particular idea it has of beautiful . . . remain a firm adherent to the healthy doctrine of absolute beauty?[52]

Grand Tour Italy and the realization and failure of the cosmopolitan ideal

If the polite cosmopolitan fraternity of connoisseurs and cognoscenti described by Joullain in the quotation at the start of this chapter could be said to have been realized it was in late eighteenth- and early

nineteenth-century Rome, Florence, and Naples. A common interest in the heritage of Antiquity and the Renaissance acted as a form of bond between international society. This is, perhaps, most cogently expressed in the largest portraits of Pompeo Batoni (1708–87), the painter who in the 1770s best succeeded in persuading the international community that he was the natural heir to this tradition. Batoni expressed his sitters' sense of common purpose by having them pose in front of an assortment of conventional classical 'studio props' drawn from his cast collection. Whatever influence a patron's nationality or personality had on his reason for being in Rome, these props declared their common veneration of a single canon of Antiquity. Batoni's portrait of the Russian Count Kirill Grigorjewitsch Razamovsky (1766) [**54**] shows the Count proudly posturing before the same group of antiquities employed two years later in the portrait of Thomas Dundas, first Baron Dundas, at Aske Hall, in West Yorkshire [**55**].

As the numbers of Europe's high society making a Grand Tour increased, the city of Rome was drawn ever more emphatically into the role of Europe's premier artistic arena. By the last decades of the eighteenth century it had become *the* world in which an artist who wished to address a European rather than a national or regional constituency had

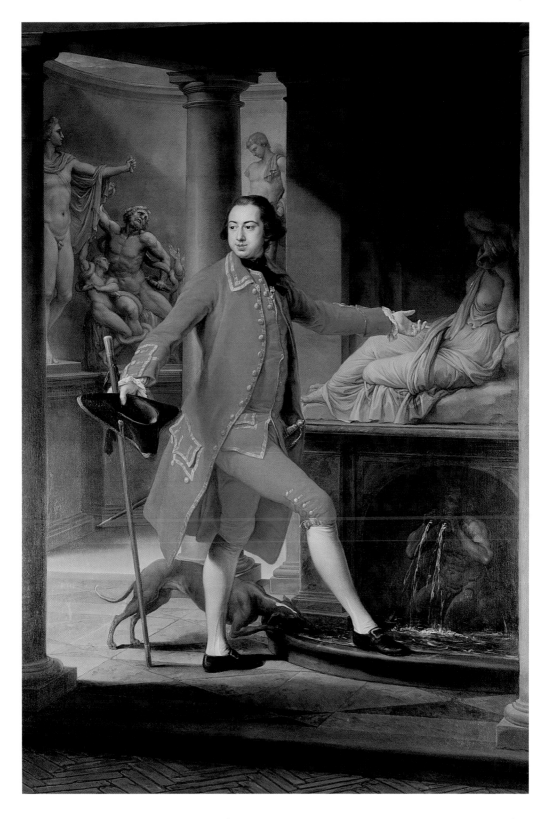

to establish him- or herself. Surpassing those capable of achieving recognition in their home countries, an élite of automatically recognizable European art celebrities emerged of which Mengs and Batoni were the first real examples: after their successes most ambitious young artists who came to Rome aspired, if not to emulate their art, then to reach their status within Grand Tour society.

In 1790, for instance, we find the 35-year-old John Flaxman determined, at the risk of financial ruin, to remain in Rome and make a *tour de force* that would establish him as an international celebrity. In April of that year he wrote to Lord Bristol informing him that he might have to leave without having executed 'a work that might establish my reputation as a sculptor'.[53] Responding to the pressure his Lordship commissioned the major group now known as *The Madness of Athamas*. It was a subject calculated to make an international impact, an exploration of the expression of extreme human passion in the tradition of *The Laocoon Group* which was probably Europe's most universally acclaimed piece of classical statuary at this date. The patron struck a hard bargain, however, and Flaxman was forced to make the group at a financial loss gambling that it would serve to establish him as the sort of figure who would not have to settle for such humiliating terms in the future.

By the end of the century a high proportion of ambitious young artists who came to Rome did so not only with the intention of completing their studies but also of setting up a permanent workshop. The Prussian painter Asmus Jacob Carstens was one of these. On arriving in Rome he immediately attempted to set himself up as a European *maestro* by hiring Batoni's old studio. He proceeded to court all the prominent European connoisseurs into attending exhibitions of his graphic works. With his eyes on international celebrity he rejected all attempts to get him to return from Rome to fulfil certain obligations to the Prussian Academy. He haughtily informed the Minister of Education: 'I do not belong to the Academy, but to humanity, which has the right to require of me the greatest development of my ability.'[54]

Even after the Napoleonic wars Rome continued to be the place where any European artist who wished to be perceived as a truly important figure had to make a mark. Francis Chantrey was heard to joke with Lord Farnborough that his main reason for going to Rome was to increase public confidence in his abilities. He complained that works executed in Rome were automatically considered more 'meritorious' than similar works made in London.[55]

Thorvaldsen, who certainly benefited financially from staying as long as possible in his Roman workshop, spurned the pleas of his countrymen to return to Copenhagen by maintaining that he was a talent of more than European stature. Christian Friedrich, the Danish monarch, wrote to Thorvaldsen in December 1811 begging him to

return to Copenhagen maintaining that Rome was no longer the uncontested centre of European art culture.[56] The king was exaggerating the demise of Rome's reputation. Thorvaldsen kept his workshop there as his best means of furthering his claim to a European stature rivalling that of Canova.

No artist was more zealous in his support of Rome's stature as an international centre than Canova, who argued passionately with Napoleon against the emperor's contention that Paris was destined to become the cultural capital of Europe. On his trip to England to see the Elgin Marbles in 1815—a journey made possible by the cessation of hostilities in 1814—Canova returned Benjamin Haydon's hospitable greeting with the exclamation: 'Come to Rome, vous y verrez la veritable démocratie de l'Art!'[57]

Canova's idealistic view of Rome as a 'democracy of art' in which foreigners could meet and study their art on equal terms was conventional. The English sculptor John Gibson (1790–1866) recalled that when he arrived in Rome in his youth it was an artistic utopia. Here, he declared, the spare hours could be spent, 'listening to conversations on art, not only between Canova and Thorvaldsen, but between artists of talent from all nations'.[58] Throughout the war-torn decades that followed the French Revolution the belief that Rome represented some sort of cosmopolis of art where national enmities could be put aside continued to flourish. Indeed, it possibly became more urgent. Rome continued to be, for some at least, a place where patrons came to acquire the work of the cream of European talent while leaving national prejudice or enmity at home. Thorvaldsen, for instance, took a major commission from the trend-setting English connoisseur Lord Bristol in Rome at the very time that the British Navy were pounding his native city of Copenhagen into ruins.

Whatever their formal reputation as ideal cosmopolitan communities Rome and Florence were, in practice, the breeding ground for the most intense international enmities. Close contact between artists and connoisseurs of different nationality in Grand Tour Italy provoked ungenerous sentiments and vehement competition. The English painter James Northcote recalled that the exhibition of paintings of modern painters from all over Europe at the Florence Uffizi in the 1770s was considered an opportunity to form one's opinions as to the relative merits of the various national schools. His general opinion after spending some time on the Tour was that 'no people hate, envy and despise each other like painters'.[59]

The world of the Grand Tour was typically riven by tensions between the ideal of cosmopolitanism and the practice of national prejudice. Far from uniting the international community the shared Classical and Renaissance inheritance merely gave the various sectors of that community a common ground upon which to compete. From

the 1770s onward nationalistic rivalries provoked a vigorous debate upon the question of which nation could be considered to provide the cultural, political and climactic conditions most advantageous to the spontaneous generation of a modern classical renaissance. It is an indication of the intensity of this debate that James Barry considered it worth spending a considerable portion of his time in Rome writing a long dissertation countering the suggestion of Winckelmann and others that this nation could not possibly be Britain.[60] Also arising out of this debate was J. H. Tischbein's famous 1781 review of David's *Oath of the Horatii*. The German painter turned his generous cosmopolitan public statement of support for a French contemporary into a witty exposé of the narrow-minded quibbles which divided the international community in Rome. Praised to a ridiculous degree by the French, condemned out of hand by the Italians, David's painting was portrayed as the focus for every pompous theory of cultural superiority circulating in Grand Tour Rome.[61] As the culture of Rome was made to look ridiculous by the exhibition of such petty chauvinism, so the real merits and value of a work that set a majestic artistic example to the age were seen to get lost in the irrational furore.

Tischbein's independence from the fray was exceptional, particularly for a member of the Germanic community in Rome. As we shall see in the final chapter, there were numerous complaints that, after the international success of Winckelmann and Mengs, Rome had become the target of what we might now term a Germanic take-over bid. In the last six decades of our period a growing sense of nationalist awareness in the German community encouraged many of their number to believe themselves the true inheritors of the artistic traditions they came to study. Despite his desire to construct an art for all humanity, Carstens's austere works were immediately, and with his own complicity, interpreted as signs that German-speakers were destined to lead a new art renaissance. His art was promoted in a series of German art periodicals and depicted by his most fervent supporter Karl L. Fernow as evidence of the superior virility of the Germanic temperament. Fernow wrote from Rome in 1795 that Carstens had brought a welcome sense of masculine virtue to the Roman art world: 'This artist, when he came to Rome, had already given his talent and study a most fortunate direction and acquired a simple masculine style—one, we conjecture, that could come to fruition only on this side of the Alps.'[62]

Fernow led the spirit of open animosity towards Canova which fermented within the German community of Rome. As Stendhal recalled, many Germans in Rome in the early years of the nineteenth century dismissed Canova's statues as too 'expressive', a word redolent of decadent feminine sensuality and the clear inverse to German values of reforming 'masculine' virtue. Having dismissed Canova for not conforming to their stern virile ideal they vigorously propounded the

superiority of German-speaking sculptors such as Thorvaldsen and Danneker. The sculptors themselves were not innocent bystanders in the controversy. To some extent Thorvaldsen himself fuelled animosity by setting out to create statues on the same subjects as Canova's most recent triumphs. To facilitate the efforts of partisan critics seeking to make comparisons in his favour he obligingly made his statues more classically severe.[63]

Although the ideal of an international artistic fraternity in Rome continued in the wake of the Napoleonic wars it seemed that the divisions between the communities were hardening. In his published diaries Ludwig Richter recalls that relationships between the German and French communities in Rome throughout the immediate post-Napoleonic decades were exceedingly frosty.[64] Some formal efforts, most notably the international exhibition in Rome of 1829–30, were made to bring the various communities together. In 1829 Leopold Robert enthusiastically wrote to his sister telling her that:

we have formed a society of friends of the arts and that at this moment an exhibition is underway in the capitol of works from all nations. This society was conceived by German, Italian and English artists . . . Horace Vernet, Director of the French Academy in Rome, with national glory in his heart and all the members of that society's committee begged us very insistently to unite with them for an exhibition and eventually after many approaches . . . we joined altogether in a group.[65]

International fraternity was evidently an ideal that some artists embraced wholeheartedly and others reluctantly. Horace Vernet appears to have been willing to enter into the cosmopolitan scheme out of the spirit of 'national glory'. Even after the exhibition's successful opening some commentators chose to use it as an opportunity to reinforce their preconceived ideas concerning the superiority of the productions of one national school over another. When a francophile friend of the French painter Baron Gerard wrote to him from Rome concerning the exhibition he limited himself to the terse statement: 'there was an exhibition in Rome in which artists of different nations who live there appeared. The French without doubt occupied the first place.'

Cosmopolitanism had always been more of an ideal than a reality in eighteenth-century Rome. By the 1830s the ideal of the cosmopolis of art was further from reach than it had been in the previous hundred years. The smile of international fraternity was, perhaps, more forced than ever.

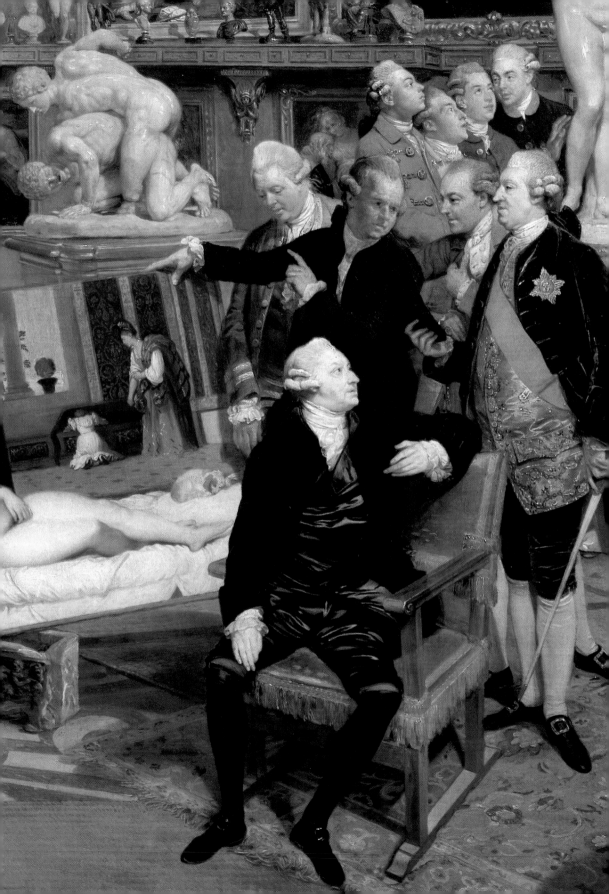

'And 'tis in vain to find faults in the arts of deceiving...'

3

In April 1735 the *Prompter*, an English periodical which concentrated on theatrical criticism, published an article on the appreciation of the visual arts. The article was based upon a translation of a dialogue on the 'principles' and 'pleasures' of painting by Charles Antoine Coypel (1694–1752), the Parisian painter, art commentator, and playwright. The editor introduced Coypel's dialogue with the following statement:

There's a sort of magic in the art of painting, which charms by the *deception* it puts upon us. To have nature as it were, forc'd from itself, and transplanted upon a canvas, under the representation of some delightful landscape, enrich'd with the grateful variety of sunshine, water, greens, distant views and interrupted with figures, that seems animated, and in motion: or else to have some celebrated action, expressed with so much force, that we see dignity, or grief, terror or love according to the circumstances of the story, and before our eyes: To see a stabbed Lucretia, or a dying Cleopatra, an exposed Andromeda or a forsaken Ariadne ...[1]

In this passage the writer explores a moral conundrum which was central to much eighteenth-century debate on the visual arts and the 'imitative' art of theatrical performance. In order to find pleasure in art, or to ennoble one's spirit by exercising one's sympathy over some 'celebrated action', the spectator must submit to being deceived by 'a sort of magic'. Like the passionate lover the viewer must accept that they have been seduced by surface 'charms'.

Eighteenth-century thinkers were by no means the first to be concerned by such problems. The issue of whether an art form based upon 'imitation', or the deceit of the senses, could be morally justified or deemed worthy of intellectual respect was, as the editor of the *Prompter* was probably aware, one of the great perennials of European artistic discourse. Many of the best-known classical commentators on painting had debated the question of how a man of intellectual rigour whose mind was trained to search out fundamental principles should respond to arts which set out to deceive his senses. Such issues were, however, of particular concern to eighteenth-century thinkers. As Marian Hobson has observed in her study of 'the theory of illusion in eighteenth-century France', the concept of illusion, whilst not entirely

novel, assumed a new significance within eighteenth-century com-mentaries on art and in particular within the new Enlightenment dis-course of aesthetics.[2]

The intellectual culture of the Enlightenment was both preoccu-pied by and deeply distrustful of optical deception and, in particular, anything which smacked of a magician's tricks. As Maximilian Novak has argued, eighteenth-century literary culture was haunted by the notion that modern man had created an 'unreal' or 'un-natural' civilization, a world which revolved around deceit and false impres-sion. With some justice he described this period as the 'Age of Disguise'.[3] Defining what it meant to be 'natural', or speculating upon the condition of man before the evolution of civic society with all its intriguing artifice, luxurious comforts, and polite manners, became a veritable intellectual hobby horse. It is an indication of the extent of this cultural preoccupation that A. O. Lovejoy was able to compile a list of no less than eighteen discrete interpretations of the term 'nature' that were used or coined in various European languages in this period.[4]

The very idea of intellectual 'enlightenment' was frequently associ-ated with the exercise of 'penetrative' insight. To be enlightened was to show a capacity to transcend the alluring deceit of surface appearances and to see through those seductive fictions which encouraged irra-tional fears and beliefs. William Duff, for instance, suggested that 'original philosophic genius as should be exercised in all spheres of arts and sciences' was generally found in men with a 'depth of penetration'. The 'province' of the genius was

to survey with attention the various phenomena of the natural and moral world, and, with perspicuity of discernment, to explore their causes; proceed-ing in this enquiry from the knowledge of effects to the investigation of causes by which they are produced. The objects he has, or ought to have in view, are to bring into open light those truths which are wrapped in shades of obscurity, or involved in mazes of error, and to apply them to the purposes of promoting the happiness of mankind.[5]

For many artists with a strong 'civic humanist' agenda—men such as Hogarth, Chodiewecki, and Goya—the process of moral reform became profoundly associated with that of maintaining or restoring the public's clarity of vision. Such figures subscribed to what we can call a 'civic humanist theory of illusion'—the belief that it was permis-sible to deceive the senses of their viewers for the sake of a higher moral mission. Hogarth and Goya, in particular, seem to have been pro-foundly aware of the fundamental tensions which existed between the processes of imitation and moral instruction. Their art explores a rich vein of irony inherent in the work of the visual artist concerned with moral reform; an individual who was obliged to harness an essentially

deceitful medium of imitation to the task of clarifying his public's moral vision.

This 'civic humanist theory of illusion' was born of a spirit of opposition to the power of polite French culture which came to dominate early and mid-eighteenth-century Europe. It can be understood as a reaction against a tendency within this dominant culture to regard illusion as an amoral 'diversion', a voyeuristic search for 'emotional occupation'[6] or an amorous flirtation with the senses. Such attitudes to illusion were particularly in evidence in the art works of those involved in the design of entertainments for the *ancien régime* court, men such as C. N. Cochin *fils*, Moreau le Jeune, and Paret y Alcazar. These painters regularly combined their attempts to disorientate the viewer by plunging him into a complex world of multi-layered illusion with the assumption of an ambivalent moral tone. Their art shares much with the spirit of the masquerade which, as moralists throughout Europe habitually complained, encouraged the decay of that clear sense of reality and personal identity upon which man's sense of moral constraint was considered to be founded.

Artists cannot be divided neatly into camps of those who were happy to acknowledge the diverting sensual pleasures of deception and those who sought to justify their task of duping the senses by assuming a higher moral mission. As the initial quote from the *Prompter* suggests, these were not mutually exclusive positions; our journalist was not only able to appreciate the pure pleasure of escaping into an ideal landscape but also to recognize the importance of witnessing a morally edifying illusion such as a depiction of the death of the virtuous Lucretia. However, despite the existence of many subtle shades of opinion, the friction between these philosophical attitudes to deception became a central dynamic source of creative energy which played an important role in determining the course of European artistic developments in this period.

It is, of course, easier to document the existence of this cultural preoccupation with deceit and false impression than precisely to determine its historical causes. However, it would be neither controversial nor unreasonable to suggest that it was, to some degree, a manifestation of a broader cultural concern with the pace of urban growth and the social effects of broadening access to wealth, leisure, and consumer goods. The growth of the European leisure industry—an industry which then as now was driven by the commercial race to provide the public with ever more captivating alternative worlds—enabled a widening circle to partake in complex fictions and persuasive illusions. Entertainments such as those held within the rotunda at London's Ranelagh gardens, an oval pavilion of 150 ft. (about 45 m.) diameter built entirely of wood, struck many with a strong sense of the elusiveness of reality. One contemporary observer recalled that London

society revolved around the four central pillars of this pavilion 'like gaily coloured distaff, sauntering in a compact throng'.[7] Despite initial appearances of solidity, Ranelagh was no more than a theatre set in which the players were the public themselves. Indeed, it was a general characteristic of polite life in the mid-eighteenth century that the barriers between the world of theatre and civic space became increasingly hazy. As Richard Sennett has observed, the concept of *theatrum mundi* was adapted to these new social circumstances; streets and public places being regarded as venues for performance in which the leisured public could draw entertainment from watching and being watched by their peers.[8]

To negotiate the complex civic *theatrum mundi* the 'polite' public came to demand cultural products, both works of art and literature, which not only plunged them into fictional worlds but also suggested cogent philosophical means of coming to terms with the apparent fictitiousness of their world. Politeness itself was increasingly defined in terms of an individual's ability to assume some intelligible and erudite attitude to fiction and artifice. Accordingly an inability to make subtle distinctions between the fictional and the real became a definitive sign of a lack of education and polite graces. Society was increasingly divided into a polite public who were at ease in a world of complex fictions and a world of 'others' readily deceived by cheap illusions, quackery, and charlatanism.

Making a whore of the truth

There could be no better point of departure for a discussion of late eighteenth-century attitudes to illusion and disguise than Goya's *Los Caprichos* etchings (completed 1799). This print series constitutes the most sophisticated intellectual attack on artifice and superficial appearance undertaken by a visual artist in this period. In plate number 7 which bears the caption *He cannot make her out even this way* [**56**] Goya summarizes many of the intellectual themes of the series. Goya directly addresses the subject of visual perception; he shows a fashionable young man approaching a well-dressed young lady in the street and holding a pocket looking-glass up to her face. His close inspection renders him blind to a reality which he could have seen from a distance—this is a whore who, conforming to the custom of her profession, walks with her heels outward to give a clear signal from a distance that she desires to trade.

The image of a man inspecting the object of his sensual desire with an eyeglass appears commonly in European satirical art of the period. Goya's image has it ancestry in works such as Pietro Longhi's *The Geography Lesson* (c.1752) [**57**]. Here a tutor, who is meant to be instructing a young lady in a subject which will allow her to grasp the widest possible vision of the world, uses his lens to survey attractions

56 Francisco Goya

*He cannot make her out even
this way* (from *Los Caprichos*,
1799, no. 7), etching, aquatint
and dry paint

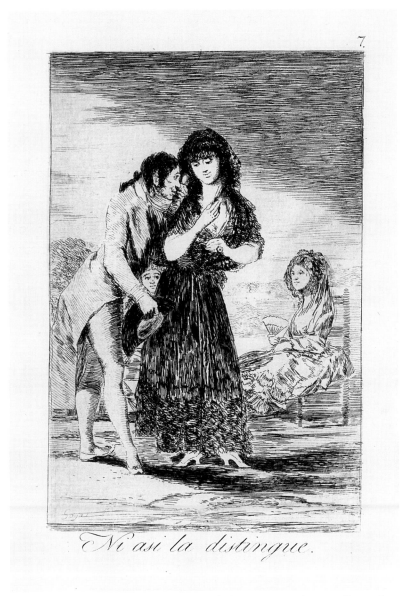

7.

Ni así la distingue.

closer at hand. The image is intended to expose the intellectual or
moral myopia of the lecherous or amorous individual whose attentions
are fixed only on shallow sensual objectives.

Although the device of the eyeglass used in this way occurs fre-
quently in satirical oil paintings, it assumed a particular significance in
the medium of satirical print. Volumes of prints such as Goya's *Los
Caprichos* were generally produced for detailed inspection in the priv-
acy of a collector's study. Most of these rooms were equipped with a
magnifying glass which assisted the 'curious' collector to inspect his
prints in detail. Looking at the surface of artworks with such a device,
the unenlightened collector was prone to being seduced by minute and

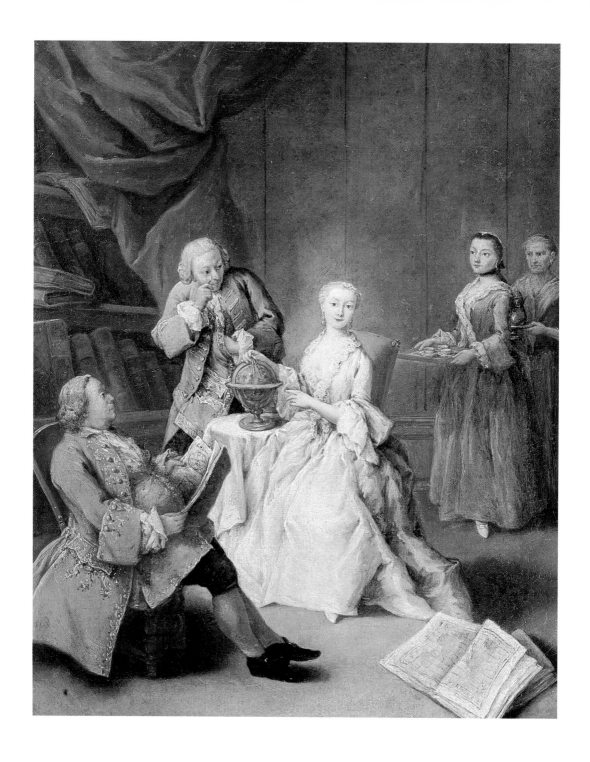

superficial beauties. As with Goya's beau, the harder this type of collector looked at his subjects the less he appeared to see. Such a viewer could be expected to fail to comprehend the deeper meanings of a print such as Goya's *Los Caprichos* or to recognize the broader aesthetic merits of his compositions. Indeed, Goya explicitly addressed this series to those of penetrative intelligence who looked for something beyond superficial meanings in a work of art; those whose intent perusal of his images was not motivated by liking for 'curious' superficial detail but by the desire to obtain profound philosophical insights. In an essay promoting the *Los Caprichos* series the chemist Gregorio Gonzalez Azaola explained that:

Their subtlety is such that even the sharpest minds do not perceive the whole of their moral point at the first perusal. Less perceptive minds need time and help to understand them at all. If I am not mistaken it is the most suitable work to sharpen the minds of the young, and an appropriate touchstone by which to judge the percipience and intellectual agility of all people.[9]

This conception of art was neither original nor unusual. The question of whether art should exhibit a certain *difficultas*, designed only for those of penetrative insight who were prepared to look hard for hidden meaning, was frequently debated in connoisseurial circles throughout eighteenth-century Europe. There had been critics, Diderot being the most conspicuous, who regarded such conceits as reprehensible signs of 'manner' and self-conscious artifice. Goya seems to have been willing to accept the fundamental irony that a series of prints which set out to attack deceit and artfulness should communicate their message in an oblique, encoded manner. His decision to indulge in this contradiction clearly reflects his broader 'civic humanist' agenda. Goya's mission to sharpen the minds of the young reflects his belief, which we shall explore in more detail below, that educated Spanish society at the turn of the century was finding solace in the delusions and superstitions which had haunted the pre-Enlightenment mind.

To appreciate the subtleties of Goya's joke in *He can't make her out even this way* an observer would have had to be aware of the sophisticated inflections of the contemporary term 'curiosity', a word that was frequently used to describe collectors' or antiquarians' attitudes to works of art. Pedantic concern with 'curious' minutiae was considered to inhibit a man's ability to come to that broad philosophical understanding that was held to be indicative of a true liberal education. The word 'curiosity' also had pornographic inflections, well illustrated by the image of a disconcerting and intrusive voyeur who inspects the objects of his sexual desire as if they were curios or botanical specimens.

Although Goya's image related to a conventional quasipornographic type it differed significantly from it. In most other cases, including Longhi's *The Geography Lesson*, the man with the magnifying glass is

58 Thomas Rowlandson

Buck's Beauty and Rowlandson's Connoisseur, pen and watercolour, 1800

depicted as a worldly debauchee and the woman inspected as the innocent object of his sinister curiosity. Rowlandson employed this grotesque contrast to most shocking effect in works such as *Buck's Beauty and Rowlandson's Connoisseur* (engraved 1800) [**58**] and *Old Member on his Way to the House of Commons* (engraved 1801). Goya's beau, by contrast, innocently seeks a respectable lady and finds a whore. By twisting the joke Goya was able to make the woman appear the focus of man's naïve illusions and the very personification of deceitfulness.

The image strikes a certain bitter misogynist chord frequently encountered in the *Los Caprichos* series. There is little doubt that this bitterness was to some extent born of personal experience (he appears to have had a disappointed infatuation with the Duchess of Alba in the mid-1790s). Nevertheless it should not be forgotten that Goya was the child of an era, and more generally of a long tradition of Western thought, in which the very concept of duplicity had habitually been invested with a feminine gender. More than a hundred years earlier, John Locke discussed the notion of 'eloquence', a beguiling rhetoric which could induce a man to suspend his usual sense of intellectual judgement, in the following terms: 'Eloquence, like the fair sex, has too prevailing beauties in it, to suffer itself ever to be spoken against. And 'tis in vain to find faults with the arts of deceiving, wherein men find pleasure in being deceived.'[10]

Goya's interest in the subject of the human capacity for self-deceit obviously grew out of his musings into his own professional role as a producer of illusions. He worked within, and deviated from, a strong art tradition of Parisian origin in which the craft of the artist was habitually conceived in terms of the enigmatic woman's ability to beguile. Many mid-eighteenth-century writers on illusion had, indeed, described the power of art to deceive in overtly sexual terms. Willingly to fall for the artist's optical tricks was severally compared to being 'ravished', 'enchanted', or 'seduced'.[11] A fundamental distaste for this frivolous 'polite' art tradition—a distaste which Goya shared with reformist French contemporaries such as David and Guérin—is encoded into this print. Unlike Watteau, Pater, and Fragonard, Goya did not set out to please and divert with flirtatious eloquence and agreeable fantasy but to hold up a vision of truth that was as enlightening as it was disagreeable to behold.

Although Goya's print focuses particularly on the deceitfulness of women and the seductiveness of eloquence, it also gives potent expression to broader cultural anxieties over the failure of dress to act as a meaningful outward symbol of class and social respectability. Terry Castle talks with some justice of 'the massive instability of sartorial signs' in this period.[12] Since the mid-eighteenth century the problem of making clear distinctions between prostitutes and respectable ladies

had preoccupied European urban society. At a social venue such as Vauxhall gardens in the 1740s it became notoriously difficult for the proprietor to exclude well-dressed prostitutes who mingled in the polite crowds. One particularly disgruntled mid-eighteenth-century English moral commentator complained that behind 'that mask of modesty which women promiscuously wear in public, they are all alike, and you can no more tell the kept wench from the woman of honour by her looks than by her dress'.

As the international cloth and garment industry expanded, and high fashion clothing became increasingly accessible, dress began to disguise rather than to articulate the social order. The nobleman was in danger of being mistaken for the wealthy tradesman. The clothing of the tradesman's wife was in turn not immune from being artfully imitated by her servants. In Montpellier in 1768, for instance, it was decreed that servants should have a star sewn onto their garments so as to distinguish them formally from their masters when walking in public places.

This dilemma is subtly explored in one of Jean-Baptiste Chardin's finest, and superficially most charming, genre paintings which shows a young female servant handling a handsome joint of meat in her downstairs kitchen [**59**]. An engraving of the painting was produced by Lépicié with an inscription suggesting that the scene is not as innocent as it first appears. It encouraged potential buyers to interpret the composition as a subtle exposé of feminine duplicity. Like Goya, Chardin and Lépicié appear to have associated the growing availability of high fashion garments amongst women of lesser social standing as a threat to the moral decorum of society. The viewer was asked to look at some of the good quality accessories which adorned the servant's clothing and inquire as to where she got the money to dress in this way. The answer was obvious: she was funding her personal beautification by stealing and selling the fine foods with which she was entrusted. By beautifying herself in this way she expected, no doubt, to make herself alluring to husbands and sons above stairs.

It is uncertain whether Chardin at first intended the painting to be seen in this way or was induced by his engraver to add this twist of meaning to his original scene. At some stage, however, a decision seems to have been made to turn what at first sight appears to be a pleasing scene of bourgeois industry into an exposé of domestic indolence and corruption. Chardin or his engraver may well have intended to use this ironic device to reveal the power of art both to deceive and inform. Like the majority of prints based upon Chardin's genre scenes which cost only one livre, it was intended to appeal to householders of modest income. The print was probably intended to function as a warning to the industrious member of the 'third estate'.[13] It directly addressed the anxieties of socially aspirant householders that their

J.B. Simeon Chardin pinxit Lepicie Sculpsit 1742

LA POURVOIEUSE.

servants were, like themselves, capable of dressing in a manner which belied their station.

Compared with Goya, Chardin and Lépicié were mild critics of the foibles of those who allow themselves to be deceived by beguiling appearances. Goya's graphic works exude a kind of raw disgust with those who played games with reality which had no real precedent in Chardin's generation of European artists. Plate 6 of Goya's *Los Caprichos*, a print which bears the caption *Nadie de conocie*, or *Nobody knows himself*, savagely attacks the social ritual of masquerade [**60**]. Once more the print focuses upon the duplicitous coquetry of the young ladies and the leering sinister physical presence of men drawn by the allure of sexual intrigue. A contemporary explanation of the print, phrased with a certain cadence of doom, captures that sense of dark moral anxiety which pervades the image itself: 'The world is a masquerade; face, dress, voice, everything is feigned. Everybody wants to appear as what he is not; everybody deceives and nobody knows anybody.' Goya was not the first artist to depict masquerade entertainments as threatening and disturbing rituals. An etching by Daniel Chodowiecki (published in 1775), for instance, depicted a group of masked revellers at the Stuttgart masquerade whose hilarity suddenly turns to horror. Like some sinister flock of birds they turn on a girl in their number and proceed to peck at her clothes with the intent, we assume, of some sort of sexual molestation [**61**].

Chodowiecki's print reflects the conventional criticism of those who denounced the masque as an opportunity to commit morally repugnant acts under the cover of anonymity. Such views had been expressed in popular moralistic essays since the early decades of the eighteenth century. Despite its critics, the masque continued to captivate European polite society during the mid-eighteenth century. By the seventh and eighth decades of the century, however, the criticisms began to be taken more seriously and the popularity of the masque rapidly declined. The decline of this particular social activity can be considered as a manifestation of a far broader social development: a strong pan-European backlash against the mid-eighteenth century tendency to delight in thoroughly contrived artifice and ritualistic games of disguise.

The fifteen years preceding the French Revolution can be regarded as the denouement of 'the age of disguise'. This is most evident in the study of European sartorial fashion. Taking the broadest possible historical perspective, it would appear that European fashionable society became caught between poles of extravagant artificiality and contrived naturalness. It was both the era of the return to natural hair—or, at least, wigs to imitate natural hair—and the most theatrical headdresses seen in the eighteenth century. An insight into the tensions between these two tendencies can be drawn from the analysis of *Les*

Adieux, one of a series of 'fashion plate' engravings entitled *Le Monument du costume*, an impressive entrepreneurial venture that kept a succession of artists in employment between 1774 and 1783. *Les Adieux* was engraved in 1777 by Robert Delaunay after a design by Jean-Michel Moreau le jeune [**62**]. The print gives a remarkable insight to the world of extravagant frippery on the fringes of *ancien régime* court society. It was a world with which Moreau, who as Dessinateur des Menus plaisirs du Roi was responsible for the design of court masquerades and entertainments, was fully conversant.

The engravings of *Le Monument du costume* belonged to a well-worn genre; for over a hundred years Parisian printers had produced a series of fashion plates in an attempt to exploit their city's position as the capital of the European fashion industry. However, these were far from conventional images. Most previous fashion plates featured figures standing in stark isolation posed in attitudes which best exhibited the shapes of the garments. The designers of *Le Monument du costume* showed garments being used within naturalistic settings; each fashion plate took the form of an engaging narrative, the story-line of the first phase of production being drawn from the life of a society beauty before marriage, that of the second phase following her life after marriage.

The print series records a life of inexhaustible leisure. It exudes an

Das Masquen-recht.

61 Daniel Chodowiecki
Masquerade with Rape Scene, etching, 1775

unambiguously aristocratic set of values and a certain permissive moral code. Designed as a set of light-hearted moral commentaries on the life of fashion, the series was aimed at the more reflective purchaser of expensive garments who aspired to social graces beyond the grasp of gaudy *nouveaux riches* consumers. Some narratives appear to endorse and glamorize an existence which revolved around the self-indulgent pursuit of sensory pleasure and the consumption of exceedingly expensive luxury products.

Such a defence of Parisian high society consumerism was rendered necessary by recent social developments. At the time the *Monument du costume* series was being produced the styles of clothing and the mode of life which it promoted were drawing considerable public criticism both at home and abroad. A number of Parisian lampoon prints published at the juncture of the seventh and eighth decade of the century give memorable expression to this reaction against the excesses of the fashion industry and fashionable society itself. These lampoons are typified by a splendid print which captures the moment when the vast head-dress of a lady of fashion catches fire on one of the chandeliers at the Café Royal d'Alexandre (published *c*.1780) [**63**]. Members of Parisian high society had, to some degree, been driven to these excesses in order to differentiate themselves from their perceived social inferiors. An assortment of sensationally impressive, thoroughly

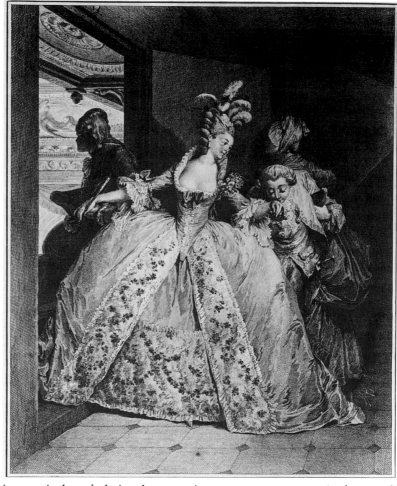

impractical, and obviously expensive garments were required to mark out the genuine élite socialite.

In London a similar process was afoot, as is testified by a number of Reynolds's most flamboyant portraits of London's most notable society figures of the 1770s such as Sir Banastere Tarleton and Lady Worsely. This was the era of the notorious Macaronies who were a veritable godsend to the English comic print industry. The Macaronies shared something of the philosophy of the compilers of the *Monument du costume*; they accepted the broad argument that, if civilized society was by definition to be considered artificial, it followed that embracing extreme artificiality with zest could be considered extremely civilized. Far from being cowed by the criticism of their vanity and effeminacy these young beaux adopted ever more extreme and fanciful attire and deportment. Through his absurd and obvious artificiality the Macaroni intended to single himself out from the mass of society. There were, indeed, a number of English prints produced which show such beaux walking contemptuously through the common streets of

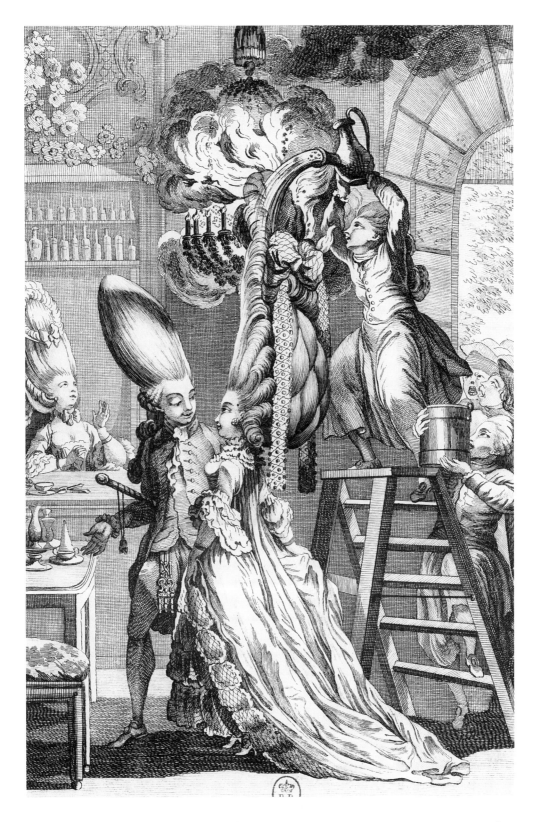

London courting the jeers of the mob.[14] The Macaronies' exaggerated commitment to every excess of Continental fashion signalled their contempt for all bourgeois 'roast beef' notions of plain Protestant decorum. The pious indignation of the throng of hack moral censors whose voices boomed from low-church pulpits and cheap periodicals only increased the delights of their round of theatrical conceits.

At the point when the *Monument du costume* series was being produced, Paris was beginning to lose its position as the unchallenged capital of the European world. French fashion was increasingly tainted in the international market place by the supposition that it was a morally corrosive agency, a threat to those natural virtues upon which the national character of importing nations was considered to be founded. This distaste for French politeness was summarized by Daniel Chodowiecki in a series of twelve etchings made in 1779 which contrasted natural and affected behaviour. In certain respects Chodowiecki, who publicly protested that his industry was motivated by a desire to educate and reform society, set out to be the antitype of French print producers such as Moreau and Delaunay. His stolid disdain for the deceitful frivolities of the masque, which we encountered above, contrasts markedly with the courtly Parisian attitudes of Moreau whose *chef-d'œuvre* was an engraving of the masked ball sponsored by the city of Paris in 1782 to honour Louis XVI and Marie-Antoinette.

Chodowiecki appears to have had a strong personal interest in discouraging over-sophisticated dress and unnatural manners. In 1785 he undertook a project at the behest of the magazine publisher Franz Ehrenberg to design a set of 'natural' attires which could be adopted by those who wished to reform the fashion of the day. His satire of natural and affected behaviour was intended to shame Germans who had forgotten their national instinct of sobriety and self-control and turned to the affected manners, dress, and attitudes of foreigners. The illustration of 'Affectation' in the series [64] features a similarly attired couple to the characters in Moreau's *Les Adieux* (although the head-dress of Chodowiecki's lady is obviously a parody of the type).

Chodowiecki's real targets, however, were the less sophisticated types of French fashion plates and illustrations in French conduct manuals which the publishers of the *Monument du costume* series were seeking to supplant. He was exposing to ridicule those who deemed to tell the rest of Europe how to dress and behave. They are the antithesis of, for instance, L. P. Biotard's illustrations of F. Nivelon's *Rudiments of Genteel Behaviour* (1737), a work which promised readers that, if they imitated a series of starched postures and gestures which the authors recommended, they would find themselves immediately agreeable to high society. Chodowiecki cleverly transformed the formulaic conventions of 'how to do it' manuals into a 'how not to do it' manual.

The vulnerability of this stilted type of fashion plate to parody may well explain the decision of the publishers of the *Monument du costume* series to employ a narrative form. The unsubtle didactic conventions of the traditional Parisian fashion plate and conduct manual were so evidently open to ridicule that the designers of *Le Monument du costume* may well have considered it essential to abandon them. If they were to promote effectively the French fashion industry in a more hostile cultural climate, they would need to explore refreshingly witty alternatives to the hackneyed formula of those who made a commodity of French polite culture.

The erosion of the international authority of the French polite culture—a development which reflected the decline in literate European society's tolerance of flamboyant artifice—left a vacuum into which the culture of France's principal commercial and military opponent expanded. Throughout Europe the English developed a strong reputation for providing the antidote to Gallic affectation and contorted artifice; the English became associated with a certain stylish 'naturalness' which manifested itself in the national demeanour, dress, and taste for landscape. It is this sense of 'naturalness' which Chodowiecki recommends in the first image of *goût* or taste. Everything in the scene—the untrammelled landscape-garden background, loose and modest dress, the natural hair or a more natural type of wig—was to be associated with English fashion. There is, indeed, a striking resemblance between this image and Thomas Gainsborough's (1727–88) well-known portrait of *Mr and Mrs William Hallett* of 1785 [**65**]. Although it is possible that Gainsborough knew of these German prints it is more probable that the artists accidentally accorded in their vision of English virtues.

Many nationalistic German print buyers at this time felt a certain temperamental kinship with the English. Huber and Rost, writers of a popular German handbook on the arts published in 1796, considered that the influence of the natural, sober, and industrious English was to be embraced as an antidote to the 'theatrical affectations' and 'suavity of false graces' promoted by the French. Generations of over-exposure to fashionable artifice had, in their opinion, rendered French painters incapable of sincerity:

If one looks, for instance, at the image of a French woman painted by a French man, one usually finds a forced simpering of expression, the forehead and eyes have no understanding, and throughout no stirring of the spirit is indicated.[15]

Moreau and the designers of the *Monument du costume* series made few concessions to this perception of fashionable French culture. Rather they appear to have responded to the threat by becoming all the more strongly committed to the cultural values under assault. They did their best to confirm all that the sonorous moral commentators had to say

Natur

Affectation

Geschmack
Gout

Geschmack
Gout

64 Daniel Chodowiecki

Natural and Affected Behaviour (second series, 1779), four etchings

The purpose of this print series was to put instructive and entertaining comparison of human behaviour before the public. The innocent virtue of the naked pre-lapsarian couple who gaze at each other lovingly is contrasted with the self-absorbed vanity of a modern fashionable couple who glance around proudly. The prints illustrating *gout* or taste point out the difference between genuine easy grace, in the natural English manner, and the mannerisms of those who feel obliged to make a show of cultivation.

65 Thomas Gainsborough

Mr and Mrs William Hallett (The Morning Walk), oil on canvas, *c*. 1785

about French dress, manners, and printmaking. Far from retrenching and denouncing the 'suavity of false graces' and 'theatrical affectations' the prints celebrated such values with unprecedented panache.

In an era when, as Michael Fried and Angelica Gooden have shown, moralizing French critics were likely to denounce flamboyant theatricality in the visual arts, *Le Monument du costume* was overtly and uncompromisingly theatrical. Indeed, Moreau's *Les Adieux* reflects the sort of close familiarity with the behaviour of theatrical audiences which might be expected of an artist who was trained as a set designer. A gloriously attractive figure dressed in the latest Parisian style stands in the doorway of a theatre box. She is caught between the attentions of competing beaux: one kisses her hand in the dim light of an antechamber behind the theatre box, the other drags her into the glare of the theatre itself. The print's title *Les Adieux*, a rather permanent statement of departure, suggests that the gallantry of the beau in the antechamber is losing out to the assertive pull of his rival.

The young lady not only bids *adieux* to a suitor but also to the world outside the theatre. Moreau's heroine balances between two worlds or levels of reality. Part of her dress has already crossed the threshold into a world of still more beguiling illusions than the one she relinquishes. Although she passes into a brightly lit space from a dim world lit by a single triangular beam of light she does not pass from a sphere of dull 'reality' to a world of fiction. The antechamber in which she is treated to a rather over-theatrical display of bowing gallantry is only marginally less artificial than the world of the stage which she is about to enter. It is a kind of intermediate space which we can assume is symbolic of the world of the *ars amatoria*, a province of self-delusion somewhere between the theatrical and real world. The centrality of the beautiful woman within Moreau's world of appearances accords with a long tradition in Parisian art. As can be seen in Watteau's *L'Embarquement pour Cythère (1720–1)*, an image of the fictional island province of the *ars amatoria*, the world of courting and flirtation was

one in which the female had central authority to accept or reject the wooing lover.

The diligent observer of Moreau's print was engaged in a sophisticated commentary on the concept of *theatrum mundi*. The artist appears to set out to sharpen the viewer's understanding of the urban world of appearances, assisting the viewer in negotiating a polite fashionable world in which the vulnerable senses were habitually deceived and charmed. By appreciating intellectually the delightful complexities of the polite *theatrum mundi* the individual could enter into the

arena of sensual folly without becoming a dupe to his senses. Looking at art, going to the theatre, or, for that matter, dressing up like a fashion plate and going out courting, could be regarded as intellectually respectable activities. As Helen R. Lane has suggested, learning to delight in folly, in particular the follies of love and entering imaginative worlds, became a recognized accomplishment of Parisian 'high' culture in this era.[16] It is significant that this was produced at about the same time as Laclos was writing his famous literary exploration of the hazards of failing to control the game of life and its illusions, *Les Liaisons dangereuses* (first published 1782).

Although the print's title *Les Adieux* is a reference to a particular social encounter it can, with the benefit of historical hindsight, be taken as symbolizing a more general farewell to a set of cultural

67 Elizabeth Vigée Le Brun

Self-Portrait in a Straw Hat (in the guise of Rubens's wife), oil on canvas, after 1782

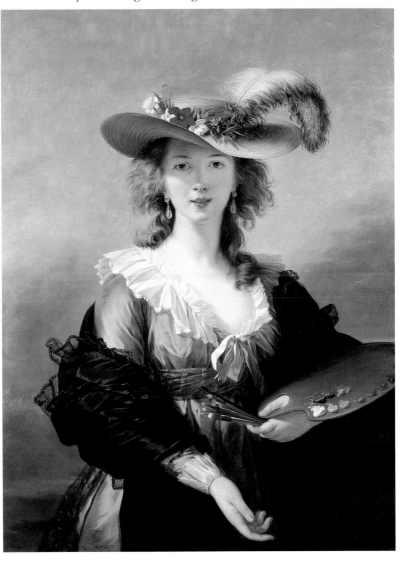

attitudes which were themselves entering a final phase. Within eight years of the publication of *Les Adieux* Moreau was to join in the movement against the artistic values which he had himself perpetuated. On a trip to Rome in 1785 he came into contact with members of the circle of David and immediately began to reform his style. At the Revolution he immediately took the strongest possible republican stance. In the role of ardent revolutionary he produced works whose dour morality was conceived to make full amends for his earlier reputation for playfulness and moral ambivalence. Whether out of genuine artistic conviction or the desire to save his career and, latterly, his neck, Moreau embraced what Robert Rosenblum has described as 'the new moral tenor of the age'.[17]

The Revolution put an end to that particularly feminine world found in *Les Adieux* and the *Monument du costume* series. Since the 1760s the complaint that the moral polity of French civic life had been eroded by the decline of traditional sexual roles, the rise of the dominant woman and the effeminate ineffectual man, had been a familiar topos of Parisian moralizing discourse. Rousseau complained that the whole of Parisian society, in particular that connected with the theatre, had begun to revolve around women. His observation that 'Every woman in Paris gathers in her apartment a harem of men more womanish than she' seems to apply to the world of Moreau's *Les Adieux*.[18] As Sarah Maza and others have shown, there was a strong current of misogyny in Revolutionary and pre-Revolutionary reformist movements. High society ladies were, indeed, held to be the fountain-head of all social corruption.[19] A famous thumbnail sketch of Marie-Antionette on the way to the guillotine usually attributed to David seems to summarize this tendency [66]. Sucking on toothless gums with her hair covered by a simple bonnet the former arbiter of fashion displays a pathetic natural demeanour. All her games of disguise had come to an end and with them the values of an entire generation.

Few felt the wind of change more profoundly than Marie-Antoinette's favourite portraitist Elizabeth Vigée Le Brun. Indeed, she complained in her diary that the Revolution had put an end to a world of stylish and intelligent women which she had come to love. Le Brun's artistic career in exile was, in some respects, dedicated to preserving in images the vestiges of the society celebrated in *Le Monument du costume*. Her very evident fascination with extravagant stylish dress and flamboyant feminine beauty—a preoccupation most completely realized in her portrait of Emma Hamilton—was itself an expression of her conservatism. The famous self-portrait [67] in the guise of 'Rubens's wife' (after 1782), a popular masquerade costume of the day, is a lasting monument to a world of self-confident feminine elegance which was ebbing away under the pressure of moral reform movements a decade before the onset of violent political revolution.

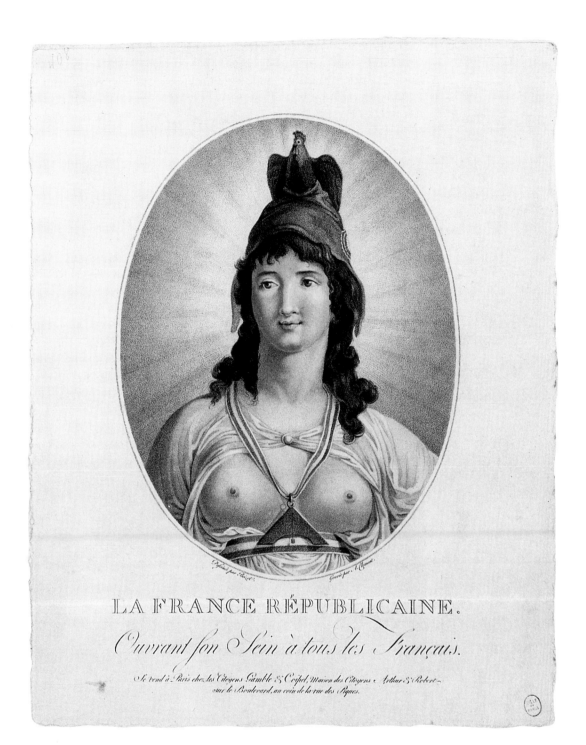

LA FRANCE RÉPUBLICAINE.

Ouvrant son Sein à tous les Français.

Se vend à Paris chez les Citoyens Gamble & Coipel, Maison des Citoyens Arthur & Robert
sur le Boulevard, au coin de la rue des Piques.

The Revolutionary ideologues' distaste for the refined, manipulative, and enigmatic femininity of the *ancien régime* was, to some degree, signified by the invention and veneration of the emblematic patriotic figure depicted by Marianne [**68**]. This feminine symbol of the Republic was envisaged as a strong, healthy young woman dressed in simple classical robes. These robes were usually pulled open to reveal a pair of large healthy breasts with which to suckle the nation. Her bared breast appears to have had few erotic connotations but rather to have functioned as a symbol of open, natural virtue.[20] A similar vision of womanhood appears in David's *Intervention of the Sabine Women* [**1**] in which the patriotic feminine virtue of the Sabine women is expressed through their open gestures and bold presentation of the maternal breast. Such women seem the contrived opposites of those stock types which had become familiar in the art of the preceding generations: the secretive readers of *billets doux*,[21] the enigmatic inhabitants of *fêtes galantes* idly flirting in withdrawn glades, or the gallery of refined ladies who, as the conventional symbolism of feminine caprice dictated, play aimlessly on swings before their hopelessly beguiled suitors.[22]

The tendency to associate the virtue of 'naturalness' with open gestures which transparently communicate a character's purpose or intentions runs throughout David's art and that of many of his pupils. The vigorous outstretched arm of the oath-taker which was first employed in the *Oath of the Horatii* (1785) and reappears in a number of David's major works became a sort of trademark. David strongly associated

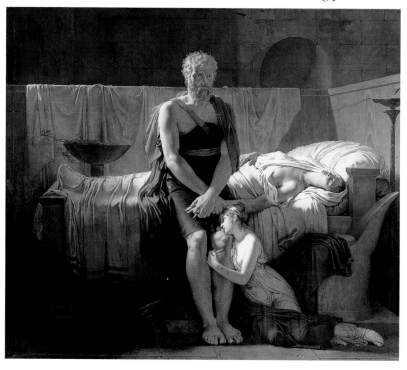

69 Pierre-Narcisse Guérin
The Return of Marcus Sextus, oil on canvas, *c.*1799

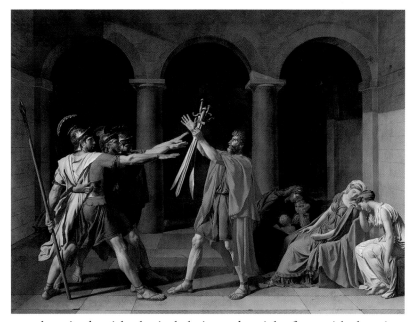

moral rectitude with physical clarity and social reform with the reimposition of visual perspicuity. His whole artistic technique—from the stark clarity of his pictorial spaces and compositions to his rather austere handling of paint—functioned as an emblem of his broader moral agenda. All forms in his mature paintings are clearly apparent, rather than suggestive, emblems of a penetrative vision which ushered obscurity from the material world. He and his pupils frequently used the device of hanging a curtain behind the main focus of the action in their paintings in order to concentrate the mind of the viewer on a single foreground level of fiction. In his *The Return of Marcus Sextus* (1799) P. N. Guérin makes perhaps the most remarkable use of this device. Struck by profound grief at the loss of his wife Guérin's hero exhibits a bold masculine control over his emotions [**69**]. The solemn purity of Guérin's architectural space echoes the sense of masculine dignity and *gravitas* exhibited by the principal object of the viewer's compassion. The world of Guérin's painting was, like that of David's *Oath of the Horatii* [**70**], the province of heroic masculinity. David's architectural environment was, indeed, dominated by a set of columns of the Tuscan Doric order, a primitive architectural form which, free from all luxuriant effeminate decoration, was deemed an appropriate emblem of the rugged masculine martial spirit.

The impulse of late-eighteenth-century reformers to avoid complex illusionistic effects—an aesthetic which has been documented by Robert Rosenblum in his thesis on 'the style of 1800'—was commonly associated with the exercise of masculine virtues. Much as the desire to beguile the senses with illusions or to draw the viewer into willing self-deceit was associated with feminine coquetry, the desire to simplify

spaces and compositions was associated with masculine resolve. As I noted in the last chapter, Carl Fernow explicitly praised the works of Asmus Carstens, who shunned not only complex perspectival effects but also the use of colour, for their 'masculine' character. The late eighteenth-century preoccupation, which we shall discuss fully in the next chapter, with reinjecting a spirit of raw primitive virility into the visual arts played a major role in turning European art culture away from its preoccupation with exploring the intriguing barriers between fiction and reality.

Levels of sight: moral myopia, prurient curiosity and penetrative vision

Moreau's *Les Adieux* bears witness to the conventional belief that the person of refined manners and education should be able to demonstrate a sophisticated awareness of distinctions between the fictional and the actual. The ability to make such distinctions was regarded as a necessary accomplishment of the learned and discerning in polite society throughout Europe. In this sense the engraving has much in common with a roughly contemporary painting by the Spanish painter Luis Paret y Alcazar (1747–99) which shows the interior of a shop selling luxuries, trifles, and accessories for masque balls (painted for the Infanta Don Lois in 1772) [**71**]. Paret's witty composition was designed to poke fun at the vanity of the wealthy leisured Madrid society which he as a prosperous court painter had the financial means to inhabit. All those visiting the shop appear to enjoy the experience of dressing up: one woman delights in her own reflection, another attired in the type of dress worn on gala days inspects a jewelled comb. The seated gentleman in the foreground is presented as somewhat of a poseur; he is dressed in a French-style embroidered suit, the front of which is bedecked with a type of frogging that was frequently denounced as a beau extravagance.

Whilst Paret was clearly indulging in a critique of human vanity and folly, his tone is by no means harsh. Indeed, it is doubtful whether he is suggesting that society should avoid such excesses. Like Moreau he appears to have thrived on the role of the fashionable courtier and to have been given responsibility for the design of court entertainments and masques. He was at one point exiled on a charge of having procured fancy women for Carlos III's younger brother. That he himself aspired to the life-style which he gently censured can be determined from his fine portrait of his wife wearing just such extravagant attire. Far from denouncing this life-style, his painting demonstrates the advantages of forming a refined awareness of the pitfalls of luxury and artifice. This attitude allowed those engaging in this idle world of make-believe to enjoy their conceits, or to 'find pleasure in being deceived'. Paret's sophisticated engagement with the world of appear-

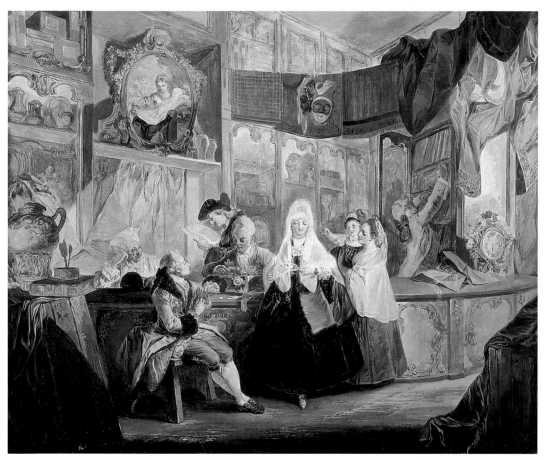

71 Luis Paret y Alcazar
The Antique Trinket Shop,
oil on panel, 1772

ances can be compared with the dark suspicion of artifice encountered in the work of Goya, one of his direct successors as Bourbon court painter. The comparison reveals not only a strong difference in personal vision but also a hardening ethical attitude to disguise and caprice in 'enlightened' Spanish society.

It does not seem that when designing *Les Adieux* Moreau was as morally indulgent or unreservedly permissive as his Spanish contemporary. An element within the engraving implies a chastening awareness that those who played such polite games inhabiteda province of privilege. Lurking in the shadows behind themagnificently attired focus of our attention is another young woman. This is probably the ladies' maid who has been dressed in her best clothes to accompany her mistress for the evening. Unlikely to be allowed to enjoy the performance with her mistress, the maid uses the opportunity of the hold-up in the doorway to gain a fleeting glance of the glittering world of the theatre beyond.

In his *Masked Figures with Fruit Seller* (*c.*1760) Pietro Longhi makes a similar point [**72**]. A masked couple in their dominoes who have probably recently left the theatre walk past oblivious to a young fruit-

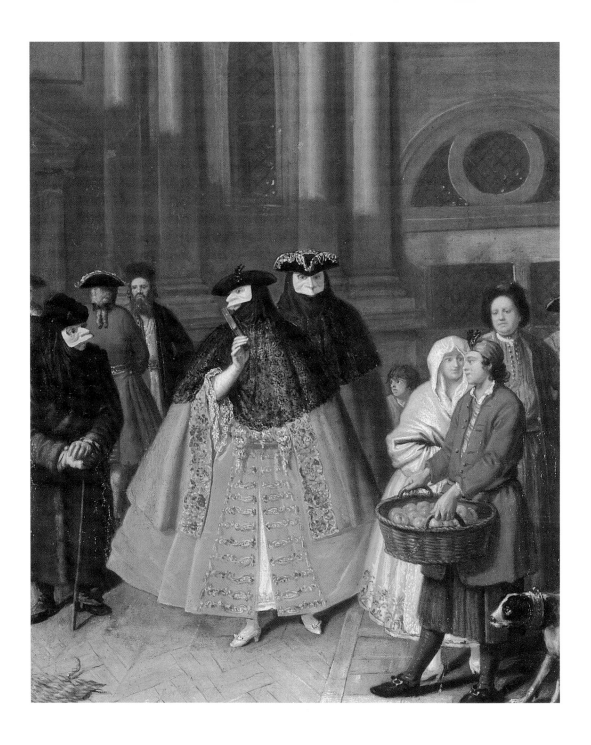

seller. The boy, who sports a decorated gold turban, has been obliged to dress theatrically to peddle his wares successfully in this theatrical street world. Beside him a dog with sorrowful countenance wearing a large gold collar pushes himself into the picture. This is probably the painter's device for making plain the idea that a golden disguise cannot hide the reality of the apple-seller's pitiful role in the drama of life. Behind the throng the head of a poor street urchin can be glimpsed, a character one degree more miserable and more removed from the fiction. It was an appropriate moral message for the élite of a city of no less than seven major theatres and 850 wig-makers which could be considered the place in Europe where barriers between fiction and reality were most disturbingly and intriguingly blurred.

Longhi's decision to focus this painting on the plight of the fruit-seller was undoubtedly inspired by Gaetano Zompini's book of engraved images of the tradesmen and workmen whose humble endeavours made the great masquerade possible, entitled *L'arti che Vanno per la Vie nella città di Venice* (published 1753) [**73**]. Zompini's engraving of the lamp-man is particularly close in conception. Its inscription reads:

> At night outside the theatres or the ridotto
> I provide light with my lantern;
> I earn the right to go where I want.[23]

Like Longhi's *Fruit Seller*, this image is a sophisticated commentary on the relationship between moral vision and physical sight. The light-bearer allows the masked couple to see but is himself invisible, no more than a vehicle for the light. It was a matter of stimulating irony that the more removed from the theatrical world an individual became, and the less artificial his existence, the more invisible he became socially.

Whilst such images certainly encourage a thoughtful response to the social consequences of the privileged life of elaborate fictions there is no suggestion that they attack the social order itself. As we have already observed, Longhi's was explicitly designed to appeal to the Venetian aristocratic élite. His *Fruit Seller* neither subverted the social order nor condemned the theatrical conceits of fashionable Venetian life. It merely suggested that such games should not be played at the expense of the fundamental values of Christian charity. A cynic might observe that such nods toward moral responsibility allowed the games of life to be played with conscience intact.

Probably the most sophisticated commentary on the artifice of street life is Watteau's famous sign for the shop of the picture dealer E.-F. Gersaint (1720–1) [**74**]. It is a measure of the influence of this painting, which was known widely through engravings, that it provided the inspiration for Paret's picture [**71**] which was painted some fifty years later. Watteau placed a similar group of 'fashion

De notte ora ai teatri, ora al Redutto
Son quel che col feral serve de lume;
E pur che i paga mi so andar per tutto.

7

victims' in the foreground of his composition. They seem to be involved in the purchase of some sort of vanity box or cosmetics case and to have become engrossed in the sight of their own reflections in a mirror which has been set up for them on the shop counter.

By placing a group such as this in a shop selling paintings Watteau creates an intriguing sense of the incongruous. However, looked at with more philosophical 'penetration', it appears that such a group is far from out of place in a painting shop. His witty device sets up a critique on a certain type of painter and those inclined to purchase his flattering illusions. Indeed, flattering or mechanical portraitists were often dismissively referred to as 'face painters' and the practice of applying cosmetics commonly described as 'face painting'. The specific

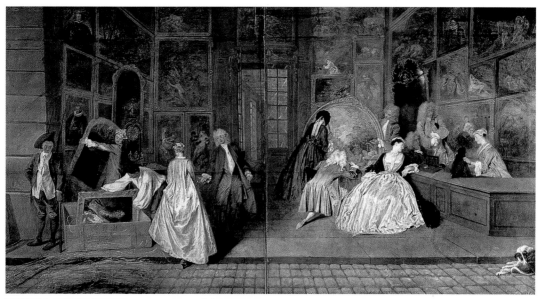

74 Jean-Antoine Watteau

The Shop Sign of Gersaint,
oil on canvas, 1720–1

postures of the group immediately behind this vain coterie suggest that Watteau saw more than one type of false connoisseurship at work in the Paris of his day. A man and woman closely inspect a large painting which would be best observed from a distance. Significantly the attentions of the male pedant are focused on a group of naked nymphs frolicking in the undergrowth, indicating his 'curiosity' has base, lecherous undertones. Watteau's use of this image may well reflect his knowledge of demanding academic texts such as Niceron's *La Perspective curieuse* (1638) which maintains that looking at a picture from an appropriate distance is 'the key to the confusion—the way of viewing the object which shows one its intelligible properties'.[24] His witty conceit is self-consciously erudite and exclusive, intended only for such viewers as had an awareness of the theoretical debate concerning artistic imitation.

In this painting Watteau overtly committed himself to the view that the world of fictions is inherently superior to that of modern-day urban life. The common reality of Paris is represented by the street outside the shop which forms the foreground of the painting, the 'real' space in which the illusion of the shop sign was originally to be observed. Here a dog finds his own form of base reality by chasing a flea, and a scruffy bored young porter, an individual obviously outside the realm of polite learning, stares around vacantly expressing no interest in the glorious world of fiction within. For the more sophisticated type of potential customer the message of the shop sign was obvious, though expressed in the most decorous of commercial terms—'Come in! the world of the street you now occupy is inferior to the world of art you can now enter.'

Johann Zoffany's famous painting of the *Tribuna* at the Uffizi (1772–8), a painting similarly devoted to the representation of a group

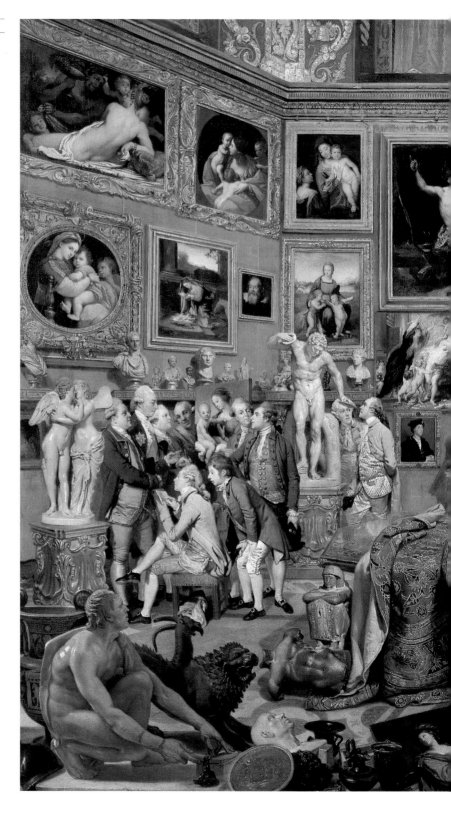

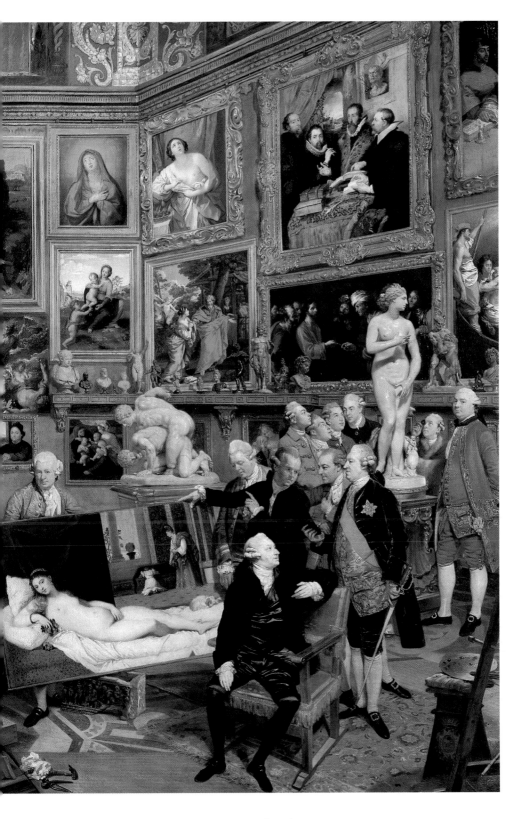

of connoisseurs looking at art, also invites viewers to rethink their attitudes to illusion and fiction [**75**]. At the edge of his composition Zoffany included the popular device of the man staring at the object of his interest through an eyeglass. It is in the hand of a wealthy young connoisseur, a certain Mr Wilbrahams, who, pressed against the wall at the left-hand corner, closely inspects the surface of the statue of the Venus de Milo. Wilbraham's interest appears to be not entirely elevated. It is probably no coincidence that the figure standing in front of him looking out of the canvas and gesticulating towards the Venus was James Bruce, a notorious adulterer who was well known in Grand Tour society as 'the terror of married men, and a constant lover'.

The most absorbed groups of connoisseurs gather around works with a contemporary reputation for being of erotic interest. Particular attention is given to Titian's *Venus of Urbino* which also appears in Zoffany's irreverent self-portrait as a monk [**76**] (completed at roughly the same time as the *Tribuna*). An engraving of a clothed Venus of Urbino appears pinned to the wall of Zoffany's studio, a wall which is otherwise draped by a number of contraceptive sheaths. The painter's decision to clothe the Venus was, perhaps, less a gesture of propriety than a commentary on the quality of sex with an eighteenth-century contraceptive.

In the *Tribuna* itself Zoffany appears in far more respectable guise

77 Joshua Reynolds

A Parody on Raphael's School of Athens, oil on canvas, 1751

In this painting completed a year after his arrival in Rome, Reynolds parodied the cultural pretensions of the latest 'gothick' hoard to invade Rome, the gentlemen of the Grand Tour, lampooning the claim of this shambolic group of less-than-perfect physical specimens that they were the true inheritors of the mantle of antique civilization. In the place of Raphael's athletic and venerable figures Reynolds postured the gawky youths, corpulent connoisseurs, myopic antiquarians, and emaciated beaux with whom he associated on the tour. The painting was commissioned by some of those parodied and is somewhat of an 'in joke'. Reynolds's humour kept irreverance within the boundaries of acceptability and was in no way subversive.

pressed against the wall in the far left of the painting holding up a sweet and virtuous image of femininity in the form of Raphael's *Niccolin-Cowper Madonna*. The painter's rather sinister laughing visage implies that a joke is intended. Zoffany's bogus respectability is contrasted with that of Mr Wilbrahams who appears in the exact equivalent position on the right. This gesture of mock piety was probably intended to bring a smile to the face of those 'insiders' who were intimate enough with the painter to grasp his rather decadent sense of humour. It belongs to a genre of comical images of groups of English connoisseurs on the grand tour which we shall encounter later in the form of Joshua Reynolds's lampoon of Raphael's *School of Athens* (1751) [**77**].

Commissioned by Queen Charlotte (consort to George III of England), a woman with a reputation for being anything but a libertine, the *Tribuna* may very well play the ultimate game of appearances. It seems to be a wholly upright image of worthy virtuosity but contains an encoded piece of gentleman's club humour to which the worthy patroness was expected to be entirely oblivious. She might not have been as naïve as expected. There were reports that the Queen turned against the painting on the grounds that it was 'improper' and refused to have it in her state apartments. Although Horace Walpole suggests that the impropriety was that of crowding the painting with men

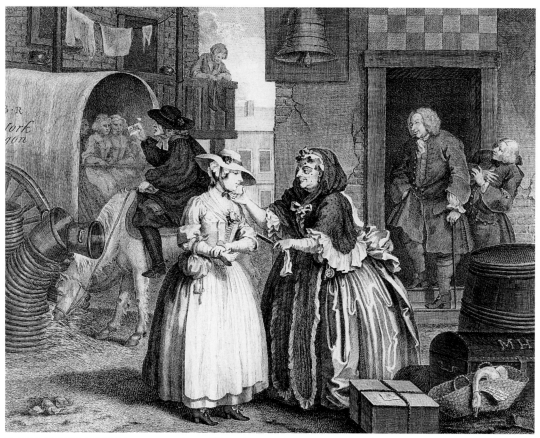

78 William Hogarth:

A Harlot's Progress, plate 1, engraving, *c.*1731

unworthy of Royal attention, it may be that privately she realized the presence of subversive sexual innuendo. If Zoffany did, indeed, hope to indulge in a private joke at the expense of the Queen, who did not pay him sufficiently for his labours on the painting, this can be considered one of the most extraordinary feats of artistic deceit accomplished in this 'age of disguise'.

Zoffany appears to have intended to subvert the 'civic humanist' ideal of the moral utility of artifice. Much as Goya designed his *Los Caprichos* to yield up their elevating moral messages on long reflection, Zoffany appears to reveal his base and debauched levels of meaning only on close inspection. He was by no means the only painter of his day to accept humorously that the painter and connoisseur were fundamentally driven by their sense of prurient erotic 'curiosity'. We shall shortly encounter the same attitude to the process of creation in the work of Thomas Rowlandson. Zoffany's attitude to imitation was, I suggest, much influenced by cultural theories which stressed the generative origins of man's creative drive. He was soon to enter into the patronage of Richard Payne Knight and the Baron D'Harcanville, amateurs who formulated the notion that man's fundamental creative and religious impulses were the by-products of his primitive pro-

creative energies. The harder we (viewers) look into Zoffany's mirror of life and art, the more we discern the earthy primitive impulses which lie behind man's most civilized occupations.

Zoffany was wittily inviting his viewers to rethink their expectations of a type of painting. His *Tribuna* was superficially based upon a well-known form of gallery interior best known through G. P. Pannini's *tour de force* paintings of collections representative of *Ancient and Modern Rome* (1757). Zoffany implanted a level of humorous erotic meaning into a type of image in which an artist was expected to give expression to his elevated reflections on the history of art and civilization. Somewhat sardonically the painter appealed to his viewers' capacity for 'penetration'. Unlike the myopic connoisseur or antiquarian the more searching art lover was expected to look for something beyond the conventions of the genre, the judicious technique, or the dreary formulae of learned allegory.

The concept of the penetrative gaze was already well established at the time Zoffany was painting his *Tribuna*. It had already received its most complete expression in the engravings of William Hogarth. Subscription tickets to Hogarth's *Harlot's* and *Rake's Progress* imply

79 William Hogarth

The Laughing Audience, etching, 1733

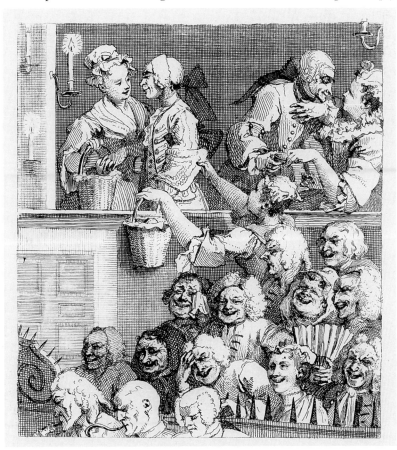

that the artist's prints were intended to be interpreted on a number of distinct levels.[25] This, as Ronald Paulson suggests, probably accorded with Addison's advice that: 'The Story should be such as an ordinary reader may acquiesce in, whatever Natural, Moral or Political Truth may be discovered in it by Men of greater Penetration.' Hogarth's print series were by his own admission commercial schemes intended for the consumption of (to use his own words) 'the public at large'.[26] It is, perhaps, reasonable to posit that he developed several layers of meaning within them—varying from burlesque humour to subtle philosophical reflection—to lend an air of intellectual respectability to populist ventures. The prints of his popular series are certainly peppered with rather sophisticated allusions to the process of seeing. It is probably significant, for instance, that the first print of *Harlot's Progress*, the arrival of the future Harlot in London, contains a direct allusion to the levels of sight [**78**]. The fresh young country girl is procured into service by a haggard old 'Mother Needham' from beneath the nose of a somewhat short-sighted rural cleric. Seated on the back of a horse he studies a letter from the notoriously corrupt Bishop Gibson of London concerning a potential preferment.[27] He is as oblivious to the moral perils which threaten those around him as the horse he sits upon which blithely chews on some hay addressing the primary animalistic urge to fill its belly.

In his subscription ticket to the *Rake's Progress* of 1733, an engraving now known as *The Laughing Audience*, Hogarth launched a direct attack on those without the wit to see the distinctions between fiction and reality [**79**]. In so doing he was clearly addressing his print series at those with the cultivation and perceptive intelligence to see the more sophisticated abstract points which lay behind his superficially engaging fictions. The general mass of Hogarth's audience appear to be of the 'middling sort' who laugh in an unattractively raucous manner, showing themselves to be over-involved in the fiction which they witness. Indeed, as many contemporary English conduct manuals advised, laughing with the mouth wide open was to be avoided in the name of good taste.

Hogarth's image explores the distinction between a polite public and a mob. Forgetting all polite sense of decorum his crowd threaten to become a common rabble. The spikes dividing audience from orchestra—devices which were generally installed to prevent rioters attacking the actors—act as a reminder of their potential savagery. Such exhibitions of savagery were depicted as the inevitable consequence of the coarser elements of the public's inability to acknowledge that a play was only a fiction. Above the raucous mass appear two refined, or by implication over-refined, noblemen who take the advantage of the moment of hilarity to molest the girls selling refreshments. These depraved gentlemen show the opposite failing to the audience as a

80 Francis Hayman

The See-Saw, oil on canvas, 1741–2

This painting is one of a series which the manager of Vauxhall Pleasure Gardens, Jonathan Tyers commissioned from prominent members of the St Martin's Lane circle, most notably Hayman and Hogarth. They were intended as decorations for the interiors of supper boxes in which visitors to the gardens dined. Like a number of other paintings in the series *The See-Saw* was designed to alert its viewers to the frailty of human life and the transience of youth and joy. The see-saw acted as a metaphor of the precarious and unstable in life and the ruins around hinted at the vanity of man's attempts to create permanent grandeur and security. In their original setting the pictures were probably intended to provide a sobering backdrop for those indulging in the shallow pursuit of pleasure and the comforts of alcohol.

whole. Their inability to enter into a fiction and the spirit of society as a whole demonstrates that they lack the human capacity for 'sympathy', that flux of fellow feeling which was considered to bond a civilized society.

By exhibiting these two extremes Hogarth insinuates that he wishes his own work to fall into neither pitfall. He assumed the classic 'civic humanist' position that the central ethical justification of the manufacture of artifice lay in its capacity to contribute to the perpetuation of a polite and morally elevated civic society. His own agenda appears to have been to produce an elevating fiction which engaged the sympathies of the polite public and, in so doing, improved the moral condition of society as a whole. Indeed in his written works Hogarth actively proclaimed an intention of imitating the effects of morally elevating theatre, in which the audience were drawn into a fiction by their sympathy for the noble and humane sentiments of the characters.

Even in his attitude to illusion Hogarth exhibited his 'anti-Gallican' repulsion for Parisian 'polite' culture. His sharp variance of opinion with artists such as Watteau and Pater, who considered themselves to have fulfilled a useful social function if they produced an engaging intellectual 'diversion', was supremely evident throughout his *œuvre*. Hogarth may, indeed, have been reacting directly against the suggestion put forward by Dubos, who in 1719 had suggested that art operated by its ability to excite strong voyeuristic responses. Dubos argued that man's historical love of spectacles such as gladiatorial shows, cockfights, boxing matches, and gaming was motivated less by 'pity for the suffering of others' than 'a search for emotional occupation'.[28] It followed that, in the opinion of Dubos and his followers, the desire to

look at art works could be legitimately viewed as part of man's amoral search for emotional entertainment or, to put it more colloquially, thrills. By contrast Hogarth emphasized the importance of elevated and elevating fiction, pointing out the dangers of stimulating the emotions without fundamental moral purpose.

Like many of the St Martin's Lane group (which included Francis Hayman, painter of *The See-Saw* [**80**]), Hogarth came to regard art as a moral force to preserve the decorum of a public society which hung continually on the edge of collapse under the influence of cruel and inane spectacle. As noble fictions could help engender the humane sympathies which cemented polite society, so ignoble spectacles could rapidly transform the polite crowd into the bestial mob. In his engraving of *The Cockfight*, a choice of subject perhaps influenced by a desire to oppose Dubos, Hogarth exhibits his oft-stated repulsion at man's tendency to lose his individual judgement when falling prey to the pack instinct [**81**]. All humanity is here degraded by a gross corporate absorption in a low and cruel spectacle. Robbed of their reason by the excitement of the betting and the influence of alcohol, noblemen and respectable bourgeois gentlemen alike are brought down to the level of the street vagabond. Wigs slip, clothing becomes disarrayed, the thin veneer of civilization is lost, and man spontaneously returns to the beastliness inherent in his fallen state.

The print positively overflows with references to the nature of vision. At the centre a blind nobleman stakes his fortune on the outcome of proceedings. In the foreground a couple of bewigged gentlemen in the company of a jockey stare at proceedings through telescopes, their lenses focusing blindly on each other. All around are distributed men whose eyes are glazed or shut, individuals whose blurred vision becomes a mere emblem of their loss of moral focus. Just as polite society was to be led 'by men of greater penetration', those with a capacity to focus their intellects like beams of light passed through a convex lens,[29] the greatest threat of the breakdown of polite society was posed by those with an incapacity to focus.

Hogarth, like many of his European contemporaries, considered man to be at his best in states of quiet individual reflection or sober conviviality. As Michael Fried has pointed out, in his analysis of French art in mid-century, images of industrious states of quiet 'absorption' were highly valued within certain sectors of the Parisian art world.[30] They hold a central importance within the Enlightenment vision of artists such as Chardin and Grueze who, to some degree, shared Hogarth's 'bourgeois' values of industrious moral decorum.

A terracotta bust of Hogarth by his friend, the Huguenot *émigré* Louis François Roubiliac [**82**], shows the artist in just such a contemplative mood. Hogarth is shown as the archetypal man of quietly reflective and incisive vision; his shirt is unbuttoned in the abandon of

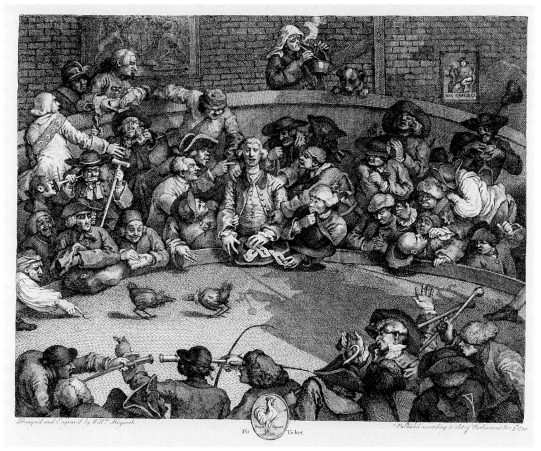

81 William Hogarth

The Cockfight, etching and engraving, 1759

thought, his head clothed in a form of tasselled cloth thinking cap which was conventionally associated with the notion of the scholar in his private study. The bust's posture and expression—that of a man caught at a moment when he had not deemed it necessary to arrange his dress for public presentation—suggest that this was intended as an image of the private face of the public man. To be considered self-aware, over-attentive of 'polite' convention, or not capable of full absorption in one's thoughts and emotions was, as Fried has demonstrated, a considerable insult in certain Enlightenment artistic and critical circles. Such an artist could, in the critical scheme of commentators such as Diderot, be dismissed as the creator of 'unnatural' or 'mannered' works. The ability to overturn tired formulaic convention, to enter sincerely into the emotions of others and encourage one's viewers to do so, was accordingly held to be the sign of 'natural' artistic genius.

Roubiliac shared Hogarth's preoccupation with engaging the more penetrative viewer. Indeed, a review of the monuments in Westminster Abbey in the *Martin's Magazine* of 1759 explicitly extolled Roubiliac's monuments for exhibiting a superior quality of 'penetration' to those of

his rivals. The author implied that the sculptor's images were designed to challenge the hackneyed conventions of genre and to encourage the viewer to look for the philosophical meanings which lay behind the formulaic visual language of mourning and fame. His major monuments were designed for the perusal of the sophisticated viewer who sought something beyond the 'unmeaning'—a term popular in St Martin's Lane circles—formulae of art.[31]

Roubiliac looked to undermine the hackneyed world of conventional symbols employed by contemporary sculptors, symbols which they extracted, like dress patterns from fashion plates, in fashionable textbooks such as Caesare Ripa's *Iconologia*. His use of allegory and fiction required more than the pedant gaze of the 'curious' connoisseur who prided himself on his 'judgement' or taste in matters of art. On the contrary he appears in many of his most important works to have required his viewers to forget that they were beholding a mere piece of artifice.

Roubiliac's treatment of the grief of mourning widows within funerary sculpture is particularly revealing. His central objective appears to have been to produce the strong sensation of sincere and abandoned grief. The importance he attached to this aesthetic objective can only be understood with reference to contemporary social context; there being a literary convention in mid-eighteenth-century European literature of making the insincere grieving widow the butt of all jokes about feminine insincerity.[32] Indeed, the crocodile tears of a widow who was considered to have only grieved in accordance with her public obligation to serve a period of mourning had become a veritable symbol of human insincerity itself.

In his monument to the antiquarian George Lynn (Southwick, Northamptonshire, 1760) Roubiliac set out to create an image of something other than decorous public grief [**83**]. He placed the highly realistic image of his grieving widow on the floor level in front of the monument. In so doing he created the powerful illusion that the widow is on a separate level of reality to the monument itself; a level of fiction somewhere between that of the spectator and the conventional world of art. It is a device that invites the viewer to feel an empathy with the sorrow of the bereaved which was neither sought nor attained in the works of his contemporaries. In more orthodox monuments, such as Scheemakers's, Delvaux's, and Plummier's monument to the first Duke of Buckingham (erected in Westminster Abbey *c.*1722), the sculptured image of the grieving widow had been placed in the same fictional plane as the rest of the monument [**84**]. The latter type of imagery encouraged a more detached response, requiring of the spectator no more than a formal acknowledgement that the widow portrayed had expressed her social duty to honour her husband's memory.[33]

82 Louis François Roubiliac

Bust of William Hogarth, terracotta, *c.*1741

Roubiliac's desire to encourage an empathic response implies that he approved of the idea that viewers should become totally involved in an artistic illusion or lose their desire to draw a firm distinction between reality and fiction. If we assume that Roubiliac shared Hogarth's 'civic humanist' convictions as to the capacity of artifice to preserve the moral fabric of society, we can posit that he considered that society as a whole benefited from the stimulation of the generous humane instinct to share in the virtuous grief of another. To encourage such sympathetic emotions appears to have been considered a justifiable pretext for playing tricks upon his spectators' senses; for temporarily disengaging that sense of perceptual discretion that was held to be essential to the maintenance of polite society.

This notion that the civilized 'public' was constantly in danger of tipping over the edge into states of abject indignity and moral degradation continued to have a strong influence within the late eighteenth- and early nineteenth-century British comic art tradition. Like Hogarth, Thomas Rowlandson became fascinated by reflections on the acute instability of public society. His also is an imaginative world of toppling chairs and spectacular collapses. Unlike his predecessor,

83 Louis François Roubiliac

Monument to George Lynn, Southwick Church, Northants., 1760

84 Peter Scheemakers, Delvaux, and Plummier

Monument to the first Duke of Buckingham, Henry VII Chapel, Westminster Abbey, c.1722

however, Rowlandson does not appear to have entertained many worthy suppositions of the capacity of art to act as a moral balancing agent. Although Rowlandson can be described as a moral commentator, there is little in the biographical anecdotes of his life to suggest that he would have had any cohesive reformist agenda. While this contrast between the two great masters of the British comic tradition may be put down to differences in temperament, it may also reflect a broader shift in social attitudes. The absence of a clear sense of moral mission in Rowlandson's work can be taken as evidence of the gradual erosion of mid-eighteenth-century civic humanist assumptions in the field of British satirical art in the final decades of that century.

Rowlandson's views on the capacity of art to elevate society may be gleaned from his amusing image of a gathering of London's polite society at Somerset House, the venue for the Royal Academy exhibition at the time (*c.*1800). We witness the polite company falling unceremoniously down the spiral staircase whilst attempting to reach an art exhibition. Ascending the stairs in search of a civilizing experience they find themselves being stripped of their clothing and with it the most basic attributes of their dignity. Entitled *The Exhibition 'Stare' Case*, the drawing focuses on the tendency of lecherous old men, one of whom bears a prying eyeglass, to stare at young women in places of public entertainment [**85**]. Rowlandson focuses on the simple pun between the words 'stare' and 'stair' in order that he might squeeze some further

humour out of a familiar joke. The public, as dozens of contemporary images and literary descriptions of art exhibitions assert, attended such events primarily to look at each other rather than the paintings. Far from elevating the moral consciousness of the public, the exhibition of art was seen to provide just another forum in which the crowd could indulge their base voyeuristic impulses.[34]

The image of the 'stare' case is both moralistic and reminiscent of superior quality French erotic art with which Rowlandson may well have become familiar during his early artistic training in Paris. It closely resembles Nicolas Ponce's *L'Enlèvement Nocturne* (*c.*1780) in which a couple of eloping girls are seen to fall into an intriguing state of spontaneous undress as they descend the ladder to sexual freedom [**86**]. That Rowlandson's work had such indecent influences was reflected in the persistent criticism that he received for his alleged moral depravity. Whether Rowlandson deserved such criticism remains uncertain for he became a master of moral ambivalence. In his image of the 'stare case' he appears to invite his viewers to question their motivations for looking at art. We the viewers remain unsure as to whether we are asked to share in the voyeuristic delights of the occasion or to reflect upon the moral failings of society at large. It is, indeed, likely that Rowlandson would have been more sympathetic to viewers of the former persuasion than the latter. He was, as the title of his print of 1800 *Buck's Beauty and Rowlandson's Connoisseur* [**58**] intimates, refreshingly

willing to admit that his art attracted the perusal of 'dirty old men' who entertained no grand ideas of 'civic humanist' nobility of purpose.

Confronting the 'common' illusionist: magic lantern men, quacks, charlatans, magicians, and alchemists

The final section of this chapter will be devoted to a brief analysis of the European art world's preoccupation with the subject of 'common' and spurious illusion: images of magic lantern men, puppeteers, fairground entertainers, magicians, and alchemists. The belief that 'common' or ill-educated people could be recognized by the ease with which they were duped by unsophisticated illusions and crass, formulaic tricks of the senses had a strong impact on the history of art throughout this period. In the late seventeenth century art commentators began to place much store on the notion that the 'common people' were dupes to their senses. Indeed, the absence of a capacity for discerning the fundamental concepts which were assumed to lie behind the confusing ephemera of sensual experience became a defining sign of commonness and stupidity. Perceiving the threat to the grand classical tradition of painting posed by the popularity amongst connoisseurs of Dutch 'naturalist' works, the late seventeenth-century 'classicist', G. P. Bellori devoted his attention to demonstrating the association between the tastes of the 'common people' and 'naturalism'. In his *Le vite de pittori, scultori, et architettori moderni* of 1672 he argued that:[35]

The common people refer everything they see to the visual sense. They praise things painted naturally, being used to such things; appreciate beautiful colours, not beautiful forms, which they do not understand; tire of elegance and approve of novelty; disdain reason, follow opinion, and walk away from the truth in art, on which, as on its own base, the most noble monument of the idea is based.[36]

Such views continued to have an impact long after the heat of the late seventeenth-century academic controversy between the 'naturalists' and 'classicists' had dissipated. In the mid-1730s James Ralph, a hack journalist and playwright and influential member of the St Martin's Lane coterie, expressed very similar ideas. His contempt for low naturalism caused him passionately to condemn the Dean and Chapter of Westminster Abbey for their practice of exhibiting waxworks of famous deceased persons. In a popular series of newspaper articles on the buildings and monuments of London and Westminster (published 1734–6) which were explicitly designed to raise the polite London public's awareness of the visual arts Ralph recommends the figures be 'demolish'd' without hesitation.[37]

In the first place, therefore, with all submission to better judgements, I think they are ridiculous and unnatural in themselves, expressing neither figure like

KING WILLIAM III (1650-1702)
AND
QUEEN MARY II (1662-94)
Buried in the Chapel of Henry VII

statuary, nor colour like painting: secondly, I am humbly in the opinion that they would become a puppet shew better than a church, as making a mere farce of what would seem to be great and solemn: and, thirdly, I think them highly injurious to the characters which they represent, as shewing them like jointed babies, to the stupid admiration of the vulgar, and the contempt of men of sense; instead of characterising their persons, and perpetuating their virtues.

In Ralph's opinion the exhibition of wax figures turned the tour of the Abbey, during which the 'polite' individual was expected to indulge in a conventional set of reflections upon the nature of true nobility and mortality of the flesh, into a trip to the fairground. He complained particularly about the recently completed wax models of King William and Queen Mary [**87**]. Highly realistic images of such august figures were deemed to have lessened the mystique of royalty. Unlike the marble monument with its complex fictive conventions, a wax model presented the great national 'worthy' in a disconcertingly mortal light. Low realism not only appealed to the 'vulgar' but also vulgarized national society, threatening that sense of the innate superiority of the court élite upon which the social order was founded.

By highlighting 'the stupid admiration of the vulgar' Ralph aggrandized himself by implication. His own admiration for complex fictions identified him as part of a polite intelligentsia. It was for similar reasons that painters and connoisseurs of this period came to enjoy jokes at the expense of itinerant magic lantern men who made their living bearing portable slide shows and peep-hole contraptions around the villages and provincial towns of Europe. Lampoons of magic lantern shows in which rustics, savages, or children are shown in crass amazement at the sight of cheap illusions appear in the art of most European countries at this time. Indeed, the fact that they were among the most enduringly popular subjects of eighteenth-century art is a good indication of the urgency with which artists and art consumers approached the task of differentiating themselves from the 'vulgar'.

In many such images the lantern show's viewers are compared; each individual revealing the extent of their social gaucherie by their degree of amazement at the sight of some crude illusion. In a print of 1778 concerning the imposition of the notorious Tea Tax in America, Carle Guttenberg depicted the female personifications of the four continents watching a magic lantern show. The more 'civilized' continents of Europe and Asia react calmly to the show whilst Africa and America, commonly regarded as the homelands of less advanced civilizations, start back in stupefaction. The Dresden artist Johann Eleazar Zeissig (1736–1806) employed a similar joke in *The Magic Lantern* of 1765 [**88**]. Here the artist explores the effect of a rural magic lantern show upon a group of country children. The display fails to impress the older children, who are probably used to such experiences. It does, however,

greatly disturb their younger siblings whose distress is only exceeded by
that of a dog who barks furiously at the illuminated wall.

Significantly Zeissig's lantern show appears to be a ridiculously
melodramatic display of rank superstition; an old maid taken for a
witch is dragged off to hell by an assortment of demons. The print
appears to function as an intellectual play on the concept of enlighten-
ment. We witness a scene of spurious enlightenment; the physical
illumination of the dark barn is presented as anything but a philosoph-
ically enlightening experience. The scientifically produced modern
magic of cheap illusion is depicted as the medium through which belief
in insidious ancient forms of magic are perpetuated in rural back-
waters. It should be remembered that Enlightenment opinion had
only recently put an end to the practice of witch-burning in the

German-speaking world. Any attempt to rekindle such retrogressive superstitions within rural communities could be considered thoroughly contrary to the values of modern enlightened civilization.

By parodying the magic lantern man artists could define exactly the type of character with which they did not want to be confused. These grubby peripatetics functioned as convenient antitypes around which artists could articulate their role in society. Their task of supplying cheap sensory thrills to viewers who lacked urbane sophistication could be starkly contrasted with the self-appointed role of members of the emerging art professions as the providers of elevating and sophisticated images to polite urban publics. Magic lantern men were to the art professions what travelling quacks with their spurious patent medicines were to respectable representatives of the medical establishment. A reflection of this sort probably lies behind Pietro Longhi's satirical painting of a quack who attracts attention to his spurious love potions

with the assistance of a puppet show [**89**]. In his contempt for the quack—a man whose spurious curatives can only be sold with the aid of histrionic showmanship—Longhi covertly declares his own professional aspirations to be recognized as the producer of sophisticated and genuinely efficacious illusions.

Watteau's attitude to magic lantern men, who are the subject of four surviving chalk studies, was rather more ambivalent. One drawing, in particular, seems to take a positively sympathetic view of such humble showmen. Watteau's figure, who labours beneath the weight of his portable equipment, appears to pause on his journey and look directly at the draughtsman. The eyes of two illusion-makers embarking upon entirely different paths of life meet for a poignant moment [**90**]. A similar melancholy expression haunts Watteau's more famous image of *Gilles* or *Pierrot* (1718–19) [**91**]. As characters disporting themselves with a donkey behind him indicate, Gilles was also accustomed to acting as the butt of the jokes of more sophisticated and intelligent men. Both the magic lantern man and burlesque comic performer were forced to play the conventional role of the simpleton whose function is to make everyone else feel clever.

Watteau's image of Gilles or Pierrot is intended to communicate, as Dora Panofsky was first to demonstrate, the painter's sense of professional kinship.[38] Both the painter and the comedic actor in this conventional guise share the common role of 'the ape of nature'. This identification between the artist and the tragi-comic performers and acrobats of the *commedia dell'arte* was, as we have already seen in the analysis of Tiepolo's fascination with the figure of Punchinello, a strong trend in mid-eighteenth-century art. As Elizabeth Vigée Le Brun hints in a nostalgic passage in her diaries when she recalls parties in her carefree youth when the painter Hubert Robert (1733–1808) entertained all present with imitations of *commedia dell'arte* acrobats, it was part of a playful, diversionary tradition of art which finally became redundant in the era of the Revolution.

A highly persuasive socio-historical explanation of the rise of this trend in early eighteenth-century Paris has been provided by Thomas Crow in the opening chapters of *Painters and Public Life*. Crow explains the process by which professional Italian *commedia dell'arte* banned from performing in polite Parisian theatres set up a rival street theatre which so captivated the imagination of the polite public that it caused it to desert the officially endorsed comedy and opera. This precipitated an unprecedented blurring of the distinctions between élite and popular culture. Thus, an officially marginalized tradition was socially legitimized, becoming a valid source of inspiration for the artistic meditations of highly sophisticated 'high culture' artists such as Watteau and his master Gillot. The formulaic mimetic displays of *Commedia dell'arte* performances became the focus of highly refined

meditations on the relationship between fiction and artifice which were assuming a new significance within leisured civic society.

The melancholy air of Watteau's Gilles or Pierrot reminds us that it was intended to be construed as a *vanitas*, a self-imposed reminder of the inherent foolishness of attempting to construct illusory imitations of nature. There is a measure of irony in the fact that by formally acknowledging his foolishness he intended to make it clear to his viewers that he thought deeply about his role as an artist. The artist's formal acknowledgements of the inherent futility of imitation played an important role in the struggle for social status in early and mid-eighteenth-century France. Figures such as Watteau and Chardin realized that if their art was to be taken seriously by philosophically literate minds they would have to stress the fact that they intended to achieve something more cerebrally demanding than a reproduction of the base visual impressions of 'nature'.

It was to satisfy the more intellectually demanding viewer that Chardin twice included a painting known as *The Chemist in his Laboratory* amongst the still lives and genre scenes he submitted to Salon exhibitions. The importance of the painting in articulating Chardin's public image can be discerned from the fact that it was first exhibited at the revived Salon of 1737, a premier opportunity for an artist to influence the way in which the 'public' construed his art. It would seem likely that Chardin, whom Diderot described as 'the greatest magician of his age' on account of his unrivalled ability to conjure up astoundingly realistic illusions, was attempting to make a sophisticated commentary on the relationship of painting to magic.[39]

The painting was undoubtedly intended to be construed as a *vanitas* on the theme of the relationship of the art of the painter to the futile machinations of the alchemist. An engraving was produced by Lépicié in 1744 under the title *Le Souffleur* or *The Alchemist* and advertised as being an image of 'an alchemist in his laboratory attentively reading his book on alchemy' [92]. A later review of the picture revealed that the model for the alchemist was Chardin's friend Joseph Aved (1702–66), a portrait painter who had spent a period of his life in Holland studying the work of the Dutch 'naturalists' and built his career around a reputation for startling mimetic skills. The inscription to the print read:

> Despite your steady vigils,
> And this vain paraphernalia of chemical science
> You could well find at the bottom of your retorts
> Misery and despair.

The philosophical quest of the alchemist and the painter could be equated; like the alchemist who sought to turn base metal into gold, the painter sought to turn the base chemicals of paint into an image of nature itself. The alchemist was, in the rational enlightenment vision

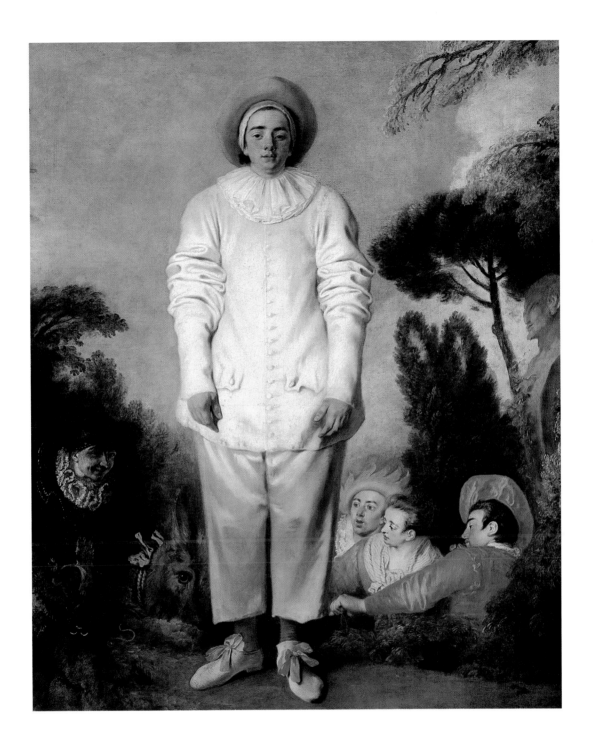

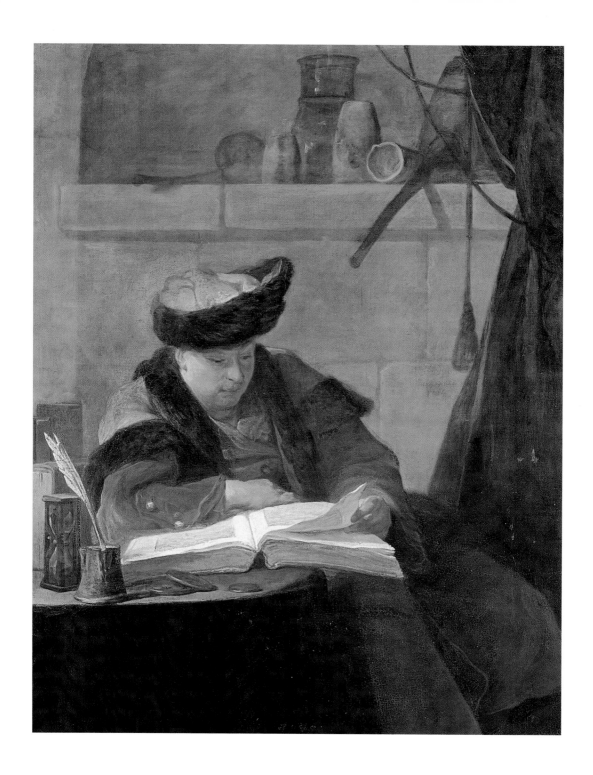

200 'AND 'TIS IN VAIN TO FIND FAULTS IN THE ARTS OF DECEIVING…'

of his science, doomed to quest for the unobtainable. Similarly, the artist familiar with classical aphorism, *ars longa et vita brevis*, was aware that his search to master the mysteries of nature was in itself little else but a mortifying reminder of the futility of human ambitions. The painting reminds one of Chardin's favourite aphorism, 'Painting is an island whose shores I have skirted.'

Three years after the first exhibition of *Le Soufleur* Chardin played a similar game with the Salon public by exhibiting a painting of *The Monkey Painter*, a reference to the antique criticism that the base illusionist painter was naught but the 'ape of nature'. He also exhibited a pendant image of *The Monkey Antiquarian* [**93**] who peers at the world through the familiar lens of the pedant philosopher. The purpose of exhibiting these paintings along with an assortment of still lives and genre scenes was presumably to appeal to those of the Salon crowd who took a discerning interest in the theory of painting and connoisseurship. As Crow informs us, the 'magic realism' of Chardin's works tended to amaze the bulk of the public.[40] Naturally this led élitist critics to associate his form of naturalism with the mundane tastes of the 'third estate'. Chardin may well have been attempting to counter this perception of his work. Whilst amazing the crowd with his still-life illusions he appealed beyond the level of common understanding to those of more 'penetrative' intelligence who would see the deeper meanings of his musings on alchemy, curiosity, and imitation.

This period's most oblique and sophisticated commentary on the relationship of the painter's art to that of the magician or alchemist was produced by G. B. Tiepolo. A group of Tiepolo's etchings on matters supernatural which was published posthumously by his son Domenico under the titles *Capricci* and *Scherzi* have enthralled and puzzled twentieth-century art historians.[41] The prints, the date of which is a matter of considerable controversy, have succeeded in dividing scholars into camps: those who insist that Tiepolo had a cogent iconographical agenda; and a majority who argue that the prints defy conventional iconographic analysis. My sympathies are with the latter. Indeed, I believe that those scholars who have attempted to find precise meanings in the etchings have fallen for Tiepolo's humorous ruse.

The point of the etchings is, surely, their pointlessness. Like Chardin's alchemist, the observer is destined to find only 'misery and despair' at the bottom of his 'retorts' to find meaning in the reflections of magicians and alchemists. The world of imaginative caprice is subtly defined as the world of folly. Although the prints are superficially packed with profound symbols of human vanity—burning skulls, broken monumental statuary, skeletons in debate, Eastern magicians in enigmatic huddles—we are destined to find no clear meaning in them [**94**]. The prints are at once meaningful and meaningless. It is probably significant that Tiepolo intended the frontispiece to the

etchings to be an image of owls huddling around an ancient inscription tablet; owls being at this date a symbol with dichotomous inflections, capable of being employed in some circumstances as an emblem of wisdom and in others as an emblem of foolishness.

Tiepolo subscribed to a tradition within Italian art in which the artist's role as creator of imaginative worlds was obliquely identified with that of the conjuror or magician. The *Capricci* and *Scherzi* owe much in form and technique to the influence of Salvator Rosa whose dabblings in black magic and alchemy were well known and explicitly associated with his 'savage' preternatural fecundity of imagination [**95**]. Although Tiepolo appears to have shared Chardin's belief that magic was a form of mortifying folly we can assume that, in other respects, his attitudes to magic were at sharp variance to those which would have been acceptable in Parisian Enlightenment circles. We can, I suggest, assume that Tiepolo shared the belief of the orthodox Venetian theolo-

93 Jean-Baptiste Chardin
The Monkey Antiquarian,
oil on canvas, 1740

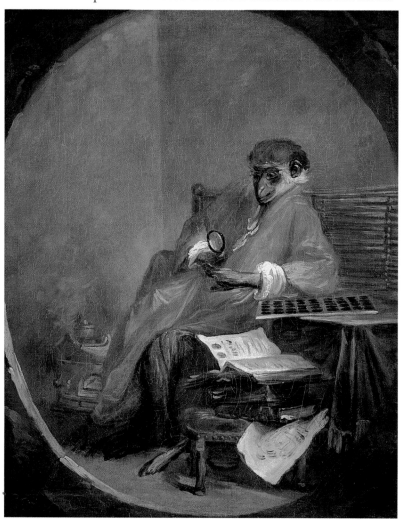

Magician and Others Looking at a Burning Pyre with a Man's Head (from *Vari Capricci*), etching, published 1785

gians of his day, that magicians really did exist and the world really did have a supernatural realm.[42] Tiepolo appears to have been a devout and somewhat conservative Catholic. Thus he was probably inclined to ascribe to the argument of orthodox Venetian theologians that, if belief in the miraculous world of the New Testament was not to be undermined, it must be acknowledged that magic continued to play a part in contemporary life. It is probably significant that the *Capricci* and *Scherzi* series include numerous images of wizards though no images of witches; this conforms to the arguments of orthodox Venetian theologians that wizards, though not witches, had a real existence.

It was probably because of this trend in Venetian theology that supernatural speculations became 'chic' amongst that city's polite classes long before the rise of 'counter-Enlightenment' occultism in the rest of Europe. As Focillon has pointed out, the phenomenon of fashionable occultism arose in Venice long before the era of 'Casanova's mystifications'. This precipitated strenuous attempts among Venice's

more progressive or 'enlightened' community, most notably the Marchese Maffei and his circle, to counter the culture of superstition. Whilst acknowledging that Tiepolo's creative intentions are formidably obscure, I tend towards the belief that he was more likely to have taken the part of those who indulged in fashionable meditations on the supernatural rather than 'enlightened' sceptics such as Maffei.

The rise of fashionable occultism and Freemasonic mystery cults in the final three decades of the eighteenth century had a major effect on the development of the discourse concerning the relationship of artistry and magic. Throughout Europe, but particularly in France, Britain, and Sweden, a significant proportion of the community of painters, sculptors, and architects were drawn into speculative freemasonic cults and magic circles. The effects of the cultural movement were almost as profound on those who did not partake in it as those that did. It is clear, for instance, that Goya, who took the orthodox Enlightenment stance that belief in supernatural phenomena was a retrogressive social phenomenon, was forced to harden his rationalist position by the apparent credulity of his supposedly educated contemporaries. He appears to have regarded the occultist preoccupation of polite Spanish society with unmitigated contempt. Throughout his *œuvre* magic is firmly identified with rustic gaucherie, deformed primitive barbarity, and demeaning sexual licentiousness.

As Goya's treatment of the occult indicates, occultism was a fad that was far from universally admired. In the late eighteenth century British artists who became heavily identified with supernatural cults were likely to become the subject of the ridicule of at least some part of the public. The level-headed James Northcote was not alone in laughing at the miniature painter Richard Cosway's (1742-1821) apparently limitless credulity:

He believed in Swedenborgianism, he believed in animal magnetism; he conversed with more than one person of the Trinity; he could talk to a lady at Mantua through some fine vehicle of sense, as we speak to a servant downstairs through a conduit pipe.[43]

Itinerant charlatan showmen such as Guiseppi Balsamo, the self-appointed Comte de Cagliostro and Franz Anton Mesmer (1734-1815) never completely shook off the taint of public disrepute which had formerly been reserved for travelling quacks and magic lantern men. The painter and stage-set designer Philippe De Loutherbourg's (1740-1812) well-publicized association with the freemasonic cult of Cagliostro, whom he followed into exile in 1786, did very little for the artist's public reputation in Britain. Nevertheless he had already succeeded in popularizing his own form of spectacular magic show. His famous *Eidophusikon* in London's Lisle Street (established 1781), a form of 'pre-cinematic' entertainment in which moving images were projected from

a newly invented incandescent cylinder onto a small screen. Through this technology De Loutherbourg produced phantasmagoric illusions which astonished the city.[44]

De Loutherbourg's objectives were certainly not to facilitate his public's ability to make calm and rational distinctions between illusion and reality. On the contrary, he set out to terrify, bemuse, and disconcert. Towards this end he chose to conjure up a series of terrifying apocalyptic visions, scenes from Milton, awesome cataracts, and bemusing fogs. Such visions, accompanied by a range of realistic sound effects, caused members of the most urbane London audiences to run out of the theatre in panic. By improving the technology of illusion he was able to shatter the comfortable Enlightenment presumption of men such as Zeissig that supernatural light-shows were beneath the contempt of civilized society and only capable of deceiving the senses of the most naïve of rural children and animals.

A number of late eighteenth-century artists who became heavily involved in speculative forms of Freemasonry appear to have set out to overturn the belief that it was possible and desirable to maintain a firm rational control over the imagination and senses. In some late eighteenth-century social circles it would have been positively *recherché* to produce art which strongly upheld man's capacity for rational discernment. The court of Gustav III of Sweden, a king who publicly paraded with a gold box around his neck containing a magic powder to ward off evil spirits, was just such an environment. Like the majority of important Swedish courtiers of this era the artist L. J. Desprez became a fervent adept of occultist Freemasonry.[45] It was from his association with the dark world of Freemasonic theory, in particular that of Cagliostro the 'self-proclaimed Grand Coptha of Egyptian Rite', that he drew his abiding fascination with Egyptian mysteries and dark subterranean vaults. One such ancient vaulted structure appears in his extraordinary etching of the bizarre Chimera, a beast reported to have inhabited the Numidian palace of Masinissa in the second century BC whose very name defines the concept of the illusive and wildly fantastical [**96**]. Desprez's creation of such a terrifying monster might well have been designed to contradict Voltaire's famous assertion that the 'moderns' should no longer be interested in mythical beasts.[46]

This print can also be interpreted as a commentary on the nature of artistic invention. As Abrams has pointed out in *The Mirror and the Lamp*, the ability to construct Chimera became a sign of the artistic genius's capacity for 'combination'. The chimera became a veritable emblem of the 'concept of the inventive process in its boldest flights'. For some commentators the production of such monsters was the province of such geniuses whose imagination had run riot and, like the diabolic conjuror, had lost all sense of the moral responsibility which ought to accompany the exercise of creative fancy. Alexander Gerard

95 Salvator Rosa

Democritus in Meditation,
etching with dry point, 1662

Rosa's imaginative etchings
proved highly collectable in
the eighteenth century and
were very influential, appealing
to artists as diverse as G.B.
Tiepelo and Wright of Derby.
The *Democritus* was no
exception, becoming the
definitive image of the concept
of contemplative melancholy.
The etching, which was based
on a painting completed a
decade before, is inscribed
with the gloomy lines,
'Democritus, the mocker of
all things, is transfixed by the
end of all things'.

Democritus omnium derisor
in omnium fine defigitur

Salvator Rosa Inu: fecit

declared that such fictions were the production of 'incorrect and irregular artists':

As an animal body will become monstrous, though it has all its essential members, if one part is to be transferred to the place of another, so a poem will become perfectly disagreeable and fantastical, by the transposition of its parts. A dislocation destroys the vigour of any member of the body and unfits it for proper function.

97 Francisco Goya

*The Sleep of Reason
Produces Monsters* (from *Los
Caprichos*, 1799, no. 43),
etching and aquatint

By flying in the face of those such as Gerard who believed the function of the artist was to create an agreeable harmony, Desprez embraced the role of the deviant magician or alchemist who combines disparate elements in search of mystical solutions. His chimera was the production of a sort of creative magic which could not be confined by the demands of moral responsibility. Although some contemporaries considered the talents of Goya and Desprez comparable, their attitudes to magic and fantasy were profoundly different. Goya strongly maintained the Enlightenment tradition that fancy needed to be firmly regulated by the exercise of reason. Impossible monsters appear in his art as the products of deranged imagination and a threat to civilized order. The chimerical, like the magical, could be associated with the 'sick' elements of society. Goya's important *Caprichos* no. 42, entitled *The Sleep of Reason Produces Monsters* [**97**], dealt directly with the capacity of the mind to create chimeras. As Goya himself explained, the print showed a state of mind in which: 'Imagination deserted by reason, begets impossible monsters. United with Reason she is the mother of all arts, and the source of all wonders.' As George Levitine has noted, the print probably draws its inspiration from a poem composed by the artist's

friend Thomas Iriarte which accompanied the latter's translation of Horace's *Ars Poetica*.[47] In this verse the painter who sought to make Chimera was dismissed as a public laughing stock, an individual 'whose substantial ideas resemble the dreams of delirious sick men'.

In the particular case of Goya and his 'enlightened' circle it is possible to detect a strong belief in the absolute difference between the rational imagination and magical or superstitious fancy. In the widest perspective, however, Goya was espousing a minority cause. Many of his European contemporaries saw no real distinctions between these spheres of thought. Late eighteenth-century European thought was to some extent characterized by a strong conviction that it was possible to unite the rational and the mystical intelligence. It was the era of men such as Lavater, divine and progenitor of the pseudo-science of human physiognomy, and Swedenborg, an engineer turned mystic.

Part of the attraction of Freemasonic and occultist ideas to persons of intellectual discernment—men such as the French architect Éti-enne-Louis Boullée (1728–99) and the sculptor Jean-Anton Houdon (1741–1828)—was that they were engrafted onto well-respected scientific and rationalist doctrines. Well before the rise of Mesmer and Cagliostro, Freemasonry had come to rely upon the potent fusion between the rational and the mystic. The individual most commonly associated with the foundation of speculative freemasonry in Britain, John Theophilus Desaguliers (1683–1744) was also a prominent academic in the field of natural philosophy and ardent promoter of Newtonian precepts. Similarly Boullée, whose most famous work was his design for a cenotaph to Newton, was both an enthusiastic occultist Freemason and the author of a learned text on the theory of solids and their effects on the senses. Some of these theories appear to have been put into practice in the design for the cenotaph to Newton in which Boullée explores the sensory impact of placing a vast elemental sphere in a flat landscape. The design intended to inspire that sense of metaphysical awe which can be generated by the experience of the fundamental physical concepts of natural law; it lends a profound sense of supernatural mystery to a celebration of the material and the 'natural'.

Boullée probably first encountered occultist Freemasonry through meetings with Count Cagliostro at the Lodge of the Seven Sisters, a Lodge with which Voltaire and a number of other prominent *philosophes* had been associated. It was at this Lodge that Voltaire and Cagliostro met Jean-Anton Houdon who produced their most notable sculptural portraits. A comparison of these works provides an interesting point of reflection. Houdon generally depicted Voltaire looking quizzically toward the viewer; this unforgettable relaxed wry expression is frequently described as 'the smile of reason'. There could, indeed, be no better sculptural illustration of the concept of 'penetration': Voltaire sees through the distracting flotsam of human experience to a

higher philosophical truth and smiles knowingly at the folly of life [**98**]. Houdon's image of Cagliostro (1786), by contrast, looks away from the world of humanity towards some higher reality which lurks in the ether. His unbuttoned negligence of personal appearance, a sartorial state revealing elevated contemplative genius, denotes that he too is worthy of being considered a meditative philosopher. Indeed, the very fact that the bust is inscribed CAGLIOSTRO, at a date when the fraudulence of Balsamo's claim to nobility was common knowledge, suggests that Houdon, like De Loutherbourg, maintained through adversity his confidence in the trickster's claims to special insight [**99**]. Despite glaring disparities in their philosophical outlook, Houdon was ready to give public credence to both men's claims to greatness. The admiration of one did not preclude that of the other; they are simply considered to exhibit a different type or level of philosophical insight.

This apparent combination of opposites also occurs in the artistic personality of Joseph Wright of Derby (1734–97), who was a prominent amateur scientist associated with the Lunar society as well as an enthusiastic speculative Freemason. The fascinating blend of these philosophical outlooks has its most extraordinary manifestation in his masterpiece of 1771, *The Alchymist in Search of the Philosopher's Stone, Discovers Phosphorous, and Prays for the Successful Conclusion of his Operation* [**100**]. Wright clearly intended this painting to be viewed in terms of abstract or mystical philosophic concepts rather than as a narrative record of a real or possible event. Although the drama of the event appears to take place in some medieval gothic environment, the painting refers to the discovery of phosphorous which occurred in the year 1676.

Like Zeissig's engraving of the magic lantern show, this painting can be interpreted as an elaborate commentary on the concept of enlightenment. It depicts a moment when, in the midst of his supernatural quest, the alchemist is startled by an extraordinary illumination, a natural phenomenon more amazing than the dreams of magic. Wright conforms to the tendency within speculative Freemasonic circles to regard alchemy as a serious time-honoured field of enquiry. In so doing he shuns the opinion of those in more sceptical rationalist Enlightenment circles who considered alchemy a futile craft rendered redundant by the revelations of modern science. Wright's alchemist is more venerable sage than a figure of fun. The experiments he conducts are far from futile. Indeed, they lead to an important and useful scientific discovery. Even the gothic architecture may reflect a Freemasonic concept of tradition, there being a long tradition within British Freemasonry of venerating the masons of gothic architecture as a race of sage ancient worthies. English gothic masons were considered to have derived their craft directly from traditions

traceable to the Egyptian world of the Masonic patriarchs in which the craft of alchemy was also supposed to have originated.

Wright's understanding of the concept of 'enlightenment' as expressed in this painting is Freemasonic, it recalls the prominent Masonic motto *Lux e Tenebris* (Light out of Darkness). The alchemist's discovery seems to contradict the 'classic' understanding of the concept of enlightenment as put forward a few years later by Immanuel Kant in his essay *What is Enlightenment?* (published 1782). Here Kant famously equates man's progress beyond superstition and irrationality to his 'emergence from his self-incurred immaturity'. Wright's image of the Alchemist suggests that enlightenment and material progress are not to be achieved through the exclusive pursuit of reason. To be enlightened does not demand a dismissive break with the mystical tra-

dition of 'gothick' musings but to have a profound respect for the magical world of the ancients. In reconciling the worlds of magic and science Wright achieved an illusion that is at once an illumination and a mystification.

It has been suggested that Wright's strangely illuminated interiors resemble the illusions attained in contemporary peep shows. The artist is, indeed, known to have had an interest in such devices. Like De Loutherbourg, Wright seems to have set out to satiate the late eighteenth-century urban public's burgeoning appetite for startling illusions, light shows, and camera obscura, rather than oppose it. The two major paintings with which he established his reputation at London's Society of Artists' exhibitions seem to express his interest in the concept of showmanship. *A Philosopher Giving a Lecture on the Orrery* and *An Experiment with a Bird in the Air Pump* both show scientific experiments conducted as a form of intimate lamplit theatre. The artist implicitly cast himself in the role of the showman of natural magic. As Stephen Daniels has argued, these paintings may well reflect the Rosicrucian concept of 'chemical theatre'.[48]

It is significant that Wright's concept of his role as an artist seems to have alienated him from London's academic mainstream. He was never fully accepted into the culture of the Royal Academy. Like his friend John Hamilton Mortimer, he stayed loyal to the Society of Artists until 1778 when it became evident that this rival society was a complete lost cause.[49] The friends seem to have regarded themselves as social outsiders. It is an indication of this shared self-image that when in Italy Wright, like Mortimer, painted a self-portrait in the turbaned guise of 'a captain of the banditti'. In so doing both men identified themselves with Salvator Rosa whose magical and alchemical musings had placed him outside the realm of ordinary society. Wright's central artistic preoccupations, in particular his enjoyment of imaginative caprice and his interest in spectacular light effects and unusual illusions, were not given a central priority by those who managed to assume a controlling influence at the Royal Academy and dictated its theoretical agenda.

Showmanship, the interest in the bizarre and spectacular, continued to be considered outside the realm of serious academic art into the early nineteenth century. Like Wright, John Martin, who succeeded to the tradition of exotic fantasy established by De Loutherbourg, remained an outsider to academic circles. In his evidence to the Select Committee on the arts in 1836 Martin suggested that there had been a conspiracy by an inner-circle at the Academy to marginalize him. He had valid cause for complaint. In a review of the Royal Academy exhibition of 1823 Charles Westmacott (1782–1868), an associate of that inner-circle, penned the following comment on John Martin's *The Pamphian Bower*:

Mr Martin's talent is wholly scenic, and not natural; for, to the lover of nature and correct taste, there cannot be a more offensive style; it is Loutherbourg out-heroded; extravagance run wild. In a theatre or on a glass window [here he presumably refers to the transparencies commonly employed to illuminate London shops of the period] we might palliate such gaudy effects but in an Academy . . . it cannot be too severely censured.[50]

Despite his rather haughty and dismissive tone, Westmacott was perceptive enough to recognize the milieu to which Martin's art belonged. Martin, who had, in fact, made a glass shop window advertisement in 1821, owed his immense popularity to an ability to match the mood of sensationalism in a London accustomed to thrills of illuminated entertainments. His work accords with the 'gaudy' sensational atmosphere of street entertainment captured in Thomas Rowlandson and A. C. Pugin's *Bartholomew Fair* (1808) than a Royal Academy exhibition [**101**].

Aware that his art jarred with certain notions of academic respectability, Martin chose to exhibit the majority of his works at the more liberal British Institution and at London's most popularist exhibition venue, William Bullock's Egyptian Hall in Piccadilly. As its very name suggests, the Egyptian Hall set out to match the thrills of an exotic bazaar. The name may well have been borrowed from a Freemasonic extravaganza at Fonthill Abbey in Wiltshire designed by De Loutherbourg in 1781 for William Beckford, the purchaser of *The Pamphian Bower*. At Bullock's Egyptian Hall Martin's paintings could, somewhat appropriately, be seen in a forum that came to resemble an 'up-market' fairground at which vast crowds could view a selection of wondrous natural history curios and sensational ethnographic displays.

Although Martin's critics accused him of being a popularist, it would be simplistic to classify him as such today. He had admirers at court and amongst the ranks of the most celebrated cognoscenti. Thomas Hope, fashionable society's most conspicuous promoter of chaste classicism who shared Beckford's taste for bizarre *exoticisme*, was prompted to buy one of Martin's early works. (Although Hope was sufficiently élitist to abandon his interest in Martin after the artist had become internationally famous.) Martin, like De Loutherbourg and Wright, strayed into a world of bazaar showmanship which jarred with certain conventional notions of professional respectability. However, like his predecessors, he did not appear intentionally to have cut himself off from all circles of aristocratic connoisseurs and patrons. All three found quarters of polite society in which their work was appreciated.

This was, in a sense, their most conspicuous achievement. They had the pure artistic talent to bring a brand of illusionistic sensationalism which lay on the fringes of polite society into the consideration of

101 Thomas Rowlandson & A. C. Pugin

Bartholomew Fair, aquatint from Rudolph Ackermann, *Microcosm of London*, 1808–10

'high' cultural circles. The world of peep-shows, phantasmagoria, bazaar or 'curious' *exoticisme* and gas-lit entertainment was re-explored by those whose majestic technical command inevitably brought admirers in the most elevated circles. Parallels can be drawn between this artistic development and that which Crow observed in early eighteenth-century Paris where artists drew inspiration from a type of *commedia dell'arte* spectacle which had begun to transcend the barriers between 'low' and 'high' culture.

Charles Westmacott's attempts firmly to classify Martin's bizarre illusionism as something outside the realms of serious academic art strikes a familiar note. His equation of sensationalism with the common people broadly echoes the comments of G. P. Bellori and James Ralph quoted at the beginning of this section. He too subscribed to the belief that only a polite élite aspired to understand the fundamental intellectual concepts upon which art in its highest form was based; concepts which the common populace, in their crass desire to indulge their visual senses, remained unable to grasp. Westmacott, the half-brother of a sculptor who was one of Britain's premier exponents of purist classical academicism, was, like Bellori, protecting a vested interest. He was attempting to eject from the pantheon those artists whose thrilling illusionism had begun to engage a world of elevated connoisseurship in which he and his family and associates wished to

hold sway. That Martin and De Loutherbourg had appealed to a connoisseur such as Thomas Hope, whom Westmacott profoundly admired, only accentuated the need to convince the world that they were not 'real' artists.

The tendency to associate the sensual thrill of illusion with the tastes of the naïve or uncultivated became, if anything, more marked in the late eighteenth and early nineteenth century than it had been in the eras of Bellori and Ralph. 'Real' works of art were increasingly identified as objects which stimulated the more exalted realms of the imagination rather than exhibited the artist's mimetic gifts. Canova, for instance, felt positively insulted if his figures were considered to appear palpably alive. A visitor to his studio who declared that the figure of *Hebe* (1795–8) seemed to be on the point of flight was tartly informed that:

I do not aim my works at deceiving the beholder; we know that they are marble—mute and immobile . . . if my work were indeed taken for reality, it would no longer be regarded as a work of art . . . I would wish to excite the fancy only, not deceive the eye.[51]

An ethos of exclusivity ran throughout late eighteenth- and early nineteenth-century high classicism. The movement towards 'anti-illusionism' and 'linear abstractionism'—a movement described in detail by Robert Rosenblum in his thesis on 'the International Style of 1800'—drew some strength from the imperative of re-establishing art as an élite preserve. It was to this end that Thomas Hope, against the will of the artist, tried to limit the circulation of Piroli's engravings of Flaxman's linear illustrations of the *Divine Comedy*. In July 1793 Mrs Flaxman complained to William Hayley that: 'Mr Hope does not mean to make them public, as he wishes to give them away himself to a chosen few, whom he may think from their taste and virtue entitled to them.'[52] It is significant to observe that Hope was preventing not only the distribution but also the sale of the engravings. He seems to have regarded 'high art' of this type as outside the realms of contemporary consumerism. At a time when showmen entrepreneurs were accumulating fortunes from attracting the public to view a range of startling 'pre-cinematic' illusions—the era of the Eidophusikon, the Eidometropolis, the Panorama, and Diorama—the appeal of chaste classical imagery to those who wished to consider themselves above the sordid whirl of material concerns naturally increased. It is an indication of the futility of 'modern' desires to create barriers between 'high' and 'low' culture that this stark form of classicism also became the province of popular taste. As Étienne Delécluze complained in 1835, this 'high' culture style failed to maintain the *cachet* of exclusivity. Even the frieze-like decorations of antique vases initially admired by only the most *avant-garde* connoisseurs such as Thomas

Hope and Sir William Hamilton quickly became the inspiration for popular fashions:

Whatever the case, the fact is that this fad for imitating the ancients caught on, if not with the keenest minds, at least with those who were most energetic and enterprising. The imitative arts, theatre, literature in general, and everything down to the furniture all manifested the furore to imitate first the Romans and, later, the Greeks. It was some time after the Terror that a knowledge of Greek vases—called Etruscan—became more familiar to artists, and it is from just that period that the taste for Greek forms and ornaments dates, and was applied to feminine fashions, the decoration of apartments, and the most common utensils.[53]

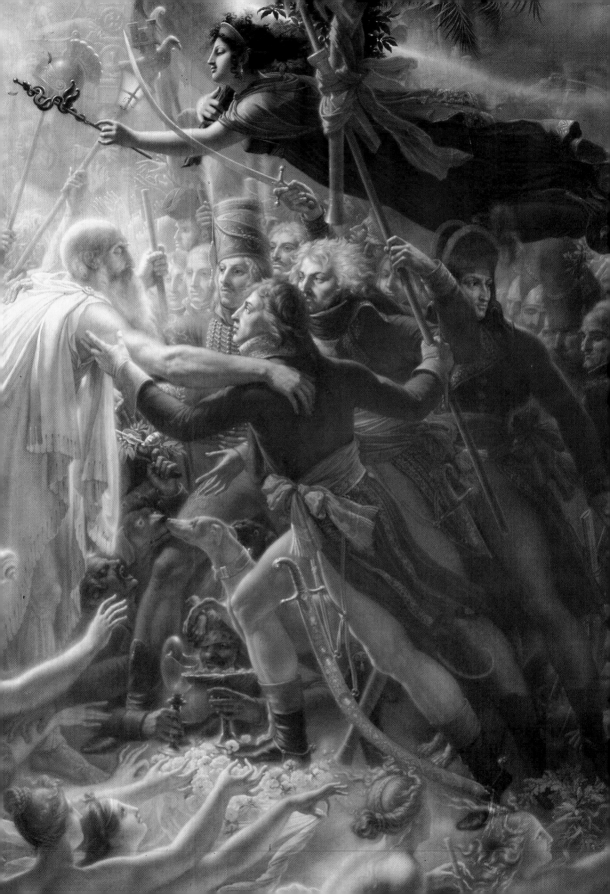

'First Freedom, and then Glory…'

4

This period, in particular its last six decades, witnessed a marked growth in the quantity and sophistication of literary works in which the historical context of artistic achievements was debated.[1] With unprecedented frequency the triumphs and failures of the arts were observed to bear witness to broader historical processes of reform and decline; were cited as a reliable index of the health of national or European society. As Alex Pott's excellent closely argued essay on 'the rise of historicism' in the early nineteenth century makes clear, this was a complex area of discourse embracing many subtle shades of opinion that now demands sophisticated historical analysis.[2] However, the generalization may be safely upheld that most historical writers of this period tended to invest culture with biological characteristics; to believe that civilization developed cyclically from a state of healthy youthfulness towards maturity, decadent old age, and death.

The biological vision of civilization was more than the prevailing historicist theory of cultural change, indeed, it constituted a kind of academic orthodoxy. Intellectual discourse centred less upon questioning the basic validity of the biological model than identifying the mechanisms through which it could be considered to operate. Argument settled upon matters such as determining which political and climactic conditions best favoured the development of supreme artistic cultures or the question of whether the cycle of culture could be expected to weaken in vitality as European civilization progressed from the primitive energy of its antique origins.

The rise of this theory of historical change had major consequences for the actual development of the visual arts. It was no accident that the arrival of this idea in popular consciousness during the 1760s and 1770s broadly coincided with the appearance of those cogent movements for artistic reform which came to characterize late eighteenth-century European artistic culture. Equally European intellectual culture's preoccupation with the visual imagery of decay, congenital contamination, youth, and regeneration was clearly associated with this vision of history. The 'eighteenth-century mind', if such an entity can be deemed to have existed, tended not only to see biological characteristics in the workings of civilization but also to see the state of

Detail of 129

civilization reflected in the biology of the individual, his physical form, posture, bodily functions, and ailments. Similarly, the health of society in the 'private' sphere of family life was, as never before, seen to determine the health of broader public society.

The conception of landscape and cityscape was also profoundly influenced by the rise of this view of history. Prospects of cities and rural life were, with increasing regularity, considered to be a focus for profound reflection on the cycle of history and the viewer's fears for his own inevitable biological decay. On seeing Hubert Robert's paintings of the ruins of Rome and the surrounding 'campagna' in the Salon of 1767 Diderot remarked:

The ideas which ruins awake in me are great. Everything is destroyed, everything perishes, everything passes on. There is only time which endures . . . From whatever point I cast my eye the objects which surround me announce to an end and resign me to the one that awaits me. What is my crumbling being in comparison to this crag that is crumbling, with this valley that is growing deeper, with this forest that is wavering . . . I do not want to die!

Biological theory received its most obvious emblematic expression in cityscapes of Rome which were produced for Grand Tour buyers or by northern European landscape artists studying in the city. Piranesi's printed views of gigantic Roman ruins, the focus for myriad reflections on the demise of civilization, had a particularly strong effect on the northern European imagination. Flaxman, for instance, claimed that he came to Rome with such a strong impression of Piranesi's views on his mind that it had taken him some time to come to terms with the disappointment of encountering the real city.[3] As the Grand Tour developed in the second half of the eighteenth century, the ruins of Rome emerged as a form of universal *vanitas* for the ascendant military and economic powers of northern Europe.

The rise of biological theories of history in art-historical circles was fundamentally associated with the growth in the popularity of the Grand Tour. It was closely connected to the rise of travel literature, in particular the genre of conventional tourist reflections on the supposed collapse of civilization in the Italian peninsula. The most influential literary expressions of the theory were written by northern Europeans who whilst living in Rome had gone through the conventional process of attempting to come to philosophical terms with the shattered fragments of Antiquity. Edward Gibbon's *The History of the Decline and Fall of the Roman Empire* (first volume published 1776) and, in the field of art history, Winckelmann's *The History of Art in Antiquity* (first published 1764) were both conceived in this way. Gibbon informs the readers of his autobiographical memoirs that he was first inspired to write the *Decline and Fall* on a day in October 1764 when the stark comparison between modern Roman society and the colossal Roman

civilization whose shattered city it occupied suddenly became clear to him. He recalled that a shaft of melancholy inspiration came to him 'in the gloom of evening, as I sat musing on the Capitol, while the barefooted fryars were chanting their litanies in the temple of Jupiter...'[4]

Gibbon was not, as we shall see, alone in associating the decline of modern 'Italian' civilization with the depredations of the Catholic Church. During the immediate pre-Revolutionary decades travellers from the Protestant North, and northern European states which were finally breaking the power of the Catholic Church, came increasingly to regard Catholic 'Italy' as a dying civilization. The belief that the cradle of past European society was terminally degenerate was confirmed by the obvious failure of the economies of many modern Italian states. These failures were reflected in the physical decay of Italian cities and the absence of 'improvements' in the countryside. The dramatic contrast between these mouldering sites and the splendid new metropolises and sophisticated agricultural schemes of the northern powers did not escape the attention of travel writers, poets, and landscape painters.

European culture, in the imagination of most writers of art-historical texts in this period, was not considered to rise and fall as a whole. Rather certain parts of Europe, or nation states, were deemed destined to degenerate as others were destined to rise in their stead. The consensus amongst art-historical writers, even those of Italian birth, was that it was the star of Italy and southern Europe as a whole which had sunk. This imaginative conception of Europe, a form of moral geography, had a major, though rather underestimated, influence on the development of the European arts in this period. It certainly gave some theoretical substance to German, French, and British suspicions that they were the fated nations whose time for great artistic achievement had arrived.

The manifest failure of the French Revolutionary experiment of turning society back to what were believed to be the values of the primitive Roman republic punctured certain of the more naïve manifestations of biological theory. A few early nineteenth-century French art commentators, most notably Stendhal and Quatremère de Quincy, turned their backs on the idea that it was either possible or desirable to return art to the forms of Antiquity. The idea of returning to primitive classical precepts failed to appeal both to those who subscribed to the doom-laden apocalyptic vision of European destiny and those who subscribed to the most self-confident and progressive visions of imminent improvement in man's condition. The former urged a return to specifically Christian roots when confronted by the threat of secularism and capitalist modernity. The latter, in their confidence, saw no purpose in blindly aping the achievements of past civilizations. It was

in this confident spirit that Stendhal famously mocked the Davidian use of classical nudity on the basis that modern northern European society had neither the climate nor the social customs to merit an artistic preoccupation with nakedness.

The decline of the belief that society could be returned to the innocence and grandeur of Antiquity did little to erode public confidence in the cyclical conception of history itself. Despite his irreverence for classical revivalists Stendhal continued to think of history as a cyclical process. His greatest work of art history, *L'Histoire de la peintre en Italie* (1811-17), became an influential example of the biological theory at work. The great majority of early nineteenth-century commentators on the history of art in Europe clung on to biological concepts of cultural development. Those who thought in terms of the revival of Christian art and medieval society were often as naïve in their confidence that a primitive past could be recaptured as the French Revolutionaries whom they despised.

The late eighteenth and early nineteenth century brought stark reminders that the recent flourishing of northern European culture might have serious negative effects. Early nineteenth-century northern European society was haunted by the suspicion that it had entered too quickly into the mature phase of its biological cycle. Like an overblown hothouse flower this society was seen to teeter on the edge of sudden disintegration. The horrific events of the Revolutionary and Napoleonic wars were widely interpreted as the consequences of the northern imperial powers having become drunk on the vain prospect of power. Similarly there was a gradual realization that economic and industrial growth might have terrible effects on the physical and moral well-being of society.

The acute sense of culture's contamination, the yearning for primal purity, which had been so important a part of the late eighteenth-century European art world did not abate. On the contrary in some artistic circles it became more pronounced. In Britain it became exceedingly fashionable to indulge in grand reflections on the catastrophic decline of empire. In July 1808, at the height of the Napoleonic conflicts, Benjamin Haydon wrote in his diaries of an imaginary project to erect a colossal figure of Britannia on the cliffs of Dover which would survey France 'with a lofty air'. The statue would symbolize a gigantic and noble enmity similar to the antique rivalry of Carthage and Rome. It would one day stand in ruins as a reminder of the grandeur and spirit of British claims to empire.

Haydon's compatriot J. M. Gandy (1771-1843) produced an accomplished watercolour for the architect Sir John Soane (1753-1837) of the latter's recently erected Bank of England in an imagined future state of ruin. It enabled Soane to appear to be a model architect of sublime philosophical disposition who, above the vanity of his patrons and his

102 J. M. Gandy

Architectural Ruins—A Vision
(*John Soane's Rotunda of the
Bank of England in Ruins*),
watercolour heightened with
white, exhibited 1832

age, entertained no hopes for the permanence of his grandest monuments [**102**]. Although most prevalent in Britain this type of fatalistic fantasy makes its appearance in other European art traditions. Indeed, Gandy may well have been aware of the work of the Parisian painter, Hubert Robert who had probably invented the sub-genre of the anticipated ruin.[5] Some years before in 1796 Robert first exhibited at the Salon a magnificent pair of canvases, one depicting the Great Gallery of the Louvre in all its glory, the other the same gallery in a state of ruin brought about by some unspecified future catastrophe.[6] It was a gloomy vision of man's vain ambition which, perhaps, acted as some sort of consolation to a man who had been imprisoned in the Revolution and lived to see his opponents' brash confidence in social rebirth turn sour.

The American landscapist Thomas Cole's highly impressive cycle of paintings depicting *The Course of Empire* (*c.*1836) belong to the tradition established by Robert. Analysis of the paintings provides a useful insight into some of the social origins of this fascination with dreams of civic desolation [**103**]. Like many former reflections on the rise and fall of civilization the paintings were, at least, partially inspired by an experience of Rome. Cole embarked upon the cycle not long after returning from a grand tour of Europe. A man of pronounced literary bent, Cole chose as his motto a line from Byron's *Childe Harold* (1816), a line which had itself been inspired by the sight of the ruins of antique civilization: 'First freedom, and then glory; when that fails, wealth, vice, corruption.'

In Europe Cole had the opportunity of seeing not only the ruins of

103 Thomas Cole

The Course of Empire: Desolation, oil on canvas, 1836

Rome but also the depredations of nature brought about by the advance of northern European urban capitalism. Returning to America he discovered that even the primitive wilderness of the New World was being despoiled. It was the realization that modern European commercialism had the power to stretch its tentacles to even these virgin worlds which seems more than anything to have inspired him to paint the *Course of Empire* series. In a letter to his friend Luman Reed of 26 March 1836 Cole penned the following lament:

> They are cutting down all the trees in the beautiful valley on which I have looked so often with a loving eye. Tell this to Durand—not that I wish to give him pain, but that I want him to join in with me in maledictions on all dollar-godded utilitarians.[7]

Painting his images of a world passing from *Savage State* to *Consummation* and thence via *Destruction* to *Dissolution* may well have provided Cole with the philosophical consolation that even the machinations of the 'dollar-godded utilitarians' were bound to submit to the grand forces of nature. The biological theory of civilization provided Cole, as it had Martin and Turner before him, with a certain reassuring sense of superior vision. Assuming the stance of the prophet of doom the artist could feel himself more powerful than the politician or industrialist. As the child of nature and monitor of its grand cyclical processes the artist could be considered above the petty follies of materialism and could lay claim to being, in the words of Shelley, 'the unacknowledged legislator of the world'.

The biological conception of art history's entry into public consciousness

It is important to remember that the tendency to see history in general and art history in particular as a biological progression was not new to the eighteenth century. It had been central to Vasari's 'classic' account of Italian Renaissance art, which had a splendid print run throughout Europe in the late eighteenth and early nineteenth century. The importance of the biological model of culture depended not on its intrinsic originality but on the proportion of society which was influenced by it. What had been a matter for solemn reflection in élite intellectual circles was transformed into a hobby-horse of 'public' discourse.

It seems reasonable to suggest that the various revolutions which were considered to have transformed the national schools of the later eighteenth century happened because a broad sector of the public which was literate in matters of art history had come to expect and require reform. This statement does not contradict the arguments of those who maintain that late eighteenth-century European reforms in the arts were the work of particular artistic factions sponsored by identifiable political pressure groups. Thomas Crow's argument, for instance, that the main impetus towards the reform of state- and court-sponsored art in the era of David was generated by particular 'old nobility' reforming factions of government, is not weakened by the contention that such reform only came to fruition because there was a broader art-literate public who had been intellectually primed to welcome it.[8]

The late eighteenth-century French movement against the art of the immediate past was a truly 'public' phenomenon which concerned the whole art market. As the De Goncourt brothers observed, in the late eighteenth century the entire French art market turned with a sort of dismissive disgust against the masters of the first half of the eighteenth century. Art buyers of what the De Goncourts described as 'a dismal epoch of correct taste' attached a derisory value to works which a mere generation before had been considered to be the greatest artistic achievements of the age. Chardin's *Artist at Work* and *The Lace Worker* were bought for a mere forty francs, an autograph replica of La Tour's once famous portrait of Rousseau failed to reach a reserve of just three francs.[9]

A broadening social exposure to literature with an historicist content generated an expectation that a period of demonstrable corruption should rightfully and naturally be followed by the instigation of a new cultural beginning. To some degree art markets and the broader viewing public were primed to expect, or in certain quarters to demand, the emergence of heroic artistic reformers who promised to form the vanguard of regeneration. The *Mercure de France* of October 1781, for

instance, published an exclamatory call to this 'painter destined for immortality' to resist the seductive allure of money and steadfastly strive to acquire greater and more lasting 'delights'.[10] David's role as a stoically minded artistic reformer was, like that of many of his European contemporaries who sought to rejuvenate their national school of art, as much of his public's as his own invention.

The idea that there was a moral revolution in the art world of the late eighteenth century crystallized with time. It was not in the interest of the early nineteenth-century northern European art world in general to place doubt on the idea that such art revolutions had taken place. Even the most discontented heirs did not wish to deny their inheritance. Many of those French commentators whose admiration of David was qualified or who disliked him personally (most notably Delécluze, Stendhal, and Vigée Le Brun) considered that he had been one of the instigators of a much needed reform. To have denied David his role of Hercules cleaning the Augean stables would have been to deny that the whole early nineteenth-century French art tradition which was touched by his influence was representative of a regenerative phase of culture.

Similarly few, if any, European art commentators of the period between 1770 and 1830 were willing to come to the defence of the reputation of François Boucher, whose star was artificially blackened to enhance the light of the new dawn. The biographical details of his life were distorted and moulded to fit the characteristics of the degenerate phase of culture which he was supposed to represent. His work became the very incarnation of degeneracy, visible proof that the French artistic tradition, on a downward spiral since it reached maturity in the age of Louis XIV, had reached its final nadir. Again, the uniform enthusiasm for discrediting Boucher—his work was referred to as a form of poisonous infection by figures as diverse as Barry, Northcote, Huber, and Rost—suggests a broader cultural propensity to welcome proof of the biological process at work.[11]

Those who preached moral revolutions in their national art tradition were not prophets crying in the wilderness. It is difficult to believe that even the strong-willed Denis Diderot would have carried on his ferocious assaults on the character and works of Boucher had his readers been resistant to the creation of a cultural scapegoat. When delivering his twelfth *Discourse* Sir Joshua Reynolds was able to dismiss Boucher, and by implication the entire modern French school he had dominated, with a single, and probably apocryphal, anecdote. He claimed to have met Boucher who had explained that 'when he was young, studying his art, he found it necessary to use models; but had left them off for many years.'[12]

Reynolds needed no long-winded argument to inform his 'public' that Boucher was a frivolous, 'mannered' degenerate no longer con-

cerned with the study of nature. He could presume that his image of the Parisian painter as a universal coxcomb was already fixed in their imagination.

The influence of the biological theory of civilization was out of all proportion to its abstract philosophical worth. As Karl Popper has powerfully argued in his essay on *The Poverty of Historicism*, the historicist tendency to apply biographical or biological characteristics to the analysis of cultures or civilizations is, in abstract philosophical terms, an entirely fallacious thought process.[13] It can, however, be considered to be one of this period's most influential fallacies. By sheer force of repetition the idea assumed the power to alter the actual course of late eighteenth-century art history. The decay and reform which were projected by determinist theory were inevitably put into practice. Historical actuality was made to dance to the tune of historicist myth.

Degeneration and cultural contamination

When, as we observed in the last chapter, Rousseau pronounced that the degeneration of French society in his day was precipitated by the emergence of dominant women and effeminate men he was striking up a somewhat hackneyed tune. Cultural degeneration, as many eighteenth-century moral commentators commonly supposed, originated and expressed itself in a breakdown of the 'natural' roles of the sexes. Some thirty years before Rousseau began to attack the unmotherly traits of the modish Parisian women, Jean Raoux (1667–1734) produced a series of small paintings lauding the virtue of classical maidenhood. The best of these are a comparative pair now at the Musée des Beaux Arts, Lille (1733): one shows a group of simply attired and demure antique vestals surrounded by chaste classical furnishings; the other a group of modern women preening themselves in an opulent boudoir.

Such sentiments were not a French prerogative. In Britain the *Gentleman's Magazine* (first published 1732) printed a fairly consistent stream of moralistic essays on the degeneration of the sex roles. Particular contempt was reserved for those high society mothers who set a bad example to the lower orders by farming their children out to wet nurses, thereby renouncing their motherly duties in order to maintain their position in fashionable society. The most vehement proponent of this cultural theory in British literature was John Brown, a zealously patriotic cleric who resoundingly blamed his country's failure as a military power in the decade following the ignominious Pelhamite Peace of 1748 on the 'effeminacy' of fashionable urban youth.[14] Hogarth, whose City 'patriot' political stance was broadly similar to that of Brown, was clearly influenced by this topos when designing his engraving of *Gin Lane* (pub. 1751) [**104**]. Here the corrupt state of the nation in general, and the city of London in particular, is symbolized by the appalling sight of drunken 'mother gin', a hideous counterpart

GIN LANE

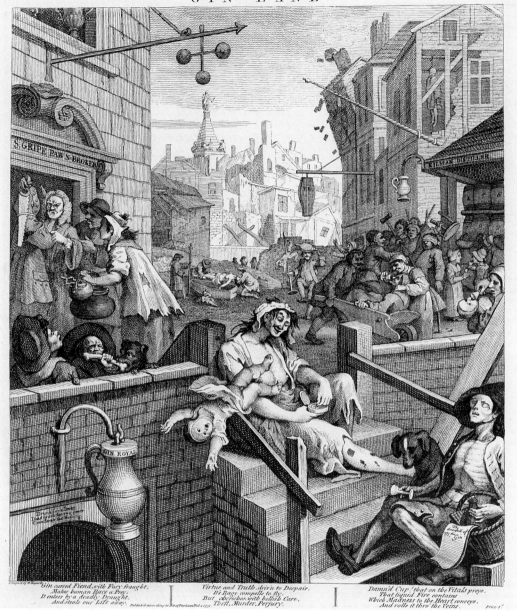

Gin cursed Fiend, with Fury fraught,
Makes human Race a Prey.
It enters by a deadly Draught,
And steals our Life away.

Virtue and Truth, driv'n to Despair,
It's Rage compells to fly,
But cherishes with hellish Care.
Theft, Murder, Perjury.

Damn'd Cup! that on the Vitals preys,
That liquid Fire contains,
Which Madness to the Heart conveys,
And rolls it thro' the Veins.

to the healthful and firm-breasted emblematic figure of mother nature, dropping her child from her distended breast down the side of a flight of steps.

It was, however, in French culture of moral reform during and immediately before the Revolution that the notion of the nation being founded on healthy family values reached its apogee. A highly didactic aquatint by Louis Philibert Debucourt (1755–1832) entitled *Paternal Pleasures*, the first proofs of which were produced shortly before the Revolution, shows that ideal state of domestic harmony upon which the nation's health was founded [**105**]. Debucourt's print is a modernized version of the traditional theme of the three ages of man. A vigorous father with his hunting dog embraced by his dutiful wife looks on whilst a fond grandfather bounces their child on his knee. Ever the good businessman, Debucourt, who like J. Moreau le Jeune turned from courtier to radical revolutionary, altered the print to suit new republican styles of dress. The print in its altered state conformed to

105 Louis Philibert Debucourt

Paternal Pleasures, aquatint, c.1792

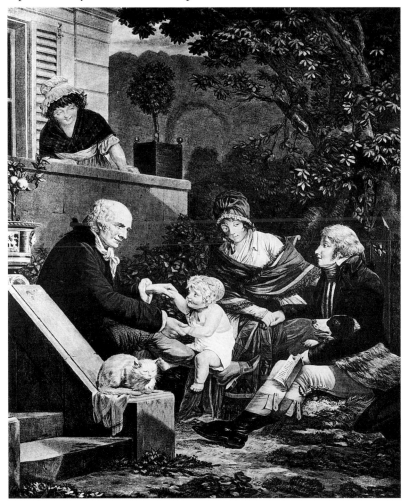

106 Claude-Nicolas Ledoux

Oikema, 1780–1804
(from C. N. Ledoux,
*L'architecture considerée
sous le rapport de l'art*,
vol. I, 1804)

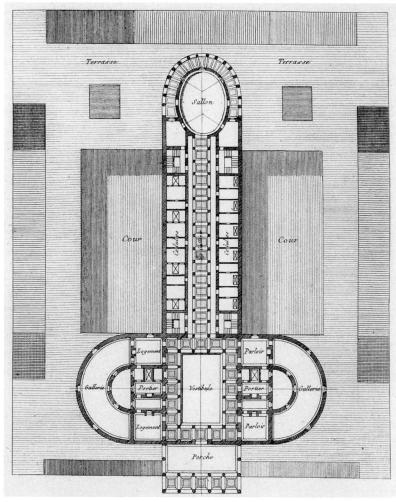

the artist's pledge, delivered in a document entitled *L'Almanach national dédié aux amis de la constitution* (1791), to turn all his talents to promoting the ideology of the Revolution.

The French reformist demand for a civic society in which each citizen conformed to the 'natural' or appropriate behaviour expected of their sex and age was seldom more completely expressed than in Claude-Nicolas Ledoux's (1736–1806) utopian designs for an *Ideal City at Chaux* (1780–1804). Ledoux's design reflected a cultural tendency, explored in some detail by Richard Sennet, to associate the dirtiness and spatial disorder of established urban environments with states of moral degeneration.[15] Ledoux's aesthetic broadly conformed with that of David who, as we saw in the last chapter, associated the imposition of spatial purity and perspicuity with the process of moral reform. Ledoux, like David, associated openness with cultural cleanliness. Accordingly his ideal city was to be situated on a plain of a mountainous region so that purifying mountain winds might permanently

cleanse it of foul air. Unlike Rome which many contemporaries believed had been gradually enfeebled by a build up of stagnant and unhealthy air emanating from its ancient subterranean vaults and undrained marshes, the City of Chaux was given every chance of avoiding terminal contamination.[16]

A vast sexually segregated complex of public baths was designed to stand in woodland at the city's centre. Supplied with salt water this would function to purge the community of corrupting illnesses. On the outside of the town was to be situated a phallic-shaped temple called the *Oikema* [106]. This was designed as a form of purifying brothel where the young men of the city might be exposed to the full range of virile pleasures in order that they might settle comfortably into stolid procreative marriages in later life. Indeed, civic buildings throughout the ideal city were to be designed to encourage the population to celebrate each stage in the cycle of life: birth, arrival at manhood, marriage, and death.

Ledoux appears to have been profoundly influenced by the Roman conception of death as contamination.[17] Conforming to the city's general standards of hygiene (but against the general practice of the age) the dead were to be cremated rather than inhumed. The ashes of citizens were to be exhibited in a catacomb. Here, in the spirit of *égalité*, each deposit was to be accorded equal significance. The sight of the smoke of cremation was to act as a moral symbol for the community. To use Ledoux's own words: 'The dead are purified to excite the living to virtue.' It was as if the proper observation of the pattern of life and death and the purifying disposal of the dead might avert society's contamination. By preventing Chaux's citizens from carrying from one generation to another their stock of physical corruption Ledoux halted or, at least, retarded the 'natural' tendency of his new civilization to pass biologically into states of ripe maturity and decay.

Despite the fact that Ledoux was placed in prison as a counter-revolutionary, many of his basic ideas were in harmony with the Revolutionary moral agenda. The idea of cremation appealed strongly to the Revolutionary mentality. Jules Michelet in his famous historical apology for the Revolution was to compare the terror to 'an immense chemical apparatus' which had cleansed France of its corrupt past that it might be reborn in a state of purity.[18] As Michelet was no doubt aware, the symbolism of the purgative flame had played a large part in civic rituals of the Revolution. The Festival of Unity and Indivisibility held in Paris in August 1793, for instance, centred upon the ritualistic burning of carved emblems of aristocratic and ecclesiastical power. Such acts of ritual destruction featured in the agenda of the Société Populaire et Republicaine des Arts, the association of Jacobin artists established in 1793 to replace the Académie Royale. Some particularly zealous members moved that the works of the *émigré* François-Xavier

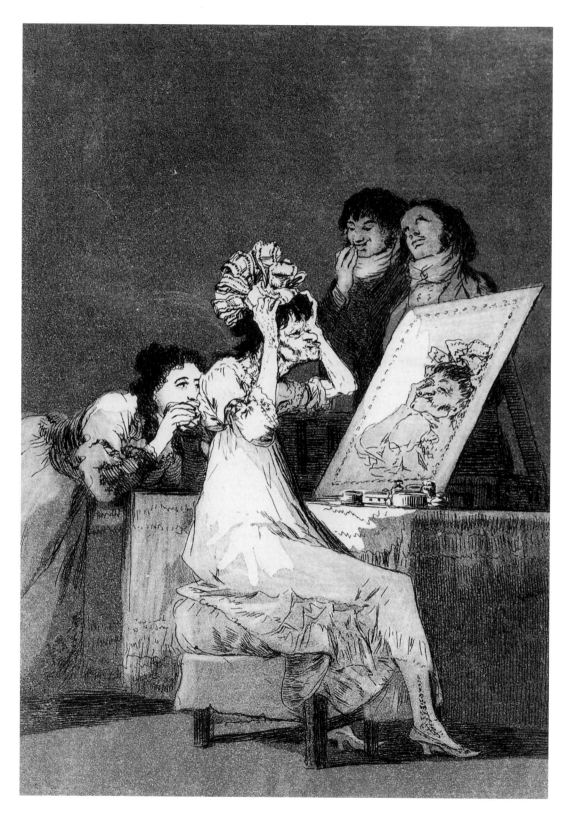

Fabre (1776–1837) at the Louvre should be dragged to the Tree of Liberty, ritualistically mutilated by each member of the Society, and burned.[19] Fortunately the motion was not carried.

A concern that the material evidence of a transcended past should be disposed of methodically, like a corrupt and unhealthy corpse, stimulated one of the most violent outbursts of iconoclasm in Western history. Chateaubriand, returning to France after ten years of exile complained that the programme for the removal of the symbols of Church and Monarchy had been carried out with such efficiency that the towns of post-Revolutionary France appeared as if they had been 'newly built in the middle of the new world'.[20] Civilization had in Chateaubriand's words been 'stripped of its memories'. Time as symbolized by the introduction of the new Revolutionary calendar had started again, and society had, in theory at least, regained that cleanliness and vitality associated with a state of healthy youthfulness.

The rituals and ceremonies which were to be performed in Ledoux's *City at Chaux* were designed to remedy the denatured state of man: the populace was to be continuously reminded of their duty to harmonize with the cycle of nature and to be cleansed by the ministrations of the elemental forces of wind, fire, and water. Again this type of idea was to appeal to Revolutionary ideologues. Revolutionary festivities often proliferated with images of perpetual regeneration. The stage-set for the Festival of Unity and Indivisibility set up in August 1793 on the site of the destroyed Bastille centred upon a vast figure of Isis, emblematic of natural regeneration, from whose breasts shot powerful streams of milky coloured liquid. Less squeamish citizens took up the invitation to regenerate their patriotic spirits by drinking this liquid. David's design for a fete in the following year involved the construction of a huge mountain with the tree of liberty at its summit. On the slopes of the mountain 'ordinary' men, women, and children were to gather in rather unnatural groups to celebrate the abstract virtues of regenerative nature, the mothers suckling their babies or holding their infant sons up to the heavens in a gesture of veneration towards nature. Boys, echoing the famous poses seen in the *Oath of the Horatii*, were required to present their swords to their fathers whilst swearing to use their weapons in the cause of liberty.

The idea that society was failing to purify itself by respecting the natural cycles of life was one of the enduring preoccupations of late eighteenth-century European graphic artists. The corpus of graphic satire of virtually every European country contains stock depictions of an old hag applying make-up at her dressing table, a subject first explored in an engraving by L. Surugue after Charles Coypel of 1745 entitled, *La Folie par la décrépitude des ajustements de la jeunesse.* The folly of such grotesque figures was held to be more than a personal failing. The vanity of the hag was a metaphor for broader degeneration of

societies and social institutions whose members refused to see their own decline and the necessity of reform. The English diarist Robert Southey (1774–1843) was reflecting a common opinion when he observed to an associate on a trip to the then declining University of Cambridge: 'The truth is, Sir, that the Institutions of men grow old like men themselves, and like women, are always the last to perceive their own decay.'[21]

Goya, whose *Caprichos* include a particularly disturbing image of an old lady dolling herself up to celebrate her seventy-fifth birthday, was personally preoccupied by the idea of society's inability to cleanse itself of the corruption of past generations [**107**]. In a letter to his friend Zapater of 1785 he indulged in some rather disjointed reflections on the tendency of human viciousness to transcend death. He talks of the ability of the 'fatter ones' who feed on the mass of society to carry their evil beyond the grave: 'Even when dead they do not cease to be offensive because their cruel behaviour extends even to neighbouring corpses; there is no remedy except knowing how to put yourself beyond the reach of their cruelty.'[22]

A similarly macabre image occurs in one of his unpublished sketches for the *Caprichos* series. Entitled simply *To grow after one is dead* the print shows the emaciated and ghastly corpse of a Spanish noble dressed in antiquated clothing growing to twice life-size and propped up by a cleric. The print is, of course, an exposé of a Spanish social system whose ills were perpetuated by the support of particular antiquated institutions and traditions. It also symbolically articulates Goya's revulsion at the sickness of all those societies whose corruption is perpetuated by the inhibition of nature's healthy cycle of death and rebirth. Although expressed in a very different way, Goya's ideas were much akin to those which drove Ledoux to fantasize about carrying out huge-scale ritual cremations.

Goya's visceral disgust for human corruption and degeneration was exceptional. If any Spanish court artist of the eighteenth century had developed such a contempt for human foibles and deformities he had certainly not considered it appropriate to set them out on paper. However, it should be remembered that many of Goya's most shocking images of human corruption—such as the huge syringe designed for administration of a curative enema to ease society's ills—were part of the established iconography of late eighteenth-century French and English political print-makers.[23] Even Goya's sense of the ills of society being preserved in the corpses of the ruling élite had precedents in English graphic satire. In the 1740s, for instance, a particularly disturbing print had been produced of the dissection of a Pelhamite minister whose nightmarish corpse was shown on close inspection to contain a variety of contagious gasses and rotten organs in which his political corruption was preserved [**108**].

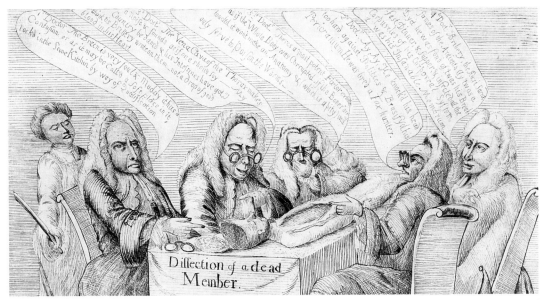

The speech bubbles in the image read (partially legible):

"Doctor the Brain is very foul & Muddy this Confusion, or as it may be Cald a Softness may be Locked in the Stone Kitchin by way of Rectification"

"a House is found's Prison be Hand & his Intestines have got'd Country be found & his Intestines have got'd only serve to be Don C the Theor to say"

"3 Doct The Vena Cava of the There makes it wont make on Anatomy &"

"as if the Whole Lobe was Corrupted of the Bone"

"Doct There's a most potent Factor Period within It was one a Fox hunter"

"Foot and within It was one a Fox hunter."

"Dont' Ay Ay See knock'd his Brains & his Jelly a little Mr we his Jelly a little Mr"

"I Don't Antony the Ancients Ay the first Last Dinner & Supper, which was fed Corpuscles of his Gutt'ry Horror."

Diffection of a dead Member.

108 Anonymous

Dissection of a Dead Member of Parliament, etching, 1746

The world of eighteenth-century English and French political satire was a place of gross corporeal disgust in which men were prone to impose corruption upon their fellows through their vomits, farts, or spontaneous and utterly foul eruptions from the bowel. There was, as Albert Boime has shown in an essay on French Revolutionary caricature, a veritable 'scatological discourse' within eighteenth-century political prints.[24] Indeed the French term for caricature, *charge* (noun) and *charger* (verb), related to the term *decharge* or the expulsion of excrement.[25]

Eighteenth-century French and English graphic satirists were not, of course, the first artists to feel and express the rottenness and carnality of the physical and material world. They were, however, the first to be able to associate routinely the political process with man's gross physical urges, appetites, and deformities. It was in England, in which the political press was granted unprecedented freedom of expression, that the scatological and carnal visual language of European political satire first developed.[26] Here, in contrast with much of the rest of Europe, this visual language was routinely employed in lampoons of a truly subversive nature; widely distributed images which cast those statesmen and royal personages under whose authority the artists lived as the villainous enemies of the state.

In some respects the sense of physical disgust which eighteenth-century artists and their publics felt for the corruption of politicians and the aggression of military opponents of the state was a redeployment, in a secularized form, of that imagery of intense loathing which former generations had reserved for unbelievers and heretics. Much of the gross visual language invented by the makers of political prints in both France and England was borrowed from the standard

The Conduct, of the twoB★★★★★rs.

Qui facit per alium, facit per se.

quia factum est per alium, factum est per se.

Undertaker General

Cape Breton.

O England, how revolving is thy State!
How few thy Blessing! how severe thy Fate
O destin'd Nation, to be thus betray'd
By those, whose Duty 'tis to serve and aid!
A griping vile degenerate Viper Brood,
That tears thy Vitals, and exhausts thy Blood.

A varying Kind, that no fixt Rule pursue,
But often form their Principles anew;
Unknowing where to lodg Supreme Command
Or in the King, or Peers, or People's Hand.
Oh Albion, on these Shoulders ne'er repose
These are thy dangerous intestine Foes.

iconography of religious art.[27] A high quality English print protesting at the terms of the Pelhamite Peace of 1748, for instance, adapted the imagery of Poussin's then famous *Martyrdom of St Erasmus* (*c*.1666) into an image of the beautiful form of Britannia being violently disembowelled by the chief ministers of state with the assistance of a kind of appalling winding machine [**109**]. The offence against the state had literally replaced the offence against God in the same way as the civic humanist model of the biology of civilization had begun to replace the Christian vision of man's fall from innocence. The belief in man's inherent and inevitable corruption and brutality had been secularized and politicized.

The image, mentioned above, of the corpse of a Pelhamite Minister which had absorbed physically the moral corruption of the state was a manifestation of a common eighteenth-century thought process. Withered and degenerated even before death, the body of the citizen had become an emblem of the broader body politic. The rise of graphic satire relied upon the establishment of a vocabulary of such picaresque imagery. A typical device, the bandaged foot grown tender with gout (the acknowledged disease of luxurious excess) was effectively used by Hogarth and Rowlandson. It appears in the opening print of his *Marriage-à-la-Mode* series, in which Hogarth attempted to express the idea of a disastrous marriage between the daughter of an avaricious merchant with the foppish representative of an ancient blood line named Viscount Squanderfield. As the fop's name indicates, the family has turned its back on the administration of its country estates and opted for a luxurious life in a city house which can be seen through the window in the process of construction by a company of jerry builders. The rather overdressed father of the groom is responsible for commissioning the house and leading the family towards ruin [**110**]. As Hogarth indicates by his choice of title for the series, he considered such marriages were becoming disturbingly frequent; the degeneration of the private institution of the family is made an emblem of a broader malaise in public life.

The father of the groom is depicted resting his gouty foot on a footstool in the foreground of the picture proudly holding up his family tree, his blood line being the only virtue he has now to recommend him. His gouty foot speaks volumes for the chain of circumstances that have led to the ill-fated alliance. The snuff-taking son of this gouty English gentleman exhibits the mannerisms and emaciated sharpness of form which Hogarth usually reserved for his satirical images of depraved Frenchmen and Continental rakes. In the light of Hogarth's acknowledged anti-cosmopolitan views we can assume this character to be one stage more corrupt than his father.

The idea of congenital contamination—that the jolly extravagances of one generation had become the disastrous failures of the next—is

110 William Hogarth

Marriage-à-la-Mode, plate 1
(*The Marriage Contract*),
engraving, 1743

subtly communicated by a patch on Viscount Squanderfield's neck. Such patches were often worn to hide the characteristic sore of scrofula, a disease which was thought to be passed to the children of the aristocracy by lowly wet-nurses. It was, thus, a clear sign that the son was a victim of his mother's choice of a life of luxury rather than the virtuous nursing of her children. Scrofula was known to attack the eye and was, presumably, inhibiting the ability of the son to see properly the pitfalls of life into which he was stumbling.

Hogarth here employed an effective, and to some degree novel, means of compressing a complex narrative into a limited number of images. By a series of such clever physical observations he could suggest an unseen narrative of events which had shaped and contorted the bodies of the main figures of a drama. Thus, despite being limited to a few plates, Hogarth could hint at a narrative of the complexity of a contemporary novel. Not surprisingly this means of communication was adopted by many other artists. Like the device of the gouty-footed British degenerate, that of the vicious emaciated Frenchman caught the public imagination and became the standard visual shorthand for satirical commentaries on corruption. Subsequently Rowlandson also became fascinated by the idea of the Frenchman as a vicious parody of

manhood, a class of humanity whose body had been distorted into an angular symbol of degeneration.[28]

Rowlandson perpetuated for one more generation the idea that French male bodies had absorbed an entire recent history of luxury and venality; their natural physiques congenitally mutated by being forced into constraining fashionable garments and absurd polite poses. This satirical image gradually became so ingrained in the British imagination that by the late eighteenth century some found it difficult to think of the French otherwise. James Barry was to claim in all seriousness that recent French art had been handicapped by the Academy's inability to find male models whose skeletons had not been hideously mutated by modern urban life. He commented that: 'It is difficult to find any Frenchman who would make a tolerable model at the Academy. The rules and laws of dancing, impressed early upon them, has distorted and unhinged the whole people.'[29]

Visions of lost virility

The rise of biological theory in European art culture brought with it the supposition that the man of primal virility, in particular the virile artist, could be expected to regenerate society and art. This idea runs particularly strongly through the art and literary works of Henry Fuseli. In Fuseli's imagination, and that of many of his contemporaries in Rome during the 1770s, antique civilization in its most pure cultural phases began to seem a world overtly dominated by primitive masculine impulses. Since it was assumed that in raw nature masculinity was the ascendant force, it followed that in its primal biological stages civilization was the domain of the fundamentally virile man.

Throughout his literary *œuvre* Fuseli persistently associated human passion with virility. Indeed this association of ideas allowed him to valorize emotion. It enabled him to mount a fundamental attack upon the whole Enlightenment tradition of regarding the sight of men in the throes of disturbing emotions (mental anguish, terror, and pain) as a challenge to the mental equilibrium of the viewer. This challenge to decorum is expressed most strongly in his reviews of the famous classical group of Laocoon and his sons wrestling with biting serpents. On a number of occasions he attacked the stance of those 'tame antiquarians' who had argued that the group exhibited states of pain sublimated for the sake of decorum. He meant, of course, to criticize Winckelmann and Lessing whose argument over the expression of sublimated pain in the Laocoon group was by then famous all over Europe. Fuseli believed the Laocoon group to be an expression of a set of pure uninhibited masculine emotions which were in the ascendant in Antiquity. These bodies in their rhythmic spasms of pain appealed to his imagination as a sort of icon of virility. The central figure, he suggested, embodied 'every beauty of virility verging on age'.[30]

Fuseli allowed these views to dictate his attitude to painting, his mode of life, and, in particular, his attitude to women. His personal papers proliferate with outbursts which it would be generous to describe as misogyny. Like his friend Rousseau, he had an abiding fear, loathing, and fascination for dominant women which comes across strongly in many of his graphic works. A number of frankly erotic drawings testify to his desire to experiment sexually. Although indulging in such fantasies was obviously a pleasure in itself, it seems likely that these drawings had a more serious purpose. Fuseli believed that the exploration of his raw generative impulses would help him to become the sort of virile creative figure who was best placed to pioneer a cultural rebirth. As a well-read classicist he may well have been aware that the very word 'genius' had been derived from the Latin *gignere*, meaning to beget or sire and had been used in the earliest Latin sources to denote a procreative spirit allotted to every male at birth.

Influenced by such ideas, Fuseli and a number of his circle in Rome, most notably the Swedish sculptor Johann Tobias Sergel, took part in quasi-bacchanal festivities. On such occasions the assembled throng released themselves from all the inhibitions of respectable bourgeois society. All manner of orgiastic excess, most culminating in energetic bouts of vomiting, were recorded in Sergel's private sketchbooks. Sergel, whose wonderfully uninhibited sculptured groups uniformly reflect the erotic energy of antique myth, appears to have shared fully Fuseli's conception of the generative impulse of artistic creation. In one particularly vibrant drawing Fuseli shows a group of sculptors led by Sergel carving an erotic classical group in which he makes a clear association between the act of carving and sexual penetration [**111**]. One of

112 Johann Tobias Sergel

Mars and Venus, terracotta
model, 1775

the group appears to drill into the marble with an implement emerging from his groin.

Sergel's interest in the bacchanal aspects of Antiquity may reflect his contacts with members of the French Academy in Rome who appear to have absorbed the Boucheresque culture of eroticism into their antiquarian reflections. He is reported to have learnt his technique of terracotta modelling from Clodion, whose titillating classical groups were becoming highly valued by collectors all over Europe. Whether Sergel knew Clodion's associate Fragonard is less clear. He almost certainly knew of him. The Swede's most erotic works seem to have much in common with the brilliant, though thoroughly *risqué*, etchings of Bacchanal subjects, known as the *Bacchanales ou Jeux de satyres* (1763), which Fragonard produced on his Italian sojourn.

One of Sergel's most patently erotic groups was commissioned by the English connoisseur, Richard Payne Knight. Unfortunately the statue of *Mars and Venus*, for which a model was made in 1775, was never executed in marble [**112**]. Sergel's fascination with the primal

113 Johann Tobias Sergel

Self-Portrait on Crutches,
black chalk, pen and brown
ink wash, *c.*1777

generative impulse also reflects his contacts with the circle of Payne Knight and his friend P. F. Hugues, alias Baron D'Harcanville. These irreverent scholars were the foremost intellectual proponents of the idea that all primitive religious movements had begun as fertility cults. Their theories gave no quarter to the demands of conventional moral values or religious propriety. It was even suggested that the central Christian symbol of the cross had evolved from a primitive phallic symbol.

Knight and Hugues were happy to acknowledge that their fundamental motivations for being interested in Antiquity were erotic. Not for them the hypocritical 'curiosity' of the antiquarian who pretended to look at art to elevate his spirit while he covertly indulged his baser appetites. Zoffany's painting of Hugues, Payne Knight, and Charles Greville in Charles Townley's Park Street Library surrounded by the latter's collection of Roman antiquities (1782) captures their attitude to collecting. On the table in front of the seated Hugues is an antique bust of a woman apparently emerging from a flower. True to Hugues's theories, Townley insisted that the bust was an image of Isis, a symbol of the 'passive means' of generation. He is reported to have referred to it as his 'wife'.

Although, as his drawings indicate, Sergel was also capable of such light-hearted reflections on Antiquity he was no one-dimensional *bon viveur*. His bacchanal life-style left him with a ruined physique. Unfortunately he did not even aspire to the healthy corpulence of a Silenus. Somewhat ironically for an artist so enamoured of primal states of virility, he began to suffer from gout, the acknowledged disease of the degenerate. The victim of a naturally depressive and neurotic disposition he was quick to realize his own body had become a cruel antitype of the noble athletic classical figures he was famous for sculpting. His disgust and despair at his own gouty corpulence is wonderfully caught in some of his drawn self-portraits [**113**]. These express brilliantly the terrible gulf between idealistic dreams of antique virility and the reality of modern corruption.

Sergel's harshly realistic self-portraits express the absolute futility of modern dreams of antique virility. They distil that sense of crushing pessimism which his friend Henry Fuseli brought into his literary commentaries on the visual arts. Pitting himself against trends of confident progressivism in Enlightenment thought, Fuseli argued that the noble naïvety and sense of simple public spirit which was perceived to have existed in Antiquity was largely unrecoverable. History was seen as an ongoing process of sophistication in which man's attempts to recover his primal virility and grand sense of public duty became increasingly futile. Although Fuseli regularly demonstrated his general accord with the biological vision of culture, he appears to have believed that modern attempts to regenerate culture were necessarily limited.

The Artist Moved by the Grandeur of Ancient Ruins, red chalk with sepia tint, 1778–9

Modern man was spiralling into a state of decline, his course dictated by an ungovernable quest to pursue his own petty private interests.

For Fuseli, who claimed to have been unable to stand his native Zurich because it had become a society of 'bourgeois gentilhommes', the rise of the urban middle classes with aspirations to enter the art market only aggravated this process.[31] Attempts to re-establish a sense of public duty through the imposition of public institutions such as art academies were doomed to failure as they went against the inexorable processes of history. Contemplating Antiquity, coming into physical contact with its shattered remains, was to grasp tragically for a state of innocence and primal grandeur to which the modern artist was fated never to be able to aspire. Fuseli's well-known drawn portrait of an artist, probably himself, sunk into despair amongst the gigantic remnants of Antiquity is a potent symbol of this sense of loss [114].

Fuseli's belief that the antique world was governed by colossal forces of primal masculine energy which were spent in civilization's youth, and gone probably never to return, may well have originated in his readings of Winckelmann, whose *Reflections on the Imitation of the*

Greeks (1755) he translated into English in 1765. More than any other European writer of the mid-century Winckelmann was responsible for introducing a sense of yearning for the lost, and probably unrecoverable, virile forms of Antiquity into European literary discourse.[32] Despite the unorthodoxy of his homoerotic vision, his impassioned descriptions of the youthful male body as obliquely encountered in the shattered fragments of antique statues, struck a chord with a mass of European readers. That his studies of antique art proved to be art history's first 'best sellers' may well be attributable to his capacity to trigger in the European reading public that same vein of raw physical disgust with the denatured state of modern manhood which fuelled the comic print industry.

Despite the widespread belief in the contamination of modern urban society, few late eighteenth- and early nineteenth-century commentators shared Fuseli's pessimism. On the contrary, artists such as Canova, Thorvaldsen, and Flaxman, whose productions could be directly compared with classical remains were routinely acclaimed as the equals, if not superiors, of their antique forebears. In order to accept the idea that a 'modern' could be considered to rival the achievements of the ancients, however, it was usually necessary that his reputation should be distanced from the taint of modern consumerism and sophisticated urban ways. European art commentators and academic administrators of this period were particularly receptive to the optimistic notion that the urban art scene could be rejuvenated by young protégés born in rural backwaters whose natural genius had not been dimmed by exposure to luxury and sophistication. The function of such artists was similar to the purifying mountain winds at Chaux. They brought a refreshing current of 'naïvety' into the stale and cynical urban world. Naïvety, a quality of mind little esteemed in early eighteenth-century Europe, became a much-prized attribute for late eighteenth- and early nineteenth-century art biographers.

The rise of this conception of the artist as 'a force of nature' reflected the central developments in the theory of genius in the later decades of our period; the characterization of the genius as someone fresh if not wild, original, uncramped by convention, and free from bourgeois constraint. Diderot, whose conception of genius is widely held to anticipate that of the early nineteenth century, was one of the first commentators of the period to urge a search for artistic talent in the ranks of those 'uncontaminated' by consumerism. He declared that:

Painters, poets, sculptors, musicians and all the arts grow from the soil, they are the children of the good god Ceres: and I answer you that wherever they originate in that type of luxury they will flourish and will always flourish.[33]

Later in the eighteenth century an expectation arose that the rocky purity of the Alps, a region whose savage untrammelled beauty was

'discovered' by European artists and sightseers in the late eighteenth century, would naturally cast up great primeval talents. The Swiss painter Joseph Koch was reportedly discovered drawing with charcoal upon a rock as a shepherd boy and sent thence for education in the Stuttgart Academy. Similarly the prodigiously talented twins, Pierre and Joseph Franque, were discovered in the mountains of the French Alpine region of Drone. Described as 'the children of the nation' they were educated at national expense under the supervision of David himself. It is a measure of the influence of the topos of the shepherd-boy artist that Stendhal in his 1824 account of *The State of European Sculpture* was erroneously to assume that Francis Chantrey, the son of a Sheffield carpenter, had been a shepherd in his youth.[34]

Conforming to the same mode of thought, a number of Canova's biographers were to rejoice in the idea that he had been born in an Alpine hut. J.S. Memes, Canova's British biographer, promoted his hero as a raw natural talent who, like a force of natural redemption, had single-handedly resurrected the dormant tradition of Italian painting: 'The mud-walled cabins of an Alpine village witnessed during the first twelve years of his existence, the dawning of a mind, whose productions now constitute the most precious treasures of the noblest palaces.'[35] Both Canova and his rival Thorvaldsen, who could hardly be described as innocents abroad in the modern city life of Europe, seem to have done their best to confirm contemporary expectations that they should not feel at home in the sophisticated urban world. Canova's biographers, like Thorvaldsen's, considered their hero refreshingly 'naïve' in social manner.[36] Their agenda, however, was slightly different from that of Thorvaldsen's apologists. Canova's 'naïvety' was seen in his artless charm, his generosity and simple piety, Thorvaldsen's 'naïvety' was generally a euphemistic term for his lack of social graces, flagrant impiety, and poor education.

Thorvaldsen, the son of a Danish ship's carpenter, successfully adopted the air of the mythic elemental genius. Although he proved very capable of embroidering his own mythological persona—he compared himself to the great Kraken of the North, a sea monster celebrated in Scandinavian myth—his admirers left him in need of little self-promotion. They proved willing to cultivate a succession of myths as to his birth and ancestry which cast Thorvaldsen as little short of a Norse god. On his arrival in Copenhagen in 1838, for instance, Thorvaldsen was read a congratulatory address by the Secretary of the Historical Society of Rhode Island, North America which suggested that the sculptor was a descendant of the most primitive American colonialists:

it has been satisfactorily shown that Rhode Island was visited in 1007 by an Icelandic expedition under Thorfinne Karsefne, who settled in the winter near

Mount Hope, where his wife Gudrid gave birth in the following year to a son named Snome. From that genealogical chart of Snome's posterity it is apparent that Bertel Thorvaldsen descends in direct line from him, who was thus the first native American of European origin.[37]

Thus, Thorvaldsen was associated not only with the great primal heroes of Norse myth, the primitive forbears of the northern European 'old world', but with the first settlers of the European 'new world'. His emergence as one possessed of great talent was not accidental; he was the very quintessence of all things primal in European civilization.

Late eighteenth-century British art commentators were also highly receptive to the notion that those associated with the virgin soil of the New World would emerge with purifying talents. American painters coming to London arrived with the expectation that they would exhibit a natural genius more pure than that of men from the old European world. Both Benjamin West and John Singleton Copley profited from the dissemination of biographical anecdotes which depicted them as spontaneous and untutored geniuses whose talents had emerged irrepressibly from a first-hand contact with the fresh natural world of America. John Galt, Benjamin West's principal biographer, claimed, somewhat unconvincingly, that West had been tutored in his colour sense by conversations with native Americans:

the mythologies of antiquity furnish no allegory more beautiful; and a painter who would embody the metaphor of an artist instructed by Nature, could scarcely imagine any thing more picturesque than the real incident of the Indians instructing West to prepare prismatic colours.[38]

The West 'origins myth' was aggrandized by classical precedent. It had the same stature as those mythological tales of the origins of painting which appeared in classical sources. West drew considerable advantage from the compelling idea that his early discovery of art in the New World closely resembled the narrative accounts of the discovery of art in the old European world. There was, indeed, a vogue in Britain at the time of West's rise to prominence for paintings illustrating Western art's genesis myth. Joseph Wright of Derby, John Mortimer, and Angelica Kauffmann all painted images of the moment when the Corinthian maid, Dibutade, was first inspired by love to sketch the profile of Endymion by tracing his shadow cast on a rustic wall [**115**].[39]

It was an earlier 'origins of painting' legend, Vasari's famous tale of Cimabue's discovery of Giotto as a shepherd boy, which had inspired the search for rustic boys sketching in charcoal in the Alps. The majority of writers who propagated the cyclical vision of art history during the late eighteenth century had, as we have already noted, Vasari's biological account of Italian Renaissance art firmly implanted in their memory. To some degree the reform of the arts which some

115 Joseph Wright of Derby

The Corinthian Maid,
oil on canvas, 1782–4

modern art historians describe as the 'anti-rococo' or 'neo-classical' movement was stimulated by the desire to engender a second Renaissance.

Vasari, however, talked of art growing 'from the smallest beginnings ... to the greatest heights'.[40] He did not describe the sort of violent or radical transformation of culture for which those in the period of the 'neo-classical' reaction hungered. Vasari's cultural cycle, a 250-year progress from youth to maturity, was considerably slower than that envisaged in the late eighteenth century. Commentators of the later half of our period considered that artists such as Vein, David, Mengs, Canova, Banks, and Flaxman had, in the course of one epic career, transformed their national traditions from a state of ultimate decadence to the absolute pinnacle of human achievement.

The dramatic speed of the process of artistic reform was, at least, partially a result of the arts being sucked into campaigns of political propaganda. A growing tendency to regard the state of the polite arts as an index with which to measure the moral tenor of a national society or political administration increased the imperative of fabricating truly radical reforms. Across Europe those who expected to feel the energy

of national regeneration in their encounters with the visual arts did not wish to find their national artists to be patiently labouring to contribute the foundations of a slow and protracted process of reform. The financial and political investment in the foundation of national academies, schemes for the improvements of the arts and the erection of public monuments was not made by those who were content to believe the true benefits would accrue a hundred years hence. What was required was a sense of dramatic artistic change resembling a burst of heroic military conquest or a moral purge conducted by a new political administration.

It was in this spirit that David and his pupils came collectively to be applauded as 'les généraux des arts'. Supporters of the young protagonist of a new rigorous classical style Jean-Germain Drouais (1763–88), celebrated their hero's victory in being awarded the 1784 *Prix de Rome* in the manner of a classical military triumph, carrying him through the streets to the beat of drums borrowed from the military stores in the *Hôtel des Invalides*.[41] The triumphant painting, on the subject of Christ and the Cananite woman, was executed in a style somewhat between that of Poussin and Le Brun. It represented a heroic return to that phase of high classical painting which was frequently cited as a peak in the cycle of modern French tradition which had ended ignominiously in the decadent art of Boucher.

Drouais's master, Jacques-Louis David, pioneered the process of creating a chain of associations between the role of a reforming artist and that of virile martial hero. It was no coincidence that his *Oath of the Horatii*, a *tour de force* with which he hoped to launch his European reputation as reformer of the arts, depicted a moment of martial courage which heralded the birth of a new culture [**70**]. As J. H. Tischbein declared in his famous review of the painting at David's Roman studio, David hoped that his painting would 'transport' his viewers back to an epic juncture in the history of the ancient world. Tischbein suggests that when we look at the painting we should 'find ourselves suddenly transported back to Rome's first youth, and realise that the descendants of such warriors must become the rulers of the world'.[42] Significantly the *Oath of the Horatii* also included an overt reference to the biological cycle of life: the oath is taken by youths, the swords are distributed by their elderly father, and timorous male children look on wrapped in the protective arms of women. The viewer is covertly invited to associate the achievement of the youthful David with the virile heroism of the three oath-takers. His art did not appear to be the early fumblings of a cultural rebirth but rather a mature phase of reform conducted by an artist with the virile resolve to bring art back to its primal roots.

In the highly competitive late eighteenth-century markets of Rome, Paris, and London artists who succeeded in being associated

publicly with moral reform, and a return to purer forms of classicism, gained a considerable advantage. It had the dual effect of making all their competitors appear behind the pace of cultural development and their immediate predecessors seem utterly worthless. The great careers of aspiring reformers sprung forth with prodigious speed out of the manure left by the rotting reputations of those artists singled out as the last representatives of a decadent tradition. Anton Raphael Mengs, whose own theoretical discourses promoted the biological model of cultural development, had the ability to persuade those around him that he was the only figure in their cultural orbit worth consideration. As his most recent biographer informs us, he was greeted as 'nothing short of a messiah of the arts, a reincarnated genius of ancient Greece, born to lead a moribund art back to its former splendour and glory'.[43] One of those persuaded was Charles III of Spain who responded by treating Mengs differently from any other artist in his employ. In 1777 he granted Mengs a huge pension to go to Rome. No real obligations were attached, the only expectation being that the king's sponsorship of such a prestigious genius would have its own reward in the sovereign's fame as a patron of vision. Before leaving for Rome Mengs had exerted his messianic authority over art in the Spanish court to assure that G. B and D. Tiepolo's paintings for the chapel of St Pascual Baylon, Aranjuez, which were hardly dry, would be replaced by a cycle painted by himself and his pupils. Suddenly Tiepolo's work was not just unfashionable it was irrelevant, the representative of the final phase of cultural decay before the arrival of a great reformer.

Perpetuating the biological theory of civilization was in the basic commercial and political interests of the reforming figures who strove to assume the helm of the art professions in the last three decades of the eighteenth century. This vision of historical change underpinned the majority of the educational lectures delivered at new and reformed art academies in the mid-eighteenth century. It was part of the propaganda of such institutions that they were instrumental in rescuing the national arts from some sort of cultural nadir.

Similarly, it is no accident that the rise to prominence of this vision of history coincided with the rise of the art critic; the emergence of a generation of literati whose word was considered to have the power and authority to fashion the course of the civic art world. A critic, like an evangelical preacher, could boast a worthy social role in a world which was deemed inherently corrupt but possible to reform. The cyclical theory of history had an important role in legitimating a profession or occupation that was frequently dismissed as the last resort of the intellectual parasite. Employing a pungent analogy between cultural decay and the rotting of flesh, Voltaire compared the social function of the critic with the meat inspector at the market whose job it was to sort the contaminated from the healthy carcasses. It was upon this

role that Denis Diderot, whose writings were suffused with what one commentator has described as 'an acute if not woeful sense of decadence and degradation', based his authority.[44] The theory was not only promoted but sustained through the vested interest of art writers and critics. It could be said that the enduring popularity of the biological model in the critical and art-historical literature of this period rested in it being too powerful a weapon to abandon.

The rise of the north

The replacement of works by the Venetian Tiepolo family at St Pascual Aranjuez with those of Mengs, a reformer from Dresden, was a portentous moment in European art history. It marks a crucial juncture in the history of the decline of 'Italian art'; a final collapse in the authority of an art tradition which had held sway in European courts since the High Renaissance. In late eighteenth century Rome, the primary theatre of European talent, artists from Italy were playing a diminishing role. After Batoni's fall from favour in the 1770s Romans could no longer claim that they were providing the indigenous talent to set the standards of artistic achievement for Europe.

In 1760 it would still have been true to say that Italy, along with France, was considered Europe's primary source of well-honed artistic talent. A mere ten years later this was no longer the case. Richard Payne Knight advised that those Englishmen wishing to have certain evidence of the decline of Italian art need do no more than compare the works of Titian with those of Biagio Rebecca, a muralist currently working for Robert Adam.[45] Demand for Italian artists in Britain in the late eighteenth and early nineteenth century was certainly less than it had been in the early eighteenth century. The era had passed in which Italian painters such as Amiconi and Pelligrini came to England on the expectation that they would be considered inherently superior to their British counterparts. There was no longer a call for a man like Hogarth to ridicule the allegedly over-esteemed productions of living Italian masters. A broad look at the careers of artists from the Italian peninsula who came to Britain in our period reveals that the great majority arrived before 1760. There was a similar decline in the number of Italian artists who made their fame and fortune in Paris and rose to prominence in the French Academy.

The trend toward severe forms of academic classicism which gathered force in the 1760s, 1770s, and 1780s, was initially generated by northern European artists who felt the charge of inheriting classical culture most intensely. As Fuseli complained in the early years of the nineteenth century, the German community in Rome began at this time to apply a cultural aptitude for systematic thought to the study of the artistic heritage of Antiquity in a manner which deeply impressed the rest of Europe:

About the middle of the last century the German critics established in Rome began to claim the exclusive privilege of teaching the art and to form a complete system of antique style. The verdicts of Mengs and Winckelmann became the oracles of antiquaries, dilletanti and artists from the Pyrenees to the utmost north of Europe, have been detailed, and are not without their influence here [i.e. Britain].[46]

It was not only Germans who rose to the fore. Northern Europeans, many from regions which had very little previous claim to the helm of the European arts, began to dominate the Roman art world. Scandinavia provided Rome with sculptors who set the agenda of international style, such as Sergel, known as 'the Swedish Phidias' and Thorvaldsen, a Dane with Icelandic blood. For the first time Scots and English, such as David Allan who was awarded a prize medal at Rome's Academy of St Luke in 1773 and Joseph Wilton who won the jubilee gold medal of the Roman Academy in 1755, began to command the highest respect in Rome. The Scottish history painter, archaeologist, and Roman tour guide, Gavin Hamilton (1723–98), had established an international reputation as an ardent champion of severe classicist history painting more than a decade before David arrived in Rome. Catherine the Great became the first European potentate to turn regularly to Scots and English for high quality artistic workmanship. She appointed the Scots Jacobite Charles Cameron as her principal architect and, probably upon his advice, attempted to recruit workmen from Scotland for court building projects.

The causes of the relative decline in the international authority of 'Italian' art and the coincidental elevation of northern Europeans are highly complex. However, we may assume with confidence that the rise of the belief in late eighteenth-century northern Europe that modern cultural reform would not, or could not, occur south of the Alps contributed to this process. By promoting the idea that the Italian peninsula had at last spent its store of creative energies, intellectuals from the politically and economically superior cultures of northern Europe set the stage for a new northern European renaissance. David Hume, for instance, was airing his own expectations for the intellectual blossoming of Scottish culture, whose past performance in the field of the arts was considered as negligible as 'Italy's' had been majestic, when he penned the following observation: 'When the arts and sciences come to perfection in any state, from that moment they naturally, or rather necessarily decline, and seldom if ever revive in that same nation, where they formerly flourished.'[47]

By the same criterion an American rather than an Italian could be expected to lead to a rebirth of classical painting. Galt states that the arrival of Benjamin West in Rome set the artist thinking on the subject of the rise and fall of civilizations. It appeared to the artists that:

In America all was young, vigorous and growing,—the spring of a nation, frugal, active, simple. In Rome all was old, infirm, and decaying,—the autumn of a people who had gathered their glory, and were sinking under the disgraceful excesses of vintage.[48]

Napoleon utilized such cultural myths to give moral legitimacy to his Italian invasions. In 1796 when the French fleet was fired upon as it cruised the Lido of Venice, providing a pretext for an invasion of the ancient republic, Napoleon is reported to have exclaimed, 'This Government is old: it must fall!' In a similar manner the Napoleonic invasion of Rome was depicted as a new and virile strand of European civilization imposing its rightful control over a decadent culture which had been declining irreversibly since the High Renaissance. Accordingly, Thorvaldsen's *Alexander Frieze* (1812) set up in Napoleon's Roman apartments compared Bonaparte's triumphal entry into the city with Alexander's conquest of the infamously corrupt city of Babylon.

Napoleon attempted, unsuccessfully, to persuade Canova to move permanently to Paris from Rome on the pretext that Roman culture had been enfeebled by papal corruption.[49] Canova, a fervent supporter of papal authority whose own sense of national and civic pride had been re-enforced by the Napoleonic invasion, replied indignantly with a list of recent Roman artists whom he regarded as the equal of any in the past. In Napoleon's view the focus of European civilization had shifted a thousand miles north; Paris rather than Rome was to be the capital of a 'new' European world.

Napoleon's decision to move the majority of the finest pieces of antique sculpture from Rome to Paris was only a formal symbol of this shift. As Ian Jenkins has put it:

French Imperial ambition justified the plunder of Italy in historicist terms as the prevailing of military virtues over spiritual decadence. Modern events were seen as comparable with the supposed defeat of the Egyptians by the ancient Greeks and of the Greeks in turn by the Ancient Romans.[50]

Although Napoleon's single act of plunder was repellent to much of the European art world he was only taking to its natural conclusions a process which had been going on without a great deal of complaint for at least 150 years. Italy had been systematically stripped of its artistic heritage by art collectors from the economically and politically stronger societies of northern, central and eastern Europe in a manner not wholly unremoved from the colonial depredations of art works in the nineteenth century. Selling and producing art works, dealing in real, forged, or 'restored' antiquities and providing entertainment for the wealthy grand tourists assumed a central importance within urban economies which were not thriving in other ways. In his notable essay on David's *Oath of the Horatii* J. H. Tischbein accused modern Romans

of having, after the decline of papal authority, little claim to glory but their heritage of art works:

For who in Rome today does not want to be a *bel esprit* and achieve prominence as a connoisseur of the Fine Arts? The most ordinary Roman claims this privilege; his judgement in the field of aesthetics is decisive; and he believes that people north of the Alps can have a taste for the beautiful only if they have sojourned in the capital of Italy. The nature of the Romans is to see other nations as their inferiors. Since the shackles of power and prejudice by which they bound the ancient and recent worlds to Rome are now broken, their pride and superiority depend upon the possession of the greatest works of art.[51]

Tischbein's muscular assertion that 'people north of the Alps' need not feel themselves in any way culturally inferior is significant. It became a convention amongst northern Europeans travelling to what Tischbein's compatriot Schlegel later called 'the Capital of the Old World' to record their astonishment at its impoverishment. It was not only the cities which appeared to be backward.[52] To northern Europeans such as Arthur Young who were armed with a knowledge of the latest agricultural techniques the Italian countryside seemed highly underdeveloped and primitive in the worst sense of the word. In his *A View of the Society and Manners of Italy* (published 1795) John Moore recalls being greeted by a brusque Scotsman in Italy who complained that 'their desert of a campagna, as they call it' would not stand comparison with 'the fertile valley of Stirling'. Moore himself observed that:

In the Campania of Rome, formerly the best cultivated and best populated spot in the world, there are no houses, no trees, no enclosures, Nothing but the scattered remains of temples and tombs, presenting the idea of a country depopulated by pestilence. All is motionless, silent and forlorn. In the midst of these deserted fields, the ancient mistress of the world rears her head in melancholy majesty.[53]

Since Mediterranean and Adriatic societies, which had originally given birth to classical culture, appeared to have degenerated, it was natural to assume that the more vigorous and politically powerful nations of northern Europe were better equipped to inherit the mantle of a great classical civilization. There was, of course, an element of the ridiculous in the idea that the overfed, bewigged gentlemen of northern Europe who formed the core of Grand Tour society were the rightful inheritors of classical civilization, the new cultural master-race. Even the most serious antiquarians were not above laughing at the absurdity of such cultural pretensions and enjoyed a visual joke at the expense of their claims. Joshua Reynolds's memorable caricature painting of the *School of Rome* (c.1751), in which an ugly gothic hoard of

116 Giovanni Battista Piranesi

The Temple of Portunus (The round temple near S. Maria in Cosmedia), etching, 1758

British Grand Tourists strike up the exact poses of the great figures of the classical world depicted in Raphael's *School of Athens*, is just one example of such humour [**77**].

Despite such jokes at the expense of 'gothick' claims to cultural virility, the feeling that the time of the northern European had come was taken very seriously. Northern European culture found its self-esteem much enhanced by the oft-repeated contention that Rome was 'the tomb' of old Europe. Travellers to Italy probably exaggerated their accounts of the shabbiness and decadence of modern life south of the Alps to reinforce their own sense of cultural vitality. It is significant that Piranesi, whose vision of Rome captured the northern European imagination like no other, devoted his talents to reinforcing the idea that modern Roman society had degenerated from its Classical and Renaissance past. Piranesi's unique vision of gloomy grandeur was born of a profoundly pessimistic cultural outlook. He claimed, for example, that he had been forced to devote his talents to the production of engravings of great architectural schemes because there was little prospect of finding modern patrons who would enable him to realize his grand architectural dreams in stone.[54] His engravings depict a squalid and effeminate modern world living in the shadow of its titanic past: fashionable connoisseurs gesticulate feebly amongst the great ruins; humble Roman women use the great monuments of antiquity as props upon which to hang their washing; and, repeatedly, deformed beggars lounge about the ruins of buildings built by a race of heroes [**116**].

Rome and Italy in general became famous in the later decades of this period for its bizarre and gnarled collection of beggars which appear frequently in the sketchbooks of northern European artists. The Scottish artist David Allan who made his living in Italy by making engravings of Italian street life and festivals commented that one of the great advantages of working in Rome was that one had an endless supply of such ragged and picturesque models.[55] It seems reasonable to suggest that these images of beggars contained some element of commentary on the state of culture in Italy. John Moore, for instance, commented after a visit to Padua that: 'The excessive number of beggars with which this place swarms, is strong proof that trade and manufactures in general are by no means in a flourishing condition.'[56]

Like many of his contemporaries Moore was confirmed in his poor impression of modern life in the Italian peninsula by the discomforts and dangers of travelling there. Many travellers complained that inns were dirty and roads hazardous. They complained with reason; the surviving statistics of highway crime in late eighteenth-century Italy still have the power to shock.[57] A number of artists and connoisseurs lost their lives in knife attacks whilst travelling in Italy, Winckelmann being only the most conspicuous murder victim of his age. The Scottish artist John Brown's (1749–87) wonderfully evocative drawings of a stabbing at the Basilica of Maxentius and a stiletto-seller remain a testimony to the very real fear of murder under which many artists lived while staying in late-eighteenth-century Rome.

Typical of his generation, Moore argued that the tendency of the common people of Rome to resort to such 'violent fits of passion' was a sign of the more general cultural malaise. Somewhat unconvincingly he blamed the Roman Church for the problem of knife murders, claiming that the Church's practice of offering asylum to fugitives allowed criminals to evade justice. As we have seen in the introduction, it was not unusual for northern European travellers to blame the ills of modern Italian society on the decadence of the Church. Predictably enough it was Protestant visitors who found this theory most appealing. John Brown has left us with a particularly hateful drawing of Roman clerics lurking in the streets and staring lustfully at an extravagantly dressed woman of the city who passes by flirtatiously [117].

This preoccupation with the cultural decay of civilization south of the Alps dictated the form of the great majority of northern European accounts of the history of art in Italy. Historical accounts of Italian art published in the late eighteenth and early nineteenth century, even those written by Italians, were largely generic accounts of the rise and fall of an art culture. Debate concentrated more on when degeneration had begun rather than whether it had occurred. In the late eighteenth century, however, the high point of art was most commonly assumed to

have been in the era of Raphael and the decline somewhere around the time of the Carracci or Correggio. Which of the latter was the first degenerate was a focus of much late eighteenth-century debate. However, by 1819 Schlegel felt the argument was settled; in his opinion the idea that Italian Renaissance painting had begun to decline in the era of the Carracci after reaching a summit with Raphael, Michelangelo, and Titian was 'no longer disputed' by 'those who know'.[58] There were, of course, those of contrary temperament who would have disagreed. Blake, for instance, regarded Titian and the Carracci as corrupting figures.

Opinion varied more sharply on the question of which period marked the earliest phase of considerable achievement in Renaissance civilization. Generally speaking, artists and art commentators became more receptive to the idea that the Italian Renaissance had a noble primitive phase with the revival of the interest in 'truly Christian' art forms after the fall of Napoleon. In this period it became quite acceptable in certain circles to admire previously overlooked Christian 'primitives' such as Masaccio and Fra Angelico. The rise of the notion that the early Renaissance represented a lost world of noble Christian primitivism only served to make modern Italian art seem more acutely degenerate.

The belief that the Italian tradition was terminally degenerate became so pervasive in the last six decades of our period that sectors of

the northern European art world began to assume that Italian soil was no longer capable of giving succour to great artists. This expectation led some commentators to express a sense of genuine amazement at the rise of an Italian, Antonio Canova, to the status of Europe's most famous and admired sculptor. Reflecting on his Italian travels in 1817, Stendhal commented:

Painting here is dead and buried. Canova has emerged quite by chance out of sheer inertia which this warm climate imposed. But, like Alfieri, he is a freak. Nobody else is the least like him, and sculpture in Italy is dead as the art of men like Correggio.[59]

Several of Canova's posthumous biographers accord with this view. J. S. Memes, for instance, refers to Canova as a genius emerging from 'adverse and unfavourable circumstances' in a period when 'the sound of the mallet was scarcely audible in any city of Italy'.

The sound of the mallet, both that of the sculptor and stonemason, had certainly been in evidence in many northern European cities at this time. Many of the most ambitious urban architectural schemes and massive patriotic monuments which transformed the great metropolises of northern Europe were heralded as the bearers of symbolic witness to a nation's claim to be the true heir of the classical world. Several northern cities assumed titles which reinforced this claim: the new seaboard city of St Petersburg rejoiced in the title 'Palmyra of the North'; Moscow was claimed to be a 'third Rome'; during the building of the classical 'new town' Edinburgh became know as the 'Athens of the North', a title which encouraged the construction of a second acropolis on Carlton Hill which would have boasted, had not money run out, a full-scale replica of the Temple of Athena as a memorial to the battle of Waterloo.

A craze for colossal patriotic sculpture which began in northern Europe during the Napoleonic wars suggested that the epic tenor of military affairs was considered not only to rival but also to exceed those described by the classical authors. Thorvaldsen's magnificent statue designed to stand in Warsaw commemorating the heroic death of the Polish patriot and ally of Napoleon Joseph Poniatowski (1826–30) [118] is an obvious imitation of the famous equestrian statue to Marcus Aurelius though at least four times as large. Britain had a particular enthusiasm for such monuments; although frequently the scale of the proposed monuments reflected more closely the patriotic zeal rather than the practical intelligence of those who proposed them. Consequently few were ever executed. In 1814 the sculptor George Garrard proposed that a 48-foot (15 m.) statue of Wellington be erected 'in the costume of a Roman general resting upon his truncheon; the horse in gallop, under which are represented the furies sinking into the earth'. Francis Chantrey exceeded this by proposing a monumental

statue of Nelson to be mounted on a 140-foot (43 m.) platform jutting
out over Yarmouth harbour. Conforming to the tradition of a Roman
triumph, the platform was to be built from the bows of captured naval
vessels.

Flaxman's proposals for a gigantic monument to Britannia to be
built near the Greenwich observatory are even more indicative of the
pretensions of the British empire to become the new focus of global
power. In the final passage of the letter sent in December 1799 to the
committee for the erection of the monument Flaxman gives a clear
indication of the seriousness with which some citizens of the energetic
northern European capitals took their self-appointed role as inheritors
of Antiquity:

It is also to be remembered that the port of the Metropolis is the great port of the whole kingdom; that the Kent Road is the ingress from London to Europe, Asia and Africa; and that, as Greenwich hill is the place from whence the longitude is taken, the monument would, like the first milestone of Rome, be the point from which the world would be measured.[60]

The belief that the architecture of the city of London should aspire to symbolize its role as capital of the world in a new imperial phase markedly intensified in the last four decades of the eighteenth century. There had, however, been certain earlier eighteenth-century architectural and engineering projects which were of a scale to encourage grandiose dreams among those who believed themselves at the heart of a civic culture embarking on a 'classic' phase of dominion and greatness. The pediment of the new mayoral Mansion House (begun in 1747 and completed in 1752), a building which could justly claim to be the new centre of the city, was itself centred upon a female emblem of the City of London dressed in an imperial stoa and 'bearing a praetorian wand representative of the Chief officer of Rome'.[61] The contract which was the subject of a public competition was awarded to the only truly English competitor, the young Robert Taylor (1714–88), to mark the building committee's belief that a new age was dawning in which the country would no longer be reliant on foreign talent.

The project to rebuild the Mansion House was rivalled in ambition by the magnificent struggle to find an engineering solution to the problem of building a great load-bearing bridge to straddle the Thames at Westminster. Engineering works in progress were sufficiently dramatic to stimulate a host of painted records. Probably the most memorable of these was painted by Canaletto not long after his arrival from Venice in May 1746, for a principal bridge commissioner, Sir Hugh Smithson, 2nd Earl of Northumberland.

Canaletto used the bridge (or, more specifically, the wooden supporting frame used in its construction) as a form of proscenium arch through which to view the main perspectival illusion, a compositional device familiar from his days as a stage designer [119]. It is difficult, as with much of Canaletto's *œuvre* of cityscape, to demonstrate concretely any clear level of commentary on the phenomenon of urbanism at work within his wonderful representational bravura. However, there does seem some purpose behind choosing the view down towards the old city of London and encompassing St Paul's Cathedral—clearly London's most impressive classical structure before the Westminster Bridge project. It seems likely that either Canaletto or Smithson was suggesting that this latest vast feat of engineering encompassed and set in a new context the entire history of the ancient city.

It is interesting to compare this canvas with another of Canaletto's great paintings of a city in the process of construction; this is his image of Venice's Campo S. Vidal and S. Maria della Carita now known as

119 Canaletto

London Seen Through an Arch of Westminster Bridge, oil on canvas, 1746–7

The Stonemason's Yard (1726–30) [**120**]. In the foreground of this painting masons may be seen carving columns to be used in Andrea Tirali's new façade for S. Vidal. The painter alerts us to the fact that, contrary to the legend of its complete degeneration, Venice continued its vigorous tradition of church building and civic reconstruction. Nevertheless there is something curiously soporific about Canaletto's image of labour in this city backwater. From ramshackle sheds the masons work away singly rather than toil on some vast endeavour. In responding to building works in the city of London in such a different manner to those in his native city, Canaletto has unconsciously left us with a strong impression of the gulf which divided the experience of urban life in the Italian peninsula from that in the great northern European metropolis.

As, through the agency of cityscapes such as Canaletto's ruin *capricci*, or Pannini and Piranesi's Roman ruins, 'Italy's' reputation as a scene of urban decay crystallized, those reinventing the genre of northern European cityscape became increasingly concerned with the imagery of titanic change. The contrast between these forms of cityscape appears most strongly in the work of the French Academician Hubert Robert, who made his early reputation in Rome as a 'painter of ruins' in the manner of Piranesi and Pannini with whom he was friendly. Returning to live in Paris in 1765 his Italian ruin scenes soon became, as Diderot's brilliant reviews of the Salon of 1767 testify, a standard departure point for northern Enlightenment reflections on the rise and fall of civilizations. On his return to France, however, he turned his skills to producing paintings of the building works he saw

around him in the fast changing cityscape of Paris, most of which are now to be seen in the Musée Carnevalet.

One particularly dramatic work in that museum's collection records festivities on the day in 1775 when the Neuilly bridge was opened for public use. This was commissioned by M. de Trudaine in his capacity as Directeur des Pontes et Chaussées [**121**]. It was an example of a veritable mini-genre of 'work in progress' cityscapes, commissioned by prominent engineers or ministers with responsibility for building and transport infrastructure, which was developed in France and Britain in the period after 1745. It is a type of painting which reflects better than any other the immense energy of northern civic culture. The rise of this mini-genre was probably hastened by the popularity of Claude-Joseph Vernet's painting of the new colonial port of Bordeaux as seen from the Chateau Trompette with a portrait of M. de Tourny, the superintendent of works, standing proudly in the foreground (completed in 1759 and subsequently widely disseminated through engravings).

Vernet's massive project to paint and engrave the cityscapes of the ports of France, sponsored by Marigny as Directeur des Bâtiments, was clearly intended as a celebration of France's pride in its status as an imperial trading nation. The paintings gave expression to the growing awareness of imperial dominion which features strongly in the art of both France and Britain in the era of the Seven Years War. In Britain, the country which incontestably took the upper hand in the race for empire, this period marked a turning point in the history of the national school of art. Britain's meteoric rise to the status of leading European force in the field of arts in the seven decades after the famous *annus mirabilis* of 1759 was not altogether a spontaneous flowering of

120 Canaletto

The Stonemason's Yard,
oil on canvas, 1726–30

121 Hubert Robert

The Opening Ceremony of the Neuilly Bridge, oil on canvas, 1772

talent. A vast array of public-spirited 'projects' were embarked upon in order to meet the strong public expectation that the nation's sensational military and economic achievements should be matched by its artistic performance.

Most obvious of these was the project to establish a Royal Academy of Arts which was brought to fruition in 1768. William Hazlitt, a fervent critic of this establishment, astutely observed that one of the covert purposes of those who founded and ran it was to associate themselves with sensational reforms which made the whole history of past British art appear irrelevant. The artistic triumphs of the Academy echoed the triumphs of 1759 which were supposed to have put all Britain's past martial achievements into the shade. Hazlitt was particularly contemptuous of Flaxman's academic lectures on sculpture in which the sculptor damned the generation of Roubiliac and Rysbrack in order to add lustre to his friends in the Academy.[62] Hazlitt suggested that the purpose of the lectures was 'to insinuate that Britain had neither patriots nor heroes to boast 'till after the establishment of the Royal Academy'.

As with David and his school's reforms of visual arts in France during the 1770s and 1780s, the drive to establish an artistic renaissance was strongly associated with the regeneration of the virile martial spirit of the nation. In no field was this spirit of martial confidence more apparent than that of print-making and export. John Boydell, then an aspirant London print entrepreneur, began a concerted campaign to take on the dominance of the French in the European print market in 1761. He began the campaign by commissioning William Wollet (1735–85) to engrave Richard Wilson's (?1713–83) landscape rendition of the Niobe legend, attempting successfully to draw first blood by outselling the French print industry in a genre (i.e. the landscape print) of which they had the virtual monopoly. Boydell was particularly keen to outsell

Vernet's prints, most notably the *Storm* and the overtly nationalistic *Ports of France*. The international triumph of Wilson and Wollet's *Niobe* was the beginning of a forty-year period of growth in which English engravers and mezzotinters were to become the incontestable leaders of not only the European but also of the world print trade.

A turning point in British sculpture equivalent to that wrought by the Niobe print was marked by the publicly funded monument to General James Wolfe at Westminster Abbey (1760–72), whose glorious death during the British victory over French forces at Quebec in 1759 came to symbolize that essential moment when Britain came of age as an imperial power [**122**]. The monument was commissioned after a triumphalist memorial speech by William Pitt as part of a concerted attempt to manufacture a hero to embody his own aggressive imperial policy. In his official capacity as Lord Chamberlain, Pitt's acolyte the Duke of Devonshire was ultimately responsible for choosing Joseph Wilton, a young English artist fresh with triumphs from Rome, to execute the monument. Wilton was chosen from a throng of established foreign-born masters and more experienced indigenous sculptors who submitted designs to a public competition. As with the choice of the young Robert Taylor to execute the Mansion House pediment a decade before, this decision accorded with a burgeoning public expectation that a new generation of British artistic talent was ready to rise to the fore in portentous times. A youthful, vigorous British talent was again chosen to capture in marble the virile heroism of the nation. This also was not a false dawn; British sculpture, for a hundred years controlled by Netherlandish, French, and Italian workshop masters, was after 1760 to be consistently dominated by home-grown talent.

Wilton's design for the Wolfe monument was not surprisingly a piece of nationalist bombast. The Frenchman Pierre Grosley who visited the sculptor's studio in the mid-1760s noted with dismay that the model for the monument showed the foot of the dying general placed firmly on the *Fleur de Lis* of a French flag.[63] Although the imagery of the monument has an element of machismo triumphalism it was also intended to appeal to more delicate sensibilities. The naked figure of Wolfe expiring before his loyal officers has more in common with the iconography of the *pietà* than that of conventional Roman triumph. Wolfe, who was rumoured to have read passages of Edward Young's *Night Thoughts* on the eve of his death, was more a hero of male sensibility than bombastic virility.

Monuments and history paintings relating to British martial successes of the Seven Years' War—the reputedly heroic feats of men such as Amhurst, Clive, and Watson—tended to stress the humanity and compassion of the victors.[64] On occasion a sharp contrast with the cruel might of their French rivals was suggested. There appears to have been a great deal of concern that this new imperial phase of British

history should avoid the taint of despotism and bull-necked autocracy so often associated with Roman expansionism. Aware that the fall of the Roman empire could be attributed to the brutality with which the yoke of Rome was initially enforced upon the world, British artists and the sponsors of public art were keen to stress the humanity of British soldiery. Great efforts were made to illustrate the idea that British forces who made use of 'savages' brought out their tendencies toward primitive nobility rather than inhuman barbarism.

This idea was most famously enshrined in Benjamin West's *Death of Wolfe* (1770), in which a beautiful naked figure of a tattooed 'Indian' was to be seen contemplating his general's dying moments [2]. West's figure assumes a pose conventionally associated with melancholy indicating that this was no unfeeling brute, rather a dignified 'primitive' who mourned sincerely and was unfamiliar with the civilized skill of faking profound sympathetic emotion. West, and many of those who saw the painting in the Academy, was probably aware that French troops were frequently accused of bringing out the worst in their 'Indian' forces, encouraging them toward acts of mindless cruelty.[65]

This was by no means the first art work in which West had explored the inherent humanity of the savage. On his arrival in Rome from America in 1760, just a year after Wolfe's victory, the young Benjamin West was requested by the British connoisseurs Joseph Shipley and John Murray to paint *The Indian Family* [123]. The painting centres upon a figure of an Indian chief in the pose of the Apollo Belvedere. In a footnote to his poem *The Landscape: A Didactic Poem in Three Books* (1794) Richard Payne Knight recalled the following anecdote of West which helps to elucidate the artist's interpretation of the 'body language' of the native American in this painting and the *Death of Wolfe*:

It has been frequently observed by travellers that the attitudes of savages are in general graceful and spirited; and the great artist who now fills the President's chair in the Royal Academy, assures me, that when he first saw the Apollo Belvidere, he was extremely struck with its resemblance to some of the Mohawk warriors whom he had seen in America. The case is, that the Mohawks act immediately from the impulse of their minds, and know no acquired restraints or affected habits.

West's painting reflected the optimistic Enlightenment notion that man in his innocence was sensitive and tender with a kind regard for his fellows. According to this philosophical position, it was excessive exposure to civilization rather than the absence of civilization that was seen to render man vicious, unsympathetic, and forgetful of his familial feelings. The members of West's Indian family were manifestly held to be capable of deep attachment to one another and of conjugal loyalty, emotions which, as we have seen, were considered by many moral commentators to be all too rare in degenerate European society.

A similar conception of Indian familial loyalty was celebrated by
Wright of Derby in his atmospheric nocturne scene of *The Indian
Widow* (1783–5) [**124**]. Wright states in his manuscript notes that:

This picture is founded on a custom which prevails among the savage tribes of
America, where the widow of an eminent warrior is used to sit the whole day,
during the first moon after his death under a kind of trophy, formed of a tree
looped and painted; in which the weapons and martial habiliment of the dead
are suspended.[66]

One of the most revealing phrases in this passage is the description of
the 'martial habiliment' as 'a kind of trophy'. Wright was most prob-
ably aware of the practice of forming similar 'trophies' in Antiquity
upon the site of the decease of particularly 'eminent warriors'.
Moreover, the posture of Wright's *Indian Widow* and her composi-
tional relationship to the trophy most clearly relates to the iconography

of eighteenth-century English funerary sculpture, most notably Scheemakers's seated figure of the Duchess of Buckingham beside the trophy of her husband in Westminster Abbey [84]. Wright may well be implying through this use of imagery that this noble member of a 'savage tribe' is as fitting an example of rare conjugal loyalty as the worthy matron of classical monumental art.

The tendency to apply the biological theory of civilization to non-European peoples was endemic in late eighteenth-century British culture. The ghosts of the primal antique world were found in the physiques, buildings, and cultural institutions of numerous 'savage' peoples from the newly discovered South-Sea Islanders to African Negro slaves. The latter were only construed as noble savages by the most ardent eighteenth-century abolitionists who argued that Britain's claim to have a truly civilized empire could not accommodate such subjugation. Biological theory was even employed in branding the more ancient civilizations colonized by Europeans in the period as naturally degenerate and open to more worthy rule. William Hodges's *Select Views of India* of 1786 appears to revolve around the idea that contemporary Indian culture was in the final phase of the biological cycle. The book includes many illustrations of the ruins of Indian imperial palaces, a few of which are described as 'monuments of once human greatness dissolving into dust'. These images of ruin may be considered as the pictorial vindication of the polemic of those who argued that British colonial incursions into India were those of a virile culture stepping into a power vacuum which had opened up as the natural consequence of the natives' depraved hunger for internecine strife.

124 Joseph Wright of Derby
The Indian Widow, oil on canvas, 1783–5

125 John Charles Felix Rossi

The British Pugilist, white marble, 1828

Age has exposed joints on the lower thighs which place in doubt Smith's claim that the statue was constructed from a single block

With the rise of nationalist movements in early nineteenth-century Britain the search for the noble primitive untouched by modern corruption started to centre a little closer to home. Artists began to look at the physiques and postures of contemporary British manhood and to compare them with those encountered in classical statuary. Particular attention was given to the physiques of boxers who were taken to embody the British sense of manly spirit tempered by humanity. The virile British fist fighter was held to be violent without being vicious, unlike the degenerate Italian knife fighter. John Moore noted when talking of the murderous practices of the Romans that even 'the lowest blackguard in England will fight fairly with his fists'. In a manual of the art of boxing published in 1812 Pierce Egan observed that: 'The manly art of boxing has infused that true heroic courage, blended with humanity, into the hearts of Britons, which has made them so renowned, terrific and triumphant, in all parts of the world.'[67]

In June and July 1808 a series of meetings were organized for prominent British Academicians to study the forms of well-known British boxers amongst the recently imported marbles of Lord Elgin. Opinion generally favoured the idea that the muscular forms of such 'salt of the earth' British athletes, closely resembled those encountered by antique artists. One of the artists most to admire the form and proportion of the modern boxers was the sculptor J. C. F. Rossi (1762–1839) who some twenty years later carved his *magnum opus*, *The British Pugilist* (made for the sculpture gallery of Lord Egremont in 1828) [125]. This statue was to stand as permanent witness not only to the antique virility of modern British manhood but also of the capability of the modern British sculptor to exhibit a mastery over the beauties and complexities of the male form which rivalled that of the antique sculptors. The dexterity and athleticism of the sculptor was seen to rival that of his subject. J. T. Smith noted that, unlike British sculpture of the early eighteenth century which was generally constructed of many pieces of marble, this 'truly vigorous and masterly' figure was carved out of a single block.[68]

The idea that the bodies of such 'ordinary' citizens exhibited such virile perfection had a great appeal to those artists and writers with a thirst for radical political reform. It was for this reason that the subject of the manly struggle between British pugilists appealed to Hazlitt who published a notable essay entitled *The Fight* in 1822. Street athletes, cult heroes of the common crowd, could be considered to have drawn their strength from their lack of contact with the corrupt and luxurious upper classes. It was in such quarters that the primitive virility of the nation was deemed to be preserved.

Hazlitt's friend Benjamin Haydon, also an energetic supporter of political reform, expresses a similar idea in his *Mock Election* of 1827 [126] where he records the entertaining sight of a parodic election

126 Benjamin Haydon

Mock Election, oil on canvas, 1827

which he had witnessed in prison when incarcerated for debt. Although enacted by prisoners, the mock election is depicted as a less sinister and corrupt affair than the real elections of the outside world. Accordingly, those involved in the festivities exhibit physiques less corrupted by excess than those of a 'real' election gathering. Haydon was clearly aware of Hogarth's engraving of *The Election Entertainment* from the famous *Election Series* (1754–5) and intended his *Mock Election* to be compared with it [**127**].

This *Mock Election* may well have been intended specifically to mock Hogarth's *Election* rather than just a typical election in the outside world. Comparison of the paintings seems to have been intended to favour Haydon and the more classically attuned and serious era of British painting which he considered himself to represent. Much as Hogarth's painting exhibits the forms and tone of the burlesque, reminiscent of a Dutch tavern scene by a genre painter such as Teniers or Brouwer, Haydon's centres on figures of a noble bearing and evinces something of the grand spirit of a history painting. In the same way as the scene of the mock election is more noble than that of Hogarth's actual election, Haydon's mockery of Hogarth's painting is itself more noble than the original. The irony is, of course, that the painter respon-

sible for this reformation of British painting is, like the noble figures he depicts, to be found in prison for debt rather than leading his society to glory.

Haydon focuses on an extremely muscular sportsman with a tennis racket at his side who amusedly observes the proceedings. His position within the painting is roughly equivalent to that of Hogarth's Mayor who, seated at the top of the table, expires in an apoplectic fit brought about by a surfeit of oysters. Haydon's hero likes a drink and a gamble but resembles more the healthy young Bacchus of Antiquity than a modern British degenerate. He exhibits a fine straight nose and elegant poise which derive directly from the antique. The figure is, in fact, a dressed version of the so-called *Torso of Dionysus*, the principal male figure amongst the pediment sculpture of the Parthenon. Haydon knew the *Torso* well; over the past decade he had made numerous careful studies of it and the other major figures of the Elgin Marbles.

A beautiful maid with a similarly classical profile lovingly attends this British Dionysus. She assumes the same position as the degraded barber surgeon who in Hogarth's painting bleeds the Mayor for his disgusting affliction. A similarly noble youth armed with the attributes of Liberty assumes the exact position of Hogarth's grotesque female fiddle player in the centre of the composition. It was in these noble but politically marginalized figures that Haydon found the real spirit of 'British liberty'. Such figures are portrayed as the true guardians of liberty, a political tradition which, like their physical poses, ultimately derived from the example of Periclean Athens.

Haydon was not alone in feeling that Britain's chances of inheriting the mantle of classical civilization were much improved by the arrival

127 William Hogarth

The Election Entertainment (from the series *The Election*, 1754–5), oil on canvas

of the so-called Elgin Marbles in the country. Early criticism that the marbles had been effectively purloined was answered by the claim that Britain had more claim to be an inheritor of the Athenian spirit than the modern Athenians. The writer of an article calling for a new Temple or Palace to the arts in the *Gentleman's Magazine* of 1816 suggested if it were true that:

Free governments afford a soul most suitable to the production of natural talent . . . by opening to merit the prospect of reward and instruction, no country can be better adapted than our own to afford honourable asylum to these monuments.

Part of the attraction of the political and cultural tradition of the primitive Athenian *demos* in post-Napoleonic Britain was that it offered a pre-Roman origin for European civilization. Rome's primitive political order, the early republic celebrated in David's *Oath of the Horatii*, had been heavily contaminated by continuous association with French Revolutionary ideology; an ideology which even ardent supporters of political reform such as Benjamin Haydon conceded to have led to little but anarchy and atheism. The reputation of early imperial Rome was also somewhat besmirched as a prototype for the modern British state. From the 1770s onwards the intervention of imperial Rome in early British history had been regularly interpreted as an obstruction rather than encouragement to the development of the historical tradition of British liberty. As Sam Smiles has shown, paintings recording Julius Caesar's famous landing on British shores generally show a ruthless and organized force tyrancially suppressing a noble and free warrior people.[69]

The conflict between the tyrannical authoritarianism of Rome and the free spirit of the primitive Celtic British society was most apparent in images recording the indomitable nobility of King Caractacus when captured and led in triumph to Rome to be presented to Emperor Claudius. Whilst occasionally a subject for artists and poets in the first seven decades of our period, this narrative began to assume a central role in the British historical imagination after 1776 when it became the subject of a popular London stage play. Thomas Banks's magnificent relief of the presentation of Caractacus made in Rome for the Marquis of Buckingham in 1777 is probably the most memorable rendition of a subject which captured the imagination of a number of major artists. Banks makes much of the comparison of the muscular figure of the Celtic British King and that of the seated Claudius indicating that this northern hero not only shamed his Roman counterpart with his dignity of spirit but was also at least his match in the department of physical prowess [**128**].

Banks's Caractacus bears witness to the major northern European intellectual movement to resurrect and dignify its 'gothic' or

*Caractacus in the Presence of
Emperor Claudius*, marble
relief, Stowe School,
Buckingham, 1777

'barbarian' past and forever shake off the stigma of inferiority which
Mediterranean society had imposed upon the North in Roman im-
perial times. A veritable panoply of elemental northern heroes—some
invented, some plucked from the dimmer annals of history—were
spun into the political and cultural mythology of northern European
nations. Such heroic ancestors added lustre to the North's claim that it
had no lesser role than the South in the historical development of what
was great and good in modern European culture.

The most celebrated manufacturer of works purporting to be the
lost epic poetry of primitive northern peoples was the Scots versifier
James Macpherson. Between 1760 and 1765 Macpherson published
three major editions of verse which he claimed to have transcribed
from formerly unknown ancient Gaelic manuscripts or had derived
from oral sources in the Scottish Highlands. Although effectively
exposed as largely his own invention Macpherson's 'discoveries', in par-
ticular *The Works of Ossian* (1765), have a claim to be regarded as late
eighteenth- and early nineteenth-century Europe's most important
and influential literary works. This was a forgery which succeeded
because there was a cultural imperative to suspend disbelief. Herder
spoke for many when he commented that, even if the poems were not
genuine, they deserved respect as 'a pious swindle'. Although trans-
lated into Spanish and Italian the works were most applauded in
northern Europe. They provided northern Europe with an epic verse
tradition which had a primitive *gravitas* rivalling that of the poetic
works of Homer. Runge went as far as to suggest that the discovery of
Ossianic poems had negated all need to observe the old practice of
going on the Grand Tour to southern Europe.

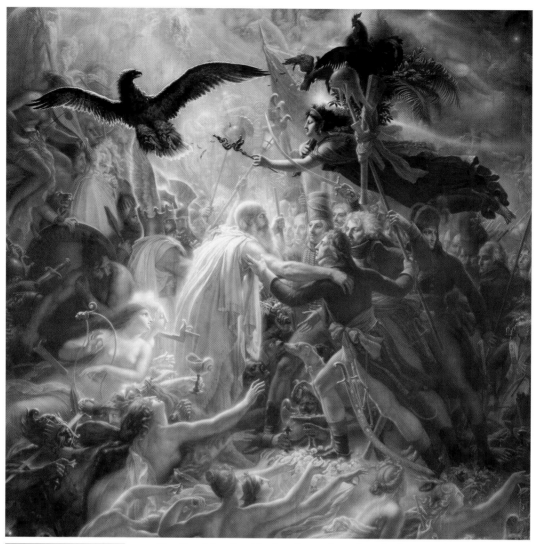

129 Anne-Louis Girodet

Ossian Receiving the Generals of the Republic, oil on canvas, 1802

Predictably the Ossian legends enjoyed their earliest popularity amongst Scottish artists. The first major cycle of Ossianic paintings were commissioned in 1771 by Sir James Clerk for the ceilings of his mansion at Penicuik near Edinburgh from Alexander Runciman (1736–85), an artist justly reputed to be the most brilliant Scottish painter of his generation. Significantly the fame of the Ossian legend encouraged Runciman to abandon his original intent of painting a cycle from the life of Achilles. Subsequently Ossianic legend was celebrated by artists of more or less every northern European country.

It was in Napoleonic France, however, that paintings based on Ossianic legend assumed their greatest significance as patriotic myths glorifying northern European warrior culture. Subjects from Ossian were particularly favoured by painters trying to attract the attention and support of Napoleon himself. It was well known that

Macpherson's book was the great man's favourite read. Ironically some of these Ossianic paintings were used to form propaganda attacks on the very nation in which the poem originated. One such was Girodet's extraordinarily complex composition showing Ossian receiving the ghosts of French warriors in the Palace of Odin, a painting which was made with Napoleon in mind in 1802 [**129**]. Girodet designed the painting as an attack on the British for opposing the fraternity of northern European nations which Napoleon claimed to be aiming to establish by the signing of the Treaty of Lunéville in February 1801. George Levitine has succinctly described the narrative of one of the central groups of figures:

the French are triumphantly marching under the figure of Victory, which seems to be supported by the sabre of one of the soldiers . . . The figure of Victory offers the caduceus of peace to the warriors of Morven. The latter undoubtedly personify the continental nations vanquished by Bonaparte, among which the Austrian Empire, alluded to by the eagle, was most powerful. They show the sad dignity of those who are 'vanquished without being humiliated'.[70]

The British, symbolized by the 'seditiously whistling' followers of Starno, attempt to disturb this northern European concord. Girodet explicitly points out the superiority of these ancient northern peoples over the Romans. As proof of their manly valour the warriors of Ossian show the ghosts of the French soldiers a helmet, standard, and eagle they have captured from the Romans. The painting as a whole is a celebration of northern European virility. The ghosts of the Napoleonic soldiers, incorrigible even in death, are clearly seen to be making advances to the Ossianic maidens.

Not only in content but in form Girodet's painting represented a confident movement away from the Greek and Roman cultural inheritance. The composition flouted every canon of classical 'rule'. It is not surprising that David is reported to have wondered out loud after seeing the painting whether Girodet had lost his mind. However absurd in historical hindsight the Ossianic legends might appear, their invention marked a vital turning point in European cultural history. They struck the first blow at the edifice of the classical inheritance: the process through which European culture extricated itself from the feeling that it was constantly occupying a place in the shadow of its Greek and Roman past. When Macpherson picked up his pen to write his 'pious swindle' he was unwittingly helping to bring about the day when antique plaster casts would be ejected from the art schools and a thorough knowledge of Greek and Roman literature would cease to be the primary indication of the cultivated European mind.

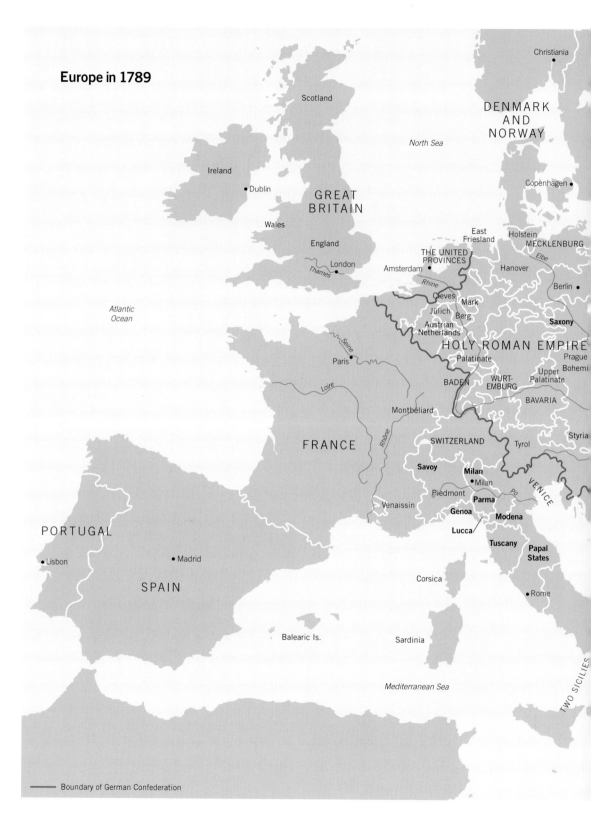

Europe in 1789

Christiania

Scotland

DENMARK
AND
NORWAY

North Sea

Copenhagen

Ireland

Dublin

GREAT
BRITAIN

Wales

England

London

Thames

Amsterdam

THE UNITED
PROVINCES

East
Friesland

Holstein

MECKLENBURG

Elbe

Hanover

Berlin

Rhine

Cleves

Mark

Jülich

Berg

Austrian
Netherlands

Saxony

Atlantic
Ocean

Seine

HOLY ROMAN EMPIRE

Paris

Palatinate

Prague

Bohemi

Loire

BADEN

WURT-
EMBURG

Upper
Palatinate

Montbéliard

Rhône

SWITZERLAND

BAVARIA

FRANCE

Savoy

Milan

Milan

Tyrol

Styria

Piedmont

Parma

Po

VENICE

Venaissin

Genoa

Modena

PORTUGAL

Lucca

Tuscany

Papal
States

Lisbon

Madrid

Corsica

Rome

SPAIN

Balearic Is.

Sardinia

Mediterranean Sea

TWO SICILIES

——— Boundary of German Confederation

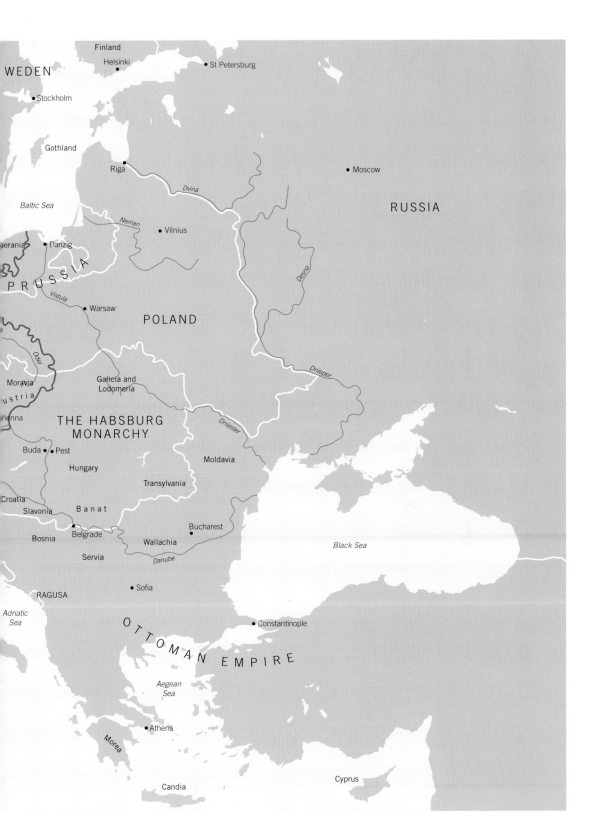

WEDEN

Finland

Helsinki

• St Petersburg

• Stockholm

Gothland

RUSSIA

Riga

Dvina

Baltic Sea

Neman

• Vilnius

• Moscow

erania

• Danzig

P R U S S I A

Desna

Vistula

• Warsaw

POLAND

Moravia

Oder

Galicia and
Lodomeria

Dnieper

ustria

• Vienna

THE HABSBURG
MONARCHY

Dniester

Buda • • Pest

Hungary

Moldavia

Transylvania

Croatia

Slavonia

B a n a t

Bosnia

Belgrade

• Bucharest

Wallachia

Black Sea

Servia

Danube

• Sofia

RAGUSA

*Adriatic
Sea*

O T T O M A N E M P I R E

• Constantinople

*Aegean
Sea*

• Athens

Morea

Candia

Cyprus

MAP 277

Notes

Introduction

1. At the beginning of ch. 2 of 'Transformations' entitled '*Exemplum Virtutis*' Rosenblum encounters the problem of historical causality and directs the reader to Marxist interpretations of the period such as Frederick Antal's *Hogarth and his Place in European Art* (London, 1962) and Milton Brown's *The Painting of the French Revolution* (New York, 1938).

2. A. O. Lovejoy, *The Great Chain of Being* (Cambridge Mass., 1936) and *On the Discrimination of Romanticism*, in *Essays in the History of Ideas* (Baltimore, 1948).

3. Translation drawn from F. X. Coleman, *The Aesthetic Thought of the French Enlightenment* (Pittsburgh, 1971), 80.

4. Quoted from J.-P.-B. Le Brun, *Almanach Historique et Raisonné des Architectes, Peintres, Graveurs, etc.*, Paris, 1776. Translation drawn from J. Focarino (ed.), *Jean-Baptiste Grueze 1725-1805* (Hartford, 1972).

5. In his introduction to *Eighteenth-Century Aesthetics and the Reconstruction of Art* (Cambridge, 1993) Paul Mattick makes a strong argument that aesthetics as a public discourse was invented in the mid-18th cent. See also W. Tartarkiewicz, *The History of Aesthetics* (The Hague, 1970).

6. For Henry Fuseli's strongest attacks on the notion of the public utility of the visual arts, see E. Mason, *The Mind of Henry Fuseli* (London, 1951), 193-5.

7. Quoted from W. Hazlitt, *Criticisms on Art and Sketches of the Public Picture Galleries of England* (London, 1866), 235.

8. In the above quotation from Hogarth's Memoirs we can detect a strong discontent with the fact that he was obliged to turn to 'the public at large' for his income after giving up the prospect of earning a living as a history painter.

9. V. Green, *A Review of the Polite Arts in France at the Time of their Establishment under Louis XIV Compared to their Present State in England* (London, 1782), 50.

10. E. and J. De Goncourt, *French Painters of the Eighteenth Century* (London, 1958), 163.

Chapter One

1. Translation appears in A. Brookner, *Greuze, The Rise and Fall of an Eighteenth Century Phenomenon* (London, 1972), 44-5.

2. H. Baily, *Francesco Bartolozzi R.A.* (London, 1907), p. xlv. Quote from a copy of the *Morning Post* published in 1802.

3. A strong account of these tendencies in French art culture is provided by Martin Weyl in *Passion for Reason and Reason for Passion: Seventeenth Century Art and Theory in France* (New York, Bern, and Frankfurt, 1989).

4. E. Mason, *The Mind of Henry Fuseli* (London, 1951), 193.

5. For Fuseli at his strongest on this matter see Lecture X and Lecture XII of his Academy lectures.

6. J. S. Memes, *Memoirs of Canova* (London and Edinburgh, 1825), 319.

7. J. Northcote, *The Conversations of James Northcote R.A. with James Ward on Art and Artists* (London, 1901), 231.

8. J. Flaxman, *Lectures on Sculpture as Delivered before the President and Members of the Royal Academy* (London, 1838), 51.

9. M. Snodin (ed.), *Karl Friedrich Schinkel: A Universal Man* (New Haven and London, 1991), 2.

10. G. Jones, *Sir Francis Chantrey R.A. Recollections of his Life, Practice and Opinions* (London, 1869), 223. A letter to C. H. Turner of February 1830 begins 'Pig, Pork, and Pheasant—All Good!'

11. E. and J. De Goncourt, *French Eighteenth Century Painters* (London, 1958), 168-9.

12. An illustration of this print can be found in E. A. Boime (ed.), *French Caricature and the French Revolution 1789-1799* (Los Angeles, 1988), 144.

13. Quoted from De Goncourt, *French Eighteenth Century Painters*, 254-5.

14. Ibid. 225–6.

15. N. Penny and M. Clarke, *The Arrogant Connoisseur: Richard Payne Knight* (Manchester, 1982), 101.

16. Turner's verse to John Taylor of *The Sun* (Jan. 1811, British Library, Add. MS 50118, fo. 24) begins 'Thanks gentle Sir for what you sent / with so much kindness praise "bespente" ' — makes one thankful that he kept up his day job.

17. Northcote, *The Conversations of James Northcote*, 31–2.

18. Ralph Wornum, writing in *Lectures on Painting by the Royal Academicians* (London, 1848), 250.

19. G. Levitine, *The Dawn of Bohemianism* (Pennsylvania, 1978), 12.

20. A positive attitude to the role of market forces in the production of novelty can be found in the unpublished speech of Henry Cheere, a leading member of the St Martin's Lane coterie, to the Society of Arts.

21. These views are drawn from Lectures V, X, XI, XII, of Fuseli's Academy Discourses.

22. The quote actually appears in a letter to Archdeacon John Fisher of Oct. 1831, in C. R. Leslie, *Memoirs of the Life of John Constable, Esq., R.A.* (London, 1949), 104.

23. Jones, *Sir Francis Chantrey*, 176–7.

24 This impression is particularly strong in Blake's jocular attitude to the drawing of the now-famous *Spirit Heads* in the presence of John Varley, the very model of the cultivated eccentric.

25. For an interesting commentary on the relationship of Hume's aesthetic views to his theories of the sociability of man, see T. A. Gracyk, 'Rethinking Hume's Standard of Taste,' *Journal of Aesthetics and Art Criticism*, 52: 2 (Spring, 1994), 169–82.

26. K. Jaffe, 'The Concept of Genius in the Eighteenth Century', in P. Kivy (ed.), *Essays in the History of Aesthetics* (Rochester, NY, 1992), 226–7.

27. A. E. Pérez Sanchez and E. A. Sayre, *Goya and the Spirit of Enlightenment* (Boston, 1989), 38.

28. L. Eitner, *Géricault, The Raft of Medusa* (London, 1972), 14.

29. G. Levitine, 'Vernet Tied to a mast in a Storm: The Evolution of an Episode in Art Historical Romantic Folklore', *Art Bulletin*, 49 (June 1967), 92–100.

30. An excellent indication of the popularity of Horace Vernet is given by Richard Wrigley in *The Origins of French Art Criticism* (Oxford, 1995), 348.

31. This aspect of Goya's career was covered well in N. Glendinning, *Goya and his Critics*

(New Haven and London, 1977), 28.

32. This painting can be found illustrated in R. Ormonde, *Sir Edwin Landseer* (London, 1981), 108–9.

33. J. Nichols, *Anecdotes of William Hogarth* (London, 1833), 31.

34. An excellent review of this painting has been written by H. Borsh-Supan, 'Caspar David Friedrich's Landscapes with Self-Portraits', *Burlington Magazine*, vol. 114 (Sept. 1972), 640.

35. I here refer to the very thorough biography of Bellotto by Stephen Kozakiewicz, *Barnardo Bellotto* (London, 1972), 2 vols.

36. J. Habermas, *Structural Transformations in the Public Sphere* (Oxford, 1989), 13.

37. K. Garlick, A. Macintyre (eds.), *The Diary of Joseph Farington* (New Haven and London, 1978), i. 208, reveals that Banks lost the contract for the monument to Capt. Montague on political grounds.

38. J. C. B. Cooksey, *Alexander Nasmyth H.R.S.A. 1758–1840, A Man of the Scottish Renaissance* (Edinburgh, 1991), 24–5.

39. R. and S. Redgrave, *A Century of Painters of the English School* (London, 1890), 210.

40. Northcote's touching memorial to Opie was published in J. Northcote, *Memoirs of Sir Joshua Reynolds* (London, 1813), 287.

41. Northcote, *The Conversations of James Northcote*, 174–5.

42. This quote appears in A. M. Clark, *Pompeo Batoni* (Oxford, 1983), 18.

43. W. T. Whitley, *Artists and their Friends in England 1700–1799* (London, 1928), ii. 310.

44. Information drawn from M. Benisovich, 'Ghezzi and the French Artists in Paris', *Apollo* (May 1967).

45. For Patch's politeness to those he caricatured see the review of his career in *The Proceedings of the Walpole Society*, 28 (1939–40), 24.

46. This point is made in J. T. Spike, *Giuseppe Maria Crespi and the Emergence of Genre Painting in Italy* (Fort Worth, 1986), 62–5.

47. S. A. Alpers and M. Baxandall, *Tiepolo and the Pictorial Intelligence* (New Haven and London, 1994).

Chapter Two

1. A fuller account of the development of the international public sphere with a useful introductory bibliography to the subject can be found in ch. 1 of E. L. Eisenstein, *Grub Street Abroad: Aspects of the French Cosmopolitan Press from the Age of Louis XIV to the French Revolution* (Oxford, 1992).

2. Quote drawn from J. Nichols, *Anecdotes of*

William Hogarth (London, 1833), 62–3.

3. For a fuller account of the imagery of this painting see P. Conisbee, *Claude–Joseph Vernet, 1714–1789* (catalogue of an exhibition organised by the Greater London Council, Kenwood House, London, 1976).

4. A persuasive argument drawing connections between Vernet's painting and Ledoux's plans for the City of Chaux can be located in A. Vidler, *Claude-Nicolas Ledoux, Architecture and Social Reform at the end of the Ancien Régime,* (Cambridge, Mass, 1994), 256.

5. This translation is taken from Christian Otto's entry on The idea of History, in J. W. Yolton, *The Blackwell Companion to the Enlightenment* (Oxford, 1991), 222–4.

6. P. Gay, *The Enlightenment: An Interpretation*, 2 vols. (Weidenfeld, 1967, 1969); P. Hazard, *European Thought in the Eighteenth Century, from Montesquieu to Lessing* (London, 1954); F. Venturi, *Italy and the Enlightenment: Studies in a Cosmopolitan Century* (London, 1972).

7. This translation is drawn from A. M. Link, 'Papier Kultur. The New Public, The Print Market and the Art Press in Eighteenth Century Germany', unpub. Ph.D. thesis (University of London, 1993), 155–6.

8. Note of the serious effects of the Napoleonic embargo on the British print industry was made in the *Gentleman's Magazine* (1804), 904.

9. An account of the collapse of Valentine Green's fortunes can be found in A. Whitman, *British Mezzotinters, Valentine Green* (London, 1902).

10. S. Woolf, *Napoleon's Integration of Europe* (London, 1991).

11. A copy of this proposal is preserved in the British Library J. P. L. L. Houel, *Projet d'un Monument Public, qui l'on pourroit élever au milieu d'une des places publiques de Paris etc.* (Paris, 1799; BL 936.c. 35 (35)).

12. This translation is drawn from P. Rimington, 'A Monument Honouring the Invention of the Baloon', *Metropolitan Museum Bulletin* (April 1944), 246–8.

13. Translation drawn from G. H. Holt (ed.), *The Triumph of Art for the Public* (Washington, DC, 1980), 179–97.

14. Translation drawn from J. Leighton and C. Baily, *Caspar David Friedrich, Winter Landscape* (London, 1990), 16.

15. Translation drawn from K. Andrews, *The Nazarenes: The Brotherhood of German Painters in Rome* (Oxford, 1964), 11.

16. A fuller account of Herder's reaction to Winckelmann may be found in ch. 8 of F. Haskell, *History and its Images: Art and the Interpretation of the Past* (New Haven and London, 1993).

17. Translation drawn from J. C. Taylor, *Nineteenth-Century Theories of Art* (Berkeley, 1987), 129–38.

18. Quote drawn from E. C. Parry, 'Thomas Cole's Imagination at Work in the Architect's Dream', *American Art Journal*, 12:1 (Winter 1980), 41–59.

19. Haydon Diaries, ii. 110.

20. Hazlitt to the *Champion*, 25 Dec. 1814. Reprinted in R. Wark, *Sir Joshua Reynolds' Discourses on Art* (London, 1988), 326–31.

21. A. W. N. Pugin, *Contrasts*, with an introduction by H. R. Hitchcock (Leicester, 1969), 9.

22. The interpretations of the painting are reviewed by various authors in T. G. Stavrou (ed.), *Art and Culture in Nineteenth Century Russia* (Bloomington, Ind., 1983), 33, 80, 116, 119, 122, 129.

23. I refer here to a press controversy in which several prominent members of the St Martin's Lane circle associated with the *Weekly Register* in 1734–5 indulged in a campaign against the Venetian mural painter Pietro Amiconi who was perceived to be dominating the British market for such work. Amiconi's works were stoutly defended by the *Grub Street Journal*.

24. Hogarth's letter signed Britophil complaining that 'poor Englishmen' had been made the 'universal dupes' of Continental artists first appeared in the *St James Evening Post* of 7 June 1737 and was reprinted in the July 1737 edition of the *London Magazine*.

25. J. Nichols, *Anecdotes of William Hogarth*, 47.

26. G. Newman, *The Rise of English Nationalism: A Cultural History 1740–1830* (London, 1987).

27. For a general introduction to this subject see E. Hobsbawn, *Primitive Rebels* (New York, 1965).

28. T. Seebass, 'Leopold Robert and Italian Folk Music', *The World of Music,* Journal of the Institute for Comparative Music Studies and Documentation in association with the International Music Council, 30: 3 (1988), 59–84.

29. A good review of this painting appears in J. M. Olson, *Ottocento—Romanticism and Revolution in Nineteenth Century Italian Painting* (New York, 1993), 140–1.

30. B. Mantura, *Leopold Robert* (Spoleto, 1986), 48.

31. Translation drawn from Taylor, *Nineteenth Century Theories of Art*, 246–59.

32. W. Hodges, *Travels in India* (London, 1793), 155–6.

33. E. Smith, *The Life of Joseph Banks* (London, 1911), 16.

34. A general introduction to the concept of the victims of history can be found in H. G. Schenk, *The Mind of the European Romantics* (London, 1966), ch. 5.

35. W. Gilpin, *Observations, relative chiefly to Picturesque Beauty, Made in the year 1776, On several parts of Great Britain; particularly the High-Lands of Scotland* (London, 1789), ii. 138.

36. Quote drawn from D. Blayney Brown, *Sir David Wilkie of Scotland (1785–1841)* (Oxford, 1987), 175.

37. A review of this print can be found in D. Bindman (ed.), *The Shadow of the Guillotine: Britain and the French Revolution* (London, 1989), 113.

38. Quote drawn from L. Brandel, *Capitalism and Material Life 1400–1800* (London, 1974), 423.

39. A fuller account of Le Prince's prints of Russian customs can be found in E. F. S. Dilke, *French Engravers and Draughtsmen of the Eighteenth Century* (London, 1902), 152.

40. Quoted from the introduction to R. Wornum, *Lectures on Painting by Royal Academicians* (London, 1848), 39.

41. C. R. Leslie, *The Memoirs of John Constable esq. R.A.* (London, 1949), 115.

42. A commentary on the intellectual context of Gibbon's views on international emulation can be found in J. G. A. Pocock, *Virtue, Commerce and History* (Cambridge, 1991), ch. 5.

43. N. Pevsner, *Academies of Art* (New York, 1973), 167.

44. D. E. Williams, *The Life and Correspondence of Sir Thomas Lawrence* (London, 1831), ii. 2–3.

45. Wark, *Sir Joshua Reynolds' Discourses on Art*, Discourse III, p. 43, ll. 56–9.

46. Ibid. p. 44 ll. 103–5.

47. Ibid. IV, pp. 57–8, ll. 24–31.

48. From Lecture 3, *Invention*, reprinted in Wornum, *Lectures on Painting by the Royal Academicians*, 419.

49. *The works of Anthony Raphael Mengs* (Translated from the Italian, publ. J. N. d'Azara, London, 1796), ii. 9.

50. Ibid. 69.

51. A good translation of this speech can be found in N. Glendinning, *Goya and his Critics* (New Haven and London, 1977), 45.

52. Institut de France, *Recueil des discours prononcés dans la séance publique annuelle le jeudi 24 Avril 1817* (Paris, 1817).

53. Quoted from a letter published in W. G. Constable, *John Flaxman 1755–1826* (London, 1927), 39.

54. Translation drawn from Holt, *The Triumph of Art for the Public*, 55.

55. G. Jones, *Sir Francis Chantrey R.A. Recollections of his Life . . .* (London, 1869), 117.

56. E. Plon, *Thorvaldsen: His Life and his Works* (London, 1874), 42–4.

57. Haydon Diaries, i. 482.

58. J. B. Atkinson, *An Art Tour to the Northern Capitals of Europe* (London, 1873), 52.

59. W. T. Whitley, *Artists and their Friends in England 1700–1799* (London, 1928), ii. 310–1.

60. Published as J. Barry, *An Enquiry into the Real and Imaginary Obstructions to the Acquisition of the Arts in England* (London, 1775).

61. A translation of this article is available in Holt, *The Triumph of Art for the Public*, 16–22.

62. Quoted from Karl Fernow's article, 'Concerning some new works of art by Professor Carstens', published in *Duer neue teutshe Merkur*, II (Weimar, June 1795).

63. B. Weinberg, *French and Scandinavian Sculpture in the Nineteenth Century* (Stockholm, 1978), 32–3.

64. Seebass, 'Leopold Robert and Italian Folk Music', 60.

65. Translated from Mantura, *Leopold Robert*, 49.

Chapter Three

1. Quoted from the *London Magazine* (May 1735), 225.

2. M. Hobson, *The Object of Art: The Theory of Illusion in Eighteenth-Century France* (Cambridge, 1982).

3. M. Novak (ed.), *English Literature in an Age of Disguise* (Berkeley and London, 1977).

4. A. O. Lovejoy, *Essays in the History of Ideas, Nature as an Aesthetic Noun* (Baltimore, 1948), 69–77.

5. W. Duff, *An Essay on Original Genius* (London, 1767), 91.

6. I quote here Marian Hobson's summary of Dubos's attitude to spectacle which she regards as a precursor to de Sade's 'aesthetics of torture' (Hobson, *The Object of Art*, 38–42).

7. M. Liversidge and J. Farrington, *Canaletto and England* (London, 1993), 91.

8. R. Sennett, *The Fall of Public Man* (New York, 1992).

9. N. Glendinning, *Goya and his Critics*, 60.

10. J. Locke, *An Essay Concerning Human Understanding* (1690), 7, 508. Quote drawn from R. Paulson, 'Hogarth and the Distribution of Visual Images', in B. Allen (ed.), *Towards a Modern Art World* (New Haven and London, 1995).

11. Hobson, *The Object of Art*, 48.

12. T. Castle, *Masquerade and Civilisation* (Stanford, 1986), 56.

13. For a general introduction to Chardin's association with the values of the 'third Estate', see E. Snoep-Reitsma, 'Chardin and the Bourgeois Ideals of his Time', *Nederlands Kunst Hist.* 24 (1973), 147–243.

14. *English Caricature, 1620 to the Present* (Victoria and Albert Museum, London, 1984), 53–4. Print entitled *The Beaux' Disaster*.

15. Translation taken from A. M. Link, 'Papier Kultur. The New Public, The Print Market, and The Art Press in Eighteenth-Century Germany', unpub. Ph.D. Thesis (Univ. of London, 1993), 304–5.

16. A discussion of the themes of Folly and Love in Fragonard's painting can be found in D. Ashton, *Fragonard and the Universe of Painting* (Smithsonian Institution Press, 1988), 227.

17. R. Rosenblum, *Transformations in Late Eighteenth Century Art* (Princeton, 1967).

18. J. J. Rousseau, *Politics and the Arts: Letters to M. d'Alembert on the Theatre*, trans. and ed. Allan Bloom (Cornell University Press, 1960), 101.

19. S. Maza, *Private Lives and Public Affairs, The Causes Célèbres of Prerevolutionary France* (Berkeley and London, 1993). In particular see ch. 4 on the 'Diamond Necklace Affair'.

20. For a brief review of the imagery of the breast of Marianne see R. Sennett, *Flesh and Stone: The Body and the City in Western Civilisation* (London and Boston, 1994), 285–92.

21. A useful introduction to the theme of the secret love letter in mid-18th-cent. France can be found in F. M. Keener and S. E. Lorsch, *Eighteenth Century Women and the Arts* (New York and London, 1988), article by P. H. Pawlowicz.

22. For a stimulating analysis of the imagery of the swinging woman see D. Posner, 'The Swinging Women of Watteau and Fragonard', *Art Bulletin*, 64 (1982), 73–88.

23. Translation drawn from F. Pedrocco, 'Artists of Religion and Genre', in J. Martineau (ed.), *The Glory of Venice: Art in the Eighteenth Century* (New Haven and London, 1995).

24. Translation drawn from Mattick, *Eighteenth-Century Aesthetics*, 87.

25. R. Paulson, *Hogarth and the Distribution of Visual Images* 29.

26. J. Nichols, *Anecdotes of William Hogarth* (London, 1833), 11.

27. This interpretation of the figure of the cleric has been drawn from a verse at the base of a pirate copy of the print published by Bowles in 1732.

28. Hobson, *The Object of Art*, 39. Referring to J.-B. Dubos, *Réflexions Critiques sur la Poésie et sur la peintre* (Paris, 1719), i. 11.

29. William Duff summarized the Enlightenment understanding of the 'penetrative mind', comparing the intellect of the philosopher with a conical beam of light focused on one point. The genius of the philosopher, Duff suggests, can be defined by a capacity to concentrate 'the rays of fancy'. Duff, *An Essay on Original Genius*, 97.

30. M. Fried, *Absorption and Theatricality: Painting and the Beholder in the Age of Diderot* (Berkeley and London, 1980), 98–100.

31. The term 'unmeaning' appears with some regularity in James Ralph's *A Critical Review of the Buildings, Statues, and Ornaments of London and Westminster* (London, 1734).

32. See ch. 2 of M. Craske, *The London Sculpture Trade and the Development of the Imagery of the Family in Funerary Monuments of the Period 1720–60* (unpublished Ph.D. thesis, University of London, 1992).

33. Ibid. ch. 6.

34. A brief review of this tendency can be found in A. Hemingway, *Landscape Imagery and Urban Culture* (Cambridge, 1992), 4.

35. For an illuminating discussion of the appeal of Dutch 'bombaccianti' to great 'Italian' patrons like Ferdinand de Medici see J. T. Spike, *Giuseppi Crespi and the Emergence of Genre Painting in Italy* (Fort Worth, 1986).

36. Translation drawn from O. Talbot-Banks, *Watteau and the North: Studies in Dutch and Flemish Influences on French Rococo Painting* (London, 1975), 23.

37. J. Ralph, *A Critical Review*, 84–5. Similar views were aired in J. T. Smith, *Nollekens and his Times*, 237.

38. D. Panofsky, 'Gilles or Pierrot? Iconographic notes on Watteau', *Gazette des Beaux Arts* 6: 39 (May–June 1952), 319–40.

39. J. Goodman and T. Crow, *Diderot on Art*, ii. *The Salon of 1767* (New Haven and London, 1995), 297.

40. T. Crow, *Painters and Public Life* (New Haven and London, 1985), chs. 3–5.

41. A reasonable summary of the arguments can be found in A. Ricci, *The Etchings of the Tiepelo* (London, 1971), 11.

42. A good introductory study of the discourse on magic in eighteenth-century Italy can be found in F. Venturi, *Italy and the Enlightenment: Studies in a Cosmopolitan Century* (London, 1972), 108–21.

43. S. Gwynn, *Memorials of an Eighteenth Century Painter* (London, 1898), 152.

44. The most complete account of the

Eidophusikon can be found in R. G. Allen, 'The Stage Spectacles of Philip James de Loutherbourg', unpub. Ph.D. dissertation (Yale University Press, 1960).

45. J. Stevens Curl, *The Art and Architecture of Freemasonry, An Introductory Study* (London, 1991), 203.

46. For Voltaire's attitude to mythical beasts and monsters see Saisselin, *The Rules of Reason and Ruses of the Heart*, p. 88, and M. Libby, *The Attitude of Voltaire to Magic and the Sciences* (New York, 1935).

47. G. Levitine, 'Literary Sources for Goya's Caprichos 43', *Art Bulletin*, 27: 1 (1955), 56–9.

48. S. Daniels, *Fields of Vision* (Cambridge, 1993), 50.

49. Some illuminating observations on Wright's association with the Incorporated Society can be found in Whitley, *Artists and their Friends*, ii. 340–2.

50. C. Westmacott, *A Descriptive Catalogue to the Exhibition at the Royal Academy* (London, 1823), 19.

51. Translation appears in M. Greenhalgh, *The Classical Tradition in Art* (London, 1978), 216.

52. D. Watkin, *Thomas Hope and the Neoclassical Idea* (London, 1968), 31.

53. Quote drawn from a translation of 'The Beards of 1800 and the Beards of Today' in J. C. Taylor, *Nineteenth Century Theories of Art* (Berkeley and London, 1987), 207.

Chapter Four

1. F. Haskell, *History and its Images: Art and the Interpretation of the Past* (New Haven and London, 1993), ch. 8.

2. A. Potts, 'Political Attitudes and the Rise of Historicism in Art Theory', *Art History* 1: 7 (June 1978).

3. W. G. Constable, *John Flaxman 1755–1826* (London, 1927), 28.

4. This particular phraseology occurs only in Gibbon's revised later edition of his autobiographical memoirs.

5. For a review of Robert's role in the creation of the genre of the 'anticipated ruin' see P. Junod, 'Future in the Past', *Oppositions,* 26 (Spring 1984), 43–63.

6. 'Hubert Robert's Paintings', *Apollo*, 26 (Dec. 1937), 363.

7. C. Tunnard, 'Reflections on the Course of Empire and Other Architectural Fantasies by Thomas Cole N.A.', *Architectural Review*, 104 (Dec. 1948), 291–4.

8. T. Crow, *Painters and Public Life* (New Haven and London, 1985), 175–209.

9. E. and J. De Goncourt, *French Painters of the Eighteenth Century* (London, 1958), 108.

10. Translation drawn from A. Boime, *Art in an Age of Revolution 1750–1800*, i (Chicago and London, 1987), 167.

11. Barry's language was not untypical of his time when he referred to Boucher as 'little better than a nuisance'.

12. Wark, *Sir Joshua Reynolds' Discourses on Art*, 224–5.

13. K. Popper, *The Poverty of Historicism* (London, 1957).

14. J. Brown, *An Estimate of the Manners and Principles of the Times* (London, 1757).

15. R. Sennett, *Flesh and Stone: The Body and the City in Western Civilisation* (London and Boston, 1994), 8, 'Moving Bodies'.

16. I owe this comment to Richard Wrigley, who was generous enough to allow me to read a typescript of his stimulating forthcoming essay, 'Infectious Enthusiasms: Influence, Contagion and the Experience of Rome'.

17. For an introduction to this Roman view of death see J. M. C. Toynbee, *Death and Burial in the Roman World* (London, 1971).

18. J. Michelet, *Histoire de la révolution francaise*, 2 vols. (Paris, 1952).

19. J. Leith, *The Idea of Art as Propaganda in France, 1750–1799* (Toronto, 1965), 113. For further analysis of iconoclasm during the French Revolution see S. J. Idzerda, 'Iconoclasm during the French Revolution', *American Historical Review*, 60 (Oct. 1954), 13–26.

20. *Mercure de France*, 13 (1803), 208–9.

21. J. Steel (ed.), *Mr Rowlandson's England* (Suffolk, 1985), 135.

22. Translation drawn from J. Wilson-Bareau, *Goya: Truth and Fantasy, The Small Paintings* (New Haven and London, 1994), 24.

23. Contemporaries noted the connections between Goya's *Los Caprichos* and English satire. Count Joseph de Maistre warned of the subversive connotation of 'this book of English-style caricatures on Spanish subjects'. N. Glendinning, *Goya and his Critics* (New Haven and London, 1977), 63.

24. A. Boime and others, *French Caricature and the French Revolution*, introductory essay 'Jacques-Louis David and the Scatalogical Discourse in the French Revolution'.

25. Ibid.

26. For a brief analysis of the remarkable freedom to mount a gross attack in late 18th-cent. English caricature see R. Patten, 'The Conventions of Georgian caricature', *Art Journal*, 43 (1983).

27. Boime, *French Caricature and the French Revolution,* 71–2.

28. Rowlandson is at his cruellest in his

celebrated *Places des Victoires, Paris*, etched Nov. 1789.

29. J. Barry, *Works* (London, 1809), ii. 228.

30. E. Mason, *The Mind of Henry Fuseli* (London, 1951).·

31. Ibid. 106.

32. By far the best account of Winckelmann's sense of loss is provided in A. Potts, *Flesh and the Ideal, Winckelmann and the Origins of Art History* (New Haven and London, 1994).

33. P. Mattick, *Eighteenth Century Aesthetics and the Reconstruction of Art* (Cambridge, 1993), 164.

34. D. Wakefield, *Stendhal and the Arts* (London, 1972), 118.

35. J. S. Memes, *Memoirs of Canova* (Edinburgh and London, 1825), 130.

36. Ibid. 288.

37. J. M. Thiele, *The Life of Thorvaldsen collated from the Danish* (London, 1865), 167.

38. J. Galt, *The Life and Studies of Benjamin West Esq.* (London, 1816), i. 18.

39. A good introduction to the late 18th-cent. vogue for this subject has been provided by Anne Birmingham, 'The Origin of Painting and the Ends of Art: Joseph Wright of Derby's *Corinthian Maid*', in J. Barrell (ed.), *Painting and the Politics of Culture* (Oxford, 1992), 135–65.

40. G. Vasari, *Lives of the Artists*, tr. George Bull (London, 1965), 46.

41. T. Crow, *Emulation, Making Artists for Revolutionary France* (New Haven and London, 1995), 24.

42. G. H. Holt (ed.), *The Triumph of Art for the Public* (Washington, DC, 1980), 16.

43. T. Pelzel, *Anton Raphael Mengs and Neoclassicism* (New York, 1979).

44. A. Becq, 'Diderot, Historien de l' Art', *Dix-huitème Siècle* 19 (1987), 423–38.

45. M. Clarke and N. Penny, *The Arrogant Connoisseur: Richard Payne Knight* (Manchester, 1982), 73.

46. Quoted from Fuseli's introduction to his Academy lectures. R. Wornum, *Lectures on Painting by the Royal Academicians* (London, 1848), 344.

47. D. Hume, *Of the Rise and Progress of the Arts and Sciences* (1742), in E. F. Miller (ed.), *Essays Moral, Political and Literary* (Indianapolis, 1987), 135.

48. J. Galt, *The Life and Studies of Benjamin West* (London, 1816), i. 99.

49. Supposed transcripts of this conversation can be read in *Napoleon and Canova: Eight Conversations held in the Chateau of the Tuileries in 1810* (London, 1825), 14–19.

50. I. Jenkins, *Archaeologists and Aesthetics in the Sculpture Galleries of the British Museum, 1800–1939* (London, 1992), 13.

51. Holt, *The Triumph of Art for the Public*, 16.

52. See the first sentence of Schlegel's 'On the German Art Exhibition at Rome in 1819 and the Present State of German Art in Rome', *Wiener Jahrbucher der Literatur* (Oct. 1819).

53. J. Moore, *A View of the Manners and Society of Italy* (London, 1795), 333.

54. K. Kroeber and W. Walling, *Images of Romanticism* (New Haven and London, 1978), 23.

55. T. C. Gordon, *David Allen, the Scottish Hogarth* (Alva, 1951), 46. Letter to Gavin Hamilton of Oct. 1788.

56. Moore, *A View of the Society and Manners of Italy*, 234.

57. For a discussion of this type of crime in eighteenth-century Italy see M. Vaussard, *Daily Life in Eighteenth Century Italy* (London, 1962). There were, for instance, 4,000 murders in Rome in the Pontificate of Clement XIII.

58. Holt, *The Triumph of Art for the Public*, 186.

59. Wakefield, *Stendhal and the Arts*, 136.

60. Published as *A Letter to the Committee for raising the Naval Pillar or Monument under the patronage of his Highness the Duke of Clarence*, Dec. 1799. Reprinted in J. Physick, *Designs for British Sculpture 1680–1860* (London, 1969), 169.

61. S. Jeffrey, *The Mansion House* (Chichester, 1994), 84–5.

62. Printed as *Lectures on Sculpture as Delivered to the President and Members of the Royal Academy by John Flaxman* (London, 1838). Here we are told that Roubiliac 'laughed at the sublime remains of ancient sculpture' and 'the other sculptors of his time were ordinary men; their faults were common, and their works have no beauty to rescue them from oblivion'.

63. P. Grosley, *A Tour of London: or New Observations on England and its Inhabitants*, 2 vols., trans. from the French by T. Nugent (London, 1772).

64. Probably the most conspicuous examples of art works directed at creating the image of compassionate conquest were Hayman's *The Surrender of Montreal to General Amhurst*, and *Lord Clive Receiving the Homage of the Nabob* which were painted in 1762 for Vauxhall Gardens. These paintings and original press cuttings relating to them have been reviewed by Brian Allen in *Francis Hayman* (New Haven and London, 1987).

65. French imperial propaganda, of course, held that it was they rather than the British who brought out the nobility in the savage. Such views were most notably expressed in the French-trained American, John

Vanderlyn's *The Death of Jane McCrea,
A Young Woman Slaughtered by Two Savages
in the Service of the English during the American
War*, 1804.
66. J. Egerton, *Wright of Derby* (Tate Gallery
London, 1990), 129–30.
67. I owe this quote and my introduction to
this subject to Marcia Pointon's article,
'Painters and Pugilism in early Nineteenth
Century England', *Gazette des Beaux Arts*,

92: 6 (1978), 131–40.
68. J. T. Smith, *Nollekens and his Times*
(London, 1986), 178.
69. S. Smiles, *The Image of Antiquity:
Ancient Britain and the Romantic Imagination*
(New Haven and London, 1994), 134–7.
70. G. Levitine, *Girodet-Trisson: An
Iconographic Study*, Ph.D. dissertation
(Harvard University, 1953; pub. New York,
1974), 173–195.

List of Illustrations

The publishers would like to thank the following individuals and institutions who have kindly given permission to reproduce the illustrations listed below

1. Jacques-Louis David: *The Intervention of the Sabine Women*, 1799. Oil on canvas. 385 × 522 cm. Musée du Louvre, Paris/photo Réunion des Musées Nationaux.
2. Benjamin West: *The Death of Wolfe*, 1770. Oil on canvas. 148.8 × 210 cm. National Gallery of Canada, Ontario.
3. Jean Baptiste Pigalle: *Bust of Denis Diderot*, 1777. Bronze. H. 52.2 cm. Musée du Louvre, Paris/photo Réunion des Musées Nationaux.
4. Henry Fuseli: *Self-Portrait*, c.1779. Black chalk. 32.4 × 50.2 cm. National Portrait Gallery, London.
5. Francisco Goya: *Self-Portrait* (from *Los Caprichos*, 1799, no. 1). Etching, aquatint, dry point, and burin. 21.5 × 15 cm. Copyright British Museum, London.
6. Edme Jean Pigal: *Academicien* (from the series *Métiers de Paris*, in *Le Charivari*, 2 October 1833, plate 6). Hand-coloured lithograph. 50 × 40 cm. Santa Barbara Museum of Art, CA, Gift of Mr and Mrs Michael G. Wilson.
7. Joseph Anton Koch: *Caricature on the Stuttgart Academy*, 1790s. Pen and pencil drawing with wash. 35 × 50.1 cm. Staatsgalerie, Stuttgart.
8. Anonymous: *Riot in David's Studio*. Lithograph. Bibliothèque Nationale, Paris.
9. Joshua Reynolds: *Self-Portrait in Oxford Academic Gowns*, 1773. Oil on panel. 125 × 100 cm. Royal Academy of Arts, London.
10. Christoffer Wilhelm Eckersberg: *Portrait of Bertel Thorvaldsen*, 1814. Oil on canvas. 90.7 × 74.3 cm. Kunstakademiets Bibliotek, Copenhagen.
11. Christoffer Wilhelm Eckersberg: *Thorvaldsen's Boat Arriving in Copenhagen*, 1838. Oil on canvas. 71.9 × 96.2 cm. Thorvaldsens Museum, Copenhagen.
12. Théodore Géricault: *The Wounded Cuirassier*, 1814. Oil on canvas. 353 × 294 cm. Musée du Louvre, Paris/photo Réunion des Musées Nationaux.
13. Horace Vernet: *Joseph Vernet Lashed to a Mast to Study the Effects of a Storm*, 1822. Oil on canvas. 275 × 356 cm. Musée Calvet, Avignon.
14. Horace Vernet: *Peace and War*, 1820. Oil on canvas. 55 × 45.8 cm. Wallace Collection, London.
15. James Barry: *Self-Portrait as Timanthes*. c.1780, completed 1802. Oil on canvas. 76 × 63 cm. National Gallery of Ireland, Dublin.
16. Thomas Rowlandson: *The Chamber of Genius*, published 2 April 1812. Coloured engraving. 21.5 × 28.8 cm. Copyright British Museum, London.
17. Giuseppe Baldrighi: *Self-Portrait with his Wife*, c.1760. Oil on canvas. 160 × 125 cm. Galleria Nazionale, Parma/photo Scala, Florence.
18. Francis Chantrey: *Two Woodcocks Killed at Holkham*, 1834. Marble relief on a grave *stele*. The Earl of Leicester and the Trustees of the Holkham Estate/photo Courtauld Institute of Art, London.
19. William Hogarth: *Heads of Hogarth's Six Servants*, c.1750-55. Oil on canvas. 62.2 × 75 cm. Tate Gallery, London.
20. Joseph Highmore: *Conversation Piece, Probably of the Artist's Family*, c.1732-5. Oil on canvas. 64.7 × 77.5 cm. Private Collection/photo Tate Gallery, London.
21. Daniel Chodowiecki: *The Study of a Painter*, 1771. Etching. 17.9 × 23 cm. Copyright British Museum, London.
22. Philipp Otto Runge: *The Artist's Parents*, 1806. Oil on canvas. 194 × 131 cm. Kunsthalle, Hamburg/photo Elke Walford.
23. Caspar David Friedrich: *The Stages of Life* (*The Three Ages of Man*), 1834-5. Oil on canvas. 72.5 × 94 cm. Museum der Bildenden Künste, Leipzig/photo AKG London.
24. Karl Friedrich Schinkel: *Portrait of the Artist's Wife, Susanne*, c.1810-13. Pencil with

black and grey wash. 85 × 59.5 cm. Nationalgalerie, Berlin/photo Bildarchiv Preussischer Kulturbesitz.

25. Carl Custav Pilo: *The Coronation of Gustav III*, 1782-93. Oil on canvas. 293 × 531 cm. Nationalmuseum Stockholm/photo Statens Konstmuseer.

26. Bernardo Bellotto: *Architectural Fantasy with a Self-Portrait*, 1765. Oil on canvas. 153 × 114 cm. National Museum, Warsaw.

27. Francisco Goya: *Family of Carlos IV*, 1800. Oil on canvas. 280 × 336 cm. Museo del Prado, Madrid.

28. Francisco Goya: *You Who Cannot Do It* (from *Los Caprichos*, 1799, no. 42), Etching and burnished aquatint. 19 × 12.2 cm. Copyright British Museum, London.

29. David Wilkie: *The Letter of Introduction*, 1813. Oil on panel. 61 × 50 cm. National Gallery of Scotland, Edinburgh.

30. Domenico Tiepolo: *Punchinello as a Portrait-Painter*, 1790s. Pen and brown ink, brown wash over black chalk. 29.5 × 41.3 (one of 104 drawings in *Divertimento per li ragazzi*). Private Collection/photo Sotheby's.

31. Giambattista Tiepolo: *Self-Portrait with his Son Domenico*. Detail from the fresco *The Continent of Europe*, 1750-3, on the ceiling of the staircase hall of the Residenz, Würzburg/Bildarchiv Foto Marburg.

32. Claude-Joseph Vernet: *Constructing a Road*, 1774. Oil on canvas. 97 × 162 cm. Musée du Louvre, Paris/photo Réunion des Musées Nationaux.

33. Claude Michel, known as Clodion: *Model for a proposed monument to commemorate the invention of the balloon in France in 1783*. Terracotta. H. 110.5 cm. Metropolitan Museum of Art, New York. Purchase. Rogers Fund and Anonymous Gift, 1944 (44. 21 ab).

34. Samuel Amsler: *Carl Philipp Fohr*, 1818. Engraving by Amsler after a drawing by Carl Barth. 15 × 11.7 cm. Copyright British Museum, London.

35. Karl Friedrich Schinkel: *Medieval City on a River*, 1815. Oil on canvas. 94 × 140 cm. Nationalgalerie, Berlin/Bildarchiv Preussischer Kulturbesitz/photo Jörg P. Anders.

36. Thomas Cole: *The Architect's Dream*, 1840. Oil on canvas. 134.6 × 213.5 cm. Toledo Museum of Art, OH. Purchased with funds from the Florence Scott Libbey Bequest in memory of her father Maurice A. Scott.

37. Karl Pavlovich Briullov: *The Last Day of Pompeii*, 1830-3. Oil on canvas. State Russian Museum, St Petersburg/photo Scala, Florence.

38. J. M. W. Turner: *The Field of Waterloo*, c.1817. Watercolour. 28.8 × 40.5 cm. Syndics of the Fitzwilliam Museum, Cambridge.

39. Francisco Goya: *As if They are Another Breed* (from *Disasters of War*, 1863, no. 61). 13.3 × 18.6 cm. Copyright British Museum, London.

40. William Hogarth: *The Painter and his Pug*, 1745. Oil on canvas, 90 × 70 cm. Tate Gallery, London.

41. John Hamilton Mortimer: *Self-Portrait in the Guise of a Bandit. c.*1775. Pen and ink. 37.5 × 28.7 cm. Board of Trustees of the Victoria & Albert Museum, London.

42. Horace Vernet: *Italian Brigands Surprised by Papal Troops*, 1831. Oil on canvas. 86.7 × 131.5 cm. The Walters Art Gallery, Baltimore, MD.

43. Bartolomeo Pinelli: *'A True Descendant of the Romans'*, 1820. Pencil drawing. 64 × 45 cm. Museo di Roma/photo Antonello Idini.

44. Francesco Hayez: *The Inhabitants of Parga Leaving their Homeland*, 1826-31. Oil on canvas. 201 × 290 cm. Pinacoteca Tosio Martinengo, Brescia/photo Rapuzzi.

45. Johann Zoffany: *Colonel Pollier and his Friends*, 1786. Oil on canvas. 137 × 183.5 cm. Victoria Memorial Hall, Calcutta.

46. Julius Caesar Ibbetson: *Aberglaslyn: the Flash of Lightning*, 1798. Oil on canvas. 67.2 × 92.7 cm. Temple Newsam House/Leeds Museums and Galleries.

47. Julius Caesar Ibbetson: *The Blind Harper of Conway* or *Penillion Singing near Conway*, 1792. Watercolour. 22.3 × 29.1 cm. National Museum of Wales, Cardiff.

48. John Martin: *The Bard*, first exhibited 1817. Oil on canvas. 215.5 × 157 cm. Laing Art Gallery, Newcastle upon Tyne (Tyne and Wear Museums).

49. David Wilkie: *A Veteran Highlander*, 1819. Oil on canvas. 35.6 × 29.2. Paisley Museum and Art Galleries, Renfewshire Council.

50. Edwin Landseer: *The Highland Still*, 1826-9. Oil on canvas. 78.8 × 100 cm. Apsley House/Board of Trustees of the Victoria & Albert Museum, London.

51. Edwin Landseer: *The Monkey Who has Seen the World*, 1827. Oil on panel. 47 × 54.6 cm. Guildhall Art Gallery, London/photo Bridgeman Art Library.

52. Alexander Nasmyth: *The Building of the Royal Institution*, 1825. Oil on canvas. 122.5 × 165.5 cm. National Gallery of Scotland, Edinburgh.

53. Jean-Baptiste Le Prince: *The Cradle*, 1769. Aquatint. 15.2 × 18 cm. Copyright British Museum, London.

54. Pompeo Batoni: *Count Kirill Grigorjewitsch Razumovsky*, 1766. Oil on canvas,. 298 × 196 cm.

Private Collection/photo Kunsthistorisches Museum, Vienna.

55. Pompeo Batoni: *Thomas Dundas* (later first Baron Dundas), 1764. Oil on canvas. 298 × 197 cm. The Marquess of Zetland/photo York City Art Gallery.

56. Francisco Goya: *He Cannot Make Her Out Even This Way* (from *Los Caprichos*, 1799, no. 7). Etching, aquatint and dry point. 17.5 × 11.5 cm. Copyright British Museum, London.

57. Pietro Longhi: *The Geography Lesson*, c.1752. Oil on canvas. 62 × 41.5 cm. Biblioteca Querini Stampalia, Venice/photo Scala, Florence.

58. Thomas Rowlandson: *Buck's Beauty and Rowlandson's Connoisseur*, 1800. Pen and watercolour. 27.8 × 18.5 cm. Royal Collection Enterprises, Windsor Castle, © Her Majesty Queen Elizabeth II.

59. Jean-Baptiste Chardin: *La Pourvoieuse* (*The Return from Market*), engraved 1742 by Lépicié. 32.3 × 24.3 cm. Copyright British Museum, London.

60. Francisco Goya: *Nobody Knows Himself* (from *Los Caprichos*, 1799, no. 6). Etching and burnished aquatint. 19 × 12 cm. Copyright British Museum, London.

61. Daniel Chodowiecki: *Masquerade with Rape Scene*, 1775. Etching. 9.1 × 12.3 cm (sheet size). Galerie J. H. Bauer, Hannover.

62. Jean-Michel Moreau le Jeune: *Les Adieux* (from *Monument du Costume*), engraved 1777 by Robert Delaunay. Courtauld Institute of Art, London.

63. Anonymous: *At the Café Royal d'Alexandre. The Burning of the Coiffures*, c.1780. Etching. 26 × 17.4 cm. Bibliothèque National, Paris/photo Bulloz.

64. Daniel Chodowiecki: *Natural and Affected Behaviour* (second series, 1779). Four etchings, each 82 × 42 mm. Copyright British Museum, London.

65. Thomas Gainsborough: *Mr and Mrs William Hallett* (*The Morning Walk*), c.1785. Oil on canvas. 236.2 × 179.1 cm. Trustees of the National Gallery, London.

66. Jacques-Louis David: *Marie Antoinette on the Way to the Guillotine*, 1793. Drawing. 14.8 × 10.1 cm. Musée du Louvre, Paris/photo Réunion des Musées Nationaux.

67. Elizabeth Louise Vigée Le Brun: *Self-Portrait in a Straw Hat* (in the guise of 'Rubens's Wife'), after 1782. Oil on canvas. 97.8 × 70.5 cm. Trustees of the National Gallery, London.

68. Princess Marie Anna of Prussia (known as Marianne): *La France Républicaine*, 1792. Etching after Clement. 31 × 21.2 cm. Musée Carnavalet, Paris/Photothèque de Musées de la Ville de Paris © DACS, 1997.

69. Pierre-Narcisse Guérin: *The Return of Marcus Sextus*, c.1799. Oil on canvas. 217 × 244 cm. Musée du Louvre, Paris/photo Réunion des Musées Nationaux..

70. Jacques-Louis David: *The Oath of the Horatii*, 1784-5. Oil on canvas. 330 × 425 cm. Musée du Louvre, Paris/photo Réunion des Musées Nationaux.

71. Luis Paret y Alcazar: *The Antique Trinket Shop*, 1722. Oil on panel. 48.3 × 56 cm. Fundación Lázaro Galdiano, Madrid.

72. Pietro Longhi: *Masked Figures with Fruit Seller*, c.1760. Oil on canvas. 62 × 51 cm. Ca' Rezzonico (Museo Correr), Venice/photo Osvaldo Böhm.

73. Gaetano Zompini: *L'arti che Vanno per la Vie nella città di Venice* (1785).

74. Jean-Antoine Watteau: *The Shop Sign of Gersaint*, 1720-1. Oil on canvas. 166 × 306 cm. Schloss Charlottenburg, Berlin/photo AKG, London.

75. Johann Zoffany: *The Tribuna at the Uffizi*, 1772-8. Oil on canvas. 123.5 × 154.9 cm. Royal Collection Enterprises, Windsor Castle. © Her Majesty Queen Elizabeth II.

76. Johann Zoffany: *Self-Portrait*, 1779. Oil on panel. 43 × 36.6 cm. Galleria Nazionale, Parma/Archivio della Soprintendenza per I Beni Artistici e Storici di Parma.

77. Joshua Reynolds: *A Parody on Raphael's School of Athens*, 1751. Oil on canvas. 97 × 135 cm. National Gallery of Ireland, Dublin.

78. William Hogarth: *A Harlot's Progress*, plate 1, c.1731. Engraving. 29.8 × 37.5 cm. Copyright British Museum, London.

79. William Hogarth: *The Laughing Audience*, 1733. Etching. 17.9 × 16 cm. Copyright British Museum, London.

80. Francis Hayman: *The See-Saw*, 1741-2. Oil on canvas. 136.5 × 241 cm. Tate Gallery, London.

81. William Hogarth: *The Cockfight*, 1759. Etching and engraving. 29.5 × 37.5 cm. Copyright British Museum, London.

82. Louis François Roubiliac: *Bust of William Hogarth*, c.1741. Terracotta. H. 71.1 cm. National Portrait Gallery, London.

83. Louis François Roubiliac: *Monument to George Lynn*, Southwick Church, Northants., 1760. Conway Library, Courtauld Institute of Art, London.

84. Peter Scheemakers, Laurent Delvaux, and Denis Plumier: *Monument to the first Duke of Buckingham*, c.1722. Henry VII Chapel, Westminster Abbey/photo A. F. Kersting.

85. Thomas Rowlandson: *The Exhibition 'Stare' Case*, c.1800. Watercolour and grey and brown

wash over graphite on woven paper.
44.7 × 29.8 cm. Yale Center for British Art (Paul Mellon Collection), New Haven, CT.

86. Nicolas Ponce: *L'Enlèvement Nocture*, c.1780. Engraving. Bibliothèque Nationale/photo Giraudon.

87. Anonymous: *Effigies of William II and Mary, c.1725.* Wax. Westminster Abbey/Dean and Chapter of Westminster.

88. Johann Eleazar Zeissig: *The Magic Lantern*, 1765. Engraving by Jean Ouvrier after Zeissig. 48.5 × 34.8 cm. Copyright British Museum, London.

89. Pietro Longhi: *The Quack*, 1757. Oil on canvas. 62 × 50 cm. Ca' Rezzonico (Museo Correr), Venice/photo Osvaldo Böhm.

90. Jean-Antoine Watteau: *The Itinerant Magic Lantern Man.* Red and black chalk. 33 × 20 cm. Musée Bonnat, Bayonne/photo Réunion des Musées Nationaux, Paris.

91. Jean-Antoine Watteau: *Pierrot* or *Gilles*, 1718-9. Oil on canvas. 184.5 × 149.5 cm. Musée du Louvre, Paris/photo Réunion des Musées Nationaux.

92. Jean-Baptiste Chardin: *Portrait of the Artist Joseph Aved* (*The Alchemist*), c.1744. Oil on canvas. 138 × 105 cm. Musée du Louvre, Paris/photo Réunion des Musées Nationaux.

93. Jean-Baptiste Chardin: *The Monkey Antiquarian*, 1740. Oil on canvas. 28.5 × 23.5 cm. Musée des Beaux-Arts, Chartres/photo Réunion des Musées Nationaux, Paris.

94. Giambattista Tiepolo: *Magician and Others Looking at a Burning Pyre with a Man's Head*, etching from *Vari Capricci*, published 1785. 22.6 × 17.8 cm.

95. Salvator Rosa: *Democritus in Meditation*, 1662. Etching with dry-point. 45.7 × 27.5 cm. Museum of Fine Arts, Boston, MA. George Peabody Gardner Fund.

96. Louis-Jean Desprez: *The Chimera*, c.1774-84. Etching. 32.4 × 38.2 cm. Syndics of the Fitzwilliam Museum, Cambridge.

97. Francisco Goya: *The Sleep of Reason Produces Monsters* (from *Los Caprichos*, 1799, no. 43). Etching and aquatint 18 × 12.1 cm. Copyright British Museum, London.

98. Jean-Anton Houdon: *Voltaire: 'The Smile of Reason'*, 1781. Marble statue. Théâtre Française, Paris/photo Caisse Nationale des Monuments Historiques et des Sites/© DACS 1997.

99. Jean-Anton Houdon: *Bust of Giuseppe Balsamo, Comte Cagliostro.* White marble. H (without base) 62.9 cm. National Gallery of Art, Washington. Samuel H. Kress Collection (1952.5.103).

100. Joseph Wright of Derby: *The Alchymist in Search of the Philosopher's Stone*, exhibited 1771 (reworked and dated 1795). Oil on canvas. 127 × 101.6 cm. Derby Museum and Art Gallery.

101. Thomas Rowlandson and A. C. Pugin: *Bartholomew Fair.* Aquatint from Rudolph Ackermann, *Microcosm of London* (1808-10). Museum of London.

102. J. M. Gandy, *Architectural Ruins—A Vision* (*John Soane's Rotunda of the Bank of England in Ruins*), exhibited 1832. Watercolour heightened with white. 53.1 × 88.8 cm. Trustees of Sir John Soane's Museum, London.

103. Thomas Cole: *The Course of Empire: Desolation*, 1836. Oil on canvas. 98.1 × 158.1 cm. New York Historical Society.

104. William Hogarth: *Gin Lane*, 1751. Engraving. 35.8 × 30.4 cm. Copyright British Museum, London.

105. Louis Philibert Debucourt: *Paternal Pleasures*, c.1792. Engraving. 46.5 × 36.4 cm. Bibliothèque Nationale, Paris/photo Giraudon.

106. Claude-Nicolas Ledoux: Oikema, 1780-1804 (from *L'architecture considerée sous le rapport de l'art*, vol. 1, 1804).

107. Francisco Goya: *Til Death* (from *Los Caprichos*, 1799, no. 55). Etching, burnished aquatint and dry-point. 19.1 × 13.3 cm. Copyright British Museum, London.

108. Anonymous: Dissection of a Dead Member of Parliament, 1746. Etching. 13.2 × 23.4 cm. Copyright British Museum, London.

109. Anonymous: *A Protest at the Terms of the Pelhamite Peace*, 1749. Engraving. 26.2 × 18.7 cm. Copyright British Museum, London.

110. William Hogarth: *Marriage-à-la-Mode*, plate 1 (*The Marriage Contract*), 1743. Engraving. 35.8 × 44.4 cm. Copyright British Museum, London.

111. Henry Fuseli: *Sergel at Work in his Studio in Rome*, 1776-7. Pen and brown ink, brown wash. 19.9 × 27.1 cm. Nationalmuseum, Stockholm/photo Statens Konstmuseer.

112. Johann Tobias Sergel: *Mars and Venus*, 1775. Terracotta model. H.39 cm. Nationalmuseum, Stockholm/photo Statens Konstmuseer.

113. Johann Tobias Sergel: *Self-Portrait on Crutches*, c.1777. Black chalk, pen and brown ink wash. 37.2 × 25 cm. Nationalmuseum, Stockholm/photo Statens Konstmuseer.

114. Henry Fuseli: *The Artist Moved by the Grandeur of Ancient Ruins*, 1778-9. Red chalk with sepia tint. 42 × 35.5 cm. Copyright Kunsthaus, Zürich. All rights reserved.

115. Joseph Wright of Derby: *The Corinthian Maid*, 1782-4. Oil on canvas. 106.3 × 130.8 cm. Paul Mellon Collection. Copyright 1996 Board

of Trustees of the National Gallery of Art, Washington.

116. Giovanni Battista Piranesi: *The Temple of Portunus* (The Round Temple near S. Maria in Cosmedia), 1758. Etching. 38.7 × 58.8 cm. Copyright British Museum, London.

117. John Brown: *Woman Standing among Friars*, 1770s. Graphite, brush and black ink, with black and grey wash. 25.8 × 36.9 cm. Cleveland Museum of Art, OH. Dudley P. Allen Fund (1969.28).

118. Bertel Thorvaldsen: *Joseph Poniatowski*, 1826-7. Plaster model. H.463 cm. Thorvaldsen Museum, Copenhagen/photo Conway Library, Courtauld Institute of Art, London.

119. Canaletto: *London Seen through an Arch of Westminster Bridge*, 1746-7. Oil on canvas. 57 × 95 cm. Collection of the Duke of Northumberland, Alnwick.

120. Canaletto: *The Stonemason's Yard*, 1726-30. Oil on canvas. 123.8 × 162.9 cm. Trustees of the National Gallery, London.

121. Hubert Robert: *The Opening Ceremony of the Neuilly Bridge*, 1772. Oil on canvas. 66.5 × 135 cm. Musée Carnavalet, Paris/Photothèque des Musées de la Ville de Paris/photo Ladet, © DACS 1997.

122. Joseph Wilton: *Major General James Wolfe*, 1760-72. White marble. North ambulatory, Westminster Abbey, London/Dean and Chapter of Westminster.

123. Benjamin West: *Savage Warrior Taking Leave of his Family*, c.1760. Oil on canvas. 60 × 48 cm. Trustees of the Hunterian Collection, Royal College of Surgeons, London.

124. Joseph Wright of Derby: *The Indian Widow*, 1783-5. Oil on canvas. 101.6 × 127 cm. Derby Museum and Art Gallery.

125. John Charles Felix Rossi: *The British Pugilist*, 1828. Marble. H.198 cm. Petworth House (The National Trust)/photo Conway Library, Courtauld Institute of Art, London.

126. Benjamin Haydon: *Mock Election*, 1827. Oil on canvas. 144.8 × 185.4 cm. The Royal Collection (Kensington Palace), © Her Majesty Queen Elizabeth II.

127. William Hogarth: *The Election Entertainment* (from the series *The Election*, 1754-5). Oil on canvas. 101.5 × 127 cm. Trustees of Sir John Soane's Museum, London.

128. Thomas Banks: *Caractacus in the Presence of Emperor Claudius*, 1777. Marble relief. Stowe School, Buckingham.

129. Anne-Louise Girodet: *Ossian Receiving the Generals of the Republic*, 1802. Oil on canvas. 188.7 × 181.3 cm. Château du Malmaison/photo Réunion des Musées Nationaux, Paris.

The publisher and author apologize for any errors or omissions in the above list. If contacted they will be pleased to rectify these at the earliest opportunity.

Bibliography

This bibliography is designed to facilitate the endeavours of readers who wish to explore further those issues introduced in this book. For the sake of brevity I have not cited every book and article used in my researches, rather I have attempted to provide a stimulating 'snapshot' of the relevant literature. I wish to stress that the books cited do not represent a canon of works which conform to my own scholastic tastes. My objective has been to put before the reader examples of a wide spectrum of art historical and historical approaches. The only criteria of choice, apart from that of relevance, is that the works selected represent exemplary standards of scholarship within their own school of thought.

This bibliography reflects my own conviction that a sound grasp of historical issues and knowledge of historical actualities is essential for the comprehension of art history. Working towards such an understanding requires scholastic application if not tenacity. A high proportion of the books cited relating to social and political history, cultural theory, and aesthetics do not constitute a light read. On account of the number of 'difficult' works listed I have marked fifteen books with an asterisk which I recommend to novices wishing to ease themselves into the subject gently.

Lastly, I stress the importance of primary material. Those who wish to encounter the art would of this period in a direct way and to form their own independent vision are advised to read source material: anecdotal art histories, memoirs, or modern anthologies of important texts. Thus, I recommend that the novice reader should begin by acquiring a few modern reprints of classic texts such as Diderot's Salon commentaries (J. Goodman and T. Crow, *Diderot on Art*, 2 vols., New Haven and London, 1995) and J. T. Smith's *Nollekens and his Times* (reprinted in paperback by Century Hutchinson, Ltd., 1986). A number of exceedingly useful source books are also available in paperback, new or second-hand: B. Denvir, *The Eighteenth Century, Art, Design and Society, 1688–1789*, London, 1983; L. Eitner (ed.), *Neoclassicism and Romanticism, 1750–1850, Sources and Documents*, 2 vols., London, 1971; E. G. Holt, *The Triumph of Art for the Public*, Washington, 1980; J. C. Taylor, *Nineteenth Century Theories of Art*, Berkeley, Los Angeles, and London, 1987.

Introduction

In my opinion the following books would be the most enjoyable and stimulating way of introducing oneself to the history of this period.

GAY, P., *The enlightenment: An Interpretation*, 2 vols. (London, 1970).

HABERMAS, J., trans. T. Burger and F. Lawrence, *Structural Transformations in the Public Sphere: An Inquiry into a Category of Bourgeois Society* (Oxford, 1989).

*HAMPSON, N., *The Enlightenment* (London, 1968).

HAZARD, P., *The European Mind, 1680–1715* (London, 1953).

—— *European Thought in the Eighteenth Century: from Montesquieu to Lessing* (London, 1954).

PORTER, R., and TEICH, M., *The Enlightenment in National Context* (Cambridge, 1981).

—— *Romanticism in National Context* (Cambridge, 1988).

*SCHAMA, S., *Citizens, A Chronicle of the French Revolution* (London, 1989).

VENTURI, F., *Italy and the Enlightenment: Studies in a Cosmopolitan Century* (London, 1972).

YOLTON, J. W., *The Blackwell Companion to the Enlightenment* (Oxford Cambridge, Mass., 1991). (Yolton's *Companion* can be used a reference book. However, it is well worth simply browsing through the articles. The subjects have been wisely selected to engage the burning issues of Enlightenment discourse and the bibliographies attached to the entries are exceedingly useful.)

I recommend these works as the most exciting introductions to the art history of the period.

ALLEN, B. (ed.), *Towards a Modern Art World* (New Haven and London, 1995).

BARRELL, J. (ed.), *Painting and the Politics of Culture: New Essays in British Art 1700–1850* (Oxford and New York, 1992).

*BOIME, A., *Art in an Age of Revolution, 1750–1800* (Chicago and London, 1987).

BRYSON, N., *Word and Image: French Painting of the Ancien Régime* (Cambridge, 1981). (A book which does not conform with my taste but may appeal to those who enjoy reading art criticism.)

CROW, T., *Painters and Public Life* (New Haven and London, 1985).

—— *Emulation, Making Artists for Revolutionary France* (New Haven and London, 1995).

DEUCHAR, S., *Sporting Art in Eighteenth Century England: A Social and Political History* (New Haven and London, 1988). (Deuchar provides not only an excellent account of a genre of art but also a sound example of how to write accessible art history in the 'New Art History' tradition.)

FRIED, M., *Absorption and Theatricality: Painting and the Beholder in the Age of Diderot* (Berkeley and Los Angeles, 1980).

KLINGENDER, F. D., *Art and the Industrial Revolution* (London, 1972).

PAULSON, R., *Emblem and Expression: Meaning in English Art of the Eighteenth Century* (Cambridge, Mass., 1975).

*ROSENBLUM, R., *Transformations in Late Eighteenth Century Art* (Princeton, 1967).

SMITH, B., *European Vision and the South Pacific* (New Haven and London, 1985). (Despite its specialist subject matter this remains probably the most compelling and stimulating read available to the student of art history in this period.)

THACKER, C., *The Wildness Pleases* (London, Canberra and New York, 1983). (An idiosyncratic and, in certain respects, superficial work but a very good read.)

WRIGLEY, R., *The Origins of French Art Criticism: From the Ancien Régime to the Restoration* (Oxford, 1993). Conservative, though well written, introductions.

ADHEMAR, J., *Graphic Art of the Eighteenth Century*, trans. M. I. Martin (London, 1964).

ALPATOV, M., *The Russian Impact on Art* (New York, 1969).

BURKE, J., *English Art, 1714–1800* (Oxford, 1976).

CARLSON, V. I., and ITTMANN, J., *Regency to Empire: French Printmaking, 1715–1814* (Exhibition Catalogue, Baltimore Museum of Art and the Minneapolis Institute of Arts, 1984).

*CONISBEE, P., *Painting in Eighteenth Century France* (London, 1981).

FOSS, M., *The Age of Patronage: The Arts in England 1660–1750* (London, 1974).

FRIEDLANDER, W., *David to Delacroix* (Cambridge Mass., 1952).

GEORGE, D. M., *Hogarth to Cruikshank: Social Change and Graphic Satire* (London, 1967).

*GODFREY, R., *Printmaking in Britain: A General History from its Beginnings to the Present Day* (Oxford, 1978).

GRIFFITHS, A., *Prints and Printmaking: an Introduction to the History and Techniques* (London, 1980).

HAMILTON, G. H., *The Art and Architecture of Russia* (London, 1964).

HAMMELMANN, H., and BOASE, T., *Book Illustrators of the Eighteenth Century* (New Haven and London, 1975).

LEVENSON, J., *The Age of the Baroque in Portugal* (New Haven and London, 1994).

LEVEY, M., *Painting and Sculpture in France 1700–1789* (New Haven and London, 1993).

—— *Painting in Eighteenth Century Venice* (Oxford, 1980).

MONRAD, K., *Danish Painting: The Golden Age* (London, 1984).

NOVOTNY, F., *Painting and Sculpture in Europe: 1780–1880* (London, 1971).

RIX, D. B., *French Printmaking of the Eighteenth Century* (Toronto, 1988).

SOUCHAL, F., *French Sculptors of the 17th and 18th Centuries* (Oxford, 1977).

THUILLIER, J., and CHATELET, A., *French Painting: From Le Nain to Fragonard* (Geneva, 1964).

University of Minnesota Gallery, *The Art of Russia 1800–1850* (Minneapolis, 1978).

WAKEFIELD, D., *French Eighteenth Century Painting* (London, 1984).

*WATERHOUSE, E., *Painting in Britain 1530 to 1790* (London, 1953).

WHINNEY, M., *English Sculpture, 1720–1830*, Victoria and Albert Museum Monograph, no. 17 (London, 1971).

—— *Sculpture in Britain 1530–1830* (London, 1964). Any student approaching this period ought to have a sound awareness of the classical tradition in art for which I recommend basic texts as an introduction.

CROOK, J. M., *The Greek Revival* (London, 1972).

DOWLEY, F. H., 'Falconet's Attitude to Antiquity, and his Theory of Reliefs', *Art Quarterly*, 31 (1968), 185–204.

*GREENHAULGH, M., *The Classical Tradition in Art* (London, 1978).

HASKELL F., and PENNY, N., *Taste and the Antique: The Lure of Classical Sculpture, 1500–1900* (New Haven and London, 1981).

HOWARD, S., *Antiquity Restored: Essays on the Afterlife of the Antique* (Hoopdorp, 1990).

KENDRICK, T. D., *British Antiquity* (London, 1950).

LEPPMANN, W., *Pompeii in Fact and Fiction* (London, 1968).

MANUEL, F. E., *The 18th Century Confronts the Gods* (Cambridge, Mass., 1959).

MICHELS, A. K., *Pompeiana, Exhibition of Pompeian Art and its Influence in the 18th. and earth 19th. Centuries . . .* (Northampton, Mass., 1948).

RYKWERT, J., *On Adam's House in Paradise: The Idea of the Primitive Hut in Architectural Theory* (New York, 1972).

SENZEC, J., *Essais sur Diderot et l'antiqué* (Oxford, 1957).

TRIGGER, B. A., *A History of Archaeological Thought* (Cambridge, 1989).

WEISS, R., *The Discovery of Classical Antiquity* (Oxford, 1969).

WIEBENSON, D., *The Sources of Greek Revival Architecture* (London, 1969).

Historical works essential for a more detailed appreciation of the period.

*ANDERSON, M. S., *Europe in the Eighteenth Century, 1713–1783* (London, 1961).

BLACK, J., *National and Necessary Enemies: Anglo-French Relations in the Eighteenth Century* (London, 1986).

CHAUNU, P., *La Civilisation de l'Europe des lumières* (Paris, 1971).

CLARK, J. C. D., *English Society: Ideology, Social Structure and Political Practice during the Ancien Régime* (Cambridge, 1985).

COBBAN, A., *The Eighteenth Century: Europe in the Age of Enlightenment* (London, 1969).

CRAGG, G. R., *The Church in the Age of Reason, 1648–1789* (New York, 1960).

DICKENSON, H. T., *Liberty and Property, Political Ideology in Eighteenth Century Britain* (London, 1977).

DORN, W. L., *Competition for Empire, 1740–1763* (London and New York, 1940).

DOYLE, W., *The Old European Order, 1660–1800* (Oxford, 1978).

DUKES, P., *The Making of Russian Absolutism, 1613–1801* (London, 1982).

HIGGS, D., and CALLAHAN, W. J. (eds.), *Church and Society in Catholic Europe of the Eighteenth Century* (Cambridge, 1979).

HOLBORN, H., *A History of Modern Germany: 1648–1840* (Princeton, 1982).

HORN, D. B., *Great Britain and Europe in the Eighteenth Century* (Oxford, 1967).

McKAY, D., and SCOTT, H. M., *The Rise of the Great Powers, 1648–1815* (London, 1983).

MULLAN, J., *Sentiment and Sociability: The Language of Feeling in the Eighteenth Century* (Oxford, 1988).

PARRY, J. H., *Trade and Dominion: The European Overseas Empires in the Eighteenth Century* (London, 1971).

*PORTER, R., *English Society in the Eighteenth Century* (London, 1982).

REDDAWAY, W. H. (ed.), *The Cambridge History of Poland*, ii (Cambridge, 1941).

SYKES, N., *Church and State in England in the Eighteenth Century* (Cambridge, 1934). (Despite its age still the best introduction to the history of the English Church at the time.)

UFTON, O., *Europe: Privilege and Protest, 1730–1789* (London, 1980).

WANGERMANN, E., *The Austrian Achievement, 1700–1800* (London, 1973).

WILLIAMS, G., *The Expansion of Europe in the Eighteenth Century* (London, 1966).

*WOLOCH, I., *Eighteenth Century Europe: Tradition and Progress, 1715–1789* (New York, 1982).

WOOLF, S. J., *A History of Italy, 1700–1860: The Social Constraints of Political Change* (London, 1979).

Manners, dress, recreation, and sexuality.

BARKER-BENFIELD, G. J., *The Culture of Sensibility, Sex and Society in Eighteenth Century Britain* (Chicago and London, 1992). (Barker-Benfield provides a thoroughly enjoyable account of sex, gender, and notions of feeling in the period.)

CUNNINGHAM, H., *Leisure in the Industrial Revolution* (London, 1980).

ELIAS, N., *The Civilising Process*, trans. E. Jephcott, 2 vols. (New York, 1982). (Elias is still the essential text in this area of scholarship.)

—— *The Court Society* (Oxford, 1983).

FOUCAULT, M., *The History of Sexuality*, trans. R. Hurley (New York, 1978). (Foucault is, of course, not an author for those who want an easy read but provides a stimulating intellectual exercise for the more enthusiastic student.)

HARRIS, R. W., *Reason and Nature in the Eighteenth Century* (London, 1968).

ISHERWOOD, R. M., *Farce and Fantasy: Popular Entertainment in Eighteenth Century Paris* (New York, 1986).

KLEIN, L., Shaftesbury and the Culture of Politeness (Cambridge, 1994). (Klein has become an essential text for those interested in politeness, one of the key concepts of the

social history of the period.)

MacCannell, D., *The Tourist: A New Theory of the Leisure Class* (New York, 1976).

Maccumbin, R. P. (ed.), *'Tis Nature's Fault', Unauthorised Sexuality During the Enlightenment* (Cambridge, 1987).

Malcolmson, R. W., *Popular Recreations in English Society, 1700–1850* (Cambridge, 1973).

Quinlan, M. T., *Victorian Prelude: A History of English Manners, 1700–1830* (New York, 1941).

Ribiero, A., *The Art of Dress and Fashion in England and France, 1750–1820* (New Haven and London, 1995).

—— *Dress and Morality* (London, 1986).

—— *Dress in Eighteenth Century Europe, 1715–1789* (London, 1984).

Books concerning the period and stylistic terms, Rococo, Neo-classicism, and Romanticism.

Abrams, M. H., *The Mirror and the Lamp* (New York, 1958).

—— *Natural Supernaturalism* (New York, 1971).

Antal, F., *Classicism and Romanticism* (London, 1966).

Barzun, J., *Classic, Romantic and Modern* (New York, 1961).

Béguin, A. (ed.), *Le romanticisme allemand. Textes et études* (Marsheilles, 1949).

Bowra, C. A., *The Romantic Imagination* (Oxford, 1961).

Blume, F., *Classic and Romantic Music* (London, 1972).

Brinkmann, R. (ed.), *Romantik in Deutschland* (Stuttgard, 1978).

Brunschwig, H., *Enlightenment and Romanticism in Eighteenth Century Prussia* (Chicago and London, 1974).

Butler, M., *Romantics, Rebels and Reactionaries: English Literature and its Background, 1760–1830* (Oxford, 1981).

Cardinale, U. (ed.), *Problemi del Romanticismo* (Milan, 1983).

Clark, K., *The Romantic Rebellion* (London, 1973).

de Man, P., *The Rhetoric of Romanticism* (New York, 1984).

Eichner, H. (ed.), *Romantic and its Cognates: The European History of a Word* (Toronto, 1972).

Furst, L., *Romanticism in Perspective* (London, 1969).

*Honour, H., *Neo-classicism* (London, 1968).

Irwin, D., *English Neoclassical Art: Studies in Inspiration and Taste* (London, 1966). (Irwin's book is representative of the most conservative wing of art historical scholarship.)

Lovejoy, A. O., *The Great Chain of Being* (Cambridge, Mass., 1936).

—— 'On the Discrimination of Romanticism', in *Essays in the History of Ideas* (Baltimore, 1948).

McGann, J. J., *The Romantic Ideology, A Critical Investigation* (Chicago and London, 1983).

Morse, D., *Perspectives on Romanticism* (London, 1981).

Prawer, S., *The Romantic Period in Germany* (London, 1970).

Praz, M., *The Romantic Agony* (London, 1960).

Rosen, C., and Zerner, H., *Romanticism and Realism* (London, 1984).

Rosenblum, R., *The International style of 1800: A Study in Linear Abstraction*, Ph.D. diss. (New York, 1956).

Rydel, C. (ed.), *The Ardis Anthology of Russian Romanticism* (Ann Arbor, 1984).

Schenk, H. G., *The Mind of the European Romantics* (London, 1966).

Taylor, B., *The Romantic Movement* (London, 1966).

Vaughan, W., *German Romantic Painting* (New Haven and London, 1980).

*—— *Romantic Art* (London, 1978).

Victoria and Albert Museum, *Rococo: Art and Design in Hogarth's England* (London, 1984).

Wiedman, A., *Romantic Theories of Art* (Oxford, 1986).

Urbanization: The country and city.

Andrews, M., *The Search for the Picturesque: Landscape and the Aesthetics of Tourism, 1760–1800* (Aldershot, 1989).

Barrell, J., *The Dark Side of the Landscape* (Cambridge, 1980).

Bermingham, A., *Landscape and Ideology: The English Rustic Tradition 1740–1860* (Berkeley, 1986).

Copley, S., and Garside, P. (eds.), *The Politics of the Picturesque, Literature Landscape and Aesthetics since 1770* (Cambridge, 1994).

Everet, N., *The Tory View of the Landscape* (New Haven and London, 1994).

Mitchell, W. J. T. (ed.), *Landscape and Power* (Chicago and London, 1994).

Solkin, D., *Richard Wilson: The Landscape of Reaction* (London, 1982).

Williams, R., *The Country and the City* (London, 1973).

Concepts of the public.

Barrell, J., *The Political Theory of Painting from Reynolds to Hazlitt: The Body Public* (New Haven and London, 1986). (In my opinion this is the most difficult book in Barrell's œuvre. For those who can persevere with the long sentences a rewarding read.)

Calhoun, C., *Habermas and the Public Sphere*

(Cambridge, Mass., 1993).

FORT, B., *Théorie du Public et Critique d'Art: De Félibien a Lefébure*, Collectaneous, SV, 265 (Oxford, 1989), 1485–8.

GERMER, S., 'In Search of the Beholder: On the Relation of Art, Audiences and Social Spheres in Post-Thermidor France', *Art Bulletin*, 74 (March, 1992), 19–28.

HEMINGWAY, A., *Landscape Imagery and Urban Culture in Nineteenth Century Britain* (Cambridge, 1992).

KAISER, T. E., 'Rhetoric in Service of the King; The Abbé Dubos and the Concept of Public Judgement', *Eighteenth Century Studies*, 23: 2 (Winter, 1989–90).

PEARS, I., *The Discovery of Painting: The Growth of Interest in the Arts in England, 1680–1768* (New Haven and London, 1988).

PUTTFARKEN, T., 'Whose Public?', *Burlington Magazine* (June, 1987), 297–9.

*SENNET, R., *The Fall of Public Man* (London, 1986).

SOLKIN, D., *Painting for Money, The Visual Arts and the Public Sphere in Eighteenth Century England* (New Haven and London, 1993).

Urbanization and economic change.

BAXTER, S. B., *England's Rise to Greatness* (Los Angeles, 1983).

BECKET, J. V., *The Aristocracy in England, 1660–1914* (Oxford, 1984).

BORSAY, P., *The English Urban Renaissance: Culture and Society in the Provincial Town, 1660–1770* (Oxford, 1989).

BOS, J. B., L'ABBÉ DU, *Critical Reflections upon Poetry, Painting and Music*, trans. T. Nugent, 3 vols. (London, 1748).

BYRD, M., *London Transformed: Images of the City in the Eighteenth Century* (New Haven, 1978).

CAMPBELL, C., *The Romantic Ethic and the Spirit of Modern Consumerism* (Oxford, 1987).

DE VRIES, J., *European Urbanisation, 1500–1800* (London, 1984).

EARLE, P., *The Making of the English Middle Class: Business, Society and Family Life in London, 1660–1730* (London, 1989).

EDELSTEIN, T. J., *Vauxhall Gardens* (New Haven and London, 1983).

GEORGE, M. D., *London Life in the Eighteenth Century* (London, 1966).

HARTWELL, R. M., *The Causes of the Industrial Revolution in England* (London, 1967).

HOLDERNESS, B. A., *Pre-Industrial England: Economy and Society, 1500–1750* (London, 1976).

HONEYMAN, K., *The Origins of Enterprise: Business Leadership and the Indrustial Revolution* (Manchester, 1982).

LANDES, D. S., *The Unbound Prometheus: Technological Change in Europe since 1750* (Cambridge, 1969).

LANGFORD, P., *A Polite and Commercial People* (Oxford, 1989).

MCKENDRICK, N., BREWER, J., and PLUMB, J. H., *The Birth of a Consumer Society: The Commercialisation of Eighteenth Century England* (London, 1983).

MATHIAS, P., *The First Industrial Nation*, 2nd edn. (London, 1983).

MUMFORD, L., *The City in History, Its Origins, its Transformations and its Prospects* (London, 1975).

POLLARD, S., *Peaceful Conquest: The Industrialisation of Europe, 1760–1970* (Oxford, 1981).

ROSENAU, H., *Social Purpose in Architecture: Paris and London Compared 1760–1800* (London, 1970).

SCHAMAS, C., *The Pre-Industrial Consumer in England and France* (Oxford, 1990).

STONE, L., *The Open Elite? England, 1540–1880* (Oxford, 1984).

SUMMERSON, J., *Georgian London*, rev. edn. (London, 1962).

SUNDERLAND, L., *Politics and Finance in the Eighteenth Century* (London, 1984).

WEATHERILL, L., *Consumer Behaviour and Material Culture in Britain 1660–1760* (London, 1988).

WILLIAMS, J. B., *British Commercial Policy and Trade Expansion, 1750–1850* (Oxford, 1972).

ZUCKER, P., *Town and Square* (Cambridge, Mass., 1970).

Art theory, aesthetics and criticism.

ADHÉMAR, J., and SENZEC, J., *Diderot, Salons*, 4 vols. (Oxford, 1957–67).

BABCOCK, R. W., 'The idea of Taste in the Eighteenth Century', *Proceedings of the Modern Language Association of America*, 50 (1935), 922–6.

BARASCHE, M., *Modern Theories of Art*, i, *From Winckelmann to Baudelaire* (New York and London, 1990).

BATTERSBY, C., *Gender and Genius: Towards a Feminist Aesthetics* (London, 1989).

BECKETT, R. B., *John Constable's Discourses* (Ipswich, 1970).

BOWIE, A., *Aesthetics and Subjectivity: From Kant to Nietsche* (Manchester, 1990).

BURKE, E. A., *A Philosophical Enquiry into … the Sublime and the Beautiful* (London, 1925).

COHEN, R., *Studies in British Art and Aesthetics* (Berkeley, 1985).

COHEN, S. A., *Theory of Art in the Encyclopédie* (Michigan, 1993).

COLEMAN, F. X., *The Aesthetic Thought of the French Enlightenment* (London, 1971).

COOPER, A., 3rd Earl of Shaftesbury, *Characteristics of Men, Manners, Opinions and*

Times etc., ed. J. M. Robertson (London', 1990).

CROWTHER, P., *The Kantian Sublime: From Morality to Art* (Oxford, 1984).

EAGLETON, T., *The Function of Criticism; from 'The Spectator' to Post-structuralism* (London, 1984).

HAGSTRUM, J. H., *The Sister Arts: The Tradition of Literary Pictorialism from Dryden to Gray* (Chicago, 1958).

HAYWOOD, B., *Novalis: The Veil of Imagery* (The Hague, 1963).

HIPPLE J., *The Beautiful, the Sublime and the Picturesque in Eighteenth-Century British Aesthetic Theory* (Carbondale, 1957).

HOGARTH, W., *The Analysis of Beauty. With Rejected Passages from the Manuscript Drafts and Autobiographical Notes*, ed. J. Burke (Oxford, 1955).

HOOKER, E. N., 'The Discussion of Taste from 1750–1770 and new Trends in Literary Criticism', *Proceedings of the Modern Language Association of America* (June 1934), 577–92.

KNIGHT, R. PAYNE, *An Analytical Enquiry into the Principles of Taste* (London, 1805).

KNOX, J., *The Aesthetic Theories of Kant, Hegel and Schopenhauer* (Columbia, 1936).

KRUFT, W.-O., *History of Architectural Theory from Vitruvius to the Present* (Princeton, 1994).

LEE, R., 'Ut Pictura Poesis: The Humanistic Theory of Painting', *Art Bulletin* (1940), 197–269.

LIPKING, L., *The Ordering of the Arts in Eighteenth Century England* (Princeton, 1970).

LUBBOCK, J., *The Tyranny of Taste, The Politics of Architecture and Design in Britain 1550–1960* (New Haven and London, 1995).

MATTICK, P., *Eighteenth-Century Aesthetics and the Reconstruction of Art* (Cambridge, 1993).

MONK, S. H., *The Sublime: A Study of Critical Theory in Eighteenth-Century England* (Michigan, 1960).

MORTIER, R., *Diderot and the Grand Gout, the prestige of History Painting in the Eighteenth Century* (Oxford, 1982).

PITTOCK, J., *The Ascendancy of Taste* (London, 1973).

PUTFARKEN, T., *Roger De Piles' Theory of Art* (New Haven and London, 1985).

REYNOLDS, J., *Discourses on Art*, ed. R. R. Wark (New Haven and London, 1975).

SAISSELIN, R. G., *The Rule of Reason and the Ruses of the Heart* (Cleveland and London, 1970).

—— *Taste in Eighteenth Century France* (Syracuse, 1965).

SCHILLER, J. C., FRIEDRICH VON, *On the Aesthetic Education of Man*, ed. and trans. E. M. Wilkinson and L. A. Willoughby

(Oxford, 1967).

SENZEC, J., *Essais sur Diderot et Antiquity* (Oxford, 1957).

SPACKS, P. M., *The Insistence on Horror* (Cambridge, 1962).

STEEGMAN, J., *The Rule of Taste: from George I to George IV* (London, 1968).

TARTARKIEWICZ, W., *History of Aesthetics*, iii (The Hague, Paris, and Warsaw, 1970–4).

VIDLER, A., *The Writing on the Wall, Architectural Theory in the late Enlightenment* (Princeton, 1987).

VENTURI, L., *History of Art Criticism* (New York, 1964).

WELLEK, R., *Concepts of Criticism* (New Haven and London, 1963).

—— *A History of Modern Criticism 1750–1950.* I: *The Later Eighteenth Century* (New Haven and London, 1955).

WEINSHENKER, A. B., *Falconet: His Writings and his Friend Diderot* (Geneva, 1996).

*WIEBENSON, D. (ed.), *Architectural Theory and Practice from Alberti to Ledoux* (Chicago, 1982).

WORNUM, R. W., *Lectures on Painting by the Royal Academicians* (London, 1848).

Chapter 1

Works relating to the art profession, art market, and academies.

ALLAN, D. C. G., *William Shipley, Founder of the Royal Society of Arts* (London, 1968).

ANDREWS, K., *The Nazarenes, A Brotherhood of German Painters in Rome* (Oxford, 1964).

BOSCHLOO, A. W. A. (ed.), *Academies of Art between the Renaissance and Romanticism*, Leids Kunsthistorisch Jaarboek, v–vi (Leiden, 1986–7).

FAWCETT, T., *The Rise of English Provincial Art* (Oxford, 1974).

FRIEDMAN, W., *Boydell's Shakespeare Gallery* (New York, 1975).

GIBSON-WOOD, C., 'Jonathan Richardson and the Rationalisation of Connoisseurship', *Art History*, 7 (1984), 38–56.

GWYN, J., *An Essay in Design Including Proposals for Erecting a Public Academy* (London, 1749).

HARGROVE, J. (ed.), *The French Academy: Classicism and its Antagonists* (Newark, London, and Toronto, 1990).

HASKELL, F., *Patrons and Painters, Art and Society in Baroque Italy* (London, 1963).

HAYDON, B., *On Academies of Art (More Particularly the Royal Academy); and their Pernicious Effect on the Genius of Europe* (London, 1839).

HUDSON, D., and LUCKHURST, K., *The Royal Society of Arts, 1754–1954* (London, 1954).

LEVITINE, G., *The Dawn of Bohemianism: The Barbu Rebellion and Primitivism in Neoclassical France* (University Park, Pa., 1978).

LIPPINCOTT, L. W., *Selling Art In Georgian London: The Rise of Arthur Pond* (London, 1983).

PEVSNER, N., *Academies of Art, Past and Present* (New York, 1973; Cambridge, 1990).

POINTON, M., 'Portrait Painting as a Business Enterprise in London in the 1780s', *Art History*, 7 (1984), 187–205.

SHAWE-TAYLOR, D., *Genial Company: The Theme of Genius in Eighteenth-Century British Portraiture* (Nottingham, 1987).

WITTKOWER, R., 'The Artist', in J. L. Clifford (ed.), *Man vs Society in Eighteenth-Century Britain* (Cambridge, 1968).

WITTKOWER, R. and W., *Born Under Saturn, The Character and Conduct of Artists: A Documented History from Antiquity to the French Revolution* (London, 1963).

WRIGLEY, R., 'Apelles in Bohemia', *Oxford Art Journal*, 15: 1 (1992), 92–107.

ZAKON, R., *The Artist and his Studio in the Eighteenth and Early Nineteenth Centuries* (Cleveland, 1978).

Source works relating to the lives and opinions of artists.

BARRY, J., *The Works of James Barry*, 2 vols. (London, 1809).

BECKETT, R. B., *John Constable's Correspondence*, 6 vols. (Ipswich, 1962–70).

BISSELL POPE, W., *The Diary of Benjamin Robert Haydon*, 5 vols. (Cambridge, Mass., 1960).

CAYLUS, COMTE DE, *Vries d'artistes du XVIII siècle* (Paris, 1910).

CHALON, J. (ed.), *Vigée Le Brun, Elizabeth Louise, Mémoires d'une Portraitist, 1755–1842* (Paris, 1989).

DALLAWAY, J., *Anecdotes of the Arts in England* (London, 1800).

DELÉCLUZE, M. E. J., *Louis David, Son école et son temps* (Paris, 1855).

DUPLESSIS, G., *Mémoires et Journals de J.-C. Wille* (Paris, 1857).

EDWARDS, E., *Anecdotes of Painters who have resided or been born in England* (London, 1808).

GAGE, G., *Collected Correspondence of J. M. W. Turner* (Oxford, 1980).

GARLICK, K., and MACINTYRE, A. (eds.), *The Diary of Joseph Farrington*, 6 vols. (New Haven and London, 1978).

GONCOURT, E., and J. DE, *L'Art du XVII Siècle* (Paris, 1948).

HENRY, C., *Mémoires in édits de Charles-Nicolas Cohcin* (Paris, 1880).

JONES, T., *The Memoirs of Thomas Jones,*

Walpole Society, xxxii (London, 1946–8).

MILLINGEN, J., *Some Remarks on the State of Learning and the Fine Arts in Great Britain* (London, 1831).

NICHOLS, J., *Anecdotes of William Hogarth* (London, 1833).

NORTHCOTE, J., *Memoirs of Sir Joshua Reynolds* (London, 1813).

PALMER, A. H., *The Life and Letters of Samuel Palmer* (London, 1892).

REDGRAVE, R. and S., *A Century of Painters of the English School*, 2 vols. (London, 1866).

ROUQUET, J., *The Present State of the Arts in England* (London, 1755).

TAYLOR, T., *The Life of B. R. Haydon from his Autobiography and Journal* (London, 1853).

TURNBILL, G., *A Treatise on Ancient Painting* (London, 1740).

WHITLEY, W., *Artists and their Friends in England, 1700–1799*, 2 vols. (London, 1928).

—— *Artists and their Friends in England, 1800–1820* (London, 1928).

WILLIAMS, D. E., *The Life and Correspondence of Sir Thomas Lawrence*, 2 vols. (London, 1831).

Monographic articles and books.

AHSTON, D., *Fragonard and the Universe of Painting* (Washington and London, 1988).

ASHTON, M., 'Allegory Fact and Meaning in Giambattista Tiepelo's Four Continents'. *The Art Bulletin*, 60 (1978), 109–25.

ALPERS, P., and BAXANDALL, M., *Tiepolo and the Pictorial Intelligence* (New Haven and London, 1994).

ARNASON, H. H., *The Sculptures of Houdon* (London, 1975).

BAILLOU, J., *Elizabeth Louise Vigée Le Brun 1755–1842*, exhibition catalogue (Fort Worth, 1982).

BAILY, J. T., *Francesco Bartolozzi, R.A., A Biographical Essay* (London, 1907).

BELL, C. F., *Annals of the Life of Thomas Banks* (Cambridge, 1938).

BIALOSTOCKI, J., 'Bernardo Belotto in Dresden and Warsaw', *The Burlington Magazine*, 106 (1964), 289–90.

BINDMAN, D., *Blake as an Artist* (Oxford, 1977).

—— (ed.), *John Flaxman, R.A.*, Catalogue of an Exhibition at the Royal Academy of Arts (London, 1979).

BINDMAN, D., and BAKER, M., *Sculpture as Theatre: Roubiliac and the Eighteenth Century Monument* (New Haven and London, 1995).

BISANZ, R. and A., *German Romanticism and Philip Otto Runge*, (DeKalb, Ill., 1970).

BROOKNER, A., *Greuze, The Rise and Fall of an Eighteenth Century Phenomenon* (London, 1972).

BRUNTJEN, S., *John Boydell 1719–1804: A Study*

of Art Patronage and Publishing in Eighteenth-Century (London and New York, 1985).

CLARK, A. M., *Pompeo Batoni, A Complete Catalogue of his Works* (Oxford, 1985).

CLAY, R. M., *Julius Caesar Ibbetson, 1759–1817* (London, 1948).

COOKSEY, J. C. B., *Alexander Nasmyth, 1758–1840, A Man of the Scottish Renaissance* (Edinburgh, 1991).

DONALD, D., 'Culumny and Caricatura: Eighteenth Century Political Prints and the Case of George Townsend', *Art History*, 6 (1983), 44–66.

EGERTON, J., *Joseph Wright of Derby*, Tate Gallery (London, 1990).

EITNER, L. E. A., *Géricault: His Life and Work* (London, 1972; repr. 1983).

FEAVER, W., *The Art of John Martin* (Oxford, 1975).

FUSSELL, G. E., *James Ward R.A., Animal Painter 1769–1859 and his England* (London, 1974).

GABORIT, J.-R., *Jean Baptiste Pigalle, 1714–1785, Sculptures du Musée Louvre* (Paris, 1985).

GAGE, J., *J. M. W. Turner, 'A Wonderful Range of Mind'* (New Haven and London, 1987).

GARNIER, N., *Antoine Coypell, 1661–1721* (Paris and Boston, 1989).

GEALT, A., *Domenico Tiepelo: The Punchinello Drawings* (London, 1986).

GLENDINNING, N., *Goya and his Critics* (New GORDON, T. C., *David Allan of Alloa, The Scottish Hogarth* (Alva, 1951). Haven and London, 1977).

HAYES, J., *Rowlandson, Watercolours and Drawings* (London, 1972).

HILL, D., *Mr Gillray, the Caricaturist* (London, 1965).

HOLLOWAY, J., *Jacob More*, National Gallery of Scotland (Edinburgh, 1987).

—— *John Hamilton Mortimer, A.R.A. 1740–1779, Paintings, Drawings and Prints* (London, Kenwood, 1986).

JOHNSON, D., *Jacques-Louis David, Art in Metamorphosis* (Princeton, 1994).

JOPPIEN, R., *Philippe-Jacques de Loutherbourg*, exhibition catalogue (London, Kenwood, 1973).

KLINGENDER, F. D., *Goya in the Democratic Tradition* (London, 1948).

KNOX, J., *Giambattista Piazzetta* (Oxford, 1992).

—— *The Punchinello Drawings of Biabattista Tiepelo*, Interpretazioni Veneziani (Venice, 1984), 439–46.

KOENER, J. L., *Caspar David Friedrich and the Subject of Landscape* (London, 1990).

LEIGHTON, J., and BAILY, C. J., *Caspar David Friedrich, Winter Landscape*, exhibition catalogue (London, National Gallery, 1990).

LEVITINE, G., *Caspar David Friedrich and the Age of German Romanticism* (Boston, 1978).

LICHT, F., *Canova* (New York, 1983).

LISTER, R., *Samuel Palmer and the 'Ancients'* (Cambridge, 1984).

O'NIELL, J. P., *Francois Boucher* (New York, 1986).

PAULSON, R., *Hogarth, His Life Art and Times*, 2 vols. (New Haven and London, 1971).

PELZEL, T., *Anton Raphael Mengs and Neoclassicism* (New York, 1979).

PENNY, N. (ed.), *Reynolds*, Exhibition Catalogue, London, Royal Academy of Arts (1986).

POSNER, D., *Antoine Watteau* (London, 1984).

POSTLE, M., *Sir Joshua Reynolds, the Subject Pictures* (Cambridge, 1994).

POULET, A. L., and SCHERF, G., *Clodion*, exhibition catalogue (Paris Louvre, 1992).

PRESSLEY, N., *Fuseli and his Circle in Rome* (New Haven and London, 1977).

PRESSLEY, W. L., *The Life and Art of James Barry* (New Haven and London, 1981).

PROWN, J., *John Singleton Copley* (Harvard, 1966).

RAINE, K., *William Blake* (London, 1974).

ROSENTHAL, M., *Constable, The Painter and his Landscape* (New Haven and London, 1983).

SHERRIFF, M. D., *Fragonard. Art and Eroticism* (Chicago, 1990).

TOMLINSON, J., *Goya in the Twilight of Enlightenment* (New Haven and London, 1992).

WAKEFIELD, D., *Fragonard* (London, 1976).

YARRINGTON, A. (ed.) *An Edition of the Ledger of Francis Chantrey, R.A., at the Royal Academy, 1809–1841*, Walpole Society, 56, 1991/1992 (London, 1994).

WEBSTER, M. D., *Francis Wheatley* (London, 1970).

WILTON-ELY, J., *The Mind and Art of Giovanni Battista Piranesi* (London, 1978).

Chapter 2

Works relating to the formation of cultural identity in Europe.

ANDERSON, B., *Imagined Communities: Reflections on the Origin and Spread of Nationalism* (London, 1991).

CLARK, R. T., *Herder: His Life and Thought* (Berkeley and Los Angeles, 1955).

CLOGG, R., *The Movement for Greek Independence* (London, 1981).

COLLEY, L., *Britons, Forging the Nation 1707–1837* (London, 1992).

—— 'Whose Nation? Class and National Consciousness in Britain, 1750–1830', *Past and Present*, 13, 96–117.

COREA, C. E., *Costumbrisos Espanoles*

(Madrid, 1964).

EISENSTEIN, E. L., *Grub Steet Abroad, Aspects of the French Cosmopolitan Press from the Age of Louis XIV to the French Revolution* (Oxford, 1992).

ERRINGTON, L., and HOLLOWAY, J., *The Discovery of Scotland*, National Gallery of Scotland (1978).

GASKILL, H., *Ossian Macpherson: Towards a Rehabilitation*, Comparative Criticism, 8 (1986), 113–46.

HAYS, D., *Europe: The Emergence of an Idea* (Edinburgh, 1975).

HECHTER, M., *Internal Colonialism: The Celtic Fringe in British National Development, 1536–1966* (Berkeley and Los Angeles, 1975).

HOBSBAWM, E., *Nations and Nationalism since 1780, Programme, Myth, Reality* (Cambridge, 1990).

—— *Primitive Rebels, Studies in Archaic Forms of Social Movement in the 19th. and 20th. Centuries* (Manchester, 1959; New York, 1965).

HOBSBAWM, E., and RANGER, T., *The Invention of Tradition* (Cambridge, 1983).

KOHN, K., *Nationalism and Liberty: The Swiss Example* (London, 1956).

KORSHIN, P. J., *The Widening Circle; Essays on the Circulation of Literature in Eighteenth Century Europe* (Philadelphia, 1976).

MEINECKE, F., *Cosmopolitanism and the Nation State* (Princeton, 1970).

NEWMAN, G., *The Rise of English Nationalism: A Cultural History, 1740–1830* (New York, 1987).

PHILIPSON, N. T., and MITCHISON, R., *Scotland in the Age of Improvement* (Edinburgh, 1970).

ROGGER, H., *National Consciousness in Eighteenth Century Russia* (London, 1960).

SCHLERETH, T. J., *The Cosmopolitan Ideal in Eighteenth Century Thought* (London, 1977).

SMOUT, T. C., *A History of the Scottish People 1560–1830* (London, 1970).

TIEGHAM, P. VAN, *Ossian en France*, 2 vols. (Paris, 1917).

TODOROV, T., *On Human Divserity: Nationalism, Racism and Exoticism in French Thought* (Harvard, 1983).

WILLIAMS, G. A., *The Search for Beulah Land: The Welsh and the Atlantic Revolution* (London, 1980).

—— *When was Wales?* (London, 1985).

YOUNGSON, A. J., *The Making of Classical Edinburgh, 1750–1830* (Edinburgh, 1966). Works applying to themes addressed in this chapter.

BLACK, J., *The British Abroad: The Grand Tour in the Eighteenth Century* (Stroud and

New York, 1992).

CONISBEE, P., *Claude-Joseph Vernet 1714–1789*, exhibition catalogue, Kenwood House (London, 1976).

DENISON, C. D., *Exploring Rome: Piranesi and his Contemporaries* (Cambridge, Mass., 1994).

DUNLAP, W., *History of the Rise and Progress of the Arts and Design in the United States* (New York, 1834).

FOX-GENOVESE, E., *The Origins of Physiocracy* (Ithaca, 1976).

GRIEDER, J., *Anglomania in France 1740–1789, Fact, Fiction and Political Discourse* (Geneva, 1985).

HURD, R., *Dialogues on the Uses of Foreign Travel Considered as Part of the English Gentleman's Education* (London, 1764).

JOULLAIN, C. F., *Reflexions sur la Peintre* (Paris, 1786).

LEWIS, L., *Connoisseurs and Secret Agents in Eighteenth Century Rome* (London, 1961).

MITCHELL, T. F., 'Caspar David Friedrich's Der Watzmann: German Romantic Landscape Painting and Historical Geology', *Art Bulletin*, 61: 3 (1984), 452–64.

OLSON, R. J. M., *Ottocento, Romanticism and Revolution in 19th Century Italian Painting* (New York, 1992).

PALEY, M. D., *The Apocalyptic Sublime* (New Haven and London, 1986).

PARRY, E. C., *The Art of Thomas Cole, Ambition and Imagination* (Newark, London, and Ontario, 1988).

PAULSON, R., *Representations of Revolution 1789–1820* (New Haven and London, 1983).

PICON, A., *French Architects and Engineers in the Age of Enlightenment* (Cambridge, 1988).

SAXL, F., *British Art and the Mediterranean* (Oxford, 1948).

SMILES, S., *The Image of Antiquity* (New Haven and London, 1994).

STUEBE, I. C., 'William Hodges and Warren Hastings, A Study in Eighteenth Century Patronage', *Burlington Magazine*, 115 (Oct. 1973), 657–66.

WACKENRODER, W., *Confessions and Fantasies*, trans. M. H. Schubert (Pennsylvania, 1971).

WEBSTER, M., *Johann Zoffany, 1733–1810* (London, 1976).

Chapter 3

Works relating to themes addressed in this chapter.

BANKS, O. T., *Watteau and the North: Studies in the Dutch and French Baroque Influence on French Rococo Painting* (New York and London, 1967).

BARCHEM, W., *The Religious Paintings of Giambatista Tiepelo, Pietry and Tradition*

in *Eighteenth-Century Venice* (Oxford, 1989).
CASTLE, T., *Masquerade and Civilisation: The Carnivalesque in Eighteenth-Century English Culture and Fiction* (London, 1986).
CORMACK, M., *The Drawings of Watteau* (London and New York, 1970).
DARTON, R., *Mesmerism and the End of the Enlightenment in France* (Harvard, 1968).
GOMBRICH, E. H., *Art and Ilusion: A Study in the Psychology of Pictorial Representation* (London, 1960).
HOBSON, M., *The Object of Art: The Theory of Illusion in Eighteenth Century France* (Cambridge, 1982).
LEVENTHAL, H., *In the Shadow of the Enlightenment* (New York, 1976).
MARTINEAU, J., and ROBINSON A., *The Glory of Venice, Art in the Eighteenth Century* (New Haven and London, 1995).
MILLAR, O., *Zoffany and his Tribuna* (London, 1966).
ROSENBERG, P., *Chardin*, exhibition catalogue (Paris, Cleveland, and Detroit, 1979).
STAFFORD, B. M., *Artful Science, Enlightenment Entertainment and the Eclipse of Visual Education* (Cambridge, Mass., 1994).
SWAN, J., *The Triumph of Pierrot: The Commedia dell'Arte and the Modern Imagination* (New York, 1986).
THOMAS, K., *Religion and the Decline of Magic* (New York, 1971).
VIDAL, M., *Watteau's Painted Conversations* (New Haven and London, 1992).
WITTKOWER, R., 'Marvels of the East, A study in the History of Monsters', *Journal of the Warburg and Courtauld Institutes* (1942), 159–97.
YATES, F., *The Rosicrucian Enlightenment* (London, 1975).
Major works on the subject of the visual arts and theatricality.
BAPST, G., *Essai sur l'histoire du théatre, la mise en scène, le décor, le costume, l'architecture, léclairage, l'hygiène* (Paris, 1893).
BERTELSEN, L., 'David Garrick and English Painting', *Eighteenth-Century Studies*, 11 (1978), 308–24.
GOODEN, A., *Actio and Persuasion. Dramatic Performance in Eighteenth Century France* (Oxford, 1986).
KLINGER, M. F., 'William Hogarth and London Theatrical Life', *Studies in Eighteenth-Century Culture*, 5 (1976), 11–27.
ROSENFELD, S., *Georgian Scene Painters and Scene Painting* (Cambridge, 1981).
WEST, S., *The Image of the Actor, Verbal and Visual Representation in the Age of Garrick and Kemble* (London, 1991).

Chapter 4

Works relating to the theory of history and historical writing in the period.
BARIDON, M., *Edward Gibbon et le myth de Rome: histoire et idéologie au siècle des lumières* (Paris, 1977).
BOWERSOCK, G. M. (ed.), *Edward Gibbon and the Decline and Fall of the Roman Empire* (Cambridge, Mass., 1977).
GEARHART, S., *The Open Boundary of History and Fiction: A Critical Approach to the French Enlightenment* (Princeton, 1984).
GOMBRICH, E. H., *Ideas of Progress and their Impact on Art* (New York, 1971).
HASKELL, F., 'Gibbon and the History of Art', in *Past and Present in Art and Taste* (New Haven and London, 1987), 16–29.
—— *History and its Images: Art and the Interpretation of the Past* (New Haven and London, 1993).
NISBIT, R. A., *History of the Idea of Progress* (London, 1980).
PASSMORE, J. A., *The Perfectability of Man* (London, 1970).
POTTS, A., 'Political Attitudes and the Rise of Historicism in Art Theory', *Art History*, 112 (June 1978), 191–213.
—— 'Winckelmann's Construction of History', *Art History* (1982), 377–407.
—— *Flesh and the Ideal, Winckelmann and the Origins of Art History* (New Haven and London, 1994).
POCOCK, J. G. A., *Politics, Language and Time* (New York, 1971).
—— *Virtue, Commerce and History* (Cambridge, 1985).
REILL, P. H., *The German Enlightenment and the Rise of Historicism* (Berkeley, 1975).
VYVERBERG, H., *Historical Pessimism in the French Enlightenment* (Cambridge, Mass., 1954).
WHITE, H., *MetaHistory: The Historical Imagination in Nineteenth-Century Europe* (Baltimore and London, 1973).
Works relating to the history of the human body.
BARRELL, J., 'The Dangerous Godess: Masculinity, Prestige and the Aesthetic in Early Eighteenth Century Britain', *Cultural Critique*, 12 (1989), 101–31.
LAJER-BURCHARTH, E., 'David's Sabine Women: Body, Gender and Republican Culture Under the Directory', *Art History*, 14 (Sept. 1991), 397–430.
OUTRAM, D., *The Body and the French*

Revolution: Sex, Class and Political Culture (New Haven and London, 1989).

PRAZ, M., *La carne, la morte e le diavolo nella litteratura romantica* (Milan, 1930).

RICHTER, S., *Laocoön's Body and the Aesthetics of Pain* (Detroit, 1992).

SENNET, R., *Flesh and Stone, The Body and the City in Western Civilisation* (London and Boston, 1974).

STAFFORD, M. A., *Body Criticism, Imaging the Unseen in Enlightenment Art and Medicine* (Cambridge, Mass., 1991).

Works relating to themes in this chapter.

ANDRIEUX, M., *Daily Life in Papal Rome in the Eighteenth Century* (London, 1968).

CUSHMAN DAVIS, J., *The Decline of the Venetian Nobility as a Ruling Class* (Baltimore, 1962).

DUDLEY, E., and NOVAK, M., *The Wildman Within: An Image in Western Thought from the Renaissance to Romanticism* (Pittsburgh, 1972).

ERDMANN, D. V., *Blake, Prophet against Empire: A Poet's Interpretation of his own Times* (Princeton, 1977).

Hubert Robert and the Pleasure of Ruins, exhibition catalogue (New York, Wildenstein, 1988).

IDEZADERA, S., 'Iconoclasm and the French Revolution', *American Historical Review*, 60 (1954), 13–26.

LEITH, J., *The Idea of Art as Popaganda in France, 1750–1799* (Toronto, 1969).

—— *Space and Revolution: Projects for Monuments, Squares and Public Buildings in France* (London, 1991).

LEVITINE, G., *Girodet Trisson, An Iconographical Study*, Ph.D. diss. Harvard University, 1953 (pub. New York, 1974).

LOVEJOY, A. O., and BOAS, G., *Primitivism and Related Ideas in Antiquity* (Baltimore, 1935).

MACMILLAN, D., 'Truly National Designs', *Art History* (1978), 90–8.

MURRAY, P., *Piranesi and the Grandeur of Ancient Rome* (London, 1971).

OKUN, H., 'Ossian in Painting', *Journal of the Courtauld and Warburg institutes*, 30 (1967), 327–56.

ROSS, W., *A Description of the Paintings in the Hall of Ossian at Penycuik near Edinburgh* (Edinburgh, 1773).

SEKORA, J., *Luxury, The Concept In Western Thought, from Eden to Smollet* (Baltimore, 1977).

STAROBINSKI, J., *Jean Jacques Rousseau: Transparency and Obstruction* (Chicago and London, 1988).

VIDLER, A., *Claude-Nicholas Ledoux, Architecture and Social Reform at the End of the Ancien Régime* (Cambridge, Mass., 1994).

WALLACH, A., 'Cole, Byron and the Course of Empire', *Art Bulletin*, 50 (Dec, 1968), 375–9.

WHISTLER, C., 'G. B. Tiepelo and Charles III, The Church of S. Pascual Baylon at Aranjuez', *Apollo*, 121 (1985), 321–7.

YARRINGTON, A. (ed.), *Reflections on Revolution* (London, 1993).

A selection of works designed to form an introduction to the imagery and ideology of Empire in this period.

ABRAMS, A. U., 'William Penn's Treaty with the Indians', *Art Bulletin*, 64 (March 1982), 59–65.

ARCHER, M., *Early Views of India: The Picturesque Journeys of Thomas and William Daniell, 1786–1794* (London, 1980).

ARCHER, M., and LIGHTBROWN, R., *India Observed, 1760–1860* (London, 1982).

BINDMAN, D., 'Am I not a man and a brother? British Art and Slavery in the Eighteenth Century', *Anthropology and Aesthetics*, 26 (Autumn, 1994), 68–82.

BITTERLI, U., *Cultures in Conflict: Encounters between European and non-European Cultures, 1492–1800* (Cambridge, 1989).

CAMPBELL, I. C. 'Savages Noble and Ignoble: The Preconceptions of Early European Voyages in Polynesia', *Pacific Studies* (Fall, 1980), 45–59.

DANIEL, N. A., *Islam and the West: The Making of an Image* (Edinburgh, 1958).

HONOUR, H., *The Image of the Black in Western Art* (Cambridge, Mass., 1989).

—— 'Benjamin West's Indian Family', *Burlington Magazine*, 125 (Dec. 1983) 726–32.

HUGHES, P., *Eighteenth-Century France and the East* (London, 1981).

JENNINGS, F., *The Invasion of America: Indians, Colonialism and the Cant of Conquest* (New York, 1978).

JOPPIEN R., and SMITH, B., *The Art of Captain Cook's Voyages*, 3 vols. (New Haven and London, 1985).

MARSHALL, P. J., *The Great Map of Mankind: British Perceptions of the World in the Age of Enlightenment* (London, 1982).

ROSENZWEIG, D. L., *Exotic Kingdoms: China and Europe ion the Eighteenth Century* (Florida, 1982).

ROSSEAU, G. S., and PORTER, R., *Exoticism in the Enlightenment* (Manchester, 1990).

SAID, E., *Orientalism* (London, 1978).

SUTTON, D., *The Daniells. Artists and Travellers* (London, 1954).

SWEETMAN, J., *The Oriental Obsession: Islamic Inspiration in British and American Art and Architecture 1500–1920* (Cambridge, 1987).

1700 1702 1704 1706 1708

Political

● 1701 Beginning of the War of Spanish Succession (1701–13). France opposed by England, Prussia, and Holland.

● 1702 Accession of Queen Anne (1702–14) in Britain.

● 1707 Act of Union between Scotland and England.

Arts

● 1704 Newton publishes his *Opticks*.
– William Kent travels to Rome where he attracts the attention of Earl Burlington.

● 1708 James Thornhill begins work on the Painted Hall at Greenwich.
– Completion of Roger de Piles's *Cours de peintre*.
– Antoine Coypell completes his melodramatic ceiling for the chapel at Versailles.

● 1713 The Treaty of Utrecht. France bankrupted by war and court extravagance.
– Pragmatic Sanction designed to ensure Maria Térèsa's succession to the Empire.

● 1714 Hanoverian Succession in Britain. Accession of George I (1714–27).
● 1715 Louis XV (1715–27) succeeds to French throne, 1715 Philippe D'Orleans Regent.

● 1720 Bursting of the South Sea Bubble precipitates financial collapse in London.
– Accession of George II (1727–60).
● 1721 Robert Walpole becomes first British Prime Minister.

● 1710 George Frederick Handel appointed Kappellmeister to the Elector of Hanover.

● 1715 Publication of the first editions of *Vitruvius Britannicus* (1715–25).
– Jonathan Richardson publishes *The Theory of Painting*.

● 1719 Defoe completes *Robinson Crusoe*.
– Dubos publishes *Réflexions Critiques sur la poésie, la peintre et la musique*.
– Watteau completes *L'Embarquement pour Cythère*.

● 1720 Watteau paints *L'Enseigne de Gersaint*.
● 1721 Montesquieu completes his *Lettres persanes*.

1722 1724 1726 1728 1730

Political

● 1725
Death of Peter I
and temporary halt
to Russian
Expansion.

Arts

● 1723
First performances
of Marivaux's *La
Surprise de
l'amour*.

● 1724
G. B. Tiepelo
paints his first
major ceiling
fresco at the
Palazzo Sandi,
Venice.
● 1724–6
Defoe produces *A
Tour Through the
Whole Island of
Great Britain*.

● 1727
First performance
of J. S. Bach's *St
Matthew' Passion*.

● 1728
First production
of Gay's *Beggar's
Opera*.

● 1733
War of Polish
Succession
(1733–8): Russia
imposes Augustus
III, Elector of
Saxony, on Poland.

● 1739
War of Jenkins's
Ear between
England and
Spain.

● 1740
Frederick II
(1740–86)
becomes King of
Prussia and lays
claim to Silesia.
– Death of Charles
VI and succession
of Maria Térèsa
leads to the War of
Austrian
Succession
(1740–8) in which
Austria, Britain,
and Hanover are
ranged against
France, Spain, and
Prussia.

● 1732
Hogarth produces
first prints of *A
Harlot's Progress.*
● 1733
Voltaire completes
Le Temple du gout.

● 1734
Montesquieu
publishes
*Considèrations sur
les causes de la
grandeur des
romains et leur
décadence.*
● 1735
Hogarth produces
A Rake's Progress.
– Baumgarten
coins the term
aisthesis in his
*Reflections on
Poetry.*

● 1737
Académie Royale
de Peintre et de
Sculpture begins
its programme of
public exhibitions.

● 1740
Richardson
produces his first
important novel,
Pamela.
● 1741
David Garrick
makes a
sensational
London debut in
Cibber's
production of
Shakespeare's
Richard III.

● 1742
David Hume
completes his
essay *Of the
Rise and Progress
of the Arts and
Sciences.*
– First
appearance of
Edward Young's
Night Thoughts.
– First
performance of
Handel's *Messiah*
in Dublin.
● 1743
Hogarth produces
*The Marriage-à-
la-Mode* series.

	1744	1746	1748	1750	1752
Political	● 1745 Jacobite Rebellion. Forces of 'Bonnie Prince Charlie' defeated and supporters suppressed. – Ascendancy of the Marquise de Pompadour in the French Court.		● 1748 Treaty of Aix-la-Chapelle ends European War.	● 1750 Rise of Plombal (1750–82) in Portugal.	● 1753 Louis XV exiles Parlement de Paris.
Arts	● 1745 Piranesi publishes his *Vedute*.	● 1746 Caneletto arrives in England. – Bellotto embarks upon his travels around various European courts. – Lafont de St Yenne publishes his first Salon commentaries. – Batteaux publishes *Les Beaux Arts réduits à un meme principe*. ● 1747 La Mettrie publishes *L'Homme machine*.	● 1748 Montesquieu completes *L'Esprit des lois*. – Smollet produces his first important novel, *Roderick Random*.	● 1750 Rousseau completes *Discours sur les sciences et les arts*. – G. B. Tiepelo begins the frescos at Würzburg. ● 1751 The first edition of the *Encyclopédie* (1751–72) published.	● 1752 Falconet begins work on his equestrian statue in memory of Peter the Great (completed 1782). ● 1753 Robert Taylor completes the pediment for the Mansion House in London. – Hogarth published 1753 *The Analysis of Beauty*.

● 1756
Outbreak of the Seven Years War in which Britain, Hanover, Prussia, and Denmark are ranged against France, Austria, Russia, and Sweden.

● 1759
Annus Mirabilis: French defeated by Ferdinand of Brunswick at Minden, Wolfe captures city of Quebec. Britain takes Montreal and Colony of Quebec.

● 1760
Accession of George III (1760–1820) to British throne coincides with rush of national spirit auguring an age of unprecedented prosperity.

● 1762
Accession of Catherine the Great (1762–96) in Russia deposing her husband Peter III.
● 1763
Peace of Paris ends the Seven Years War.

● 1764
Jesuits expelled from France.
● 1765
Rockingham, the British Prime Minister, imposes the Stamp Act to finance the defence of colonies fuelling discontent in America.

● 1754
Foundation of the Society of Arts, Manufacture and Commerce in London.
– Academy of art established in Copenhagen.
● 1755
Greuze launches his career with genre scenes such as *A Grandfather Reading the Bible to his Family*.
– Dr Johnson completes his *Dictionary*.
– Winckelmann: *Reflections upon the Imitation of Greek works in Painting and Sculpture*.

● 1757
Burke completes *A Philosophical Enquiry into the Origin of our Ideas of The Sublime and the Beautiful*.

● 1758
J. D. Le Roy produces *Les Ruines des plus beaux monuments de la Grèce*.

● 1760
Alexander Gerard publishes his *Essay on Taste*.
● 1761
Falconet produces his *Réflexions sur la Sculpture*.
– Rousseau publishes *Emile*.
– The 29-year-old Joseph Haydn engaged as Vice-Kapellmeister to the Esterhazy Court.
– Mengs completes his fresco *Parnassus* at the Villa Albani.

● 1762
James Stuart publishes the *Antiquities of Athens*.
– Lord Kames publishes *Elements of Criticism*.
– First performances of Gluck's *Orfeo ed Euridice*.
– Horace Walpole completes first volumes of *Anecdotes of Painting in England* (1762–71).

● 1764
First academy exhibition at Dresden.
– Robert Adam produces *Ruins of the Palace of Emperor Diocletian at Spalatro in Dalmatia*.
– Horace Walpole publishes his Gothic yarn *The Castle of Otranto*.
● 1765
Fragonard admitted to the Academy for *Coresus Sacrificing himself to save Callirhoe*.
– Diderot produces his *Essai sur la peintre*.

	1766	1768	1770	1772	1774

Political

● 1766
Stamp Act
repealed.
● 1767
Catherine
publishes
Instructions,
Westernizing
Russian Law.

● 1770
Start of Ministry
of Lord North
(1770–82) in
Britain.

● 1772
First Partition of
Poland marks the
start of Poland's
disappearance as
an independent
state.
● 1773
Boston Tea Party.

● 1774
Death of Louis XV.
Louis XVI
(1774–93)
succeeds in a
period of financial
and administrative
chaos.

Arts

● 1766
George Stubbs
publishes his *The
Anatomy of the
Horse.*
– Lessing
publishes *Der
Laokoon.*
– Macpherson
publishes *The
Works of Ossian.*
– Joseph Wright of
Derby completes *A
Philosopher Giving
a Lecture on the
Orrery.*
● 1766–7
Hubert Robert
returns from Rome
to Paris and
exhibits his ruin
paintings at the
Salon.

● 1768
Foundation of the
Royal Academy of
Arts in London.

● 1770
Raynal publishes
famous discourse
on colonialism, the
*Histoire
philosophique.*
– J. Zoffany
departs for Italy to
paint his *Tribuna*
(1772–8).
– B. West
completes his
Death of Wolfe.

● 1772
William Chambers
produces his
*Dissertation on
Oriental
Gardening.*
● 1773
Marat publishes
*The Chains of
Slavery.*

● 1774
J. C. Herder
publishes his
apology for
cultural relativism
*Auche eine
Philosophie der
Geschichte.*
● 1775
Lavater
produces his
*Physiognomische
Fragmente.*
– Goethe
publishes *The
Sorrows of Young
Werther.*

● 1776
American Revolution, the Battle of Bunker Hill, and Declaration of American Independence.
● 1776–7
Turgot reform period ends in failure and the succession of Necker (1777–81).

● 1778
France and America at war against the British.

● 1780
Gordon Riots in London at the threat of the repeal of anti-Catholic legislation.
● 1781
Joseph II's 'enlightened' reforms in Austria begin in earnest.

● 1783
Treaty of Versailles. Britain accepts independence of the 13 colonies but retains West Indies, and North American, Canadian colonies.

● 1785
Trial of Warren Hastings begins on charges of corruption in the administration of India.

● 1776–83
The production of the of *Monument du Costume*.
– Gibbon produces first volume of *The Decline and Fall of the Roman Empire*.
● 1777
James Barry begins his *Progress of Human Culture* for the Great Room of the Society of the Arts.

● 1778
Houdon produces his *Benjamin Franklin*.
● 1779–80
J. S. Copley produces his *Death of Chatham*.

● 1782
Fuseli completes *The Nightmare*.
– J. P. De Loutherbourg first exhibits the Eidophusikon in London.
– Laclos publishes *Les Liaisons dangereuses*.

● 1784
David completes the *Oath of the Horatii*.
– Boulée completes designs for *A Cenotaph to Newton*.
– P.-H. Hugues, Baron d'Harcanville completes *Recherches sur l'origine, l'esprit et le progrès des arts de la Grèce*.

● 1786
Richard Payne Knight publishes *A Discourse on the Worship of Priapus*.
● 1787
Robert Porter takes out a patent on the Panorama.
– Canova's tomb of Pope Clement XIV erected at St Peter's.
– First performance of Mozart's *Don Giovanni* at the National Theatre, Prague.

	1788	**1790**	**1792**	**1794**	**1796**
Political	● 1789 French Revolution: Estates General summoned 5 May, Bastille stormed 14 July, National Assembly called.	● 1790 French church lands nationalized. ● 1791 Counter-Revolutionaries organize military invasion of France from Germany. Louis XVI and Marie Antoinette placed under restraint.	● 1792 Beginning of Terror. – Assassination of Gustav III. ● 1793 Louis XVI executed, British declare war.	● 1794 Robespierre executed. ● 1795 France under Directory.	● 1796 Bonaparte comes to prominence during French campaigns in Italy. ● 1797 French invade Egypt.
Arts	● 1788 Publication of Watelet's *Dictionnaire des beaux-arts*. ● 1789 Vien appointed first painter to the King.	● 1790 I. Kant completes his *Critique on Aesthetic Judgement*. ● 1791 Schadow completes the horses on the Brandenburger Tor in Berlin. – Thomas Paine writes *The Rights of Man*, 2 parts, 1791–2 in response to Edmund Burke's *Reflections on the Revolution in France*.	● 1792 Girodet exhibits *The Sleep of Endymion*. – W. Gilpin publishes his *Three Essays* on the picturesque. ● 1793 Flaxman produces illustrations for the *Iliad* and *Odyssey*. – David completes *Marat at his Last Breath*.		● 1795 Carstens organizes an exhibition of his works in his studio in Rome. ● 1797 W. Wackenroder compiles *Outpourings from the Heart of an Art-loving Monk*.

● 1799
Nelson defeats
French fleet at
Aboukir Bay.
Napoleon returns
from Egypt and
establishes
himself as First
Consul.

● 1800
Napoleon defeats
the Austrians at
Marengo. France
dominates Italy
except for Sicily
and Sardinia.
● 1801
Accession of
Alexander I
(1801–25) as Tsar
of Russia.
– Union of Ireland
and England.

● 1802
The Peace of
Amiens.
● 1803
Britain declares
war on France.

● 1805
Nelson victorious
at Battle of
Trafalgar.

● 1806
Napoleon
institutes the
Continental
System.
Confederation of
Rhine formed.
● 1807
Napoleon and Tsar
Alexander agree at
Tilsit to divide
Europe East and
West.
– Wilberforce's Act
abolishing slavery
passed in Great
Britain.

● 1808
Spanish rising
against French
occupation. The
beginning of the
Peninsular War.

● 1798
Wordsworth
completes his
Lyrical Ballads.
● 1798–1800
Goethe produces
Die Propylaen.
● 1799
Goya publishes
his *Los Caprichos*
etchings.
– David exhibits
his *The
Intervention of the
Sabine Women*.
– Novalis
completes
*Christendom or
Europe*.

● 1800
Goya completes
group portrait
*The Family of
Carlos IV*.
– P.-H. De
Valenciennes
publishes *Advice
to a Student on
Painting,
Particularly on
Landscape*.

● 1802
Vivant Denon
publishes *Voyage
dans la Basse et
Haute Egypte*.
– J. M. W. Turner
elected Royal
Academician.
– Chateaubriand
publishes *La Génie
du Christianisme*.
– Girodet
completes *Ossian
Receiving the
Spirits of French
Heroes*.

● 1805
The foundation of
the British
Institution for the
Promotion of the
Arts.
– First
performance of
Beethoven's
Fidelio.

● 1806
The exhibition of
Gros's *Battle of
Aboukir* and
Ingres's *Napoleon
on his Throne* in
the Salon.
● 1807
The Accademia di
Belli Arti—Venice
founded by
Napoleonic
decree.

● 1808
Richard Payne
Knight publishes
his *An Analytical
Enquiry into the
Principles of
Taste*.
– David exhibits
*The Coronation
of Napoleon and
Josephine* at the
Salon.
● 1809
Flaxman
produces
monument to
Lord Nelson, St
Pauls Cathedral.
– Blake organizes
exhibition of his
works in his
brother's hosiery
shop at 28 Broad
Street, London.

	1810	1812	1814	1816	1818

Political

● 1812
War of 1812,
United States
against Great
Britain.
– Napoleon
marches on
Russia. Grand
Army retreats from
Moscow.
● 1813
Battle of Leipzig—
allies defeat
Napoleon.
– East India
Company loses
monopoly.

● 1814
Napoleon
abdicates.
– Accession of
Louis XVIII
(1814–24) in
France and
Ferdinand VII
(1814–33) in
Spain.
● 1815
Talleyrand
appointed Prime
Minister of France.
Napolean returns
to France, but is
finally defeated at
Waterloo, and
exiled to St
Helena.
– 38 German
states form a
confederation.

Arts

● 1810
Goya executes
the first of the
*Disasters of
War* series.

● 1813
G. Rossini's
Tancred first
performed.

● 1814
Goya exhibits his
*The Shootings of
May 3rd 1808*.
● 1815
Sir Thomas
Lawrence departs
for the Continent
to paint the
portraits of the
sovereigns and
statesmen
involved in the
overthrow of
Napoleon.

● 1816
Lord Elgin sells the
Acropolis Marbles
to the nation.

● 1819
John Martin
completes *The Fall
of Babylon*.
– German art
exhibition in Rome
creates critical
controversy and is
defended by
Schlegel.

● 1820
Abortive risings
in Portugal, Sicily,
Germany, and
Spain.
– George IV
(1820–30)
succeeds to British
throne.
● 1821
Greek War of
Independence
begins.

● 1825
Accession of Tsar
Nicolas I of Russia
(1825–55).

● 1827
Death of Canning,
the British Prime
Minister, who is
succeeded by
Wellington
(1828–30).

● 1829
Full Catholic
emancipation
granted in Britain.

● 1830
In France Charles
X abdicates and
a period of more
liberal rule under
Louis Philippe
follows.

● 1820
Géricault's *Raft of
the Medusa* arrives
in London and
goes on exhibition
at the Egyptian
Hall.
● 1821
First exhibition of
Constable's *The
Hay-Wain* at the
Royal Academy.
– Beethoven
begins work on his
Symphony no. 9.

● 1822
Horace Vernet sets
up independent
exhibition in his
studio after his
paintings are
rejected by the
Salon.
– The invention of
the Diorama by
L. J. M. Daguerre.
– The exhibition of
Delacroix's *Barque
of Dante and Virgil*
at the Salon.
● 1823
Quatremère de
Quincy publishes
*On the End of
Imitation in the
Fine Arts.*
– Schubert's
Fierabras
composed.

● 1826
Audubon
publishes *The
Birds of America.*

Index

Oxford History of Art

Titles in the Oxford History of Art series are up-to-date, fully-illustrated introductions to a wide variety of subjects written by leading experts in their field. They will appear regularly, building into an interlocking and comprehensive series.

Western Art

Archaic and Classical Greek Art
Robin Osborne
Hellenistic and Early Roman Art
John Henderson & Mary Beard
The Art of The Roman Empire
J. R. Elsner
Early Medieval Art
Lawrence Nees
Late Medieval Art
Veronica Sekules
Art and Society in Italy 1350–1500
Evelyn Welch
Art and Society in Early Modern Europe 1500–1750
Nigel Llewellyn
Art in Europe 1700–1830
Matthew Craske
Nineteenth-Century Art
Modern Art: Capitalism and Representation 1851–1929
Richard Brettell
Art in the West 1920–1949
Modernism and its Discontents: Art in Western Europe & the USA since 1945
David Hopkins

Western Architecture

Greek Architecture
David Small
Roman Architecture
Janet Delaine
Early Medieval Architecture
Roger Stalley
Late Medieval Architecture
Francis Woodman
European Architecture 1400–1600
Christy Anderson
European Architecture 1600–1750
Hilary Ballon
European Architecture 1750–1890
Barry Bergdoll
Modern Architecture 1890–1965
Alan Colquhoun
Contemporary Architecture
Anthony Vidler
Architecture in the USA
Dell Upton

World Art

Ancient Aegean Art
Donald Preziosi & Louise Hitchcock
Classical African Art
Contemporary African Art
African-American Art
Sharon Patton

Nineteenth-Century American Art
Barbara Groseclose
Twentieth-Century American Art
Erica Doss
Australian Art
Andrew Sayers
Byzantine Art
Robin Cormack
Art in China
Craig Clunas
East European Art
Jeremy Harvard
Ancient Egyptian Art
Marianne Eaton-Krauss
Indian Art
Partha Mitter
Islamic Art
Irene Bierman
The Arts in Japanese Society
Karen Brock
Melanesian Art
Michael O'Hanlon
Latin American Art
Mesoamerican Art
Cecelia Klein
Native North American Art
Janet Berlo & Ruth Phillips
Polynesian and Micronesian Art
Adrienne Kaeppler
South-East Asian Art
John Guy

Western Design

Twentieth-Century Design
Jonathan M. Woodham
Design in the USA
Jeffrey Meikle

Western Sculpture

Sculpture 1900–1945
Penelope Curtis
Sculpture Since 1945
Andrew Causey

Photography

The Photograph
Graham Clarke

Special Volumes

Art and Film
Art and Landscape
Malcolm Andrews
Art and the New Technology
Art and Science
Art and Sexuality
Art Critical Theory: A Reader
Donald Preziosi
Portraiture
Women in Art